TATE BRITAIN COMPANION

Tate Britain Companion *A Guide to British Art*

Edited by Penelope Curtis

TATE PUBLISHING

Contents

This Companion guide, as its name suggests, draws from Tate's unparalleled collection of British art and largely reflects the works currently on show at Tate Britain. The selection of works, both for display in the gallery and for illustration in this publication, has been made in response to a new framework underpinning the way the collection is presented. The BP Displays, which BP have supported for nearly twenty-five years, are now presented following a new pattern and pace. They have been arranged to ensure that the collection's full historical range, from 1545 to the present, is always on show. In this way we hope to meet an important set of our audiences' needs and aspirations when exploring the national collection of British art. Whilst a delight in the unexpected may on occasion counterbalance a wish for the familiar, the desire of the visitor to be able to re-visit and re-experience works in the collection remains a key consideration for any successful museum or gallery. It is with these concerns in mind that we now offer a semi-permanent circuit presenting the collection from its beginnings to its end. This 'walk through time' aims to show how the collection is one collection, rather than divided into sections, and therefore aims also always to bring the visitor right up to the present day.

However, other gallery users want and expect to see more of the collection, and in different ways. To achieve this, the circuit is off-set by changing focus galleries that offer a more heavily authored approach to specific parts of the collection. Sometimes, of course, these different requirements intersect; we hope to find ways to develop these conversations between different parts of the collection, including the archive, so that we add depth of field to the chronological spine.

The chronological circuit is, in one way, highly traditional. It presents art in chronological order. True chronology, however, rather than art historical order, is actually somewhat unusual as a display method. We also used chronology as a more radical tool through which to re-examine the collection. Using dating rather than the representation of schools or movements as the key selection criterion enables us to bring forward neglected works alongside the more obvious ones.

This is not to say that a visual approach to selection has been relegated: it has remained crucial, tempering the strictly chronological with the aesthetic in order to present a hang that is good-looking as well as relatively neutral in its categorisations. In looking beyond standard room groupings, and setting themes to one side, we have aimed to create a walk through British art which is properly historical and thus allows well-known and less well-known works to emerge within the same period, for different types of subject and style to sit side by side, and which, above all, allows our visitors to take an enjoyable stroll through time, stopping as and when they wish.

To achieve these new display approaches, the gallery layout has been reconfigured so as to create a circuit around its outer perimeter, exploiting the wonderful natural asset we have in the long enfilades of galleries that open onto each other up and down the western and eastern sides. This more instinctive approach to the gallery's existing architecture echoes the works of restoration and recreation carried out by our architects Caruso St John.

These promenades, in a continuous and unified run, aim to people any given period with a mix of the known and the unknown. This book aims to do the same, although the need to make a selection has necessarily obliged us to favour the former over the latter. Nonetheless, we hope that, in common with our new chronological circuit, it provides a cross-section that is at once representative of what we know as 'British art', while introducing some less-familiar companion pieces.

The galleries also now provide more information about the complicated genesis of a national collection of British art, which led in 1897 to the creation of the branch of the National Gallery that was to become known as the Tate. These origins mean that for purely historical reasons the collection is strongest in works from the nineteenth- and twentieth-centuries: in the past, the collection has also tended to focus more on painting, and less on sculpture, photography and works on paper. Whilst the collection reflects but does not fully represent the post-Reformation period, it comes into its own with the extraordinary bequest of J.M.W. Turner, and then with works created in Britain during its various stages of Imperial and post-Imperial security and insecurity. London (rather than England) has an inevitable dominance as the centre of the national and international art market, and from the earliest times, which means that works from Scotland, Wales and Northern Ireland, are often principally represented in other national institutions.

As in the galleries, the works in this publication are arranged in the order of their making. The texts focus firstly on the work and its history, both before and after its arrival in the gallery, and only secondly on its maker. These are individual works in time. The overall selection of works and later editing was undertaken by Chris Stephens and me; every curator has been involved in the writing, and the texts were edited in the first instance by Martin Myrone, Alison Smith, Chris Stephens and Ann Gallagher, representing the four period teams (Pre-c.1800, Nineteenth Century, Modern and Contemporary) who cover the nearly five hundred years of British art on show in Tate Britain. These entries have also drawn on the scholarship of previous Tate curators and conservators, whose detailed research provides a remarkable resource. Lorna Robertson and Judith Severne have both assisted in the process of compilation.

The richness of the Tate's British fine art collection is unequalled; it is thus possible, if tantalisingly difficult, to make a selection which can even claim to represent its history. We would like to think that this book can act both as a companion to Tate Britain, as well as a companion to British art.

Penelope Curtis Director, Tate Britain

John Bettes (active London from 1531 – London ?1570)
A Man in a Black Cap 1545
Oil paint on panel 47 × 41. Acquired 1897

This small portrait of an unknown man on oak panel is currently the earliest painting in the Tate collection. It was bought at a sale in 1897 on behalf of the National Gallery and transferred to the Tate Gallery in 1949. Once a larger portrait, at some point before 1897 the painting was cut down to its present size leaving a large central vertical panel and two thin strips on each side. Remarkably, an original inscription survives on the back of the work. telling us that the painting was 'made by John Bettes, Englishman' ('*faict par Johan Bettes Anglois*'). Original records of this nature on such early paintings are incredibly rare. Further inscriptions on the front of the painting indicate that it was completed in 1545 and that the sitter was twenty-six years old. The background behind the figure appears now as an uneven blotchy brown colour but would once have been a rich deep blue. The pigment, known as smalt, has discoloured over time.

The nineteenth-century sale record and eighteenth-century accounts of a coat of arms that once occupied a part of the larger painting suggest that the sitter is Edmund Butts. He was the third son of Sir William Butts, physician to Henry VIII. Butts's eldest son, William, was painted by John Bettes in 1543. Dr Butts died in 1545, the year this portrait was painted, and his sons inherited considerable wealth – which may account for the commissioning of this work.

British art in the sixteenth and seventeenth centuries was dominated by artists from overseas, who were considered to be much more advanced in their training and sophisticated in their technique than native-born artists. The influx of migrant artists and their domination of the most lucrative commissions caused consternation among native painters, who complained via the guild that represented them – the Company of Painter-Stainers. Bettes was one of the few successful English artists competing with the incomers. He came from a family of painters and lived in Westminster, rather than the City of London where most artists were based, but little more is known of his life and few works by him are known to survive.

Bettes's work shows the influence of the German-born Hans Holbein the Younger (c.1497/8–1543). Holbein came to England from Basel for the first time in 1526 and settled in London from 1532 until his death eleven years later. He painted the most important figures of the age, including, most famously, Henry VIII. As the earliest known figure in British art with a large, skilled and prominent body of work, he is often identified as the natural starting point for histories of British painting. Even so, traditional distinctions between 'British' and 'foreign' artists have meant that Holbein is not currently represented by any work in the Tate collection. TJB

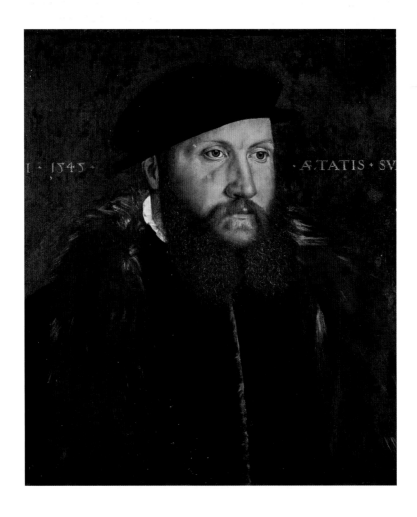

Hans Eworth (first recorded Antwerp 1540 – London 1574)
An Unknown Lady c.1565–8
Oil paint on panel 99.8 × 61.9. Acquired 1984

Despite the large and elaborate coat of arms in the upper left-hand side of the painting, which should identify the sitter precisely through a magnificent display of dynasty, the subject of this portrait remains unidentified. Technical examination has shown that the arms were added as much as a century after the portrait was painted. They are the arms of Henry Clifford, 2nd Earl of Cumberland, and his wife Eleanor, daughter of Charles Brandon, Duke of Suffolk, and as a result the painting has in the past been exhibited as a portrait of Lady Eleanor, despite the fact that she died in 1547, well before the date of this portrait. The inscription (top right), which should accurately record the age of the sitter and the date, has unfortunately been truncated, although the Roman numerals 'M.D.LXV [...]' can only apply to 1565–8. The picture was in the collection at Wentworth Castle by 1866, prompting the suggestion that the sitter is one of the three daughters of Thomas, 1st Baron Wentworth of Nettlestead.

The erroneous coat of arms is evidence of a confused memory of the sitter's identity within only two or three generations of the portrait being painted, a situation that is typical of many sixteenth-century pictures. In addition to this, the artist Hans Eworth, now acknowledged as the most important painter working in England after the death of Hans Holbein, was only established as such in an article published by Lionel Cust in 1913. Before that, portraits with the artist's signature 'HE', found on a number of Eworth's works, were incorrectly ascribed to the painter Lucas de Heere. It was as a work by de Heere that this picture was exhibited throughout the nineteenth century.

Despite her lack of a precise identity the sitter is presented here as a lady of the highest rank through the meticulous rendering of her gold-embroidered and gem-encrusted costume and her expensive jewellery, which she would most likely have actually owned. Her dress, originally a red of much greater intensity as the pigment has faded, is studded with pearls. The elaborate pendant at her throat incorporates a cabochon ruby, table-cut diamonds set in enamelled gold, and a large pearl; on each wrist she wears a pearl and ruby bracelet; and hanging from a black ribbon at her waist is her most important jewel, a chased gold and chalcedony cameo, set in diamonds, representing Prudence holding a diamond or rock crystal mirror, emblematic of wisdom.

Eworth trained in Antwerp but was working in England by the 1540s and became the principal court painter in the reign of Mary I (1553–8). Around forty paintings are now attributable to him, most of which are portraits. This work, purchased with assistance from the Friends of the Tate Gallery in 1984, demonstrates many of the characteristics of his technique identified through the technical analysis of some of his works. In line with the Elizabethan love of surface pattern, Eworth's work demonstrates close attention to detail. He also made use of underdrawing, which can be seen in the finely modelled face, showing through paint made more transparent with age. TEBB

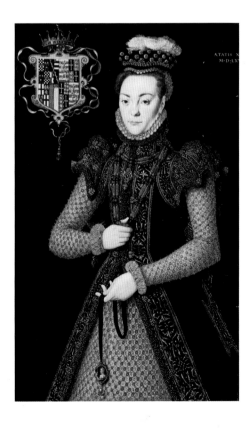

Marcus Gheeraerts the Younger (Bruges 1561/2 – London 1636)
Portrait of Captain Thomas Lee 1594
Oil paint on canvas 230.5 × 150.8. Acquired 1980

This strikingly unusual painting of a man with bare legs is full of the political symbolism and allegory that can often be found in Elizabethan portraiture. It is a piece of visual propaganda that was intended to send out a message to all that looked at it: loyalty to the Queen. It depicts Thomas Lee (1552/3–1601) who was a soldier active in Ireland, and was produced at a time when he was attempting to secure his position as the Crown's chief negotiator with the Irish. With bare legs and open shirt, he is presented in what was then thought to be the dress of an Irish foot soldier. A Latin inscription on the tree refers to the Roman soldier Gaius Mucius Scaevola, who stayed true to Rome even among his enemies. Lee's limp, injured hand being shown to the viewer may also refer to Scaevola, whose own hand was damaged in an act of reckless bravery. The inference is that Captain Lee would stay true to the queen while bravely negotiating peace with the enemy.

The sixteenth century saw the confiscation of land in Ireland and its settlement by the English, known as the 'plantations'. Small numbers of planters emigrated there during the reign of Henry VIII (1509–47) and the first mass colonisation began under the reign of Elizabeth I (1558–1603) with the Munster Plantation in the 1580s. Conquest of land in Ulster led to the Nine Years Wars (1594–1603), which preceded the colonisation of the Ulster Plantation under James I (1603–25). Thomas Lee was a key figure in this ruthless, imperialist campaign.

Marcus Gheeraerts the Younger was born in Bruges, the son of a painter, but as a Protestant was forced to flee to London owing to religious persecution. Little is known of his early life, though it is likely that he was trained as a painter by his father. In 1592 he was commissioned by Sir Henry Lee to paint a portrait for his house at Ditchley of Queen Elizabeth I, known as the 'Ditchley Portrait' (National Portrait Gallery). Sir Henry Lee KG, a relative of Captain Thomas Lee, was one of Elizabeth I's favourite courtiers, holding the position of the Queen's Champion of the Tilt and was responsible for creating the imagery for her annual Ascension Day celebrations. He may have helped devise the complex symbolism in the portrait of Captain Thomas Lee, the painting being displayed at his house in Ditchley along with the portrait of the queen.

This picture was first recorded at Ditchley in 1725, but was presumably painted for Sir Henry Lee and was always in the family collection. It was sold at auction at Christie's in 1933 and passed to a private collector, who lent to the Tate Gallery from 1953 until its purchase by Tate in 1980. It has often been displayed at Tate and in loan exhibitions as an outstanding example of large-scale Elizabethan portraiture as well as for its intriguing iconography, which seems to offer insights into late sixteenth-century elite culture. TJB

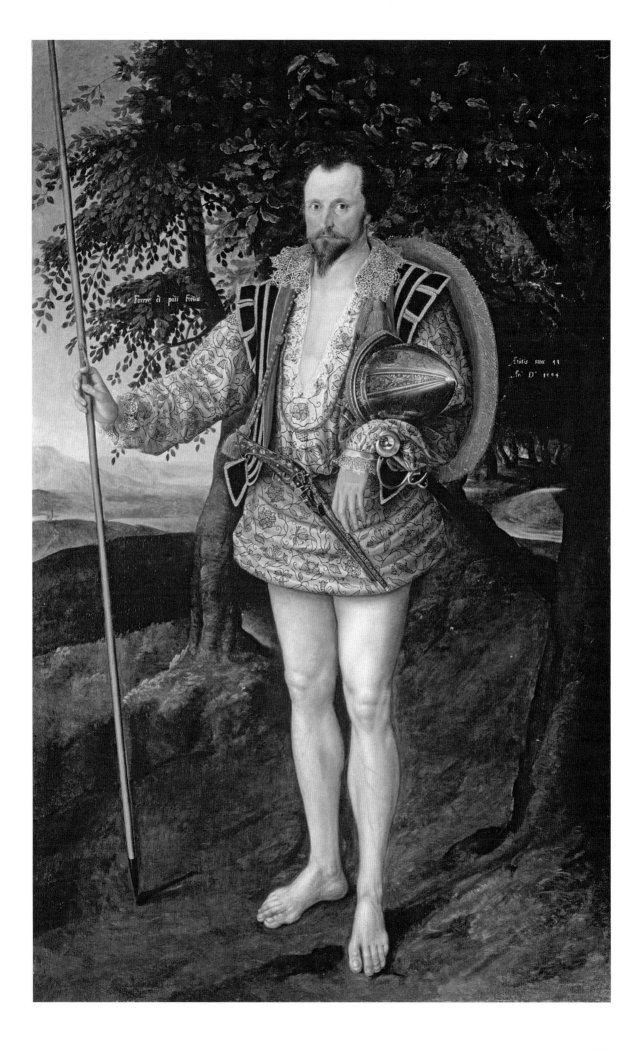

13

British School
An Allegory of Man 1596 or after
Oil on wood 57 × 51.4. Acquired 1990

The Protestant Reformation and accompanying focus on the prohibition of graven images in the Second Commandment resulted in a cultural transformation in England where religious images, especially in places of worship, were viewed with suspicion and disquiet. The danger of idolatry, or the worshipping of images instead of the truth of the Scriptures, was believed to be very real. Religious paintings of this period are therefore rare.

Acquired in 1990, Tate's small panel painting is an allegory of Christian faith. Man appears in the centre shielded by Christian and moral virtues whose inscribed names wrap themselves protectively around him. He is attacked from all sides by the Seven Deadly Sins and the temptations of the world. To the left, a lady in elaborate costume fires arrows of 'Sloth', 'Gluttony' and 'Lechery'. She wears a jewel with an hourglass device suspended from her waist, presumably alluding to time wasted by sloth. At the bottom, on the right, a winged figure representing the Devil stands in a pit of flames, aiming arrows labelled 'Pride', 'Wrath' and 'Envy'. Above him Death, shown as a macabre skeleton, wields a spear. The lengthy inscription at the bottom warns against the evil of worldly vanity and instead urges prayer to ensure the safe passage of the soul to heaven. The Risen Christ in Heaven, offering salvation, appears at the top.

The fact that the inscriptions are in English is clear evidence that the work was intended for a British audience. Originally thought to date from the 1570s, technical analysis and dendrochronology (the dating of the oak panels by analysis of their tree rings) undertaken in 1997 resulted in the slightly surprising discovery that the painting must date to 1596 or later. Its original purpose is not known. Religious imagery continued to be produced in Protestant England but it was more commonly found in a domestic setting where, divorced from divine worship, the danger of idolatry was considered less of a risk. The inclusion here of text to make explicit the Christian message reflects the Protestant emphasis on scriptural truth. As in popular woodcuts of the period, the word is used to support visual imagery.

The artist of this work must have had familiarity with other printed imagery, especially Flemish prints that show Man as a Christian Knight, flanked by Death and the Devil and assailed by arrows of sin. TEBB

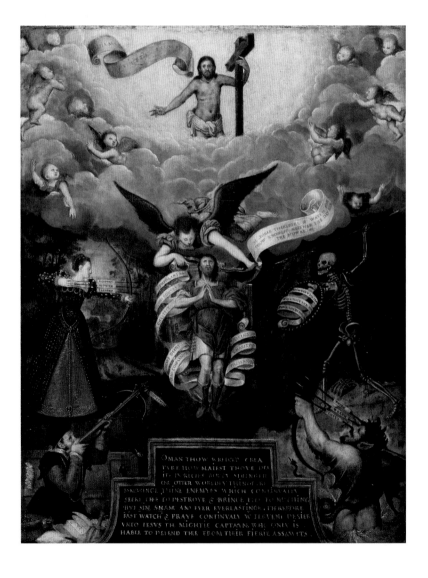

British School seventeenth century
The Cholmondeley Ladies c.1600–10
Oil on wood 88.6 × 172.3. Acquired 1955

At first glance the ladies in this highly stylised and decorative double portrait appear to be identical, but closer inspection reveals differences in the colour of their eyes, the detailing of the lacework and the jewellery that they wear. They are shown sitting up in bed each holding a baby wrapped in a red Christening robe, the embroidered design of the child's clothing matching that of their mother's. The inscription on the bottom left corner of the painting tells us that it depicts 'Two Ladies of the Cholmondeley Family, Who were born the same day, Married the same day, And brought to Bed [gave birth] the same day.' The identity of the sitters is uncertain but they may be Mary and Lettice, the daughters of Sir Hugh Cholmondeley (pronounced 'Chumley') the Younger (1552–1601) and Dame Mary Cholmondeley (née Holford, 1563–1625), 'the bold lady of Cheshire'. Sisters of a similar age, they both gave birth to children around the same time in the early 1600s and this picture was possibly commissioned to commemorate a joint baptism. At a time when child mortality rates were high, paintings making a permanent record of family units, which were all too often transient in reality, were quite common.

The identity of the painter is not known. However, the style of the painting is very archaic and might even be considered naïve, suggesting that it is by a regional artist, presumably one active in Cheshire where the probable sitters lived. Whilst the names of most of the elite painters commissioned by royalty and the London-based nobility are known, the lives of the many more painters and craftsmen working in the provinces remain obscure. The composition of the painting is also very unusual and is not found in any other picture from this period. It is more reminiscent of sculpted tomb effigies, which often have a flat, stiff and symmetrical design similar to the look of this work. The picture's unusual character and limited colour scheme may indicate that the painter was a herald, a local official who would be more familiar with the graphic representation of pedigrees and arms than the naturalistic conventions of the most up-to-date kinds of portrait painting current at court.

For most of its life the picture hung at Vale Royal, a grand house near Northwich in Cheshire and home for several centuries to a branch of the Cholmondeley family. It was sold at auction in 1939 by the Rt Hon. Hugh Cholmondeley, 3rd Baron Delamere, where it was bought by a member of the Howard family. After being sold again at auction in 1955, it was presented to the Tate Gallery anonymously in memory of Francis Howard. The painting has been on display at Tate almost constantly since then. Although an anonymous work and very unlike the more 'sophisticated' art that dominates the Tate collection, it has become a much-loved icon, the image for many years being one of the best-selling postcards in the gallery shop. Its popularity may lie in the linearity, simplicity and non-naturalism of the painting, which helps give it a distinctly 'modern' appearance. TJB

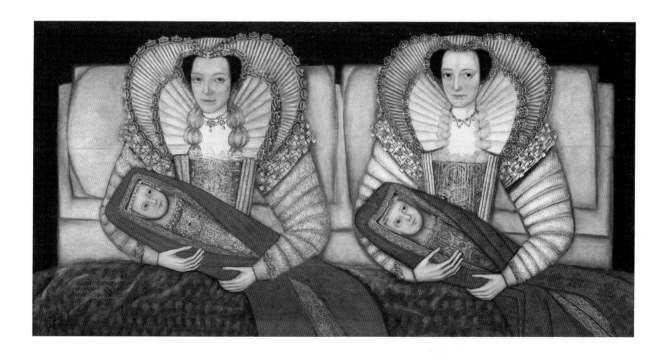

Nathaniel Bacon (Redgrave, Suffolk 1585 – Culford, Suffolk 1627)
Cookmaid with Still Life of Vegetables and Fruit c.1620–5
Oil paint on canvas 151 × 247.5. Acquired 1995

This sumptuous painting showing a cookmaid with an abundance of produce is a very unusual work for a British artist of the early seventeenth century. The painter is also atypical in that he was a member of the nobility and did not paint by profession or to earn a living, but painted for his own pleasure. The prominent cleavage of the young woman and the melons alongside her gives a sexual quality to the picture and suggests fecundity – the fruits and fertility of nature and human existence.

Sir Nathaniel Bacon was born in Redgrave, Suffolk, the youngest son of Sir Nicholas Bacon of Redgrave, the leading baronet of England. In 1614 he married Jane, Lady Cornwallis (née Meautys), an attendant to James I's queen, Anne of Denmark, acquiring Culford Hall near Bury St Edmunds from his parents and Brome Hall (now demolished) near Eye from his wife. Nothing is known of his training as a painter, but his style and choice of subject matter suggests that this was gained in the Netherlands rather than in England. Still-life painting was not being produced in Britain at this time, but it had been a popular genre in the Low Countries for a number of years. 'Cookmaid' or 'market scenes' originated there in the mid-sixteenth century and continued to be produced by later artists such as the Antwerp-based painter Frans Snijders (1579–1657). We know that Sir Nathaniel travelled in the Southern Netherlands, visiting Antwerp in 1613.

Along with painting, the other great interest of Sir Nathaniel was gardening and the cultivation of plants, which was becoming increasingly fashionable at this time. His detailed knowledge is shown in the exactitude with which he paints the various varieties of fruit and vegetable, which includes a variety of grape recently introduced from North America. Meanwhile the melons, which act as a central motif, would have had particular resonance for the artist, who had grown them on his estate at Brome Hall.

It is likely that this work was one of a set of paintings of a similar nature displayed at his grand house, Culford Hall. An early account dating from 1659 records 'Ten, Great peeces in Wainscoate of fish and fowl &c done by Sr: Nath: Bacon' hanging 'On the great Stayere [Stair] and in the Gallery' at Culford. Only twelve works by the artist are known to survive, but two of these, *Cookmaid with Still Life of Birds* (private collection) and *Cookmaid with Still Life of Game* (private collection), are thought to be part of this series. Both have a similar format and size to the Tate picture, and they share the same arrangement: a cookmaid presenting an object alongside a large display of various produce.

The Dutch character of the painting and the relative obscurity of the artist meant that for many years the picture was misattributed. It emerged on the art market in 1973 and was then thought to be the work of the Dutch painter Adriaen van Utrecht. It was sold at Christies in 1993, this time as by Nicholaes van Heussen; the private buyer at that sale sold it to the Tate Gallery a few years later. TJB

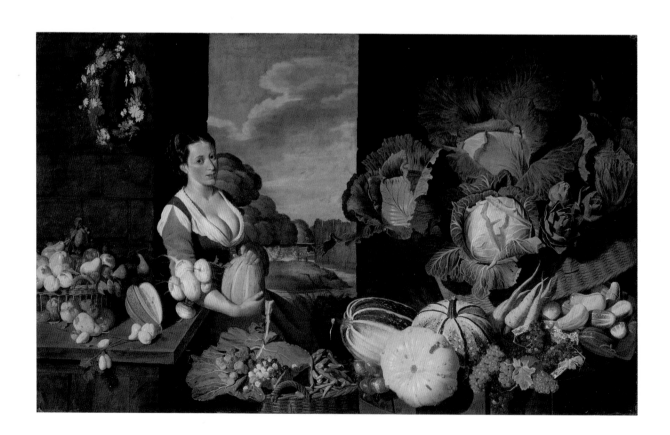

Peter Paul Rubens (Seigen, Westphalia 1577 – Antwerp 1640)
*The Apotheosis of James I and Other Studies: Multiple Sketch for
the Banqueting House Ceiling, Whitehall* c.1628–30
Oil on oak panel 94.7 × 63. Acquired 2008

Rubens was one of the most celebrated and influential painters in his time. He was active primarily in Antwerp where he had a large and successful studio, so is not a figure generally thought of in terms of British art history. But in 1621 he was approached by the British court on behalf of James I to produce paintings for the ceiling of the recently completed Banqueting House at Whitehall Palace, London. Designed by the architect Inigo Jones in the classical style, and the only building of the royal palace still standing today, the Banqueting House was where foreign ambassadors were received and court masques were performed. For various reasons the commission with Rubens stalled and James I died in 1625. A few years later in 1629 Rubens was in London at the court of the new king, Charles I, serving as a diplomatic envoy of Philip IV of Spain in an attempt to secure peace between the two countries. During this visit it was finally agreed that the artist would produce the ceiling paintings, which would be a celebration of the peaceful reign of James I.

This panel is incredibly important as is gives us an insight into Rubens's earliest ideas for the scheme, the artist sketching out how the entire ceiling might look and the different elements that would make up the composition. In the centre we can see the figure of James I being carried up to the heavens by Jove's eagle, assisted by the figure of

Justice with Minerva (Wisdom) above. On either side of the king four ovals contain allegorical personifications of his royal virtues, while across the top and bottom *putti*, animals and swags of produce symbolise the benefits of national unity and peace. It is possible that this sketch was made in London and shown to Charles I for his approval before the artist returned to Antwerp in 1630. Small painted studies of each of the scenes were then produced, before the final paintings were completed and shipped over to London in 1635 for their installation. These magnificent canvases were some of the last images Charles I would have seen on 30 January 1649 as he was led through the Banqueting House out to the scaffold to be beheaded.

The painting was acquired by Tate in 2008 following a public appeal and is the only work by the artist in the collection. His absence from the national collection of British art was due, in part, to the fact that works connected to his British commissions are few and rarely become available. However, it is also the case that the artist has traditionally been viewed as a European painter, and his works collected and displayed in a European 'old master' context. The important acquisition of this painting allows the artist to be seen in the specific context of British art history, and to highlight his important contribution to the cultural activity of this country in the early seventeenth century. TJB

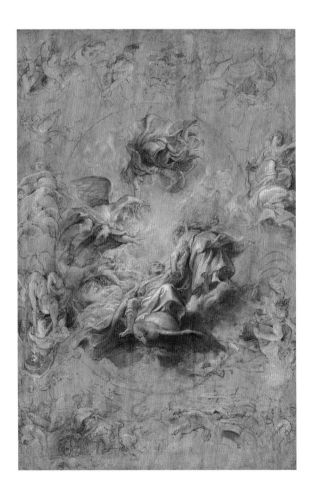

Anthony van Dyck (Antwerp 1599 – London 1641)

Portrait of Sir William Killigrew 1638
Oil paint on canvas 105.2 × 84.1. Acquired 2002

Portrait of Mary Hill, Lady Killigrew 1638
Oil paint on canvas 106.5 × 83.3. Acquired 2003

The influence of Sir Anthony van Dyck on portrait painting in Britain goes beyond that of any other individual artist. Born and trained in Antwerp, he worked in the workshop of Rubens before coming to England briefly in 1620–21. He returned to London in 1632 and was appointed 'Principal Painter' to Charles I, and given a house on the Thames at Blackfriars and a large annual pension. Apart from returning to Antwerp in 1634–5, he made England his home until his death in 1641. As the king's painter he immediately transformed the image of Charles I, Queen Henrietta Maria and the British aristocracy. The short, stuttering, monarch was presented as a commanding leader in a series of full-length and equestrian portraits; aristocratic women as beautiful and alluring in their rich, sumptuous, satin dresses; various dukes and earls as dashing and impressive in his 'swagger' portraits. Van Dyck's legacy can be seen immediately in the generation of artists that followed him, such as Robert Walker and Sir Peter Lely. But his influence extends through the centuries and a roll call of the greatest British portrait painters, from Joshua Reynolds and Thomas Gainsborough through to John Singer Sargent.

In this more modest pair of half-length portraits, Sir William Killigrew (1606–95) is shown leaning against a column, gazing pensively into the distance. Dressed in an expensive black satin jacket and white satin shirt with lace collar, the ring tied to black ribbon hanging from his neck perhaps alludes to the memory of a loved one. By the time this was painted, Sir William had been a courtier to Charles I for a number of years, holding several high offices. In 1625 or 1626 he married Mary Hill, daughter of John Hill of Honiley, Warwickshire. Holding a rose symbolising her love and marriage, she is shown wearing a simplified dress without any of the usual fine lace, making it easier and quicker for the artist to paint.

Given the importance of van Dyck to British art, it is surprising that there are so few works by him in the Tate collection. The portrait of Sir William Killigrew was acquired in 2002, only the second work by the artist to enter the collection. Within a year the portrait of Mary Hill, Lady Killigrew appeared on the market separately, from a different source, and was subsequently also acquired by Tate. In doing so the portrait pair were reunited for the first time for at least 150 years, and are now thought to be the only companion pair husband-and-wife portraits from van Dyck's English career in a British public museum. They were shown together in the exhibition *Van Dyck and Britain* (Tate Britain, 2009), which was an opportunity to reassess van Dyck's work in Britain and highlight his considerable impact on British art. TJB

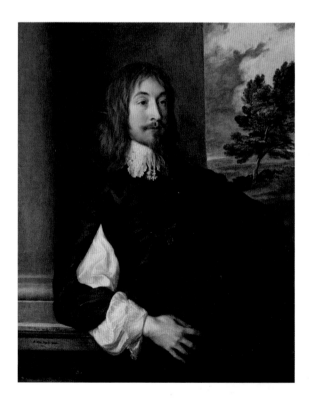
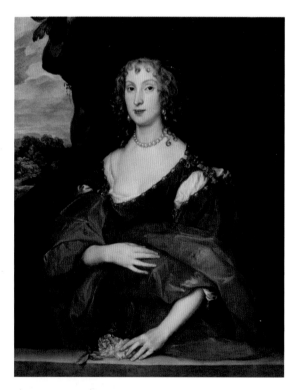

William Dobson (London 1611 – London 1646)
Endymion Porter c.1642–5
Oil paint on canvas 149.9 × 127. Acquired 1888

Endymion Porter (1587–1649) was a favoured courtier of Charles I, a diplomat, a connoisseur and patron of the arts, and played an important part in locating paintings and sculptures for the king. He is shown dressed as a modest country squire receiving the quarry of his hunt, but his pose is based on that of the Roman Emperor Vespasian as depicted in a painting by Titian – the Venetian master being the favoured artist of connoisseurs at this time. The large marble bust of Apollo, god of the arts, presides over the scene in the background symbolising Porter's cultural patronage. It may also allude to the 'Apollo Room' at the Devil's Tavern in Fleet Street, the meeting place of poets and literary gatherings. The allusion to the arts is continued in the classical frieze in the bottom right corner of the portrait, which depicts the muses of painting, sculpture and poetry.

The picture was created as Britain was descending into civil war, which would culminate in the beheading of Charles I in 1649. The king and his court had been forced to flee London by Parliamentary forces, setting up a temporary home in the safety of Oxford, and it is likely that it was here that Dobson completed his portrait of Porter. Just as this work of art was being finished, Puritans such as William Dowsing were scouring churches across the country and destroying religious paintings, sculptures and artefacts that they deemed to be sacrilegious.

William Dobson is considered the greatest native-born British painter of the seventeenth century, working at a time when British art was dominated by artists from abroad. The death of van Dyck in 1641 had created opportunities for other artists such as Dobson, but the turmoil of the civil wars cut this short. Despite the unique position and status of this native British artist in this period, the Tate collection contains only two other paintings by Dobson: a small portrait of the artist's wife (T06640) and a portrait of an unknown military officer (N04619).

The portrait of Endymion Porter was sold at auction at Christie's in 1888 where it was bought by the National Gallery, the first work by a British artist active before Hogarth to enter the national collection. In 1951 it was included in an exhibition at the Tate Gallery, and was transferred to the Tate collection the same year. The artist, the portrait and its wider context were examined in great detail in the pioneering 'in focus' exhibition *Endymion Porter & William Dobson*, curated by William Vaughan at the Tate Gallery in 1970. The painting has been on display at Tate almost constantly, and the artist's profile has been further raised by an hour-long BBC Four programme broadcast in 2011 extolling Dobson as the first great British artist. TJB

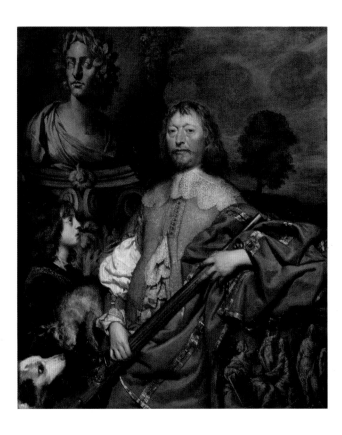

Henry Gibbs (London 1631 – Canterbury 1713)
Aeneas and his Family Fleeing Burning Troy 1654
Oil paint on canvas 155 × 159.8. Acquired 1994

Paintings of scenes from ancient history or literature are extremely rare in British art before the eighteenth century, such was the dominance of portraiture over the other genres of painting. The subject matter of this unusual work is drawn from the epic poem *Aeneid*, written by the Roman poet Virgil in the first century BC. It tells the legendary story of Aeneas, a Trojan who travelled to Italy and became an ancestor of the Romans. In this scene we see Troy under attack and in flames. The Trojan horse used by the Greeks to secretly enter the city is shown in the centre of the background, with the hatch in its side from where the soldiers emerged. Aeneas is depicted on the left wearing a yellow tunic, carrying his elderly father Anchises and ushering his young son Ascanius to safety. But his wife Creusa falls behind and is captured by a Greek soldier, sealing her fate.

This painting was offered for sale to Tate by a dealer in Brussels in the early 1990s, having been bought from an Antwerp shipping company. It is thought to have been purchased in London before the Second World War by a Dutch private collector, but records of this sale are yet to be found. Until its acquisition nothing was known of Henry Gibbs. Subsequent research uncovered a gentleman-painter of that name active in Kent in the mid-seventeenth century, who was at various times both alderman and mayor of Canterbury. This is his only known work, which is signed and dated 'Hnry Gibbs fecit/1654', although a copy of Rubens's *Judgement of Solomon* (Royal Museum and Art Gallery, Canterbury) is traditionally said to have been a work for which he was known to have been paid in the 1680s. Nothing is known of his training as a painter but his style shows the influence of Francis Cleyn, the artist who was active at the court of Charles I and became his chief tapestry designer at the royal tapestry works at Mortlake.

The original location of the painting or how it was displayed is also unknown. The unusual format of the canvas – almost square – suggests that it may have been intended for a decorative function, such as a prominent position on the wall above a mantelpiece in a grand house, or that perhaps it was a design for a tapestry. Similarly, the significance of the subject matter has yet to be fully worked out. However, the theme of a burning city, a family fleeing for their lives and death of a loved one would have been particularly resonant at this time, as memories of the civil wars that had torn Britain apart in the 1640s would have still been very raw. By the time this painting was completed, King Charles I had been executed and Oliver Cromwell had assumed the title Lord Protector of the Commonwealth. TJB

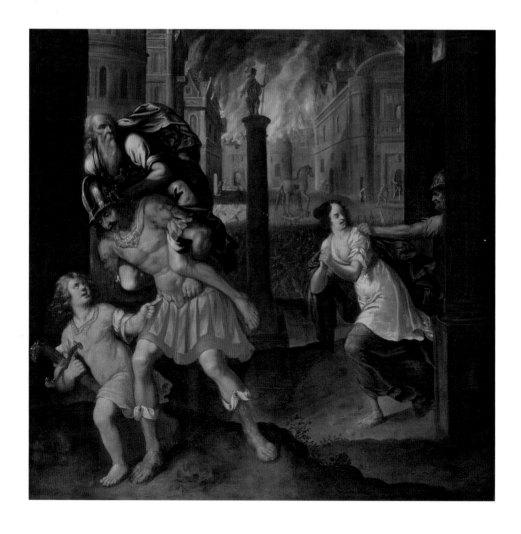

Peter Lely (Soest, Westphalia 1618 – London 1680)
Two Ladies of the Lake Family c.1660
Oil paint on canvas 127 × 181. Acquired 1955

Born Pieter van der Faes in Soest, Westphalia, and trained in Haarlem, Lely moved to England in the early 1640s and during the civil war years and Interregnum built up a highly successful portrait practice. He was to become the dominant artistic presence of the post-Restoration period.

With his appointment in June 1660 as Principal Painter in Ordinary to the King, a position previously held by Sir Anthony van Dyck, there was a clear expectation that Lely should emulate the distinct portrait aesthetic created for the court of Charles I by his predecessor. Lely's indebtedness to van Dyck's images of courtly beauty is apparent in this portrait of two ladies, shown outdoors seated on a stone ledge, perhaps in a garden, with a view on to a verdant and wooded landscape beyond. Their rich dresses of blue and bronze silk indicate their status while their setting conjures a pastoral air. Lely's portrait reflects the seventeenth-century ideal of female beauty, a quality that embodied easy, effortless grace. A deliberate visual parallel is made between the natural beauty of the younger lady on the left and the lush beauty of the landscape beyond, while her companion manages her silk scarf with a graceful gesture of her hand. Guitar-playing was a particular fashion at court in the early 1660s and the younger lady is in the act of strumming a chord, a further signal of her accomplishments and feminine charm. Lely's vision is thus carefully constructed, but reflects the natural artifice that had become a key component of court visual culture.

The precise identities of the two ladies are not known but the picture's provenance connects it to the Lake family of Canons, Middlesex, the estate purchased in 1713 and transformed into a grand mansion by the Duke of Chandos, who had married a member of the Lake family in 1696. Lely's double portraits of women were probably inspired by the double, or friendship, portraits of van Dyck, a genre that he developed particularly in England. Lely owned van Dyck's *Lady Elizabeth Thimbleby and Dorothy, Viscountess Andover* (c.1637, National Gallery, London). The portrait most likely represents two ladies related by family. Hierarchical convention should place the most important sitter to the left of the other but as the sitters remain unidentified, the nuances of their relationship to one another remains unknown.

The costume and hairstyles of the sitters as well as Lely's fine brushwork to indicate texture, the rich use of colour and sensitive modelling date the picture to c.1660. It reflects a 1706 assessment of Lely's best work as possessing beautiful colouring, a graceful air to his sitters and a 'genteel and loose management of the *Draperies*'. TEBB

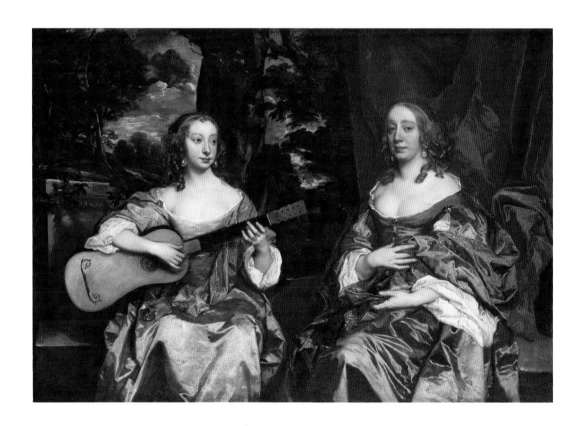

Gilbert Soest (?Netherlands c.1605–London 1681)
Portrait of Henry Howard, 6th Duke of Norfolk c.1670–75
Oil paint on canvas 127 × 107.5. Acquired 1965

In the decades following the Restoration of the monarchy in 1660, the field of portraiture was dominated by the figure of Sir Peter Lely, but other artists had respectable practices, one of whom was Gilbert Soest. Soest, pronounced 'Zoust' by his contemporaries, most probably came to England from the Netherlands in the 1640s. From 1658 until his death he lived in London, in Tucks Court, off Cursitor Street, near Chancery Lane. As with many artists operating in Britain at this time, tangible information concerning Soest is either scarce or largely anecdotal. Even his Christian name has been questioned; traditionally given as Gerard, it has recently emerged that contemporary tax records refer to him as Gilbert. Some idea of his portrait practice can be constructed from the portraits known today that are either signed or attributed to him. It was a business that stretched over thirty years but he never worked directly for the court, nor does he seem ever to have established himself in the most fashionable circles. Some of his aristocratic and gentry clients were important figures, however, including Henry Howard, 6th Duke of Norfolk, the subject of this portrait.

The grandson of Thomas Howard, 14th Earl of Arundel (1585–1646), the great 'collector Earl' and patron of the arts in the reign of Charles I, Henry Howard became head of a family noted for its loyalty to the crown during the Civil War and for its prominent Catholicism. At a time when it was difficult for Catholics to hold high office, Howard was unable to assume as useful a role in public life as he would have liked, but in 1664–5 he had travelled on an embassy to Constantinople to Sultan Mahomet IV, and in 1669–70 was in Tangier as Charles II's Ambassador Extraordinary to negotiate a commercial treaty with Sultan Rashid II, emperor of Morocco. It is to this latter embassy (despite its inglorious outcome) that the ships in the background presumably refer, and Howard's public role as ambassador that the portrait commemorates.

Soest shows Howard in a commanding pose before a rocky outcrop, one hand on his hip (suggested by the drapery of Howard's sleeve silhouetted against the sky), the other arm resting on a natural ledge. It is almost the pose of a naval officer, but instead of uniform Howard appears in fashionable finery, in a costume of embroidered silk with gold lace, and looped ribbons at the sleeves. The portrait was formerly dated c.1669 as he was thought to be wearing a 'Persian vest', a short-lived fashion introduced at court by Charles II in 1666 as an anti-French gesture. But in fact his dress is consistent with fashion of the 1670s, and is worn by sitters in other portraits by Soest dateable to this time.

Soest's drapery has a characteristic metallic-like quality and his sitters a somewhat inflated appearance (especially the skin of the hands), elements that give his work a high degree of individuality. It reminds us that beyond the dominance of Lely's studio the mid- to late seventeenth-century art world was in fact a more varied and idiosyncratic one.
TEBB

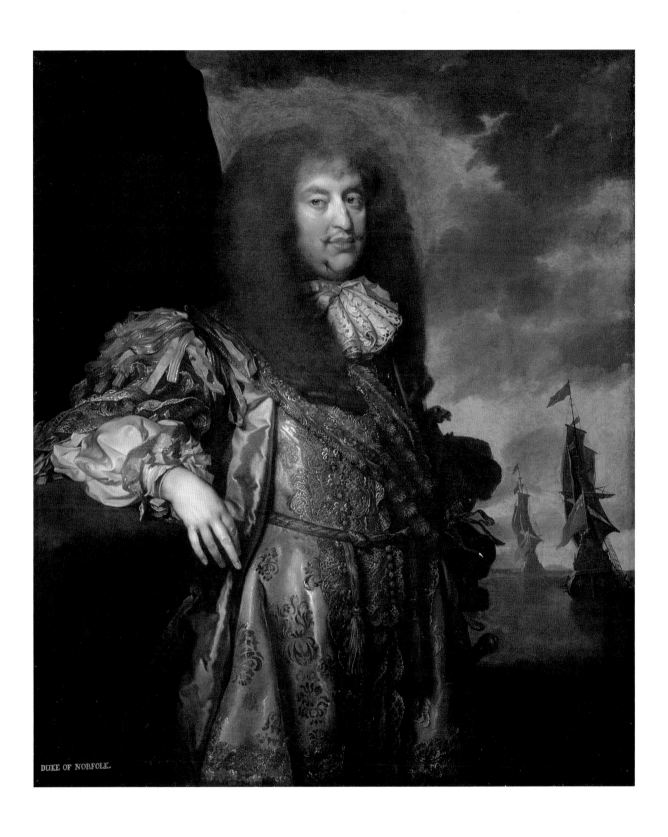

DUKE OF NORFOLK.

Godfrey Kneller (Lübeck, Germany 1646 – London 1723)
Elijah and the Angel 1672
Oil paint on canvas 176.5 × 148.6. Acquired 1954

Sir Godfrey Kneller was the leading artist working in Britain from the 1680s until his death in 1723. Known principally as a portrait painter, his studio with its numerous assistants dominated the artistic scene during his life and for several generations. *Elijah and the Angel* is therefore surprising in Kneller's oeuvre and when it was acquired by the Tate Gallery in 1954, it was the only biblical history painting by him that was known. The subject is taken from 1 Kings 19:5–6 and shows the prophet Elijah in his second exile in the wilderness beyond Beersheba. Having fled from Queen Jezebel, across the desert of Judah and into the wilds of Mount Horeb, Elijah, broken in spirit, had prayed for release and had fallen asleep under a juniper tree. He was awakened by an angel who 'touched him, and said unto him, Arise and eat / And he looked, and behold there was a cake baken on the coals, and a cruse of water at his head.' Kneller shows the moment of Elijah's awakening. The cake is shown above him, to the right, and the flagon of water is next to it.

The picture is dated 1672 when Kneller was working in Amsterdam. Painted before his departure for Italy in the same year, and before his arrival in England in 1676, it is signed 'G. Kniller', the German form of his name. Together with the signed *Old Student* of 1668 (St Annenmuseum, Lübeck), Tate's picture has been used as a stylistic guide for the attribution of other early paintings to him, and the construction of a body of work from his Amsterdam period, which now numbers around sixteen pictures. Stylistically, and with their emphasis on large-scale history painting, they demonstrate Kneller's training under both Rembrandt and Rembrandt's pupil Ferdinand Bol. In subject and composition *Elijah and the Angel* is strikingly similar to works by Bol, and his use of red and brown pigments, as well as mauve and a bright yellow, is very similar to Bol's palette, which cleaning of the picture would make more apparent.

It has been argued that, as an artist trained within the Rembrandt School, Kneller was an intellectual artist capable of inventive iconography but for which there was little opportunity for demonstration after his arrival in England, where the predominant appetite was for portraiture. No large-scale history paintings are known from his English years, although two history pieces were listed in his studio at his death. This picture is possibly identifiable as one recorded in 1713 in Kneller's own collection at Whitton House, his grand Middlesex mansion just beyond Twickenham. Specifically recorded as bearing the date 1672, Kneller must have brought the picture with him when he moved to England. TEBB

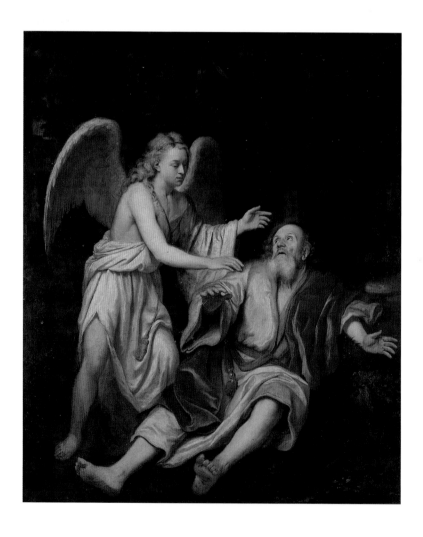

Mary Beale (Barrow, Suffolk 1633 – London 1699)
Study of a Young Girl c.1679–81
Oil paint on canvas 53.5 × 46. Acquired 1992

When this small oil sketch of a young girl was acquired in 1992 it became the earliest work by a female artist to enter the collection. In fact Mary Beale is arguably Britain's first professional female artist, and certainly one of the most prolific. In addition, she is also the best-documented artist working in seventeenth-century England. The rich material that survives – diaries, letters and her husband's notebooks – offer a vivid and very detailed picture not only of her daily life but also her artistic career and the functioning of a seventeenth-century artist's studio.

At first the Beale family lived in Hind Court, off Fleet Street, where Mary Beale's husband, Charles, was Deputy Clerk of the Patent's Office. It is difficult to determine whether Beale had much of a commercial practice at this date, but documents certainly record the production of portraits of family and friends, and a 'painting room' well-stocked with the equipment of an artist. However, on the family's return to London in 1670 following a spell in Hampshire, the Beales set up a commercial studio practice in Pall Mall. It was a business jointly run by husband and wife, with Charles Beale managing the studio, priming canvases and making and purchasing pigments while their sons, Bartholomew and Charles, took roles as painting assistants.

This portrait study is very likely an example of the paintings Beale undertook in the early 1680s for 'study and improvement', an experimental phase meticulously recorded by Charles Beale in his 1681 notebook. The trial studies were quite distinct from her commercial commissions and were undertaken to experiment with different painting techniques, the aim being to improve the efficiency of the studio. Charles Beale had long been interested in the technical aspects of painting. His notebooks are full of priming experiments and his efforts to discover, for example, methods for the quick-drying of paint layers to cut the time it took to produce finished portraits.

The trial studies were painted on a variety of supports – fine canvas, sacking, onion bag and bed ticking – and, apart from her husband and her two sons, among Beale's main models were her studio assistant, Kate Trioche, and her godchild, Alice Woodforde. This work is close to descriptions of two studies painted on 17 May and 27 May 1681 respectively. The first, of Kate Trioche, was painted 'side face fint. Up at once upon a hungry, fine Canvis, of the least Size but one with a hand in it', while the second showed Alice Woodforde 'side face', and 'painted up excellently at once upon a fine hungry canvis of ye same Size. A hand is to be in it.' 'Painting up at once' was a method of painting a finished portrait in one painting session, which the Beales were trying to perfect. Originally it was thought that this study was an example of such an experiment but further examination has revealed evidence of at least one further painting session.

Mary Beale's portrait sketches have a compelling immediacy and informality. They allow us a glimpse into her world, and of the characters that peopled it. TEBB

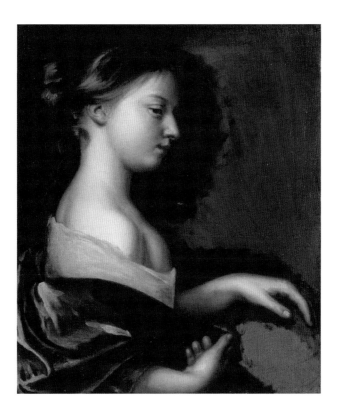

John Michael Wright (London 1617 – London 1694)
Sir Neil O'Neill 1680
Oil paint on canvas 232.7 × 163.2. Acquired 1957

Sir Neil O'Neill, 2nd Baronet of Killeleagh is depicted in the unusual and at first sight outlandish costume that would have been recognised by his contemporaries as that of an indigenous Irish chieftain. An Irish wolfhound sits by his side, on whose collar Sir Neil O'Neill's name is inscribed, and armour, identifiable as Japanese, lies at his feet as if a military trophy. Behind him a wooded landscape unfolds, opening up to a distant view with mountains beyond. His left hand rests on a large shield while the other holds a spear; to his left stands an attendant holding further weapons.

Since its acquisition in 1957 the picture has been the subject of much speculation. An early biography of Wright, published in 1706, makes clear the early popularity the picture enjoyed: his full lengths of 'a High-Land Laird in his proper Habit, and an *Irish Tory* in his Country Dress', were apparently 'in so great Repute, at the time that they were done, that many Copies were made of them'. The 'Irish Tory' can be identified as Sir Neil O'Neill, and the 'High-Land Laird' as Sir Mungo Murray, whose full length by Wright, in Highland costume, is in the Scottish National Portrait Gallery. Both pictures are known in more than one version. But whether they were intended as companion pictures, or simply brought together as a pair of exotic costume pieces, is not known. The enigmatic symbolism of Sir Neil O'Neill's image, however, surely indicates that it was intended to convey a particular message.

Both Sir Neil O'Neill and Wright were Roman Catholics. Sir Neil O'Neill was to become a Captain of Dragoons in the Catholic king James II's army, and fought against the Protestant William III at the Battle of the Boyne in 1690; and as a result of the anti-Catholic hysteria generated by the Popish Plot in 1679, Wright was compelled to move to Dublin where this picture was painted (it is signed and dated 1680 on the reverse of the canvas). In the seventeenth century the Japanese were popularly known as persecutors of Catholic missionaries in Japan. The suit of Japanese armour, at first sight a seemingly odd inclusion, appears to symbolise a hoped-for triumph of the Catholic faith, which both the artist and his Irish sitter were united in upholding.

Wright trained in Edinburgh under the artist George Jamesone but from 1642 lived in Rome, and also travelled in France and Flanders, before returning to England by 1656. Despite gaining a royal appointment as Charles II's 'Picture Drawer' in 1673, his patrons for the most part were figures on the fringes of the court and fellow Catholics. His portraits are characterised by a direct depiction of the real, rather than the prevailing court fashion for the ideal; here, he meticulously paints the detailed embroidery, feather plumes and gold fringes of O'Neill's elaborate costume. His bright red stockings were painted using the pigment vermilion, well known for darkening over time, a process accelerated by the atmospheric presence of chloride. Recent treatment has returned them to something of their original appearance. TEBB

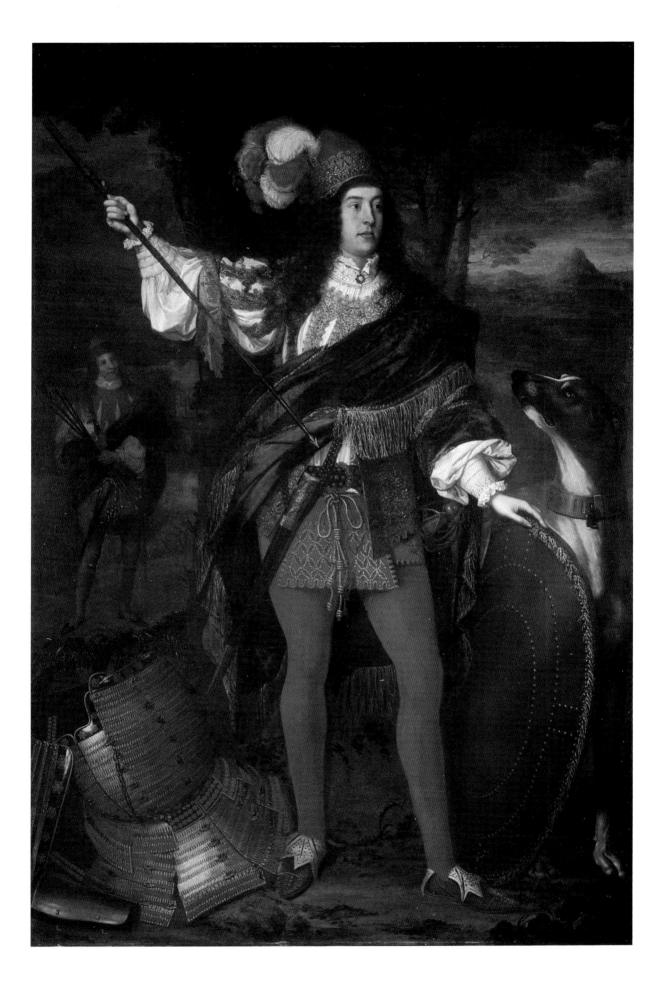

Jan Siberechts (Antwerp 1627 – London c.1703)
Landscape with Rainbow, Henley-on-Thames c.1690
Oil paint on canvas 81.9 × 102.9. Acquired 1967

Landscape painting is considered a quintessentially English form of art, but it was introduced into Britain through the work of incomer artists from the Low Countries (now Belgium and the Netherlands) in the late seventeenth century. One of the leading exponents was Jan Siberechts, a sculptor's son born in Antwerp and active as a painter of rural scenes in the Dutch tradition, often showing peasants crossing fords with their livestock and rustic carts. Travelling through the Southern Netherlands in 1670, George Villiers, 2nd Duke of Buckingham, met the artist and invited him to work at Cliveden, his impressive mansion on the Thames near Windsor. Siberechts had arrived there by 1674. The artist embarked on a successful career in Britain painting 'birds-eye' views of the grand houses and estates of the nobility and gentry, such as Longleat in Wiltshire, Chatsworth in Derbyshire and Wollaton Hall in Nottinghamshire, and has been referred to as the 'father' of British landscape painting.

This painting is one of five views of Henley-on-Thames that Siberechts produced in the 1690s. These works differ from his usual country house 'portraits' by focusing instead on the productive landscape and the river as a centre for mercantile activity. The Tate picture shows the village viewed from the Buckinghamshire bank of the Thames and the tower of St Mary's Church rising from the centre

of the riverside dwellings. On the left four men are hauling a barge, heavily laden with goods, upstream towards the merchants' wharves. Rivers were the main routes for transporting goods around the country until the arrival of the railways in the nineteenth century, and Henley was an important inland port, ideally located for loading goods from the surrounding area for delivery to London. The dark rain clouds gathering in the top right hand corner offset the double rainbow above the valley, the artist anticipating the interest in meteorology and weather effects of Turner and Constable a century later.

The reason for painting this picture and the other views of Henley by Siberechts is unclear. It may be that they were commissioned by local landowners who were also successful merchants in the City of London, as a record of their property and the benefits of trade. Unfortunately, the early provenance of the Tate picture is unknown and so does not help shed any light on this. It is first recorded in a private collection in County Sligo, Ireland, having probably been there since the eighteenth century. It appeared on the art market in the 1960s and was purchased for the gallery by the Friends of the Tate Gallery in 1967. It has often been on display since, at Tate and in exhibitions elsewhere, serving to illuminate the emergence of landscape painting as a distinct genre of art in Britain. TJB

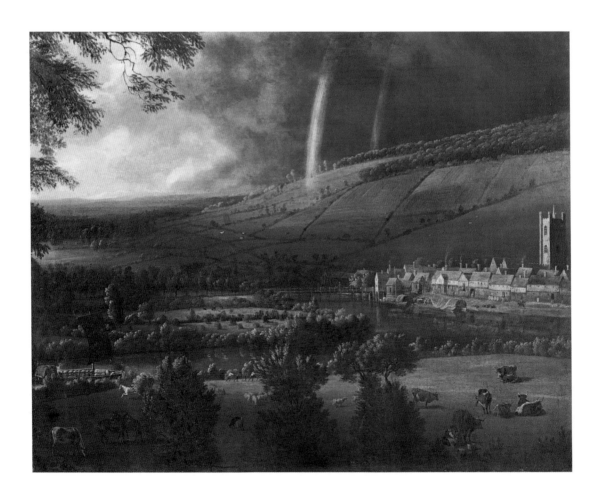

Edward Collier (Breda c.1642 – London c.1708)
Still Life with a Volume of Wither's 'Emblemes' 1696
Oil paint on canvas 83.8 × 107.9. Acquired 1949

Still-life painting became an important and highly commercial art form in the Netherlands during the Dutch 'Golden Age' of the seventeenth century, and it was through the work and activities of Dutch incomer artists that this new genre was introduced to Britain in the late seventeenth century. Known in England by his Anglicised name, the Dutch still-life painter Edwaert Colyer was active in Leiden and Amsterdam before moving to London in 1693. Collier specialised in the 'vanitas' still life, where the sumptuous displays of luxurious objects and the pleasures of life are tempered with symbolic warnings of the transience of time, the futility of worldly wealth and the mortality of human existence.

In this picture the golden goblet and casket of jewels, along with the musical instruments and wine, represent the riches and delights of human existence. Meanwhile the skull and the hourglass remind us of the passing of time and the inevitability of death. This is further emphasised by the funerary urn in the top left corner, which holds in place a piece of paper with a quotation in Latin from the Bible which translates as: 'Vanity of vanities, all is vanity.' The emblem book on the left is shown open with the text, 'What I was is passed by; What I am away doth flie; What I shall bee none do see; Yet, in that, my beauties bee.'

As a still-life painter Collier had certain stock items that he would use, and re-use, in his compositions. For example

the goblet, the casket and the porringer (two-handled silver cup) seen in this picture can be found in other works by the artist. As well as reusing objects, the artist also recycled compositions. Once he had found a composition that worked – such as a table with a globe and an arrangement of books – he would produce many variants on this image with a few slight changes. Little for certain is known of his working practice, but the multitude of such variants suggests that he may have had a workshop and studio assistants.

The period when Collier was working also marks a change in the way artists could sell their works. The old system of artistic patronage – the commission given to an artist by a rich patron – was being augmented by newly emerging auctions. Having been successful in the Netherlands for a number of years, from the 1680s sales of pictures started taking place in coffee houses, taverns and commercial exchanges. Artists now had new opportunities to make a living and instead of waiting for commissions could produce paintings speculatively for sale at auction.

Collier's paintings therefore offer insights into the newly commercialised world of art that emerged in Britain at the end of the seventeenth century. But despite the scale of Collier's production and its historical importance, the Tate collection contains just two other paintings by the artist. Even this makes it the largest holding of works by the artist in any British public collection. TJB

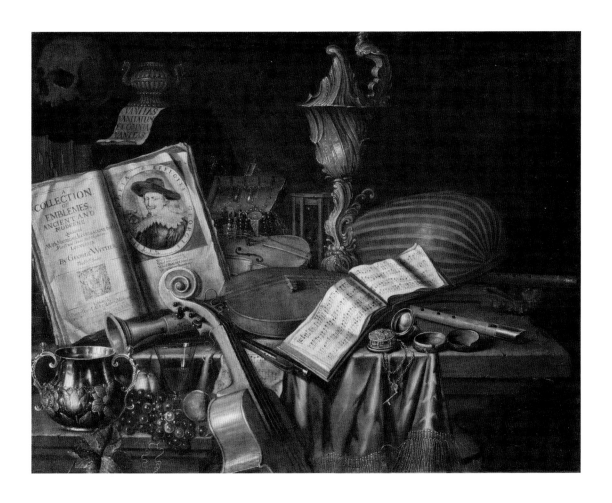

Philip Mercier (Berlin ? 1689 – London 1760)
The Schutz Family and their Friends on a Terrace 1725
Oil paint on canvas 102.2 × 125.7. Acquired 1980

The identities of the people shown in this picture are uncertain but it is thought that they are members of the Schutz family of Hanover, courtiers to the Hanoverian king George II, with some of their friends. The couple in the centre of the composition of the picture are probably Augustus Schutz (c.1693–1757) and his wife Penelope, née Madan, formerly the ward of General James Tyrrell of Shotover House, near Oxford. The painting can be interpreted as a wedding picture, with the groom, who looks out towards us, leading his bride from her own family on the left to her husband's on the right.

The painting may also be read as symbolic of the new royal dynasty introduced by the succession to the throne of the Hanoverian George I in 1714. The symbol of Hanover itself is literally pointed out in the figure of the white horse, which features prominently on the royal coat of arms of the House of Hanover. The large classical building in the background may be the Banqueting House at Whitehall Palace, built by the Stuart king James I who came to the throne after the death of the childless Tudor queen Elizabeth I, and the place where his son, Charles I, was beheaded. The large urn on the wall of the terrace contains an orange tree in blossom, a reference to the House of Orange, the royal house of William III who was invited to take the crown in 1688 and depose the Catholic king James II. The Act of Settlement of 1701 was designed to bar any Catholic descendants of James II from the British throne, the royal line legally passing to the Protestant heirs of the House of Hanover.

Philip Mercier was born in Berlin, the son of a Huguenot (French Protestant) tapestry worker. Having trained there as a painter, he travelled to France and Italy to further his studies, before settling in England in 1715 or 1716. His arrival in England was on the 'commendation of the Court of Hanover' and he was closely attached to the Hanoverian cause. Mercier was one of the first painters to introduce the 'conversation piece' to Britain, a group portrait on a small scale showing family and friends in an informal setting based on the models of seventeenth-century Dutch art and the frivolous *fêtes galantes* of the French painter Antoine Watteau.

This painting was purchased by the Tate Gallery in 1980. It had originally descended from Shotover House, the house having passed from the Tyrrell family to the Schutz family in 1742 on the death of General Tyrrell. It has frequently been on display in the context of mid-eighteenth century art, and has provided an important point of comparison for the more robustly painted early portraits by William Hogarth. Although not very well known, Mercier was important in bringing innovative French influences to bear on portrait practice in Britain, helping to forge the conventions of a new, more informal and humorous style of portraiture, which fitted emerging ideals of elegance and sociability. TJB

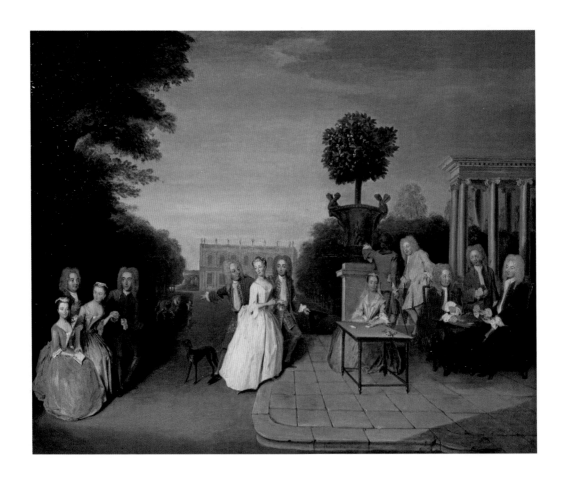

Andrea Soldi (Florence c.1703 – London 1771)
Portrait of Henry Lannoy Hunter in Turkish Dress, Resting from Hunting 1733–6
Oil paint on canvas 118.5 × 146. Acquired 2004

Dressed in full Turkish attire, Henry Lannoy Hunter is shown here as a young Levant Company merchant enjoying the pleasures of his profitable trade in Aleppo, the ancient trading capital of Syria and the Company's chief factory, or trading post. Hare coursing with hawks and greyhounds was the principal leisure activity of the English merchants. Hunter relaxes after a day's sport while the trophies of the day are held aloft by his Christian, probably Armenian, servant (identifiable as such by the red and blue of his costume and the form of his headgear). His raised knee deliberately reveals the expensive silk waistcoat and trousers that Hunter wears under his fur-trimmed gown.

Hunter does not wear fancy dress (as well as western hats, wigs and coats, inventories of the goods of English merchants in Aleppo include Turkish 'fur vests', long buttoned silk waistcoats, or 'dolemans', wide trousers and caps and sashes for turbans) but to a large extent his image is one that has been carefully constructed to impress a home audience. His finery is that of an Ottoman gentleman of wealth and status and would not have been worn by Europeans on an everyday basis. Tate's acquisition of this picture in 2005 and subsequent research has revealed a detailed picture of merchant life in Aleppo. Levant Company merchants enjoyed the highest status within the City of London and were generally viewed as rich, powerful and privileged individuals. However, the reality of daily life in the Levant could be very different. Hunter was in Aleppo from 1726 to 1733,

by which time the Company's trade of English broadcloth for silk (the most prized from Persia) was in decline. While life within the merchant community, where young factors, or representatives, of the London trading houses were stationed for at least seven years, could be entertaining and convivial, it could also be monotonous and claustrophobic. While Soldi's image is a memento of Hunter's time in Aleppo, and is based on true experience, it is also an idealised vision that perpetuates the popular public view.

The antiquarian George Vertue is the sole source for information concerning the early career of the Italian artist Andrea Soldi. He is said to have left his native Florence to travel to the Levant, where he became acquainted with the English merchants of Aleppo whose portraits he painted and on whose recommendation he came to England. Tate's acquisition of this picture has brought Soldi's career in the Levant into sharper focus. His earliest portraits, of Europeans in Turkish dress, are inscribed 1733. As well as Hunter, his patrons certainly seem to have been the English merchants of Aleppo with whom he remained in contact when in England and who continued their patronage of him. Some of his portraits of them in Turkish attire may even have been painted in England, where he settled in 1736. But rather than the contrived fantasy apparent in some later orientalist works, Soldi's images are rooted in reality as well as a shared experience between sitter and patron. TEBB

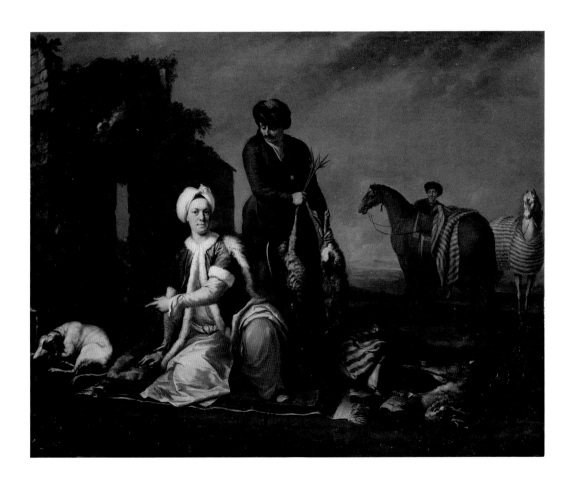

Joseph Highmore (London 1692 – Canterbury 1780)
Mr Oldham and his Guests c.1735–45
Oil paint on canvas 105.5 × 129.5. Acquired 1948

This informal group portrait commemorates a dinner party at the home of Nathaniel Oldham, a collector and patron of the arts. The author and antiquarian, J.T. Smith (1766–1833), whose father Nathaniel Smith was Oldham's godson, identified it as a picture 'that had been for the first eleven years of my life in my sleeping room'. Writing in 1827 he described the scene as follows: 'Mr Oldham had invited three friends to dine with him at his house at Ealing; but being a famous and constant sportsman he did not arrive till they had dined; and then he found them so comfortably seated with their pipes over a bowl of negus [hot spiced wine] that he commissioned Highmore to paint the scene and desired that he might be introduced in it just as he then appeared.' Oldham stands to the left of the painting, his tricorn hat still on his head. The central figure is identified by Smith as a neighbouring farmer, while to the right, dressed in black, is a local schoolmaster. Between these two figures, peering out over his glass, is the artist Joseph Highmore himself.

By the late 1720s, Highmore's studio was attracting an increasingly eminent clientele, including several members of the royal family; his rise undoubtedly aided by the death in 1723 of his rival Sir Godfrey Kneller, who had dominated portraiture in London for many years. In the 1740s Highmore began to branch out into literary and historical paintings, including his well-known series illustrating Samuel Richardson's novel *Pamela*. However, because of the unusual format of *Mr Oldham and his Guests* and the way in which it differs from Highmore's other works, it is difficult to attribute it stylistically to any particular decade of the artist's career. The curious nature of the commission may have been partly due to the fact that Oldham was a close friend of Highmore's; the artist also painted a full-length of him in hunting attire, now known only from an engraving. It also owed much to the changing nature of portraiture around this time, which saw a move towards greater informality.

Mr Oldham and his Guests has enjoyed a colourful history, typical of the way in which works by Highmore have historically suffered from misattribution, with many of his best paintings at some point credited to more illustrious peers. After Oldham's death (date unknown, though thought to have been in a debtor's prison), the portrait was given to a relative, from whom it was purchased by Nathaniel Smith. It then passed through several hands before appearing in the sales room in 1827 attributed to William Hogarth. The cast of characters had also changed: substituting Hogarth, the physician Dr Messenger Monsey and 'Old Slaughter', proprietor of the famous coffee-house which was said to provide the setting. Despite J.T. Smith's published rebuttal of this identification the very same year, the misattribution stuck and it entered the Tate collection credited to Hogarth in 1948. The following year its true identity was restored when Smith's statement was rediscovered and connected to this painting. RK

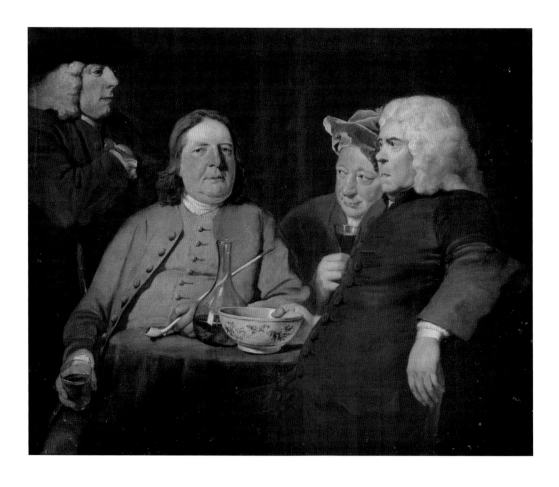

Francis Hayman (?Exeter 1708 – London 1776)
Samuel Richardson, the Novelist (1684–1761), Seated, Surrounded by his Second Family 1740–41
Oil paint on canvas 99.5 × 125.2. Acquired 2006

This small-scale group portrait, or conversation piece, shows the celebrated printer and novelist Samuel Richardson seated outdoors with his second wife, Elizabeth Leake, and their four daughters. Seated on her mother's knee is their youngest daughter Sarah (baptised July 1740), at her feet are Anne (baptised August 1737) and Martha (baptised July 1736) while Mary (baptised January 1734), the eldest child, stands by her father and cradles a small doll. The lady to the right is Elizabeth Midwinter, Richardson's ward who was living with the family at the time. She stands slightly apart from the group, as if she has just arrived, perhaps to visually convey the fact that she is not a family member yet is part of the family circle.

The precise date of the picture is not known but judging by the apparent ages of Richardson's children, it was painted at some point between late 1740 and 1741, a date which coincides with the publication of Richardson's first novel *Pamela, or Virtue Rewarded*, the phenomenal success of which this portrait presumably celebrates. A seminal work in the history of English literature, which charts the trials and tribulations of an innocent serving maid in defence of her virtue, the novel went through five editions within the first year. The popular vogue for *Pamela* included stage adaptations, parodies, 'a curious Piece of Waxwork' on Fleet Street and painted scenes, by Hayman, in the supper boxes at Vauxhall Gardens. The latter were based on two of the twenty-nine engravings by Hayman and François

Gravelot that illustrated the deluxe 1742 6th edition of *Pamela*, which Hayman may well have been working on while engaged in painting this portrait.

Richardson is shown at the centre of the family circle, his finger marking his place in a book that he has momentarily stopped consulting. It is suggestive of the collaborative creative process he followed in writing *Pamela*, which involved reading passages aloud to his wife and Miss Midwinter and adapting the text according to their reaction. He apparently wrote in a little summer house in the garden of his villa at North End, Hammersmith, before his family was up, and then at breakfast read aloud the latest instalments; and in a letter to his friend Aaron Hill, Richardson wrote that his wife and Elizabeth Midwinter would come to his closet every night. 'Have you any more of Pamela, Mr R?' they would ask; 'we are come to hear a little more of Pamela'. The scene painted by Hayman, of a family engaged in leisured genteel activity, therefore had more particular associations.

Hayman was one of the leading figures in the artistic community of London in the early eighteenth century and this work is one of his most important. Purchased by Tate in 2006, it has been argued that with this work Hayman introduced and established a formula for outdoor group portraiture, which served him consistently for the next decade and which was a major influence on the work of the young Gainsborough. TEBB

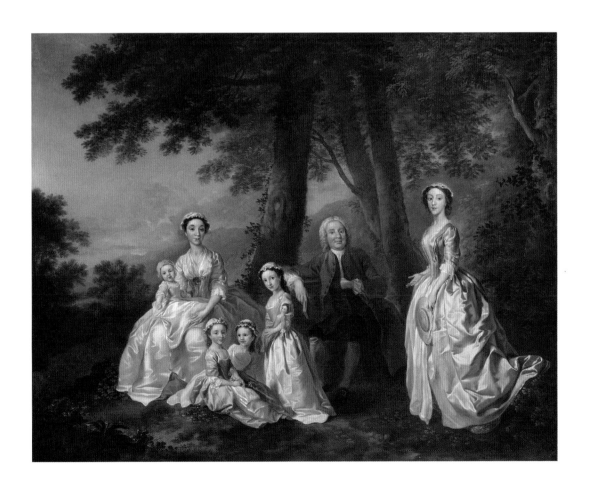

Allan Ramsay (Edinburgh 1713 – Dover 1784)
Thomas 2nd Baron Mansel, with his Blackwood Half-brothers and Sister 1742
Oil paint on canvas 124.5 × 100.3. Acquired 1988

This painting originally hung in the dining-room of Margam House, Glamorganshire, the country home of Thomas Mansel, the young man depicted at the right of the picture with gun, dog and dead partridge. The sitters have a complex relationship: at the centre is Mary Blackwood, Mansel's half-sister, and the two boys are his half-brothers, John (leaning on Mary's shoulder to look at the viewer) and Shovel (standing centre-left).

Allan Ramsay, the Scottish portraitist, essayist and antiquarian, painted the work shortly after his return to Britain in 1738 from Italy, where he studied under two Italian history painters, Francesco Imperiali in Rome and Francesco Solimena in Naples. Armed with continental influences and a range of modern techniques, he set up practice in London, where by April 1740, according to the artist's own testimony, he was playing 'first fiddle' as London's foremost portraitist. Later he was appointed Principal Painter to George III, although it is perhaps for his portraits of fellow enlightenment figures *David Hume* and *Jean-Jacques Rousseau* (National Galleries of Scotland) that he is best remembered.

Although exact details of the commission of the Mansel group are lacking, the painting was recorded in 1743 displayed as part of a family and household gallery at Margam. It hung with portraits of Mansel's grandparents, the famous Admiral Sir Cloudsley Shovel and his wife, further portraits of Lord Mansel and a 'Miss Mansel' and portraits of 'Two Africans' (possibly servants). The carved scallop shells on the pine frame perhaps allude to the naval career of Admiral Shovel, while the oak decoration on the side-swags may refer to the strength of the family tree (although such decoration is common on frames at this time). As a scene of the Baron returning with game from his shooting trip the dining-room location was clearly appropriate.

The painting has excited much interpretation since Tate purchased the work from the family in 1988. It has been suggested that it is a memorial to Anne Blackwood, the mother of all of the sitters by two marriages, and further, that she is represented in the form of the dead bird. Mansel's look has been interpreted as amused indulgence at his partially sighted younger sibling touching the corpse, or as a less innocent look, more characteristic of a courtship than a sibling group. The red patch on the bird's breast – which may be plumage – has also been interpreted as a bloody gunshot wound, more explicitly symbolic of lost innocence or the coming of womanhood than might be expected in a family portrait.

Certainly Ramsay's portrait is distinctive for the complexity of the formal and emotional relationships established in the scene, and with the viewer. In other paintings from the early 1740s, Ramsay also used props to give intrigue to family groups. In *Rachel and Charles Hamilton* a younger brother presents an elder sister with a bird-chick from a hat full of bird-chicks (private collection, Scotland), and in *Sir Edward and Lady Turner* (private collection) there is at the centre of the portrait a lace handkerchief that the man either gives to the lady, or is possibly in the act of taking away. In all cases the symbolism remains opaque. Certainly something is intended by the distinctive scene of half-siblings crossing hands over a dead bird, but precisely what remains to be discovered. GS

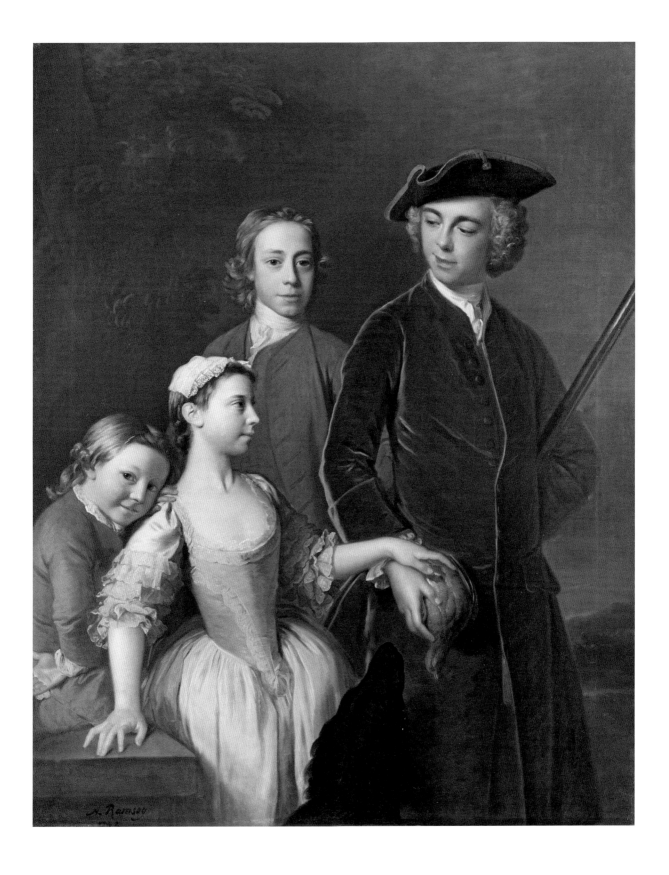

William Hogarth (London 1697 – London 1764)
The Painter and his Pug 1745
Oil paint on canvas 90 × 69.9. Acquired 1824

This was among the first pictures acquired for the national collection. It was one of nine British works among the thirty-eight pictures purchased from the collection of the late banker John Julius Angerstein (c.1732–1823) to form the National Gallery in 1824. The other eight works included the six canvases of Hogarth's *Marriage-A-la-Mode* (National Gallery, London) and paintings by Sir Joshua Reynolds and David Wilkie.

By the early 1800s Hogarth was often thought of as the first modern British artist, even sometimes being preferred over Reynolds as the defining figure of the national school despite the latter's more distinguished professional profile as founding President of the Royal Academy. Hogarth had trained as a silver engraver, but had secured tremendous success with his informal portraits and, particularly, his hugely original series of modern-life narrative pictures. These latter, casting a satirical eye on contemporary society, secured him an international reputation and were very widely disseminated in the form of engravings. His work was compared to the emerging literary form of the modern-life novel, and similarly responded to a growing middle-class market.

This self-portrait was painted over a number of years. It presents the artist's likeness as if it was an oval painting within a still-life arrangement. X-rays show that he originally painted himself wearing a wig, in line with the conventions for representing gentlemen. But in the end the painter chose to show himself wearing his own cropped hair and a soft cap, the informal costume of an artist at work. The palette draws attention to the craft of the artist, and the enigmatic inscription 'The Line of Beauty and Grace'

refers to his propositions about the naturalistic principles that should underpin art. The three bound volumes are marked as works by Shakespeare, Swift and Milton, aligning the visual artist with three of the most distinguished figures in English literature. By contrast, the dog on the right is traditionally identified a pug, the breed favoured as pets by Hogarth and implying his own 'pugnacious' character.

The portrait was engraved by Hogarth in 1749 as the frontispiece to his collected engravings. It has been reproduced and discussed many times since, serving as an emblem of his distinctive role in the history of British art and as the embodiment of enduring ideals of the national character. Typically, the novelist W.M. Thackeray (1811–63) described this image as an exemplar of the supposed good humour and commonsense of Britons:

> His own honest face, of which the bright blue eyes shine out from the canvas and give you an idea of that keen and brave look with which William Hogarth regarded the world. No man was less of a hero; you see him before you, and can fancy what he was – a jovial, honest, London citizen, stout and sturdy; a hearty, plain-spoken man, loving his laugh, his friend, his glass, his roast-beef of old England.

The painting was transferred, along with the more recently acquired *Gate of Calais* (p.38), to the Tate Gallery in 1951, at which time Hogarth's exemplary 'modern moral series', *Marriage-A-la-Mode*, which had been at the Tate Gallery since 1919, was removed back to the National Gallery. MM

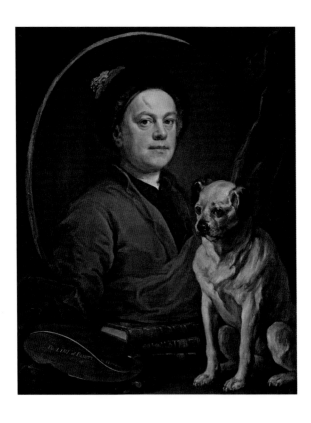

Thomas Gainsborough (Sudbury, Suffolk 1727 – London 1788)
Wooded Landscape with a Peasant Resting c.1747
Oil paint on canvas 83 × 97.2. Acquired 1889

This is one of Gainsborough's first landscapes, painted during his apprentice years in London when he was about twenty years old. The view is not strictly topographical but is clearly based on the scenery of his native Suffolk, characterised by flatness and open fields. Memories of this familiar countryside are combined with the young artist's admiration for Dutch seventeenth-century landscape painting. The model of Dutch art is evoked in Gainsborough's detailed observation of nature and the painting's highly ordered composition: a path punctuated by diminishing figures leads the eye from the wooded foreground to the sunlit landscape beyond.

Gainsborough was one of the first British painters to produce serious landscapes showing English scenery and in his early years in London in the 1740s, he seems to have been known only for this type of work. By 1748 his talent was already sufficiently noted for Hogarth to commission a small landscape from him. Yet it was portraiture that was to become the main source of Gainsborough's fame and income, particularly after his move to Bath in 1759. Nonetheless, landscapes remained his preferred subject and he continued to paint them throughout his career as a relaxation from the pressures of his portrait practice. As he famously explained in a world-weary letter to his friend William Jackson: 'I'm sick of Portraits and wish very much to take my Viol da Gam [Viola da Gamba: a musical instrument much like a cello] and walk off to some sweet village where I can paint Landskips and enjoy the fag end of life in quietness and ease.'

Gainsborough was unusual in showing rural workers enjoying moments of rest and idleness and it has been suggested that his repeated use of such figures, seen in an early manifestation here, reflects his fantasy of bucolic retirement. Others have read a religious message into the upward glance of the seated figure in this painting; the way in which the path leads to the distant church spire, while storm clouds clear over it, seeming to evoke connections between God, man and nature.

In the last year of his life Gainsborough remarked in a letter on the subject of his early landscapes: 'the touch and closeness to nature in the study of the parts and *minutiae* are equal to any of my latter productions'. Since its purchase for the national collection in 1889 (it was transferred to the Tate Gallery in 1951) *Wooded Landscape with a Peasant Resting* has been displayed in the context of Gainsborough's developing artistic vision, while also illustrating an important moment in the evolution of British landscape painting more generally. RK

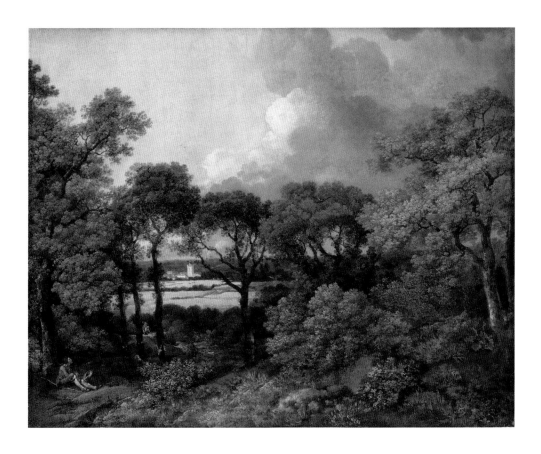

William Hogarth (London 1697 – London 1764)
O the Roast Beef of Old England ('The Gate of Calais') 1748
Oil paint on canvas 78.8 × 94.5. Acquired 1895

Hogarth achieved enormous success with his satirical images of modern life. These commented on the vices and virtues of identifiable social types and individual characters from contemporary London. Such images demand to be 'read' like a novel, and we are invited to laugh, cringe, commiserate or recoil in disgust by a succession of carefully crafted details, characterisations and comic juxtapositions.

Here we are shown, framed by a silhouetted archway, a scene at the walls of the French port of Calais. At the centre, a French cook buckles under the weight of a massive piece of imported English beef – a symbol of that nation's prosperity and hearty good health. A fat monk hovers over the choice joint, and a scrawny French soldier and Irish mercenary look on enviously: a pot of their unappetising *'soup-maigre'* is carried away to the right. In the shadowy foreground cowers a Scottish Jacobite (a Catholic rebel against Britain's Hanoverian monarchy), his hands clasped in prayer; to the left a group of fishwives cackle over the human-like face which they discern in the underside of a ray. Above them, and behind another undernourished French soldier, we can see Hogarth himself, sketching, a hand about to clasp his shoulder.

Hogarth had intended to visit Paris in the summer of 1748, but turned back at Calais after being arrested as a spy. The incident was noted by the connoisseur Horace Walpole in December 1748, who said that Hogarth had escaped prosecution by doing sketches to demonstrate that he was, simply, an artist, including, 'a scene of the shore with an immense piece of beef landing for the Lion d'Argent,

the English inn at Calais, and several hungry friars following it'. The story is confirmed in Hogarth's autobiographical notes. But far from being a direct impression of events the finished painting is a meticulously staged comedy, calculated to appeal to contemporary xenophobia and anti-Catholic sentiments. Such feelings had intensified with the recent wars with France and the Jacobite invasion of England in 1745. The claims made here about the greed of monks, the poverty of the French people and the cowardice of the Scottish and Irish would have been immediately legible to anyone familiar with contemporary satirical prints where such characterisations were rife. Meanwhile, the visual comedy is direct and graphic, apparent in the treatment of knobbly knees and goggling eyes, the animated contrasts of the plump and the meagre, the curved and the jagged, and even in the yawning structure of the Gate itself which seems ready to clamp down hungrily on the mighty sirloin.

The composition was published by Hogarth as an engraving in March 1749 with the title *O The Roast Beef of Old England*. It has been reproduced and exhibited numerous times since, and has inspired poems, songs, scholarly commentary and tributes from modern-day cartoonists and satirists. Although Hogarth is often celebrated as a supremely democratic artist, this painting has an aristocratic provenance. It appears to have been owned by Lord Charlemont in the late eighteenth century, and was later purchased by the Duke of Westminster who gave it to the National Gallery in 1895. It was transferred to the Tate Gallery in 1951. MM

Samuel Scott (London c.1702 – Bath 1772)
An Arch of Westminster Bridge c.1750
Oil paint on canvas 135.7 × 163.8. Acquired 1970

The subject of this painting is Westminster Bridge in the very last stages of its construction (indicated by the last remnants of scaffolding). It was only the second bridge to be built over the Thames in 600 years and was the major public building event of the time. Built by a 1736 Act of Parliament, the first stone of the main arch was laid with great formality in January 1739. It was completed to the designs of the architect Charles Labelye in November 1750. The bridge was a reflection of London's westward expansion, opening up connections to south London and the southern ports.

Samuel Scott made numerous sketches of the bridge during its construction, working them up into finished paintings in the years after. Scott dwells on the architecture – detailing the masonry, cornice and balustrade in great detail – along with the effects of sunlight and shade across the Purbeck and Portland limestone. In the Thames, numerous boats go about their business, while two men swim. Extra incidental detail is added by the two workmen sharing a drink on the scaffold, and the faces peering through the gaps in the balustrade.

Scott was a self-trained artist from a comfortable background. He possessed a sinecure as Accomptant in the Stamp Office for twenty-eight years and, with time on his hands, taught himself to copy the works of the seventeenth-century Dutch marine painters William van de Velde I and II.

Encouraged by other artists he began to accept commissions, and by the time *An Arch of Westminster Bridge* was painted, he ran an established studio in Covent Garden, producing marine paintings and urban landscapes (such as *A View of Covent Garden*). He trained a second generation of topographical painters, William Marlow and Sawrey Gilpin, and was involved in the early, abortive efforts to found a Royal Academy.

An Arch of Westminster Bridge combines the depiction of an engineering event – the construction of the bridge – with landscape, genre and marine painting. Scott was one of many artists attracted by the spectacle. Similar views were executed by Canaletto, Richard Wilson and Paul Sandby. Scott nevertheless found many clients, and there are four known versions of this work (in Yale Center for British Art; the Lewis Walpole Library in Farmington; the National Gallery of Ireland; and Tate owns another, smaller, sketch). This painting is thought to have been bought from the artist by Sir Lawrence Dundas in 1765, before entering the collection of the Lucas and Dingwall family in the late eighteenth century. It has been frequently displayed in the twentieth century, notably as part of the show celebrating the bicentenary of Scott's death at the Guildhall in 1972. It was purchased for the nation from a descendant of the Lucas family in 1970. GS

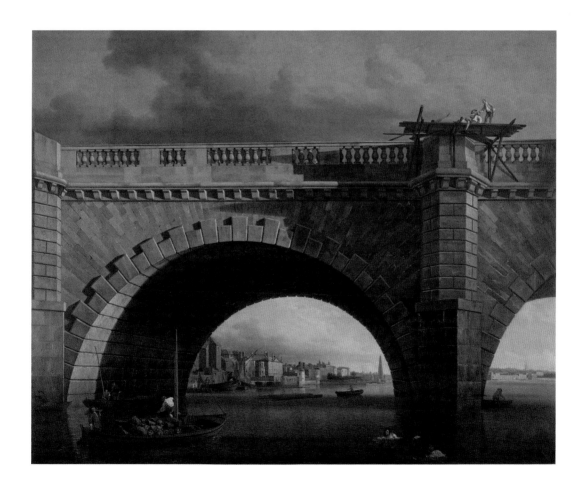

Johan Zoffany (Frankfurt am Main 1733 – Kew, Surrey 1810)
Three Sons of John, 3rd Earl of Bute c.1763–4
Oil paint on canvas 100.9 × 126. Acquired 2002

John Stuart, 3rd Earl of Bute, George III's favourite prime minister, commissioned this portrait of his three youngest sons as a pair with one of three of his daughters, also in the Tate collection. On the right is the Hon. Frederick Stuart (1751–1802) who clutches his bow and proudly points to a bull's eye he has scored on a distant target. His two brothers have abandoned their archery for bird-nesting. The Hon. Charles Stuart (1753–1801) perches in the branches of an oak tree while the Hon. William Stuart (1755–1822) reaches up to collect the nest and the bird in his black tricorn hat. The landscape behind the children is the park at Luton Hoo, Bedfordshire, which had become the Bute family seat in 1763, around the same time this portrait was painted.

Zoffany had come to England from his native Germany in 1760. Prior to his arrival he had been court painter to Johann Philipp von Walderdorf, elector of Trier. The prospect of greater artistic opportunities persuaded Zoffany to move to London but his first years in the city were difficult. Early patrons such as Lord Bute were therefore pivotal in the making of Zoffany's reputation. This portrait marked a turning point in the artist's career, for it must have been Bute, part of George III's inner circle, who introduced Zoffany to the king and queen, initiating a lucrative period of royal patronage. This painting and that of the Stuart daughters marks the beginning of a more sophisticated approach by

Zoffany to group portraiture, with larger figures, in vivid interaction, given prominence over the landscape setting. By adopting this style, he effectively reinvigorated the 'conversation piece' genre which, having enjoyed considerable popularity earlier in the century, was then in decline.

Zoffany's portrait articulates a wider change in attitudes towards children in this period. He conveys a sense of the playfulness of childhood, in marked contrast to earlier eighteenth-century images of children that tended to present them as miniature adults. Archery and bird-nesting were seen as particularly appropriate pastimes for young boys, precursors to the adult pursuit of hunting which was an important part of life on an eighteenth-century country estate, such as Luton Hoo. Both were motifs that were used by Zoffany and other artists repeatedly in this period to communicate the masculine qualities that boys would be expected to demonstrate in later life.

This painting is exceptional in having a well-documented and unbroken provenance. It descended through the Bute family until it entered the Tate collection in 2002, to become part of arguably the most comprehensive collection of works by Zoffany in the world. Since then it has been used in a variety of ways: to examine the changing face of childhood, to reveal the impact of the arrival of foreign artists on the course of British art and to illuminate Zoffany's evolving style. RK

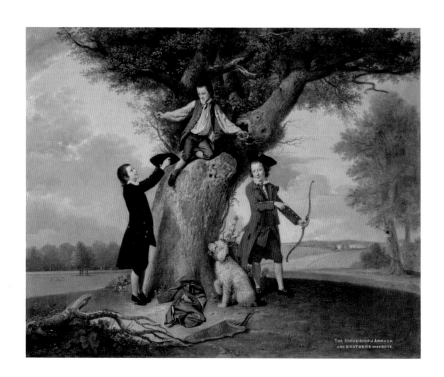

George Stubbs (Liverpool 1724 – London 1806)
Mares and Foals in a River Landscape c.1763–8
Oil paint on canvas 101.6 × 161.9. Acquired 1959

George Stubbs emerged in the 1760s as the leading British painter of 'sporting art', pictures dealing with the traditional leisure-time activities of the ruling elite, including hunting, racing and shooting. He brought an unprecedented sense of artistic ambition to the genre, creating works that appealed to a new generation of wealthy patrons increasingly concerned with the aesthetic as well as the documentary or decorative value of the paintings they owned. This carefully composed image exemplifies Stubbs's ability to convey a sense of artistic dignity and import to the most humble subject matter, and his acute powers of observation, particularly in the representation of anatomy. It belongs to a series of pictures created by him in the 1760s and early 1770s showing groups of mares and foals on a long, extended format evocative of classical friezes.

This composition is presumed to have been commissioned or purchased by George Brodrick, 3rd Viscount Midleton, MP (1730–65), or his son George Brodrick, 4th Viscount Midleton (1754–83), to decorate their new home at Peper Harrow, Surrey which was built around 1765–75. It seems to have been used as an 'overdoor', being hung with two other pictures by Stubbs above the doors in the dining room. Reflecting the ornamental use to which this painting was to be put, it seems that Stubbs did not set out to be especially original. Notably the figures of the horses are the same as those appearing within another painting

of mares and foals, created as a commission for Lord Rockingham and representing specific horses owned by him (private collection), although the colour of one has been changed from brown to grey.

Having achieved fame and critical acclaim as a sporting artist in the 1760s, Stubbs went on to attempt to diversify his practice into portraiture, subject painting and pictures of rural life, although not with the same success. He was aware of the low status accorded to painters of horses and dogs, and arguably the stigma attached to sporting art has endured through to the present day. Stubbs is the only sporting artist to feature significantly in general surveys of British art history, and the neglect of the genre was often reflected in the formation of the national collection of British art. A letter-writer in a national newspaper complained in 1944, when great efforts were being made to establish a national gallery of sporting art, that 'The super-highbrow art-lover and the eminent critic have seldom bestowed their blessings upon sporting pictures.' Even the acquisition of major works by Stubbs for the nation seemed belated. When this painting was bought by the gallery in 1959, the *Times* reported that 'With this acquisition the Tate feels that it has at last acquired a painting of a scale and quality which worthily represents an artist who has hitherto been poorly served by the national collections.' MM

Tilly Kettle (Exeter 1734/5 – en route to India 1786)
Mrs Yates as Mandane in 'The Orphan of China' 1765
Oil paint on canvas 192.4 × 129.5. Acquired 1982

This full-length portrait shows the acclaimed actor Mary Ann Yates (1728–87) as the character of Mandane in Arthur Murphy's tragedy, *The Orphan of China* (1759). It reflects the increasingly theatrical character of ambitious portrait painting in the 1760s, often literally involving the representation of famous performers in character. Alone in a bare stage-like setting, Yates is shown raising her hands in a way which would conventionally indicate that she was meant to be speaking. Her strikingly coloured costume presumably corresponds with her actual stage outfit.

The Orphan of China was first performed at David Garrick's Theatre Royal, Drury Lane in 1759, and made Yates a star. It was still in production at the time this painting was first exhibited in 1765. The play is based on the radical French philosopher Voltaire's *L'Orphelin de la Chine* (1755). Set in the medieval era, with China under the cruel rule of the Tartar leader Timkurkan, the complex plot sees a high-ranking Chinese official, Zamti, and his wife, Mandane, wrangle with the excruciating moral dilemma of whether to sacrifice their son in order to retain any hope of saving the nation from the invader's rule. Zamti remains a zealous patriot, but Mandane is overcome by maternal affection. Driven by emotion, she is outspoken in denouncing tyranny: 'Sacred Kings! / 'Tis human policy sets up their claim; / Mine is a mother cause; yes, mine the cause / Of husband, wife, and child, those first of ties, / Superior to your right divine of Kings.'

While Mandane's emotive stance resonated with contemporary ideas about the social value of 'sentiment', the stage setting also provided more immediate pleasures. Murphy recalled that Garrick had 'prepared a magnificent set of Chinese scenes, and the most becoming dresses' and the play was advertised as being performed 'in the Habits of that nation'. However, this did not reflect any genuine sympathy for Asian art or culture, and Yates's outfit is a wholly European fantasy. In a rhetorical speech delivered at the end of the play, she went so far as to apologise to the audience for the alien ugliness of the 'true Chineze' sights they had witnessed.

The emphatic colour scheme of this work, its life-size scale and its presentation of a well-known actress in her most famous and exotic role were aimed at gaining the painter attention in the context of the exhibition, a new forum for viewing art where a multitude of artists showed works which had to compete to catch the eye of critics and potential clients. Kettle had been working as a portrait painter outside of London in 1762–4, and the pictures he exhibited in 1765 would have announced his return to the metropolitan art scene. There may also be a political subtext. There was growing opposition to the monarchy in these years, with the perception among some commentators that ancient British liberties were under threat. Several artists exhibited paintings in the 1760s which contained coded references to current politics, and it may be that Kettle's representation of a dignified mother railing against the abuse of power can be counted among them. ᴍᴍ

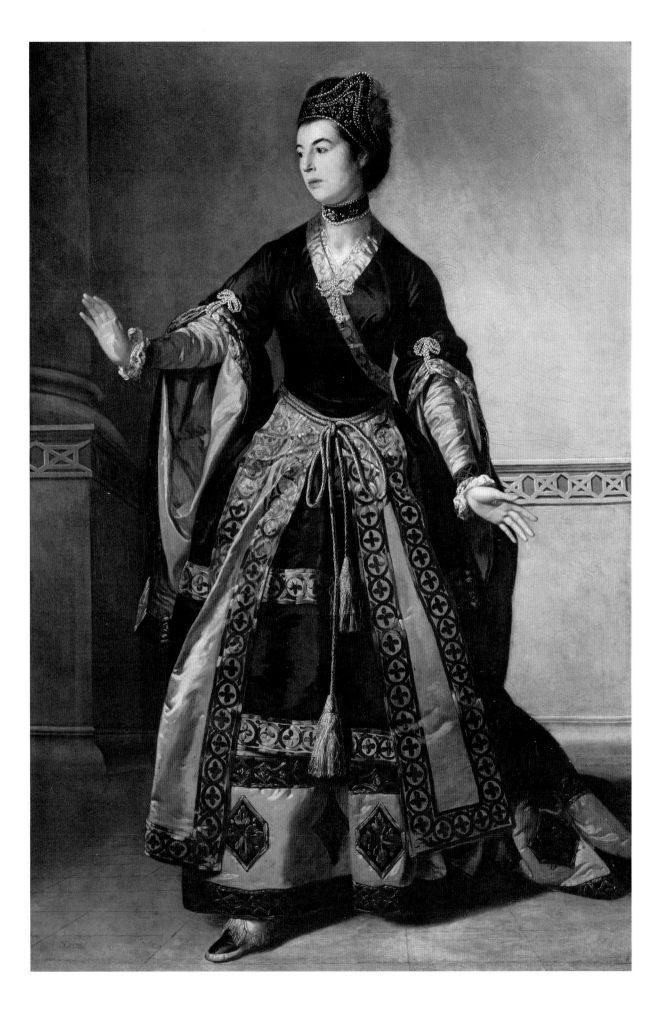

Benjamin West (Springfield, now Swarthmore, Pennsylvania 1738 – London 1820)
Pylades and Orestes Brought as Victims before Iphigenia 1766
Oil paint on canvas 100.3 × 126.4. Acquired 1826

The story depicted here is taken from the play *Iphigenia in Tauris* by the Greek author Euripides (480–406 BC). Iphigenia – the female figure with a crown – was a priestess, who was to stand in judgment over two men accused of trying to steal a gold statue of her goddess Diana (which can be seen in the background, left of centre). In the centre is a herdsman, a witness to the attempted theft, who gestures to identify Pylades and Orestes as the thieves. At the centre is the altar at which Iphigenia has resolved to sacrifice Orestes for his sacrilege.

The work is a 'history painting' – a term used in the eighteenth century to designate paintings of subjects from history, literature, mythology and religion. Although often impenetrable to modern eyes they were considered the highest achievement of a painter at the time. This particular scene gains its drama from the fact that the informed viewer would know that Iphigenia is about to discover that Orestes is her long-lost brother. Around the central scene there is a bustle of figures – guards, attendants and chorus – intended to heighten the sense of drama.

The painter Benjamin West was the first American-born artist to achieve international celebrity. After training in Philadelphia he was sent, at the expense of his wealthy patrons, to Italy, where he studied under Anton-Raphael Mengs. In August 1763 he arrived in London, apparently intending to make only a short visit, but stayed for the rest of his career. *Pylades and Orestes* was completed three years after his arrival and exhibited with a companion work, *The Continence of Scipio*, at the Society of Artists exhibition

in London. It drew on a variety of classical sources: the figures of Orestes and Pylades are taken from the Orestes Sarcophagus, which West drew at the Villa Ridolfi in Rome, and the statue of Diana is based on the statue of the goddess in the Vatican museums.

Soon after the exhibition in 1766, the painting was sold for 100 guineas to the radical Catholic priest and classical scholar Alexander Geddes (1737–1802). It was engraved on several occasions, including as illustration to *Physiognomische Fragmente* by Johann Caspar Lavater (1775) where the heads illustrated the harmony of moral and physical beauty. Not everyone was impressed: Henry Fuseli described the figures as 'characterless marionettes and copy-heads'. The painting passed through several owners before West bought it back in 1802. By that time West had established himself as Britain's pre-eminent history painter, becoming a favourite of George III, for whom he painted British history subjects at Windsor, and gaining popular fame through prints of his scenes of modern historical events, such as *The Death of General Wolfe*. In 1806 he became President of the Royal Academy.

In 1804 West sold the painting to the collector Sir George Beaumont, who bequeathed it to the National Gallery in 1826. It was the first of West's works to enter a public collection. In 1929 it was transferred to the Tate Gallery, relined and cleaned. It has been much displayed in recent years, following the revival of interest in history painting and the grand manner. GS

Joshua Reynolds (Plympton 1723 – London 1792)
Colonel Acland and Lord Sydney: The Archers 1769
Oil paint on canvas 236 × 180. Acquired 2005

This double portrait depicts two young aristocrats, Dudley Alexander Sydney Cosby, Lord Sydney (1732–74), shown on the left, and Colonel John Dyke Acland (1746–78) leaping forward on the right. Dressed in quasi-historical clothing invented by the artist, they are mimicking a medieval or Renaissance hunt, the dead game they leave in their trail underlining their noble blood and aristocratic right to hunt. The painting celebrates the men's friendship by linking it to an imaginary chivalric past, when young lords pursued 'manly' activities together against a backdrop of ancient forest. The two subjects run and take aim in perfect rhythmic harmony, at one with each other and joint masters over nature.

Reynolds painted this portrait shortly after he took up duties as the first President of the newly opened Royal Academy of Arts and delivered the first of his famous *Discourses*. Reynolds's sitter book confirms that the painting was executed in August – a month he usually reserved for personal projects rather than commissions – suggesting that it was made of his own volition, undoubtedly with an eye to the newly established Royal Academy annual exhibitions. The grand scale of the work, its dramatic, tightly organised composition and its deliberate echo of the Italian painter Titian's great mythological scenes all speak of Reynold's extraordinary determination to raise the profile

and status of British art in these years. More particularly, this painting, his most ambitious male portrait to date, demonstrated his desire to elevate portraiture to the level of high art, alongside the genre of history painting which was traditionally seen as superior.

The depiction of the two sitters hunting with bows and arrows speaks of a renewed enthusiasm for archery in aristocratic circles at this time; see for example Johann Zoffany's *Three Sons of John, 3rd Earl of Bute* c.1763–4, also in the Tate collection. Attracted by its virile and romantic associations, the figure of the archer became a fashionable reference point for privileged young men and was a popular allegorical guise for contemporary portraits.

The Archers was exhibited at the Royal Academy's second annual exhibition in 1770, after which it remained in Reynold's studio for several years. It was eventually purchased by Acland's widow in 1779, to commemorate her husband who had died the previous year of a paralytic stroke, probably caused by war injuries. The painting is a recent acquisition for Tate, entering the collection in 2005. Having been out of public view for almost fifty years, it has now joined over thirty other works by Reynolds in the collection, spanning more than three and a half decades of the artist's career. RK

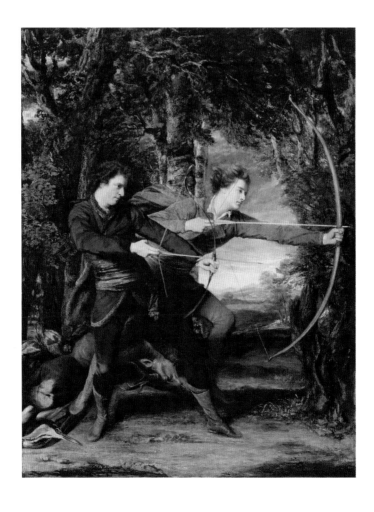

Joseph Wright (Derby 1734 – Derby 1797)
An Iron Forge 1772
Oil paint on canvas 145.8 × 157. Acquired 1992

A white-hot ingot of iron, fresh from the furnace and held in tongs by a finer, is about to be flattened by a mechanised hammer. Light radiates from the hot metal, illuminating the proud forge master and his wife, two daughters and a dog. In the foreground sits an older man with a stick, while a third girl turns her back to the scene to engage the viewer.

At the centre is a formidable piece of machinery called a belly-helve hammer. It is powered by an unseen water wheel that turns the drum at the centre, and which in turn lifts the hammer which springs back from the large beam overhead. Wright had earlier drawn such a machine at rest (Derby Art Gallery). Apart from truncating the hammer in order to compress the scene, he faithfully renders a real device. However, the dramatic lighting, range of expression, and references to Renaissance Nativity scenes and the theme of the Ages of Man, make it clear that this is not a simple piece of documentary realism.

Wright was born in Derby. He trained in London and frequently exhibited there, although he spent most of his career outside the capital. In the 1760s he made his name with genre paintings in modern settings, usually incorporating innovative and dramatic light sources. His famous works of the 1760s – *A Philosopher Lecturing on the Orrery* and *An Experiment on the Bird in an Air Pump* – were followed in the 1770s by a series of five 'Night Pieces' set in a Blacksmith's Shop, a Farrier's, and another Iron Forge (*Iron Forge seen from Without* in the Hermitage).

When *An Iron Forge* was exhibited at the Society of Artists in London in 1772, the *Morning Chronicle* said that Wright had excelled himself, albeit in his 'usual excellent style'. The face of the forgemaster 'has the Apollo and Hercules as truly blended as we have seen', while 'the child in the woman's arms is a model of prattling innocence'. The painting was reproduced in an engraving by Richard Earlom and in the 1780s as a stained-glass window. The manufacturer, a Mr Pearson, said that through glass the 'fire of Wright of Derby ... blazes with more brilliancy than it did on his original canvas'.

The painting was bought by the 2nd Lord Palmerston for £210, and remained in that family's collection until 1992. It has often been exhibited, notably at the International Exhibition of 1862, and the Tate's 1990 retrospective, *Wright of Derby*. Its meaning has been much debated. It had traditionally been seen as a novel depiction of technological progress and a study of rapid changes in the working conditions of traditional craftsmen, although it is now known that the tilt-hammer had been in frequent use since the early seventeenth century, and appeared in art as early as *Forge of Vulcan* by Jan Brueghel (1601–78). It has also been suggested that the series may be Wright's meditation on craftsmanship (his own and others'). The work certainly showcases his technique: thick red paint emphasises the texture of the brick walls, and at the centre of the painting is a thick block of white paint, with thin squiggles of red and yellow which combine to brilliantly suggest the white heat. GS

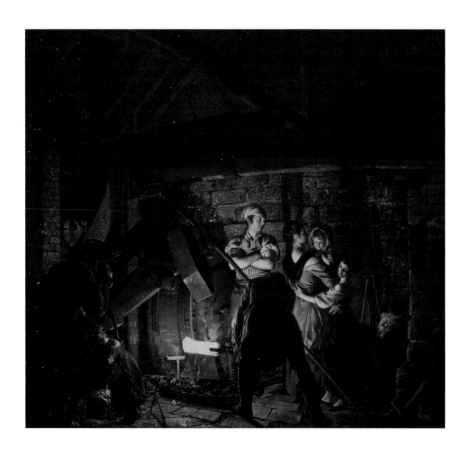

Angelika Kauffmann (Chur, Switzerland 1741 – Rome 1807)
Portrait of a Lady c.1775
Oil paint on canvas 79.2 × 63.5. Acquired 1967

This painting has always been something of an enigma. It entered the Tate collection in 1967 as a 'Self-Portrait' of the Swiss painter Angelika Kauffmann, executed when she retired to Rome in the 1790s. In the 1970s this attribution was questioned and an earlier date and the more general title it still holds were adopted. Over the years, several attempts at sitter identification have been made, including prominent late eighteenth-century female intellectuals, such as the historian Catherine Macaulay and the writer Elizabeth Montagu. These suggestions were undoubtedly prompted by the inclusion of particular portrait props; a book, a scroll, a writing implement and a statue of the Roman goddess Minerva, associated with poetry and wisdom. However, the adoption of classical dress and use of classical statues was relatively commonplace for portraits at this time and could have been used in the depiction of any aspiring or would-be intellectual.

Swiss by birth and Italian by training, Kauffmann had arrived in England in 1766 to resounding social and artistic success. The small-scale classical genre works for which she was best known combined serious poetic and historical subject matter with a characteristic lightness of touch and were entirely in tune with the fashionable neo-classical style then being promoted in London. Kauffmann also courted clients with 'classicised' portraits such as this and executed decorative work for numerous architectural schemes. In recognition of her professional standing, Kauffmann had become one of only two female founder members of the Royal Academy in 1768, only a few years prior to completing this painting.

The depiction of a female sitter with the accoutrements of learning speaks of developments in women's education in the second half of the eighteenth century. Perhaps the most prominent manifestation of this was the founding of the celebrated 'Bluestocking Society' by Elizabeth Montagu and Elizabeth Vesey in the 1750s. The society was an informal organisation of predominantly female artists, writers and scholars who gathered together to discuss literature. Kauffmann herself was pictured with several Bluestockings in a group portrait by Richard Samuel of 1778, *The Nine Living Muses of Great Britain* which celebrated the country's artistic and intellectual women.

Portrait of a Lady is the only work by Kauffmann in the Tate collection and it plays a central role in representing the output of eighteenth-century female artists. This burden stems from the fact that the collection was largely formed when historical female artists were little known and appreciated. While artists such as Kauffmann and her fellow Royal Academy founding member Mary Moser were relatively rare – female creative practitioners have had to negotiate social, political and economic hurdles unknown to their male counterparts – historical bias against their output has also affected their presence in the Tate collection today. While this is being actively remedied, *Portrait of a Lady* remains crucial to our understanding of the varied landscape of the late eighteenth-century art world. RK

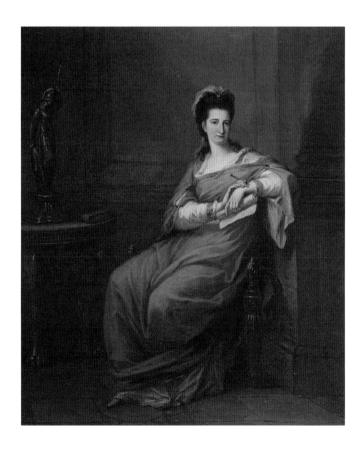

George Romney (Dalton-in-Furness 1734 – Kendal 1802)
Mrs Johnstone and her Son (?) c.1775–80
Oil paint on canvas 89.5 × 70.5. Acquired 1898

The identity of the mother and child depicted in this portrait is uncertain, although the little boy is traditionally thought to be Alexander, the grandfather of Major John-Julius Johnstone, the painting's former owner. Romney's sitter book records several appointments with a 'Mrs Johnston' between November 1778 and March 1779, which may relate to this painting. However, it has also been suggested that the pair represented may be the 'Mrs Ford and Child', dated 1778, listed in a rough overview of Romney's works made by his son. Romney himself notes that the portrait of Mrs Ford was paid for in 1785 by Major Johnstone.

Whoever the sitter might be, the portrait can be more confidently dated to the period of intense activity following Romney's return to London from Italy in 1775. The artist had much to prove in these years, the profile he had built up, in the decade between moving to London from his native Lake District in 1762 and leaving for Rome, having largely faded away. Yet, within twelve months of his return, Romney was enjoying great success. This was partly due to what he had learnt in Italy and his shrewd choice of a studio in fashionable Cavendish Square but also because of his emphasis on good value and informality. His prices were consistently lower than those of his main rivals Gainsborough and Reynolds and he chose to abstain from certain artistic rituals such as exhibiting at the Royal Academy. The loose, spontaneous handling and visible brushstrokes of *Mrs Johnstone and her Son* readily demonstrate the distinctive style of portraiture Romney was developing at this time.

The intimate atmosphere of this portrait, with its minimal accessories and plain background, focuses attention on the tender, informal relationship between mother and child. Romney produced a number of maternal images in the 1770s evoking Raphael's Madonnas, a distinguished model that bears testament to his growing artistic ambition. He was also responding to a wider cultural shift in ideas about child rearing. In the second half of the eighteenth century, a new style of 'natural', unmediated parenting was promoted, an idea which owed much to the popular theories of the French philosopher Jean-Jacques Rousseau. In particular, mothers were encouraged to breastfeed, rather than hand their children over to a wet nurse. The close embrace and affection of *Mrs Johnstone and her Son* clearly expresses these new maternal ideals.

In the final decades of the eighteenth century Romney was the most fashionable portrait painter in London, on a par with Gainsborough and Reynolds. Yet within a decade of his death in 1802 his name had been largely forgotten and by 1898, when this portrait was bequeathed to the national collection, Romney was seen as a relatively minor figure in the history of British portraiture. As his contemporary, the painter Henry Fuseli, summarised, 'he was made for the times and the times were made for him.' While American collectors continued to acquire his work throughout the twentieth century, Romney was somewhat neglected in his native land. However, retrospectives at Kenwood House in 1961 and the Walker Art Gallery and the National Portrait Gallery in 2002 have done much to remedy this view. RK

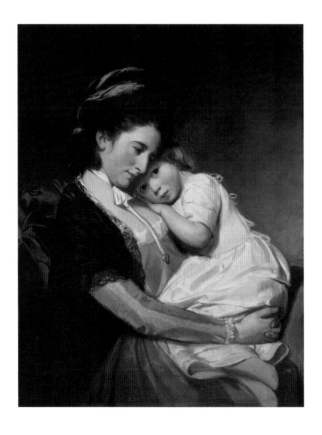

Joseph Wright (Derby 1734 – Derby 1797)
Sir Brooke Boothby 1781
Oil paint on canvas 174 × 231.5. Acquired 1925

Brooke Boothby was an amateur poet and political writer, the eldest son of Sir Brooke Boothby of Ashbourne Hall, Derbyshire. He commissioned this portrait from Joseph Wright in celebration of his association with the French philosopher Jean-Jacques Rousseau, who had died in 1778. Boothby and Rousseau had first met in 1766 when Rousseau came to stay for just over a year at Wootton Lodge, Staffordshire, near Boothby's home. Boothby visited him in Paris almost ten years later and was entrusted with the manuscript for the first volume of Rousseau's autobiographical *Dialogues*, which the philosopher was keen to have published in England. Following Rousseau's death, Boothby paid for the publication of the work and he is shown here holding the manuscript, or a prop copy of it; his left forefinger indicates the name 'ROUSSEAU' inscribed on the spine.

Wright's training as a portraitist and his developing skills as an innovative landscape painter are united in this work, not least in the unusual choice of a landscape format for a portrait subject. From the studio skies and brick walls of his early portraits, Wright graduated in the early 1770s to producing landscape backgrounds of great variety and subtlety. The close attention paid to the details of identifiable foliage in Boothby's portrait illustrates Wright's new artistic interest, though portraiture remained his most reliable source of income. Boothby continued to be a regular patron of Wright after this commission, eventually owning eight further works by the artist. He was also instrumental in attracting eminent visitors to Wright's 1785 one-man exhibition at Robin's Rooms in Covent Garden.

Sir Brooke Boothby is one of Wright's most imaginative and complex portraits and was probably highly collaborative, uniting Boothby's literary interests and Wright's art-historical knowledge. As well as the specific reference to Rousseau, the woodland setting of the painting acts as a more general illustration of the philosopher's belief in the importance of man living in harmony with nature. Boothby's reclining pose also recalls the melancholy tradition of Elizabethan portraiture. This melancholic attitude was not used to indicate low spirits, but rather Boothby's capacity to retire from the world and reflect on subjects beyond daily concerns. This point is underlined by the deliberate dishevelment of his partially unbuttoned waistcoat and sleeves. Nonetheless, Boothby ensured that Wright depicted him in the latest styles, accessorised with a fashionable hat known as a 'wide awake', a muslin cravat and formal shoes with decorative buckles.

Although he was largely based in Derby, Wright exhibited frequently in London and enjoyed a national reputation as an artist. Boothby's portrait was first exhibited at the Royal Academy in 1781 and received favourable reviews. However, in the later nineteenth century, when Wright's artistic standing was at a low ebb, his work was likened to 'the labours of a house-painter' and compared unfavourably with that of Reynolds and Gainsborough. Since *Sir Brooke Boothby* was bequeathed to the Tate Gallery in 1925, Wright's reputation has risen once again and this portrait is now appreciated as a remarkable production by one of Britain's most consistently interesting eighteenth-century artists. RK

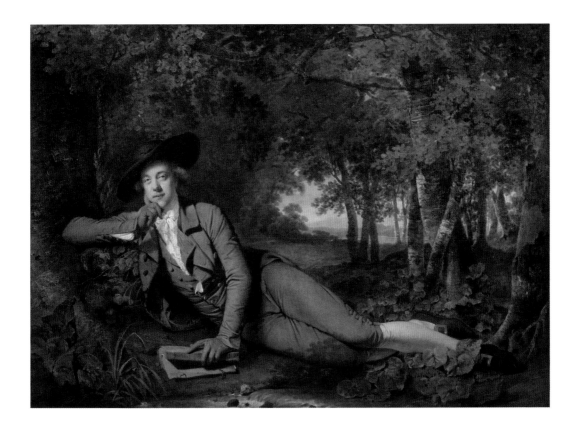

Thomas Gainsborough (Sudbury, Suffolk 1727 – London 1788)
Giovanna Baccelli exh.1782
Oil paint on canvas 281 × 183. Acquired 1975

This portrait shows the famous Italian dancer Giovanna Baccelli (c.1753–1801). She was, for many years, one of the principal ballerinas at the King's Theatre, Haymarket in London, which was partly owned by Gainsborough's friend, the playwright Richard Sheridan. Gainsborough depicts Baccelli at the height of her career, soon after her triumphant 1781–2 season. The elaborate costume she is wearing in this portrait seems to be adapted from the ballet *Les Amans Surpris* in which she had recently taken London by storm. The portrait was commissioned by John Sackville, 3rd Duke of Dorset. Baccelli had become his mistress in 1779 and was to prove his final and longest-standing companion. Gainsborough also completed a portrait of the Duke around the same time, which was intended for the 1782 exhibition at the Royal Academy at which Baccelli's portrait made its debut. However, the Duke's likeness was withdrawn at the last moment, presumably because of concerns about the decorum of hanging their portraits together.

Though Gainsborough painted many sitters from the theatrical world, he rarely depicted them in a role. Here, perhaps uniquely in the artist's work, he shows Baccelli performing, although an idealised landscape has replaced the stage. This change of approach may reflect Gainsborough's ambition to explore more complex poses and the depiction of movement in the final decade of his career. It was also a shrewd exhibition strategy, guaranteeing attention from all those who had recently seen Baccelli dance. She was said to be more charming than beautiful and when the portrait was first exhibited, it was chiefly praised as an excellent likeness:

as the Original, light airy and elegant'. At least one reviewer noted the high colouring of the portrait, something that Gainsborough had been criticised for in the past. However, in this instance the critic conceded that this was due to the sitter's heavy stage make-up; 'the artist was not only obliged to vivify and embellish; but, if he would be thought to copy the original, to lay on his colouring thickly. In this he has succeeded, for the face of this admirable dancer is evidently *paint-painted*.

Ambivalent comments regarding Baccelli's appearance indicate the uncertain status of dancers and actresses in British society in the eighteenth century, who were often assumed to be of loose moral character. The display of physical exertion required by ballerinas encouraged sexual innuendo and did not fit easily with contemporary ideas about appropriate feminine behaviour. With Baccelli, moral doubts were also fuelled by gossip regarding her well-known liaison with the Duke of Dorset. Perhaps in an attempt to make the painting acceptable for public exhibition, Gainsborough has depicted Baccelli with her eyes downcast, in an apparent display of modesty.

Baccelli's portrait was commissioned for Knole, where Dorset and Baccelli lived until their amicable parting in 1789. The painting remained at the house until 1890, when the family sold it. It was purchased by Tate in 1975 and was the first female full-length portrait by Gainsborough to enter the collection. It has been regularly displayed ever since, showcasing both the lively nature of eighteenth-century society and Gainsborough's unique painting technique. RK

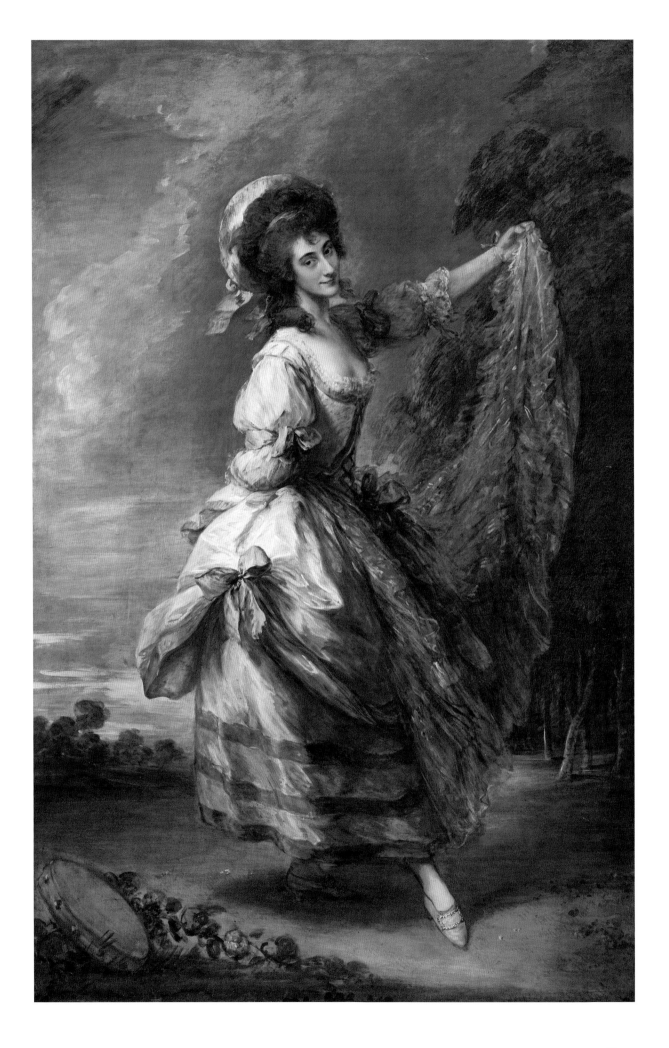

51

John Singleton Copley (?Boston 1738 – London 1815)
The Death of Major Peirson, 6 January 1781 1783
Oil paint on canvas 251.5 × 365.8. Acquired 1864

This large work depicts the British defence of Jersey against a French invasion on 6 January 1781, and commemorates the heroism of twenty-three-year-old Major Francis Peirson, who led the defence and died in the action. A small French force captured the capital, St Helier, and forced the Governor to sign a surrender. Peirson, however, led the British garrison in a successful counter-attack. According to the account that Copley printed to accompany the painting, Peirson was shot by a sniper at the moment of victory and his death was instantly avenged by his black servant, who is pictured – with a distinctive feathered hat – shooting the French gunman.

The central group, arranged like the figures in traditional images of Christ's deposition, are all members of the 95th Regiment (who sat to Copley for their portraits). Captain Clephane, a Grenadier, is seen to the left leading a charge, and a party of Highlanders is attacking on the right. On the overlooking hill other soldiers fire on the enemy. A sergeant lies mortally wounded to the left, attempting to stop the blood with his handkerchief, and a Highlander lies dead on the ground to the right. A woman and children (drawn from Copley's family) run in horror from the scene. To the right centre is a statue of George II, by the London sculptor John Cheere, erected in St Helier in 1751. In military armour and holding a baton, the pose of the king echoes across the composition, in the diagonal flag-poles, swords and in the pose of the firing servant. The gilding too is echoed in the servant's trousers and the yellow flag. Elsewhere the most striking colours are the red and white of the uniforms and the Union Flag, which unfurls above the scene, and supplies the strong diagonal thrust for the whole composition.

Copley established a career as a portraitist in Boston before leaving for Europe in 1774. After a spell studying in Italy, he settled in London where, under the influence of Benjamin West, he painted near-contemporary scenes in a grand style. This painting was commissioned by the print-seller John Boydell. After a private showing for an enthusiastic George III, the painting was displayed in a one-man show in May 1784. A *Description* was published with a key to the principal figures, and Boydell contracted the engraver James Heath to produce large and expensive prints of the painting. In August 1784 the painting moved to Boydell's gallery in Cheapside, where it was displayed in a special frame (now lost) designed by Robert Adam.

This painting is widely regarded as the artist's finest. It combines topography, portraiture and corroborated 'facts' with all the facets of the grand style – artful composition, condensed action, drama and rallying patriotism. The actions of the black servant (actually the black servant of one of Peirson's colleagues, Captain Christie, according to Copley's preparatory notes) are a striking narrative device, introducing a note of impulsive personal loyalty.

The painting was re-acquired by the artist, and passed to his son, Lord Lyndhurst. It was bought for the nation in 1864 for £1,600 and has been on frequent display since. GS

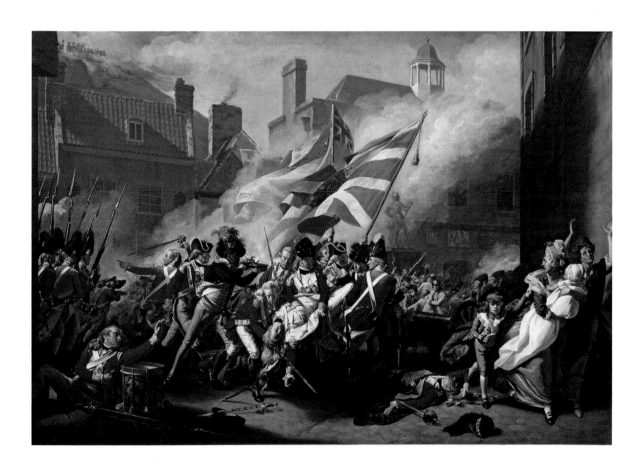

Johan Zoffany (Frankfurt am Main 1733 – Kew, Surrey 1810)
Colonel Mordaunt's Cock Match c.1784–6
Oil paint on canvas 103.9 × 150. Acquired 1994

The painting shows a cock-fight set in Lucknow, India. In the centre is Asaf-ud-Daula, the Nawab Wazir of Awadh, in animated discussion with Colonel John Mordaunt (1749–90), a British East India company employee who for many years stayed at Asaf's court, chiefly to organise the amusements. Asaf, a puppet ruler for the Company, was given to extravagant display: extensive building projects, a large menagerie of animals (note the elephant in the background) and an extensive art collection. One of his principal amusements was cock-fighting, a passion he shared with the sporty Mordaunt. In the scene depicted here the cocks have been released, and are encouraged to attack each other by their handlers. Asaf has jumped from his seat to bet with Mordaunt, who gestures to his own bird, whilst the Nawab's uncle, Nawab Salar Jung, counts the bet on his fingers.

Zoffany began this work in India, where he had travelled from London in search of rich Company clients in 1783. Initially based in Calcutta, Zoffany was invited to accompany the Governor-General Warren Hastings to Lucknow in the summer of 1784. The city, according to Hastings, was a 'sink of iniquity' that he was determined to reform. Zoffany's role was to take portraits of the Indian mughal royals with a view to furthering diplomacy, although the artist resolved to stay in Lucknow. Hastings, who had attended one of Mordaunt's cock-fights, commissioned this painting, at a cost of 15,000 rupees, in 1784. Why Hastings (who is not depicted in the scene) wanted the painting is not clear, although he was friendly with Mordaunt and had accomplished a successful diplomatic mission in Lucknow, which he may have wanted to commemorate.

Zoffany's scene was apparently based on sketches made from life. It comprises around ninety figures arranged in a bustling circular composition. There are numerous portraits of Lucknow residents, like Zoffany's friend Claude Martin (who sits on the settee), a French-born defector to the Company, who supervised the Nawab's arsenal. There are numerous colourful details: the dancing nautch girls, musicians, a water-seller and Zoffany himself seated with his arm over a chair in the right background.

The artist, having reportedly received over £60,000 worth of commissions, returned to England in August 1789. In 1792 a mezzotint of the *Cock Match* by Robert Earlom was published, followed two years later by a key to the figures. Zoffany referred to the painting as a 'historical picture', suggesting that it was not just a conversation piece but a depiction of an important historical event, with players who were worth identifying (a model of history painting adopted by Benjamin West and J. S. Copley). His treatment, however, is typically wry and suggestive of bawdy masculine humour. It also hints at the influence of the densely detailed Mughal paintings that were collected by Asaf.

This painting hung at Hastings's home, Daylesford, until 1853, before exchanging hands several times. It was in the collection of the Sutherland family from 1926 until acquired by Tate in 1992. It has been the subject of sustained academic attention throughout the twentieth century, and has been read as an index to Lucknow life and morals, as well as a part of Zoffany's remarkable career. GS

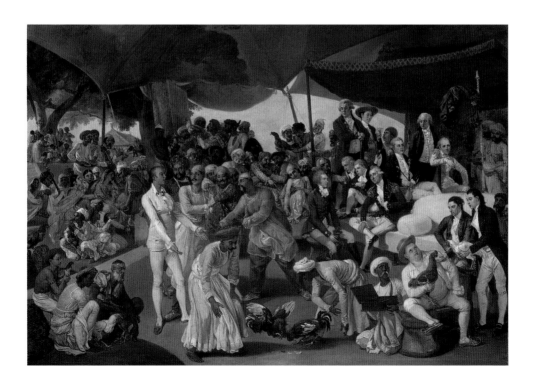

George Stubbs (Liverpool 1724 – London 1806)

Reapers 1785
Oil on wood 89.9 × 136.8. Acquired 1977

Haymakers 1785
Oil on wood 89.5 × 135.3. Acquired 1977

During the last third of the eighteenth century paintings of rural life enjoyed great popularity. Many artists created such scenes in the hope of selling the original pictures to wealthy patrons and marketing more affordable reproductions to the public at large. This pair of images shows Stubbs, well established by this time as the leading painter of horses and dogs, venturing into the field. The two pictures were first exhibited together at the Royal Academy in London in 1786 and at Liverpool's Society for Promoting Painting and Design in 1787.

While many paintings of rural life would focus on individual figures or small groups of figures, in both these pictures we are shown larger groups of men and women engaged in the different steps of their work, with centrally placed, attractive young women looking out at the spectator. In *Reapers* we also see a foreman, mounted on a horse, overseeing the scene and paying particular attention to the young woman. Although unusually ambitious and technically precise exercises in the popular genre of rural painting, contemporary critics did not look favourably on Stubbs's attempt to extend his range: one newspaper commentator complained 'In horses this artist stands unrivalled ... how difficult it is to persuade a man to pursue his forte.'

The paintings were acquired by the Tate Gallery in 1977, following a high-profile campaign to raise funds to support their purchase. Notably this extended to an appeal to the public at large, involving competitions and a prize draw.

Although the campaign stressed the universal appeal and honesty of the pictures, scholarly commentary has offered more divisive interpretations. For many commentators these paintings represent Stubbs's acute and unsentimental powers of observation yet also convey an honest vision of the English countryside with all its beauties and pleasures. At the time of the acquisition, a Tate curator called them 'the most lyrical of all representations of rural labour in England in the eighteenth century, as well as the most truthful'. Others see the paintings as adding up to a carefully orchestrated fiction of rural work, designed to prove gratifying for landowners seeking a reassuring view of the land and for urban audiences looking for sentimental and erotic amusement. The orderliness and regimentation of the workforce, and the striking cleanliness of their costumes, are important elements in conveying a reassuring sense of the rural economy, which in reality was striven by unrest and famine. Notably Stubbs treated the hats of the female workers differently each time he painted this theme, in line with current fashions (in previous versions of 1783, here in 1785 and again in further versions in 1795). Working women in the eighteenth century could, of course, aspire to fashionability, and we know that they would have access to fairly up-to-date clothes courtesy of the second-hand market. Nonetheless, the political and social implications of these images remain open to interpretation. MM

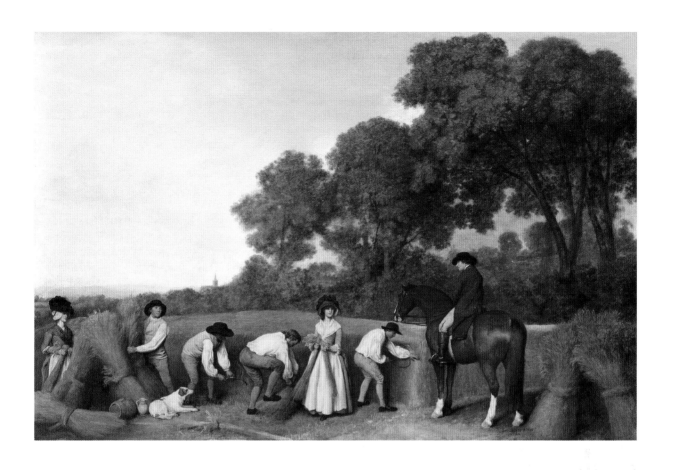

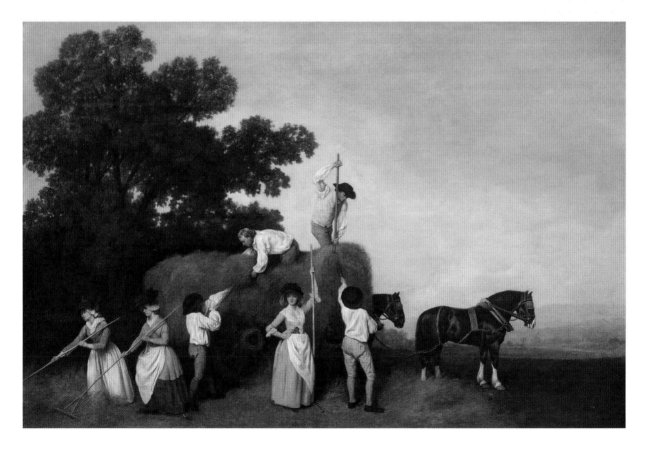

Henry Fuseli (Zurich 1741 – Putney Hill, Surrey 1825)
Titania and Bottom with the Ass's Head exh.1789
Oil paint on canvas 217.2 × 275.6. Acquired 1887

In the last quarter of the eighteenth century many prominent British artists created paintings based on the plays of William Shakespeare. While a few earlier artists had illustrated Shakespeare plays as if they were being staged, these later painters tended to treat them as literary source-materials, creating ambitious and original interpretations, which largely disregarded the conventions of theatrical performance. The Swiss-born painter Henry Fuseli was one of the leading proponents of this imaginative Shakespearian painting.

The subject of this large picture is from Shakespeare's comic fantasy *A Midsummer Night's Dream* (c.1590–6). Titania, the Queen of the Fairies, has been made by her jealous husband Oberon to fall in love with a simpleton, Bottom, whose head has been magically transformed into that of an ass. Bottom orders her fairies to serve his whims, which are now, naturally, ass-like: Peaseblossom scratches his head, Mustardseed rubs his nose, Cobweb, standing on Bottom's outstretched hand, is ordered to kill a bumble-bee. To Titania's right are two 'Maids of Honour'.

The painting was commissioned by the print publisher and entrepreneur John Boydell for the first showing of his Shakespeare Gallery in 1789. This project featured specially produced paintings by a range of the best-known contemporary British artists, shown together to promote the sale of reproductive engravings. Boydell's project was determinedly commercial, while also appealing to a growing sense of national pride. Fuseli's paintings were especially well received. A newspaper reviewer said of this work: 'Beings, which "melted into air, into thin air," are now embodied upon the canvas; and the group of tiny elves,

fairies, and fays, which gambol in the Midsummer Night's Dream, bring to our recollection the mythology of our childhood.' The last is a reference to children's fairy tales and romances, which drew from folklore tradition. Fuseli's particular achievement would seem to be the integration of such personal or folkloric references with a self-consciously Old Masterly presentation which evokes, in the poses and treatment of the various figures, Raphael and Leonardo, Michelangelo and Singorelli.

Although Fuseli had a reputation for eccentricity and extravagance, he was also commercially and professionally successful. His art combined a level of art-historical and literary references which flattered his more knowing spectators, with straightforward showmanship and visual spectacle. But his work always divided opinion, and the eroticism and idiosyncrasy of his art was increasingly considered distasteful. Three of his works owned by the banker John Julius Angerstein were simply overlooked when his collection was bought as the foundation of the National Gallery in 1824. This work was given to the national collection in 1887, when he was still viewed as an oddball, if unavoidable, feature of British art history. Its relatively early transfer in 1909 from the National Gallery to the Tate Gallery reflected the tendency to see such literary and imaginative British paintings as properly the province of the latter institution, while major landscape and portrait paintings remained at Trafalgar Square. Fuseli's general reputation was renewed from the 1930s, as he was rediscovered as a forerunner of symbolism and surrealism and paintings like this were interpreted in psychoanalytic and allegorical terms. MM

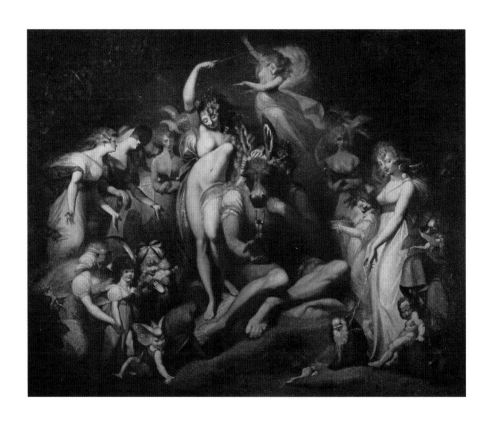

William Blake (London 1757 – London 1827)
Newton 1795–c.1805
Colour print finished in ink and watercolour on paper 46 × 60. Acquired 1939

This famous but enigmatic image was created by the visionary poet and artist William Blake as part of a series of prints created on the same format in 1795, then apparently reprinted and reworked in around 1805. These 'Twelve Large Colour Prints' combine a unique printmaking method with hand-painting, and cover imagery that ranges from relatively conventional biblical illustration to much more arcane and elusive symbolism. 'Newton' is of the latter class.

The title is derived from Blake's own notes and is evidently intended to relate the image in some way to the famous scientist Isaac Newton (1642–1727). However, the figure is patently not meant as a literal likeness of that historical individual. References to Newton in Blake's poetic writings identify him as the exemplar of the rationalism and materialism that oppresses the imagination. The compass with which the nude 'Newton' measures a geometric diagram laid out before him may also allude to the idea of an arid scientific literalism.

Blake trained as a conventional reproductive engraver but developed his own highly idiosyncratic printing and painting techniques with which he explored a complex personal mythology. His art was little understood or appreciated during his lifetime, although he had a few loyal supporters, particularly among fellow artists. Foremost among his original patrons was the civil servant Thomas Butts, who purchased this print from Blake in 1806. The print remained with the Butts family until it was sold to the artist W. Graham Robertson in 1905. By that time Blake's reputation as was on the rise and Robertson was the most enthusiastic of a new generation of collectors drawn to his eccentricity and imagination. Robertson was especially important in helping to establish Blake's reputation as a visual artist as well as a poet, and his extensive collection of drawings, prints and paintings was given to the Tate Gallery and other public collections.

The large colour prints were put on public display at the very beginning of the modern reassessment of Blake's reputation. They were included in seminal exhibitions of his art held in London in 1876 and at the Tate Gallery in 1913, and were shown at the Tate for several years in the 1920s even before Robertson gave them to the nation. From among these prints the *Newton* has always attracted particular attention, both for its intriguing imagery and its apparently miraculous technique. The Pre-Raphaelite artist Dante Gabriel Rossetti commented:

> One of these [the large colour prints], the *Newton*, consists in a great part of rock covered with fossil substance or lichen of some kind, the treatment of which is as endlessly varied and intricate as a photograph from a piece of seaweed would be. It cannot possibly be all handwork, and yet I can conceive of no mechanical process, short of photography, which is really capable of explaining it. It is no less than a complete mystery.

The image has endured as both icon and enigma, and has been reproduced and interpreted in a dazzling array of contexts. These range from the strictly scholarly, to encompass a comic rendition by the cartoonist Steve Bell and Eduardo Paolozzi's sculpture placed outside the British Library in London. MM

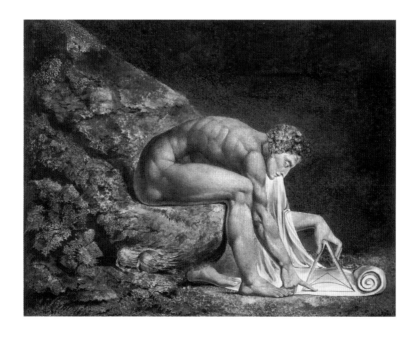

Philip James de Loutherbourg (Strasbourg 1740 – London 1812)
The Battle of Camperdown 1799
Oil paint on canvas 152.5 × 214. Acquired 1971

The subject of this powerful painting is the Battle of Camperdown, a major naval encounter that took place on 11 October 1797 between a British fleet under Admiral Adam Duncan and the fleet of the Dutch, who were then allied with the French. The battle was the most significant action between British and Dutch forces during the French Revolutionary wars and resulted in a resounding victory for Duncan. De Loutherbourg shows the decisive moment when the British flagship *Venerable*, to the left of centre, fires its last broadside at the Dutch flagship *Vryheid*. Other ships, such as *Powerfully Ardent*, *Bedford* and *Director*, can also be identified but such documentary detail was not de Loutherbourg's primary concern. The prominence given to the shipwrecked sailors in the foreground offers a profoundly human vision of the conflict, hoping to provoke strong feelings in the viewer and create an impression in the exhibition room.

The ability to conjure such pictorial drama owed much to de Loutherbourg's wide-ranging professional experience. In 1771 he had moved to London from Paris, where he had enjoyed considerable success as a landscape painter and been elected the youngest ever member of the French Academy. Though his intention was to stay in England only long enough for a difficult family situation to resolve itself, he in fact remained here for the rest of his life. While continuing to paint and exhibit regularly at the Royal Academy, de Loutherbourg also entered the employment of the celebrated actor-manager David Garrick as a set and costume designer for Drury Lane Theatre. De Loutherbourg's highly imaginative stage effects, involving coloured lights, painted glass, transparencies and smoke, attracted widespread admiration. In 1781, at his home in Soho, he launched his famous

Eidophusikon: a miniature mechanical theatre in which spectacular city views, storms at sea and scenes from Milton's *Paradise Lost* were re-created. The crossover between these two parallel strands of de Loutherbourg's career is evident in the heightened effects of his painting from the 1780s onwards, his mountainscapes and battle scenes demonstrating a flair for theatrical spectacle translated into dynamic compositions and sensational lighting effects.

Following the great critical and commercial success of two previous naval battle scenes by de Loutherbourg – *The Grand Attack on Valenciennes* and *The Glorious First of June* – this painting was one of a pair commissioned by the enterprising engraver James Fittler (1758–1835). Repeating a scheme from which he had profited handsomely before, Fittler hung *The Battle of Camperdown* alongside *The Battle of the Nile* in an exhibition room he had hired for the purpose in London. He simultaneously advertised 'superb and elegant' prints after the painting to which visitors could subscribe. Though the take-up on subscriptions was disappointing, *The Battle of Camperdown* was sold and subsequently passed through several eminent private collections, including that of George Spencer-Churchill, 5th Duke of Marlborough and the Junior Carlton Club on Pall Mall, where it hung for many years before its acquisition by the Tate Gallery in 1971. A 1973 retrospective at Kenwood House reintroduced de Loutherbourg to a modern audience and with increasing interest in ideas surrounding the spectacularisation of landscape in the late eighteenth century, his paintings have once again come under the spotlight in recent years. RK

Henry Raeburn (Edinburgh 1756 – Edinburgh 1823)
Lieutenant-Colonel Bryce McMurdo c.1800–10
Oil paint on canvas 240 × 148. Acquired 1895

Little is known of Lieutenant-Colonel Bryce McMurdo but for the fact that he lived at Mavis Grove near Dumfries and married Jane Otway of Sevenoaks, Kent, in 1802. This full-length portrait may have been painted not long after his marriage. McMurdo is shown fishing on the banks of a stream. Wallets for storing fishing tackle can be seen in his upturned hat while between his feet rests a small basket or creel for keeping live fish.

Raeburn was largely a self-taught artist who, after an apprenticeship with a goldsmith, set himself up in Edinburgh and by 1776 was painting portraits in oils. He visited London in 1785 and went to Italy that same year with letters of introduction from Joshua Reynolds. After a two-year sojourn he returned to Edinburgh where he soon established himself as Scotland's leading portrait painter. In the 1790s and early 1800s, when this painting was executed, Raeburn commanded a near monopoly over Edinburgh's fashionable portrait production. There is evidence of considerable conflict with other local artists and despite his success, Raeburn was declared bankrupt in 1808. Bryce McMurdo's portrait may date from the flurry of professional activity that followed this misfortune. The difficulty of pinpointing the exact chronology of Raeburn's paintings can largely be attributed to the fact that he rarely dated his work and that none of his sitter books or ledgers survive. Yet it also owes much to the fact that Raeburn painted concurrently with a variety of different techniques.

The diversity of Raeburn's style after his return from Italy hints at the complex interplay of artist, sitter and audience in the competitive portrait market of the late eighteenth and early nineteenth centuries. Raeburn was evidently adept at responding to the diverse requirements of his patrons and had a clear-eyed view of portrait painting's potential. Critics have lauded him as the first major Scottish artist to resist the allure of London and the long familiar notion of Raeburn as 'the portraitist of the Scottish Enlightenment' is tenacious. While this idea is founded on a somewhat romantic view of Raeburn's heroic artistic isolation in Scotland, it may more accurately reflect his acute awareness that the success he enjoyed in Edinburgh would be hard to replicate in the more crowded London art world. Far from being isolated, there is evidence to suggest that Raeburn was in fact intimately aware of developments in fashionable portraiture taking place in the capital, in particular the work of his contemporaries Hoppner and Beechey.

Raeburn's reputation dwindled immediately after his death, only to recover with the burgeoning art markets of the turn of the twentieth century and the appearance of a succession of biographical studies. This portrait was bequeathed to the national collection in 1895 at a time when British museums were just beginning to increase their holdings of Raeburn's work. It is now one of nine of his portraits at Tate, which help to represent the output of non-metropolitan artists. RK

Thomas Lawrence (Bristol 1769 – London 1830)
Mrs Siddons 1804
Oil paint on canvas 254 × 148. Acquired 1843

Sarah Siddons (1755–1831), the most celebrated tragic actress of her day, is seen here not on stage but at one of her dramatic readings. Her stoic expression signifies an affecting moment, ripe for a loaded pause in which she confronts her audience – the viewer – square-on, drawing us into the drama. The actress is accompanied by the texts that defined her career: she is perhaps reading Shakespeare's Lady Macbeth, a tragic role for which she was particularly noted, but we may also glimpse a volume of plays by Thomas Otway, whose Belvidera in *Venice Preserved* was a role Siddons had performed to great acclaim exactly thirty years earlier.

Portraiture of stage personalities was an established genre by the late eighteenth century, fuelled by the craze for 'celebrity spotting' among works displayed at the annual Royal Academy exhibitions. In the Academy's tightly packed hang, such portraits hung alongside those of the nobility, enhancing the perceived social status of actors and the respectability of their profession. It is likely that this painting was a commission from Siddons herself, intended to promote her carefully constructed persona as the most intellectual and superior of actresses. Lawrence perpetuates these values by emphasising the actress's dominant, powerful presence. In her maturity, critics often referred to Siddons's 'matronly' or 'statuesque' figure, here flattered by a high-waisted neoclassical gown, a style then considered timeless and appropriate for tragic roles.

Lawrence was particularly noted for this type of work; his full-length depictions of other famous women, Queen Charlotte and the actress Elizabeth Farren, had initiated his rise to fame in 1790. By the time *Mrs Siddons* was painted, Lawrence was a portraitist much in demand and a celebrity in his own right. His work was consistently well-received by critics; he could count George III as one of his many influential patrons and just ten years earlier he had been elected a member of the Royal Academy at the youngest possible age of twenty-five. He became its President in 1820.

Mrs Siddons is also a document of the forty-year friendship between Lawrence and his sitter, during which time he made at least five portraits of the actress (see also Tate N00785). In the decade prior to the current portrait, however, the relationship between artist and actress took a dramatic course. Between 1796 and 1798, the charismatic and flirtatious Lawrence became engaged at different times to two of Siddons's daughters. Sarah opposed each of these liaisons, apparently compelled by her own deep affection for the artist. This emotionally turbulent situation was to end tragically with the death of one daughter, and later the other, the latter having pledged to her dying sister that she would cease her involvement with Lawrence.

An engraving of *Mrs Siddons* was published between 1820 and 1840, bearing an inscription naming the painting's owner as William Fitzhugh. A Mrs Fitzhugh donated the painting to the National Gallery in 1843, where it joined Lawrence's colossal portrait of Siddons's brother and fellow actor, John Philip Kemble (Tate N00142). The Tate's collection of glamorous actor portraits also includes John Singer Sargent's *Ellen Terry as Lady Macbeth* (see p.115). AC

David Wilkie (Cults, Fife 1809 – at sea off Gibraltar 1841)
The Village Holiday 1809–11 exh.1812
Oil paint on canvas 94 × 127.6. Acquired 1824

Born in Scotland, the son of a minister, Wilkie trained at the Trustees' Academy, Edinburgh and the Royal Academy in London, where he was based for the rest of his life and won instant recognition for scenes of Scottish rural life and traditions. Besides his background and observations, including close attention to character and expression, he initially based his art on the seventeenth-century Dutch and Flemish painters he encountered in prints. His extraordinary standing in the early nineteenth century is indicated by his presence as the only modern British artist in the two founding collections of the National Gallery and thus, eventually, the Tate Gallery. Sir George Beaumont, a connoisseur and amateur painter, presented *The Blind Fiddler*, a Dutch-inspired essay in the Scottish vernacular dating from 1807. From the collection of John Julius Angerstein, City grandee, insurance broker and philanthropist, the National Gallery had already bought *The Village Holiday*, its first modern picture.

In 1808, to 'amuse myself', Wilkie began to plan a picture, *The Public House Door*, as a morality play on the evils of drink. Wilkie said he had seen the drama performed in every alehouse from Cults to Canterbury but set the scene outside an inn at Brompton, on the outskirts of West London. The picture was commissioned by Angerstein whose charitable interests may have been a factor in its theme, especially its focus on women and children who put up with intoxicated husbands and fathers. The central motif, a drunkard torn between his wife who tries to drag him home and a friend

who urges him to stay at the tavern, burlesques Angerstein's picture by Joshua Reynolds of the actor David Garrick flanked by personifications of Tragedy and Comedy, itself a modernisation of the ancient myth of Hercules choosing between Virtue and Vice. A modern actor, John Liston, sat for a man at the table waving a bottle, one of the subsidiary acts of Wilkie's drama; another, on the opposite side of the picture, consists of a man slumped beside his dog who, as Wilkie said, looks ashamed of his master.

Wilkie exhibited the picture in a one-man show in 1812, accompanied by lines from Hector Macneill's temperance poem *Scotland's Skaith*, describing a drinker caught between his 'deadly poison' and the neglected wife who 'Rave his very heart in twa'. Wilkie's change of title to *The Village Holiday* seems to underplay the role of alcohol. He may have been affected by adverse reactions to William Mulready's *Returning from the Ale-House* (Tate N00394) exhibited in 1809 (itself later renamed *Fair Time*), or come to acknowledge the ambiguity of the narrative as inviting humorous indulgence or moral censure. Drunkenness was a familiar subject of the Netherlandish painters who influenced Wilkie's early work. But his picture is more subtle and explores fresh artistic sources, notably Antoine Watteau and the French Rococo, available to him in London. It points the way to new forms of contemporary and (increasingly) historical narrative that occupied him in the coming years and made his work, as a whole, perhaps the most influential of any British painter of his generation. DBB

John Constable (East Bergholt, Suffolk 1776 – London 1837)
Flatford Mill ('Scene on a Navigable River') exh.1817, 1818
Oil paint on canvas 101.7 × 127. Acquired 1888

A pioneer of naturalism in landscape painting, Constable added working life to his picture *Flatford Mill*. It depicts the canalised River Stour at a point he knew from boyhood. His father ran the mill and helped manage the Stour Navigation that enabled barges to carry corn and coal. Constable shows a 'gang' of two barges that have passed through Flatford Lock and are being unhitched from their tow-rope to be poled under Flatford footbridge, just glimpsed on the left.

One of a small series of pictures that Constable worked on outdoors in Suffolk from 1814, *Flatford Mill* marked the latest stage in his quest, radical and distinctive when announced in 1802, to find a 'natural painture' based on his own observation and experience and a relative disregard of artistic prototypes. Having moved away from home to study at the Royal Academy and practise as a painter, he felt unduly confined to his London studio. Returning to the country in summer to paint from the motif helped to redress this, but was not undertaken in pursuit of the spontaneous and impromptu but to improve his 'finishing'. The picture was evolved from a quantity of drawings including one dated 14 August 1814, oil sketches and studies and a tracing that helped Constable to transfer the outline design to canvas. Only thus prepared did he begin work on the spot and, after the outdoor stage, he made further adjustments back in the studio. The result is a taut, rigorously controlled composition in which nothing seems left to chance save the weather (the changeable sky threatens a shower).

The brilliant lighting, and a level of detail almost the same from foreground to background, seem if anything hyper-real.

In concentrating on the working life of the river rather than its picturesque aspects, *Flatford Mill* anticipates the larger six-foot Stour scenes that Constable exhibited from 1820. As in these later pictures, realism is tempered by nostalgia and sentiment. The family-oriented subject matter surely responded to the death in 1816 of his father (whose hat might lie abandoned on the tow-path) and his own transition from youth to maturity during a protracted courtship. The passage of the two barges against the current might reflect this, and also Constable's view of his own art which contemporaries, other than his friends, were slow to appreciate. The landscape seems divided conceptually, the stream bordered by wild plants perhaps belonging to childhood and innocence, the 'navigable river' to adult experience.

The picture went unsold when exhibited at the Royal Academy in 1817 and the British Institution in 1818, although the approval of some colleagues led to a mistaken hope that Constable might finally be elected to the Academy. By contrast his plein-air naturalism was received enthusiastically in France and became part of the background to impressionism. *Flatford Mill* was bequeathed by Constable's daughter Isabel to the National Gallery in 1888. At Tate it represents the conclusion of his first phase of Suffolk realism before his subject matter expanded to embrace other locales. DBB

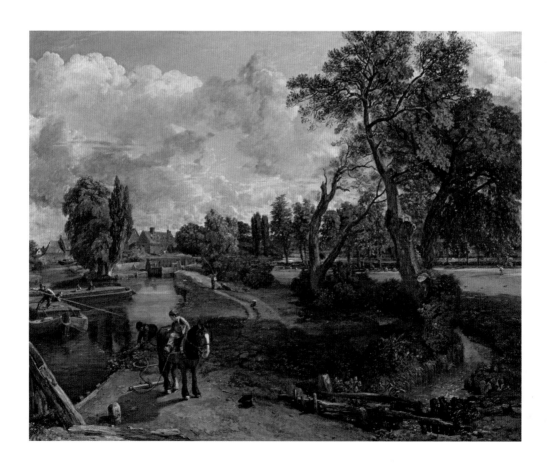

Joseph Mallord William Turner (London 1775 – London 1851)
The Field of Waterloo exh.1818
Oil paint on canvas 147.3 × 238.8. Acquired 1856

By mid-career Turner had long since moved on from his beginnings as a watercolourist and painter of landscape and topography to tackle great historical themes past and present, European as well as national. After the defeat of Napoleon by British and Prussian troops at Waterloo in 1815, continental travel and scenery became major themes of his art. His first postwar expedition in 1817 took him to the site of the battle and to the Rhineland. The battlefield was already a tourist attraction, and Turner was able to fill a *Waterloo and Rhine* sketchbook (Tate, Turner Bequest) with details of positions where 4,000 men were killed or a 'great carnage took place of the Cuirassiers by the Guards'. His on-the-spot research and note taking informed *The Field of Waterloo,* exhibited in 1818.

Although he sent the picture to the Royal Academy, Turner may have been prompted by a competition organised by its rival, the British Institution, for a 'Grand Historical Painting' to commemorate the allied victory. However, his picture does not depict the battle itself, as must have been envisaged, but its aftermath. The scene is set at nightfall, near the farm of Hougoumont, still burning in the background, where the fiercest fighting took place. The ground is piled with the dead and dying, tended by women who rushed to the field when the fighting stopped. A flare has been fired to deter thieves and pickpockets. In other pictures, notably scenes of the rise and fall of ancient Carthage, Turner allegorised the collapse of the Napoleonic empire in historical terms. But *Waterloo* is unflinching in its depiction of the consequences of modern warfare, and impartial in its mingling of the dead of all sides. Appropriately given its subject and setting, Turner echoes the sombre shadows of Rembrandt rather than the sunlit seaports of Claude Lorrain, as in the Carthage pictures. But the overwhelming impression is modern. Turner exhibited the picture with an extract from the 'Waterloos Stanzas' from Byron's recently published poem *Childe Harold's Pilgrimage*, describing 'friend, foe, in one red burial blent'.

There is no evidence that Turner shared the view of radical commentators like the writer William Hazlitt that the defeat of Napoleon was a victory for reaction. Rather the vision of common loss he took from Byron was humane. But *The Field of Waterloo* demonstrates that, even as Turner was recognised as the outstanding painter of his generation, his imagery was often challenging and controversial. Shocking in its apparent realism and seemingly unpatriotic too, the picture was judged a failure, described as 'abortive' or 'a drunken hubbub on an illumination night'. It stayed in Turner's collection, later to form part of the Turner Bequest in 1856. In this comprehensive survey of his art and times, housed largely at Tate Britain, it depicts the key event for his generation. As such, Turner later recycled his treatment of Waterloo for illustrations to the life and works of Byron (1832) and Walter Scott's *Life of Napoleon* (1835). DBB

John Gibson (Conway, North Wales 1790 – Rome 1866)
Hylas Surprised by the Naiades 1826 – c.1836
Marble 160 × 119.4 × 71.8. Acquired 1847

Gibson was commissioned to produce this statue group in Rome in May 1826. It presents a scene from Greek mythology in which the boy Hylas, the companion of Hercules, goes to collect water from a stream and is lured into the depths by water-nymphs, who are entranced by his beauty. The nymphs (Naiades) simultaneously gaze admiringly and move to physically detain the boy. The taller places her face against Hylas's hair and strokes his cheek whilst gently restraining his arm, the other places a hand around the boy's waist and takes his hand in hers. The boy seems to lose his grip on the pitcher in surprise. His extended leg suggests that he is trying to leave, although he also appears entranced by the naked naiad.

Gibson began his career as a cabinet-maker in Liverpool before moving to London in 1817. Following the advice of John Flaxman, London's leading neoclassical sculptor, he travelled to Rome, arriving in October of that year. Having received training from the Italian master Antonio Canova and the Dane, Bertel Thorvaldsen (who also made a relief of this subject), he produced works based on close study of Greek and Roman antiquity. He never returned to England, fearing he would be forced to make a living there from portrait busts and statues, rather than poetic subjects.

Gibson's *Hylas* draws on several classical sources. The boy's profile resembles an antique gem-engraving, with 'long hair in curls' as described by the third-century Greek poet Theocritus. The amphora in his hand is based on excavated examples, and his pose echoes a relief of the subject on a sarcophagus at the Villa Mattei in Rome. The Greek inscription translates as 'Beautiful Hylas'.

Hylas took many years to complete. A delay was caused by the decision of Gibson's patron, William Haldimand, to withdraw his interest. Gibson, however, found another buyer in Robert Vernon. In 1832 the *Liverpool Echo* reported to its readers that the work was almost complete. It was finally exhibited at the Royal Academy in 1837, and was given to the nation as part of the Vernon Gift in 1847. In 1850 it was exhibited in the Great Hall of Marlborough House with Vernon's busts, and in 1854 engraved for a feature in the *Art Journal*. The commentary noted that the subject – the obsession of grown women for a boy – was potentially controversial, but Gibson had treated it with care. The work was exhibited at the 1855 Paris International Exhibition.

After Gibson's death the *Glasgow Herald* declared Hylas 'amongst the most poetic and best finished' of his works. It was initially shown in a corridor at the National Gallery, before being removed to pride of place in the Central Hall, a curatorial decision applauded by the *Pall Mall Gazette* (1885) who wrote that 'it is for the first time seen to advantage, and the great hall is, for the first time, an important centre of the building'. In 1897 Hylas was transferred to the Tate Gallery, where the *Daily News* felt that it 'shows well the contrast between the old school and the new'. It was shown in *Sculpture 1850 and 1950* in Holland Park in 1957, and at Tate in *Robert Vernon's Gift* (1993) and *Return of the Gods* (2008). GS

John Simpson (London 1782 – London 1847)
Head of a Man (Ira Frederick Aldridge?) exh.1827
Oil paint on canvas 73.3 × 56.2. Acquired 1847

This head and shoulders study evokes a tradition of heroic and divine imagery stretching back to antiquity. The far-off gaze would conventionally suggest philosophical reflection or moral aspiration, while the heavy red cloak billows out like the costume of a saint in seventeenth-century religious art.

The painting is closely linked to Simpson's larger subject painting *The Captive Slave*, which reappeared on the art market and was purchased by the Art Institute of Chicago in 2008. This shows the same sitter but in three-quarter-length format, manacled to a bench. That painting was exhibited in London in 1827 accompanied by lines from William Cowper's anti-slavery poem 'Charity' (1782). Although the slave trade had been made illegal within the British empire in 1807, slavery continued in British colonies until the 1830s and remained a hugely divisive political issue. Simpson's paintings can, therefore, be interpreted as interventions in an ongoing dispute about race and slavery.

The present painting was shown as *Head of a Black* at the exhibition of the British Institution in 1827. Simpson tended to display character studies and subject paintings at the Institution, while showing the fashionable portraits from which he made his living at the Royal Academy. Although exhibited originally as an anonymous figure, as with *The Captive Slave* the model appears to be the American actor Ira Frederick Aldridge (1807–67). He had come to Britain in 1824 and made his debut on the London stage in 1825. In the face of much racial prejudice he took on a wide variety of roles and established an international reputation. He was painted by several artists in the early stages of his career, including John Jackson, Henry Perronet Briggs and James Northcote.

The painting belonged to the art patron Robert Vernon, who gave his collection of British pictures to the nation in 1847. When the work was engraved in the *Art Journal* in 1853, it was given the title of *The Negro* and mistakenly attributed to 'W. Simpson'. The accompanying text imagined it as a suitable illustration of the lead character in Harriet Beecher Stowe's recent and hugely popular novel *Uncle Tom's Cabin* (1852): 'for it is a fine noble face, notwithstanding its African origin, and its melancholy expression, as if the spirit could never, even though schooled into submission by the principles of Christianity, become inured to the state of degradation into which the body is subjected.' This commentary, connecting the image to one of the defining texts of modern racial attitudes and praising the physical beauty of the sitter in a highly qualified way, conveys an ambiguous appreciation of the work in line with dominant Victorian attitudes to race. The painting was kept among the 'Miscellaneous Works' in the basement of the National Gallery in the later nineteenth century, and it appears to have been generally kept in storage since being transferred to the Tate Gallery in 1919 where it has been listed simply as *Head of a Negro*. Its potential historical importance has become clearer with the re-appearance of the *Captive Slave* and renewed interest in the life and career of Aldridge. MM

John Constable (East Bergholt, Suffolk 1776 – London 1837)
Sketch for 'Hadleigh Castle' c.1828–9
Oil paint on canvas 122.6 × 167.3. Acquired 1935

Sketch for 'Hadleigh Castle' emanates a powerful melancholy not normally associated with Constable. The crumbling Hadleigh Castle, dramatically poised above the Thames estuary, is silhouetted against an expansive clouded sky in which bright shafts of sunlight and dark shadows jostle to suggest the departure of a storm. A lone cowherd deepens the sense of melancholy while a flock of gulls swoop around the tower, accentuating the height of our viewpoint. Constable's vigorous handling of paint has created a turbulent surface texture that reflects the emotive force of the subject itself.

The painting's origins lie in a small pencil sketch Constable made on his first and only recorded visit to Hadleigh Castle, Essex, in 1814 (Victoria and Albert Museum, London). His exhilarated response to the 'melancholy grandeur of a sea shore', the 'fine place' of Hadleigh and its view 'of the Kent hills, the nore and north foreland & looking many miles to sea' is recorded in a letter to Maria Bicknell, who would become his wife in 1816. Constable's decision to return to this subject around 1828 has often been cited in relation to his sorrow at the premature death that year of Maria.

The focus here on a historic ruin, a decaying medieval landmark, may also embody Constable's reaction to a comment from Royal Academy President Thomas Lawrence that his election to member status (after ten years as an associate member) was 'peculiarly fortunate' against strong candidates who practised the esteemed genre of history painting. Its six-foot format signifies the importance Constable attached to the composition; this was a format he reserved for the works he wished to make an impact, the ones he sought to be defined by.

Constable enacts his ambition by departing from the traditional topographical imagery of British ruins and endowing *Hadleigh Castle* with a distinctly heroic quality. The work engages Romantic sensibility of introspection and self-expression, but also indexes the trend for scientific observation of nature: the animated sky clearly benefits from Constable's intense study of clouds made in Hampstead in the early 1820s.

It was not unusual for Constable to make full-scale sketches in preparation for final works, but this sketch, bolder and more freely handled than the version he exhibited in 1829 (now at Yale Center for British Art, New Haven, USA) was believed to be the final *Hadleigh Castle* upon its acquisition by the National Gallery in 1935 (twenty years later it transferred to the Tate Gallery, when the two galleries separated). A contributing factor to this belief may be that the sketch was, at some point, enlarged along the left and bottom edges so as to more closely resemble the final version. Ostensibly repairs to the original canvas, these additions extend the space around the left-hand tower.

A key example of Constable's work in the six-foot format, *Sketch for 'Hadleigh Castle'* sits alongside *The Chain Pier, Brighton* and *The Opening of Waterloo Bridge* within the Tate's collection. It offers a counterpoint to Tate's numerous examples of the artist's more serene Stour subjects, for example *Flatford Mill ('Scene on a Navigable River')* (p.63) and enables us to see the artist at his most dynamic. AC

Benjamin Robert Haydon (Plymouth, Devon 1786 – London 1846)
Punch or *May Day* exh.1830
Oil paint on canvas 150.5 × 185.1. Acquired 1862

As a man and an artist, Haydon presents not so much an extraordinary paradox as a kaleidoscope of irreconcilable elements. His career veered between extremes of success and failure. One day admirers were queuing to see his work in touring exhibitions or to hear him lecture; the next he could be thrown into prison or his pictures seized for debt. Fuelled by his self-regard, genuine gift for friendship and ability to charm and convince some of the greatest artists, writers and critics of the day, he was hailed as an Old Master-in-waiting. He was also dismissed as a comedy turn, more appropriate to the theatre or music hall, and even his botched suicide, with gun and razor, failed to rise to the level of classical tragedy he so clearly intended. Declaring himself 'adapted to great national work, to illustrate a national triumph or a moral principle', he can be regarded as the most extreme if not altogether the last exponent of High Art as advocated by Joshua Reynolds and the Royal Academy. But having trained there, he soon fell out with it, never to return. And instead of the vast historical and religious subjects on which he wasted many years and which drove him to bankruptcy, he was reduced to painting the potboilers that are now considered his best pictures.

As Haydon described it, *Punch* sprang from a sudden inspiration, of a kind he believed was a symptom of genius. In fact it followed smaller narrative pictures, depicting an inmates' 'election' that Haydon had witnessed in 1827 while in the King's Bench Prison for debt. One, *The Mock Election*, was bought by George IV for 500 guineas (a high point in Haydon's career) and its sequel, *Chairing the Member,* belongs to Tate. With *Punch* he aimed to repeat the success of these sardonic, Hogarthian works. Toying with the idea of calling his new picture *Life*, he assembled a varied cast of metropolitan types and incidents in the Marylebone Road on May Day: a Punch and Judy show, newlyweds in a carriage, a funeral cortege, an old farmer having his pocket picked, blackened chimney-sweeps and a costumed Jack-in-the-Green are all observed with the eye of a novelist or dramatist. Of the later work of his friend David Wilkie, Haydon said it was ironic that 'he should tumble into history, and I into burlesque', but like his vivid diaries and journals, *Punch* shows where his real skills lay.

Excluded from the Academy, Haydon exhibited *Punch* in the Western Bazaar in Bond Street in 1830. The king sent for it but declined to buy it; he admired parts of it 'excessively' but thought the chimney-sweep looked like an opera dancer. Haydon fell into a long fit of paranoia, directed mainly at the royal picture adviser William Seguier whom he nicknamed the 'Torpedo of Modern Art'. Unable to sell the picture he mortgaged it to a friend, Dr Darling, who bequeathed it to the National Gallery in 1862. DBB

Joseph Mallord William Turner (London 1775 – London 1851)
Caligula's Palace And Bridge exh.1831
Oil paint on canvas 137.2 × 246.4. Acquired 1856

At the heart of this ethereal scene lies the ruined palace of the Roman emperor Caligula, who set out to confound the saying that he had as much chance of crossing the Bay of Baiae, in Italy's Bay of Naples, on horseback as he did of becoming emperor. Caligula's bridge of boats has been transformed by Turner into a bridge of stone, now as dilapidated as the palace. This subject, taken from Roman historian Suetonius's 'Life of the Emperor Caligula', showcases Turner's knowledge of classical antiquity but also his love of a paradox – he hints at the folly of power by juxtaposing the crumbling, overgrown palace with the simplicity of peasant life now being lived in its grounds. The epigraph that Turner appended to this painting in the catalogue for the 1831 Royal Academy exhibition was an excerpt from his own poem, *Fallacies of Hope*, which spoke of 'monuments of doubt and ruined hopes'. The futility of opulence was a particularly loaded message in the wake of another bout of revolutionary fervour in Europe.

Italy held a great pull on Turner's artistic imagination throughout his career. As a student he copied Italian scenes by other artists, fostering a deep admiration for the work of Claude Lorrain, whose influence is evident in the composition and glowing sunlight of *Caligula's Palace*. Turner's first visit to Italy came in 1819, a trip that fostered a series of 1820s landscapes firmly rooted in topographical observation. *Caligula's Palace* belongs to a new phase of views in which the artist synthesised his experiences of Italy to convey an essence of place, rather than an accurate document.

Here, Turner's fantastical palace – resembling the architectural wonders in prints by the eighteenth-century artist Giovanni Battista Piranesi (1720–78) – is set against a scene that in its warmth, foliage and distant mountainous peninsula evokes the popular conception of Italy in Turner's day.

At the 1831 Royal Academy exhibition, *Caligula's Palace* hung adjacent to Constable's *Salisbury Cathedral from the Meadows* (private collection); one critic described the pair as 'Fire and Water'. *Caligula's Palace* met with great acclaim, with critics celebrating its 'magical' atmosphere. And yet the painting found no buyer. This perhaps owes something to another paradox: Turner's technique – here a white ground overlaid with broad sweeps of colour and layers of fine dots, stipples and hatches – and his colouring were thoroughly modern, but his classical subject matter was outmoded. This mattered little, however, to an artist who could turn his hand to a range of subjects with equal success and who would doggedly pursue an increasingly individualistic artistic course as time went on.

Caligula's Palace forms part of the Turner Bequest, the contents of the artist's gallery and studio that were left to the nation in the artist's will. In 1987 the opening of the Clore Gallery at Tate Britain marked the first time since Turner's death in 1851 that the contents of the Bequest – comprising 300 oil paintings and many thousands of sketches and watercolours (including 300 sketchbooks) – could be housed together. AC

William Etty (York 1787 – York 1849)
Standing Female Nude c.1835–40
Oil paint on canvas 101.6 × 64.8. Acquired 1941

In this painting, not intended as a finished work, Etty has focused on the effects of cross-lighting, giving deep shadows over the model's form. The attention is focused on the stomach and breasts of the life model, and the contrast between the highlighted neck and the face, which disappears into darkness. Rich red forms a striking backdrop. The column, draperies and flowers add, arguably only half-heartedly, details from the lexicon of historical painting to soften and elevate what would otherwise be a simple study of a naked model.

This is presumably one of the many paintings that Etty made in the Royal Academy life-class in London, which he assiduously attended long after he ceased to be a student. Born in York, the son of a baker, Etty arrived in London in 1805. After a spell drawing from plaster casts in the workshop of G.B. Giannelli, he attended the RA schools in 1806. He trained briefly with Thomas Lawrence (whose rich colouring can perhaps be seen as an influence on the present work) before an uncle's inheritance made him financially secure. He travelled extensively in France and Italy, copying works by Rubens, Veronese and Titian. On his return he painted multi-figure history paintings, such as *Pandora Crowned by the Seasons* 1824 (Leeds Art Gallery) and *The World before the Flood* 1828 (Southampton Art Gallery).

Although Etty's colouring always attracted attention it was the obsessive study of the nude that made him famous. One magazine account of 1831 opined that 'the Life Academy may be said to be embodied in Etty. It first roused his latent genius, and now sustains its fervour: he has beheld generations of students pass before him to be heard of no more, yet there he is, night after night, the chief model for his emulous brethren.' The uncanny ability to evoke flesh was celebrated by his contemporaries, although it often gave a verisimilitude to his figures which, appearing in the middle of mythological, historical and religious scenes, made many commentators uncomfortable. The quotation above, in its language of 'rousing' and 'fervour', indicates the frisson that was a clear part of Etty's appeal.

The model's pose can be seen elsewhere in Etty's oeuvre: *Venus and her Doves* (Manchester City Art Gallery) contains a similar figure, her face in shadow, albeit differently draped. The strong musculature of the model's arms, shoulder and neck, along with her large flat feet, may simply be carelessness, although they may also be emphasised features of the model's body. Etty's tendency to transfer studies like these, of particular women, into history works (which were meant to depict ideal forms) have also discomfited some viewers, even in modern times. William Gaunt and F. Gordon Roe, in their influential study *Etty and the Nude* (1943), asserted that 'Etty never altogether converted the model into a complete work of poetry ... his Aphrodite remains a barmaid.'

Standing Female Nude was in the collection of a Colonel Lesser in 1880, and exchanged hands several times before entering the Tate Gallery in 1941. It has been on frequent display, and lent for retrospective exhibitions at the Arts Council (1955) and York (2011). GS

William Dyce (Aberdeen 1806 – London 1864)
Madonna And Child c.1838
Oil paint on canvas 102.9 × 80.6. Acquired 1963

As a young man in Aberdeen Dyce had taught himself to draw and paint, winning admission to the Royal Academy Schools in 1825. Within a matter of months he had grown dissatisfied with the teaching there and abandoned his place. Instead he journeyed to Rome, a city ripe with opportunity to shape his own development. Here Dyce assimilated himself into a community of British artists, attending life classes, copying works by Old Masters, studying classical sculpture and sketching the surrounding landscape. It was during one of his formative Roman sojourns that he reputedly began to consider the subject of the Madonna and Child.

Dyce depicts the young mother Mary and the infant Jesus in a tender embrace, set against a brilliant blue sky and mountainous landscape. *Madonna and Child* echoes Raphael's Madonna paintings of the early 1500s in the prevalence of outline, its smooth finish, stark lighting and Apennine-like background. The fluid scarf draped around the Madonna is also a reference to the Renaissance master. This backwards-looking aesthetic chimes with Dyce's association with the Nazarenes, a group of German painters resident in Rome in the 1820s. Recognisable by their monk-like clothing and centre-parted hairstyle, the Nazarenes lived a simple existence and sought a full-scale revival of Renaissance culture. Recognising his sympathy with their cause, and hoping to prolong Dyce's stay in Rome, the group is said to have purchased a Madonna and Child (now lost) by him.

The dating of this work has been the subject of debate. A date of c.1838, rather than the previously supposed c.1827–30, is given here because amongst the twelve recorded Madonnas by Dyce, this one most strongly demonstrates the influence of the Nazarenes. It was around 1837 that Dyce's work began to display the overt Renaissance aesthetic that the group advocated; this version is therefore likely to be that which he mentioned working on in a letter of 1837 and which he exhibited at the Royal Academy in 1838.

After two formative periods in Rome, Dyce spent almost a decade as a successful portraitist in Scotland. In 1837 he moved to London. Alongside his activities as a writer, arts administrator, composer and, from 1844 until his death, fresco painter for the New Houses of Parliament, Dyce continued to paint Madonnas. This subject, painted in Dyce's historicising manner, was evidently an important expression of his High Church Anglicanism. A *Madonna and Child* he exhibited in 1845 found a buyer in Prince Albert, who, like Dyce, was a pious man and would have valued such a work as a focal point for religious contemplation.

The present *Madonna and Child* was purchased by Joseph Henry Green, the surgeon and philosopher who taught anatomy at the Royal Academy of Arts. Green lent it to the colossal 1857 Art Treasures Exhibition in Manchester. The painting then passed through the saleroom at Christie's in 1880 and through various private collections until it was aquired by the Tate Gallery in 1963. A year later it featured in an exhibition re-appraising the artistic output of Dyce, the quintessential polymath, in his native Aberdeen. Within the Tate's collection Dyce's works provide a point of cross-reference with those of the Pre-Raphaelite Brotherhood, who he inspired and was, in turn, inspired by. AC

William Mulready (Ennis, County Clare, Ireland 1786 – London 1863)
The Ford ('Crossing the Ford') exh.1842
Oil paint on mahogany 60.6 × 50.2. Acquired 1847

Though it may appear to simply document an episode of rural life, *The Ford* was one of William Muready's most successful subject paintings, the scenes of everyday life imbued with symbolic meaning for which he was well known by the 1840s. Mulready's works could, in the words of one critic, 'tell their own story without the aid of a descriptive title'. Indeed, the title here leaves us free to muse: are the boys vying for the girl's affection? Has she made her choice? What course will their lives take?

The theme of crossing water as a metaphor for the transition into adulthood was a familiar one in the nineteenth century, having been illustrated by artists such as J.M.W. Turner in *Crossing the Brook* (Tate N00497) and also by Mulready's close friend John Linnell. Mulready had himself exhibited a painting on this theme in 1833, *The First Voyage* (Bury Art Gallery), showing a child in a tub being pushed and towed across a stream. There is a rapidly drawn sketch for this work on the reverse of *The Ford*. Front and back, this panel therefore represents the genesis and development of Mulready's expression of this symbolic theme.

Mulready started out as a landscapist but by 1816, the year he became a member of the Royal Academy, landscapes with moral content were valued above landscape *per se*. The artist thus moved towards subject pictures like *The Ford*. At a time when the rural connoted earthly pleasures and freedom from social restraint, *The Ford*'s lush, idyllic setting would be read as entirely appropriate to the narrative's romantic potential. Like its narrative, the backdrop

is also likely to be an imaginary construct, a practice to which Mulready increasingly turned as London's urban sprawl engulfed the countryside around his home near the Kensington gravel pits.

As Mulready's career progressed, his palette brightened. *The Ford*'s striking colouring results from its white ground, which enhances the brilliance of the pigments applied on top. This technique, along with Mulready's advocacy of studying outdoors, proved influential to the young artists of the burgeoning Pre-Raphaelite Brotherhood.

The Ford was Mulready's sole exhibit at the Royal Academy of 1842 and heralded a period of decreasing output. Nonetheless, the artist continued to attract patronage and command high prices for his work. This painting was purchased for 600 guineas in 1842 by patron Robert Vernon, who included it amongst the 157 works of British art he donated to the nation in 1847. The vast majority of Vernon's collection is housed at Tate and contains three other Mulreadys: *Fair Time ('Returning from the Ale-House')* (N00394), *The Last In* (N00393) and *The Young Brother* (N00396).

A year after *The Ford* was exhibited, Mulready's importance within the modern British school of painters was acknowledged in an exhibition of his work at the Society of Artists. In 1864, the year after his death, a major memorial exhibition was held at the then-new South Kensington Museum (which later changed its name to the Victoria and Albert Museum). AC

Edwin Henry Landseer (London 1802 – London 1873)
Shoeing exh.1844
Oil paint on canvas 142.2 × 111.8. Acquired 1859

Portraits of animals enlivened with a narrative element were a speciality of Landseer's. *Shoeing* was commissioned by the artist's long-time friend Jacob Bell, and depicts the bay mare Old Betty, Bell's favourite horse, in a composition that simultaneously celebrates the horse's merits and reveals Landseer's skill as a painter of texture and light. A circular path moves from Betty's powerful frame down to the farrier, whose work she patiently endures. The path continues to the drooling bloodhound, its coarse fur and the donkey's tufted mane contrasting with Betty's sleekness. The horse stands superior above all, including man, who, bent double at her rear, works in her service. Each animal's gaze is directed towards the industrious farrier, perhaps alerted to the smell of the smouldering shoeing, or its repetitive tap, which offers a counterpart to the singing blackbird in the cage above.

Landseer had shown a talent for depicting animals since childhood (see Tate N06180, a drawing of a dog he made aged eleven), becoming affectionately known as the 'little dog boy' to Henry Fuseli, who taught him at the Royal Academy schools. *Shoeing* was exhibited in 1844, by which time Landseer had become one of Britain's leading painters, lauded for characterful portrayals of domestic animals and dramatic Highland hunting scenes. Animal painting had enjoyed a gradual ascent in academic status since the late eighteenth century, benefiting from the work of George Stubbs, for example, whose anatomical horse drawings Landseer owned. Animal painting was also enduringly popular. Landseer's ability to capture

the public's imagination is attested to by his status as the most-published artist of his time – more than half of his income in the 1840s came from copyright fees on engravings such as that made after *Shoeing* in 1848.

This painting was originally conceived in the 1830s as a portrait of Old Betty with her foal. By the time Landseer committed himself to the painting, however, years had elapsed and the two foals bred by Bell especially for the purpose of the picture had grown up. Landseer's inability to commit himself to commissions was an increasingly frequent trait, particularly in the wake of his nervous breakdown in 1840. Bell provided a wealth of support from this point onwards, managing the artist's financial affairs, negotiating with patrons and printmakers and allowing Landseer use of Old Betty.

Shoeing met with a mixed response amongst critics when it was exhibited in London, perhaps owing to its evocation of then-unfashionable seventeenth-century Dutch genre painting. John Ruskin, for example, lamented the painting's level of detail and pristine finish. Nonetheless, it numbered amongst a group of works that earned Landseer the prized Gold Medal in Paris in 1855.

Bell bequeathed *Shoeing* and seven other Landseers, including *Dignity and Impudence* (Tate N00604) to the nation in 1859. Important works by Landseer also counted amongst the major British art bequests received from Robert Vernon and Sir Henry Tate. Tate has since acquired examples of Landseer's work in other genres, such as landscape, to represent the range of the artist's output. AC

Dante Gabriel Rossetti (London 1832 – Birchington on Sea, Kent 1882)
The Girlhood of Mary Virgin 1848–9
Oil paint on canvas 83.2 × 65.4. Acquired 1937

The Girlhood of Mary Virgin was the first exhibit to bear the then cryptic initials 'PRB' (Pre-Raphaelite Brotherhood). Rossetti painted it from 1848 under the supervision of his early mentor Ford Madox Brown and Holman Hunt, with whom he was sharing a studio at the time. Progress was laborious, and it was not shown at the Royal Academy of Arts – perhaps through lack of confidence – but at the 1849 Free Exhibition of Modern Art, where Brown had exhibited the previous year.

It depicts an episode of the New Testament with resolutely new imagery, but also an artist at work. Mary is shown embroidering a lily on a frame, her mother St Anne by her side. Behind them, St Joachim prunes a vine, with Lake Galilee stretching in the distance. Numerous symbols riddle the painting. To the left, an angel alludes to Gabriel and the Annunciation, whilst the dove above represents the Holy Spirit. The lily stands for purity, Mary's main attribute, and rests on six large volumes inscribed with the names of cardinal and theological virtues. On the floor, the seven-leaved palm branch and seven-thorned briar refer to Mary's seven joys and sorrows, and in the very centre of the composition stands a cross-shaped trellis below which hangs a red cloth embroidered with the Tri-point, symbolising Christ's robe at the Passion. The vine itself echoes the True Vine and announces the coming of Christ. Two sonnets by Rossetti, now inscribed at the bottom of the present frame, cast light on the subject and symbolism of the painting.

The Dowager Marchioness of Bath purchased *The Girlhood of Mary Virgin* for 80 guineas, and it passed on to her daughter, Lady Louisa Fielding. William Graham acquired it 1885 and, in 1937, his daughter Lady Jeckyll bequeathed it to the Tate Gallery, where it remains key to the Pre-Raphaelite collection and to the history of the brotherhood.

When it was produced, Brown found it closer to 'Early Christian Art' and to the Nazarenes than to the new aesthetic that the Pre-Raphaelite Brotherhood promoted. It certainly denotes the influence of the so-called primitives with its clear lines and flattened middle ground, but Rossetti's technique was equally typical of the Pre-Raphaelites. He painted thinly with watercolour brushes, 'on canvas which he had primed with white till the surface was as smooth as cardboard'. The luminous surface, together with the flat planes, are reminiscent of stained-glass windows, an impression strengthened by the grid created by the strong vertical and horizontal lines of the trellis, lily, curtain and embroidery frame.

Rossetti's rejection of traditional iconography echoed the preoccupations of the High Church movement supported by his mother and sister Christina, who posed for the figures of St Anne and the Virgin respectively. Like other Pre-Raphaelites, he favoured his immediate circle as models. The painting was well received, as opposed to its sequel, *Ecce Ancilla Domini* 1849–50 (Tate N01210), which contributed to Rossetti's shift from illusionist preoccupations to patterned, medievalising watercolours. CCP

John Everett Millais (Southampton 1829 – London 1896)
Ophelia 1851–2
Oil paint on canvas 76.2 × 111.8. Acquired 1894

Ophelia is one of several Shakespearean subjects undertaken by Millais after his censure at the annual exhibition of the Royal Academy in 1850. At eleven, he had been the youngest student to join the Academy Schools, and rose swiftly to prize-winning status. His rebellion in 1848, after joining the Pre-Raphaelite Brotherhood, had therefore prompted especially severe criticism. Shakespeare was overwhelmingly popular with British and European audiences and Millais adopted his plays as a less provocative vehicle for his radical ideas.

Ophelia sold before it was completed and received good reviews. It set Millais and Pre-Raphaelitism on the path to acceptance. Within a year Millais was elected an Associate Member of the Academy, opening the way to an internationally successful career. Just before he died he was elected Academy President. *Ophelia* was engraved in 1866 and has been in print in one form or another ever since. It was part of the original Henry Tate gift to the Tate Gallery in 1894 and is one of the gallery's best-loved works.

Ophelia's death is described by Queen Gertrude in *Hamlet*, Act IV, Scene VII. Distraught and destabilised by the death of her father Polonius, Ophelia slips into a stream and allows herself to drown. Millais departed from traditional representations, however. The Pre-Raphaelites rejected the usual hierarchy of figure and setting and gave every part of the canvas equal attention. Millais spent the summer and autumn of 1851 painting the background inch-by-inch with botanical exactness, and in natural light, on the bank of

the River Hogsmill at Ewell in Surrey. In the winter he returned to London to begin the figure. The Pre-Raphaelite model and artist Elizabeth Siddal posed over a period of four months, dressed in a silver embroidered robe. She sometimes lay in a bath of water kept warm by lamps underneath. When she caught a cold, Millais was compelled to pay her doctor's bill.

The elimination of sky and the vibrancy of green foliage are different from the harmonious perspectives of traditionally painted backgrounds. Every detail is brought as close to optical truth as possible. Millais' pure, prismatic colours, diluted with varnish as well as oil were intensified by the illuminating effect of a white ground underneath, capturing not just the vivid appearance of flowers and leaves but also the subtler translucence of Ophelia's skin and the muddy water that surrounds her.

This realism is given deeper spiritual significance by means of symbols. The willow entwined with nettle was associated with forsaken love and pain. Forget-me-nots float in the water and the daisies, pansies and poppy that have dropped from Ophelia's hand represent innocence, love in vain and death. The roses near her cheek and the field rose on the bank allude to her brother Laertes calling her 'Rose of May'. The spiritual dimension is strengthened in more innovative ways as well. The dominance of green adds an emotional impact to the picture. This is intensified by the unusual intimacy of the scene. The viewer regards Ophelia as closely as the artist did while painting. CJ

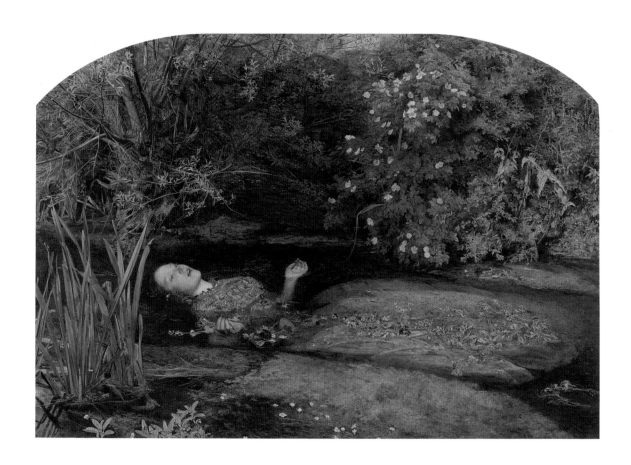

John Martin (Haydon Bridge, Northumberland 1789 – Douglas, Isle of Man 1854)
The Great Day of His Wrath 1851–3
Oil paint on canvas 196.5 × 303.2. Acquired 1945

This is one of a triptych of works illustrating the biblical Last Judgement which the painter executed in the last years of his life. It shows the vast spectacle of the end of the world, as prophesied in the Book of Revelation:

Lo, there was a great earthquake. And the Heaven departed as a scroll when it is rolled together; and every mountain and island were moved out of their places; and the kings of the earth, and the great men, and the rich men, and every bondsman, and every freeman, hid themselves in the dens, and in the rocks of the mountains. And said to the mountains of rocks, Fall on us, and hide us from the face of Him that sitteth on the throne, and from the wrath of the Lamb. For the great day of His wrath is come; and who shall be able to stand?

Martin came from a working-class background and trained as a glass painter, but became the most popular artist of the day with a sequence of large paintings of biblical and natural catastrophe, which were exhibited in London and around the country from the late 1810s. These were appreciated as extraordinary artistic spectacles and appealed to the religious sentiments of many people, although some high-minded critics frowned on them precisely because of their popularity. The rapid development of urban centres in the nineteenth century, the growth of mass media and industrialisation were making high culture more readily accessible than ever before, and Martin's success seemed to herald new, less elitist possibilities for the visual arts.

Although Martin focused on printmaking and engineering projects in the latter part of his career, he also returned to oil painting at the end of the 1840s. The triptych was conceived at that time as a highly commercial enterprise, with a plan to tour the finished pictures and publish relatively affordable reproductions. The travelling exhibition continued for more than thirty years after his death in 1854, with the pictures being hyped excitedly as they appeared in galleries, showrooms, theatres, music halls and civic buildings up and down Britain, in Ireland, America and even Australia. The exhibition was massively successful: as early as 1861 it was being claimed in advertisements that as many as 8,000,000 people had seen the paintings. But in subsequent decades Martin's reputation plummeted. The religious content and garish melodrama of his paintings seemed increasingly old-fashioned, even distasteful, and the *Last Judgement* triptych disappeared into storage in London.

The Tate Gallery purchased the painting in 1945, when Martin's reputation was only just being revived, particularly among artists and writers with an interest in the irrational and extravagant. The vortex-like forms of this composition, bordering on abstraction, disorientating sense of scale and apocalyptic theme seemed especially 'modern'. The rediscovery of Martin as an idiosyncratic painter of the extraordinary, anticipating expressionism and surrealism, has shaped perceptions of the artist in modern times, even at the expense of a fuller understanding of his commercial, populist and civic motivations. MM

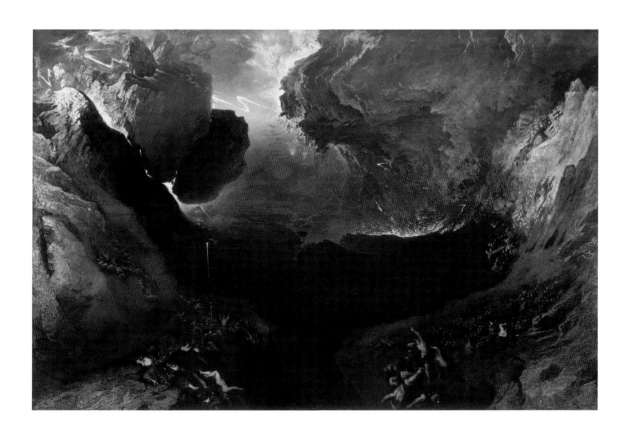

William Holman Hunt (London 1827 – London 1910)
Our English Coasts ('Strayed Sheep') 1852
Oil paint on canvas 43.2 × 58.4. Acquired 1946

Hunt exhibited this picture at the Royal Academy in 1853 as *Our English Coasts* and at the International Exhibition in Paris in 1855 as *Strayed Sheep*. The defensive tone of the first title expressed fears that the new French regime of Napoleon III would restart the terrible wars waged by his uncle Napoleon Bonaparte. By 1855 these worries had diminished.

Our English Coasts expressed the instability of the age. The industrial revolution was changing the world and 1848 saw political revolutions in almost every part of Europe. The spirit of innovation and reform affected art. Although Hunt trained at the Royal Academy, he and six fellow students founded the Pre-Raphaelite Brotherhood to challenge the conventions of the establishment. They relished the intensity of romantic and religious painting and the force and novelty of science, aiming at a new 'symbolic realism'. The flock and the rocks in *Our English Coasts* were long-standing religious motifs put to a new purpose. The crumbling cliff and bewildered sheep expressed the Pre-Raphaelites' concerns about the political, social and religious troubles of their day and the absence of leadership in art and society as a whole.

The Pre-Raphaelites searched for authority through authenticity and explored the possibility of painting optical truth. *Our English Coasts* was one of the earliest subject paintings to be made completely in the field rather than the studio and took nearly five months to finish. It shows Lover's Seat, a favourite beauty spot on the cliffs overlooking Covehurst Bay near Hastings. The design of the painting departed from conventional landscapes. Its high horizon fills the picture plane with detail. Hunt transcribed each element separately from a variety of viewpoints. The butterflies were painted indoors from a captured specimen.

Observation in natural light introduced startling new effects, such as the silvered edges to the sheep's wool and the illuminated ear of the foreground lamb. The horizon dissolves entirely. Hunt captured these brilliant effects by employing only prismatic pigments, applied in a translucent oil and varnish layer over a shining white ground. The harmonious greens conventionally used for landscape settings were replaced by newly invented, chlorophyll-bright emerald green. Shadow was traditionally understood as brown and formless, but as fellow Pre-Raphaelite Frederick Stephens wrote of Hunt in 1860, 'He was absolutely the first figure painter who gave the true colour of sun-shadows, made them partake of the tint of the object in which they were cast, and deepened such shadows to pure blue where he found them to be so.' These unprecedented observations anticipated the French impressionism of the following decade. Parisians were astonished by the 'blood red sheep in indigo bushes, on rocks chiselled like sugar candy' when *Our English Coasts* was exhibited there.

Hunt never became an Academy Member but nonetheless enjoyed international celebrity and success, brought about by print media and the tours of major subject paintings. Smaller works like *Our English Coasts* were relatively rare in his output. It passed through a series of private owners until being purchased for the nation by the Art Fund in 1946. Hunt's reminder of the beauty and vulnerability of the island of Britain seemed, perhaps, especially poignant so soon after the Second World War. CJ

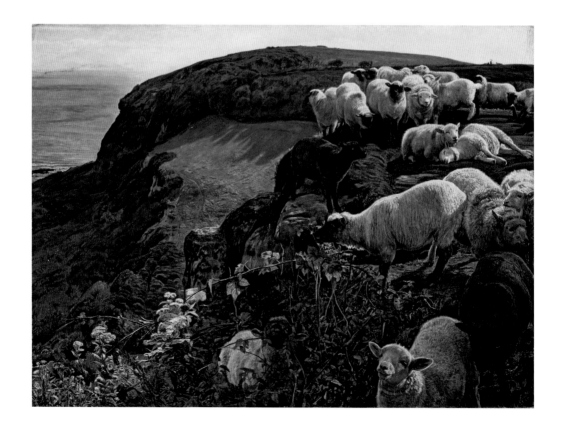

Ford Madox Brown (Calais, France 1821 – London 1893)
Jesus Washing Peter's Feet 1852–6
Oil paint on canvas 116.8 × 133.3. Acquired 1893

Ford Madox Brown wrote that he wanted *Jesus Washing Peter's Feet* to appeal '*out* from the picture to the *beholder*'. This life-sized picture places the viewer unusually close to Jesus, as if one of the disciples present at the Last Supper. The copper basin teeters on the edge of the step, about to fall into our space. Jesus was, moreover, originally almost nude: his feet and legs bare, his tunic rolled to the waist. This radical intimacy was diminished when the picture was first exhibited at the Royal Academy's annual exhibition, however, because the hanging committee 'skied' it close to the ceiling. This did not prevent critics objecting to what they saw as the picture's coarseness.

Brown was already an established unorthodox artist, known for going his own way. He had spent his youth and artistic training on the continent, settling in London in 1846, just before the Pre-Raphaelite Brotherhood formed in 1848. Brown did not join the group, remaining part mentor and part fellow rebel. He never gained prosperity or the prestige of election to the Royal Academy.

Jesus Washing Peter's Feet is a traditional scene illustrating the gospel of St John (13: 4–5, 15), but shows Brown's work maturing away from a 'revivalist' style reliant on earlier fifteenth century European art, to more modern, materialist painting. Brown treated the biblical source as though it were a historical text, in the spirit of contemporary critical scholarship of the Bible and biographies of Christ. From such 'modern research' he deduced 'the youthfulness of John, curly grey hair of Peter, and red hair of Judas'. Realism was enhanced by using friends as sitters, in the Pre-Raphaelite manner. One of the group, Frederick Stephens, posed for Christ.

Brown wanted psychological relationships to be recognisable too. An early study shows only Christ and his favourite, the young and gentle St John, seen on the right. The compression of six more disciples introduced the more tormented figure of Judas on the far left. Peter's embarrassment acts as a foil for the humility of Christ.

It was relatively unusual to put forward a religious painting in protestant Britain at this time. The Roman Catholic Church had only recently been re-established and religious scenes could still provoke prejudice. There was a move to create a Protestant tradition of sacred imagery, however. In 1848 the art critic Anna Jameson had written of the suitability of this subject. The Victorian spectator would have associated Jesus's body with the Eucharist. His energetic action stressed Christian Socialist ideals of labour and cleanliness, themes that Brown would return to in his modern life masterpiece *Work* 1851–64.

Brown never exhibited at the Royal Academy again and the picture remained unsold. Reluctantly, the artist repainted Christ in robes before displaying it at the Manchester Art Treasures exhibition in 1857, after which it was finally bought by the Pre-Raphaelite patron Thomas Plint. From Plint it passed through several private owners, each selling it on at a loss. When the picture came on the market again in 1893, the proposal of a new gallery of British Art, the Tate Gallery, prompted Frederick Stephens and others to purchase the painting for the nation. CJ

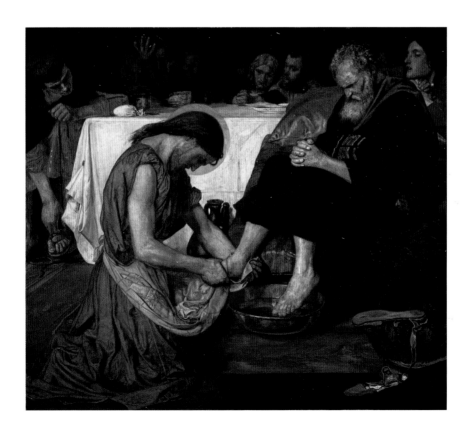

Richard Dadd (Chatham 1817 – London 1886)
The Fairy Feller's Master-Stroke 1855–64
Oil paint on canvas 54 × 39.4. Acquired 1963

This work was not exhibited in Dadd's lifetime. It was painted for George Haydon, Chief Steward of Bethlem Hospital. The artist was imprisoned there in 1844 after succumbing to a breakdown and killing his father. During the late nineteenth and early twentieth century, the work remained in the hands of private art collectors who had an interest in mental states. After World War I, it became a talisman for the surrealists and many others who opposed prejudices linking mental illness to 'degeneracy', which became prevalent in the Nazi period. In 1933 the picture passed to the poet Siegfried Sassoon, who as a soldier had served alongside Julian Dadd, the great nephew of the artist. Sassoon was one of the many who suffered from neurasthenia (shell shock) as a result of the trauma of the First World War. Both of Julian's brothers had died in the conflict and his own wounds contributed to his suicide in 1937. In 1963 Sassoon gave the painting to the nation in memory of the three Dadd brothers.

Dadd entered the Royal Academy Schools at the age of twenty and went on to become a star member of The Clique, a group committed to a more outward-looking approach to art, suited to the growing urban, middle-class audience. He created a successful style of fairy painting, a sub-genre of the Shakespearean subjects at that time popular. Dadd's public career was ended by his serious mental illness in 1843 and the remaining forty-three years of his life were spent in secure institutions.

The Fairy Feller's Master Stroke was started in 1855. It was planned as a detailed sketch and each component was built up, one by one, in tiny dabs of paint. The close technique enhances the claustrophobic feel of the space and the discontinuities of scale. The picture was unfinished nine years later and left at Bethlem when Dadd was transferred to Broadmoor. He later recalled the picture, however, in a long poem.

The subject was based on Shakespeare's play *A Midsummer Night's Dream*, and Oberon and Titania can be seen near the centre. Conventionally idealised and eroticised fairies have been replaced by stocky figures, some with more unexpected characteristics such as exaggerated breasts or tiny feet. The hazelnut refers to the miniscule carriage in which Shakespeare described the fairy Queen Mab riding through sleeping people's brains. A dragonfly playing a trumpet at the top appears to be one of her retinue. The other characters are harder to identify, even with the help of the poem. Some represent the childhood counting game 'soldier, sailor, tinker, tailor, rich man, poor man, beggar man, thief'. The penultimate profession, a figure with pestle and mortar at the top right, is a portrait of the artist's father, a pharmacist.

An air of violence pervades the scene. The faceless Fairy Feller's axe pauses above his head as it waits for a bearded patriarch, seated immediately above, to give the signal to strike. He may relate to Dadd's account of a desire experienced in Rome to attack the Pope. The subdued light and self-conscious watchfulness of the figures behind the screen of grass gives them all the look of prisoners. CJ

Arthur Hughes (London 1832 – Kew Green, Surrey 1915)
April Love 1855–6
Oil paint on canvas 88.9 × 49.5. Acquired 1909

When John Ruskin saw *April Love* exhibited at the Royal Academy in 1856, he judged it 'exquisite in every way'. He was hoping his father would purchase the painting, but William Morris acted faster: he wrote to Burne-Jones asking him to 'do [him] a great favour, viz. go and nobble that picture called "April Love" as soon as possible lest anybody else should buy it'. Henry Boddington later bought it from Morris, and in 1909, it was purchased for the nation.

The painting represents a young couple in a luxurious garden bower clad with ivy. The young man, visibly distressed, is seated behind his sweetheart. A quotation from Tennyson's 'The Miller's Daughter' accompanied the description of the picture when exhibited at the Royal Academy in 1856:

> Love is hurt with jar and fret.
> Love is made a vague regret.
> Eyes with idle tears are wet.
> Idle habit links us yet.
> What is love, for we forget:
> > Ah, no! no!

April Love was not intended as an illustration of the poem as such, but it highlights the young couple's fear that their love may pass. The ivy represents fidelity and everlasting life, but its positive significance is challenged by that of the rose – symbol of love – whose petals are strewn on the floor at the feet of the girl. The picture had an autobiographical root: in 1855, after a five-year courtship, Hughes had married 'his early and only love', Tryphena Foord, the final model for the girl. True to Pre-Raphaelite precepts, much of *April Love* was painted in the open air, but it was eventually completed in the Pimlico studio that Hughes shared with the sculptor Alexander Munro, who apparently sat for the male figure. The rich purple hues the artist adopted for the dress of the girl, echoed by the lilac in the background, became one of his trademarks.

Arthur Hughes had entered the Royal Academy schools in 1847. He admired the Pre-Raphaelites' exhibits at the Royal Academy in 1849 and became a keen reader of *The Germ*, the publication disseminating their ideas. It was Munro who eventually introduced him to Rossetti and Ford Madox Brown in 1851, and the following year to Millais, who particularly influenced Hughes's early paintings of lovers' meetings. Hughes enjoyed further success with *The Long Engagement* 1859 (Birmingham Museums and Art Gallery), also on the theme of thwarted love. Although he was never part of the Pre-Raphaelite Brotherhood as such, he was seen as one of the main proponents of their style. From the 1860s he turned to domestic and rural subject matters, and dedicated himself to illustration, most notably of works by George MacDonald, Christina Rossetti and Thomas Hughes. From 1886, to support his large family, he was forced to take on a job as examiner for the National School of Art system, based at South Kensington. He exhibited at the Royal Academy for the last time in 1908 and when he died in 1915, his obituaries branded him 'The Last Pre-Raphaelite'. CCP

Henry Wallis (London 1830 – Croydon, Surrey 1916)
Chatterton 1856
Oil paint on canvas 62.2 × 93.3. Acquired 1899

'On view for a few days only: The Extraordinary Picture of "The Death of Chatterton" … will be remembered by all visitors to the Royal Academy and the Manchester Exhibition, where it was daily besieged by crowds of anxious visitors.' This 1859 advertisement for a Dublin gallery gives the measure of the immediate fame the picture won Henry Wallis. Having trained at the Royal Academy schools and in Paris, both under Charles Gleyre and at the Ecole des Beaux-Arts, *Chatterton* was his first exhibit at the Royal Academy of Arts, in 1856, three years after his return from France. It was acquired that same year by the artist Augustus Egg, whose work also features at Tate Britain. It then passed on to Charles Gent Clement, who bequeathed it to the National Gallery in 1899. The painting was later transferred to the Tate Gallery, where it remains a beacon of the collection.

Seventeen year-old poet Thomas Chatterton (1752–70) is depicted on his deathbed in a London garret at 39 Brooke Street, Holborn. On the brink of starvation, it was widely believed that he poisoned himself with arsenic, but recent biographers have argued that his death may have resulted from a combination of opiates and medicine for venereal disease. Chatterton was notorious in the eighteenth century for his elaborate forgeries, most notably for a collection of poems passed off as medieval manuscripts by Thomas Rowley, a fifteenth-century monk. The Romantic generation, however, forever transformed his image, seeing in him the archetype of the doomed, misunderstood artist.

Wallis represented the poet's recumbent body at dawn, on a shabby, narrow bed. He gave him the features of Wallis's friend George Meredith, also a writer. In the top centre of the painting, the window opens on to the dome of St Paul's, in the purple hazed distance. Chatterton's marmorean skin contrasts with his red hair and the vibrant colours of his lilac silk breeches and garnet coat, thrown on a chair. Critics at the time saw in the sumptuousness of his clothes a sign of his pride and the origin of his downfall. An empty vial is visible by his right hand, on a floor littered with torn fragments of poetry. On a table to the right, smoke from a burnt-out candle curls up towards the window, symbolising the parting of Chatterton's soul. The fading rose on the window sill stresses the passing of time and mortality.

Although Wallis was never a Pre-Raphaelite, both his meticulous attention to detail and the jewel-like colours of the painting thinly executed on a white ground link it to the Brotherhood. It is not surprising that their early champion, Ruskin, deemed the painting 'faultless and wonderful', urging the viewer to 'examine it well inch by inch'. The literary source of Wallis's paintings was another common tie that bound him to the Pre-Raphaelites. He also tried his hand at writing, which perhaps explains why literary figures, past and present, were his favourite subject (see *The Room in Which Shakespeare Was Born* 1853, Tate T00042). CCP

William Powell Frith (Aldfield 1819 – London 1909)
The Derby Day 1856–8
Oil paint on canvas 101.6 × 223.5. Acquired 1859

The exhibition of Frith's *The Derby Day* at the Royal Academy's annual exhibition was anticipated with the kind of excitement that is now generated by the sequel to a blockbuster film. Two years earlier, Frith's modern scene *Life at the Seaside, Ramsgate Sands* had presented a panoramic crowd scene with not one but many incidents and details. *The Derby Day* doubled the number of figures to ninety. A rail and a policeman were required to protect it from eager viewers.

Frith trained at the Royal Academy and established himself as a painter of commercially successful literary and portrait subjects. He was alert to the possibilities of the new urban and global markets and the expanding printing industry that served them. He was an important member of The Clique with Augustus Egg and Richard Dadd, rejecting academic taste in favour of inventive anecdotal subjects. *The Derby Day* was commissioned by Jacob Bell, founder of the Pharmaceutical Society, for £1,500. It toured the United Kingdom and was reproduced and circulated even more widely in the form of an engraving. Bell left the painting to the National Gallery in 1859.

Frith was an avid reader and a life-long friend of the writer Charles Dickens, and his panoramas have been called 'novels in paint'. Derby Day was a national holiday. At Epsom Downs, classes mixed with unusual freedom in what the *Illustrated London News* called a 'temporary saturnalia of social equality'. Frith adapted academic pyramidal grouping into a landscape of people below a traditional sky with a few ominous clouds giving way to blue. He spent fifteen months painting it from models and specially commissioned photographs.

Crowds inspired fear as well as excitement, so Frith gave the chaos an artificial order. He used fashion as a sign to 'sort' the crowd, for example, a widow in black stands at the left-hand edge. He also exploited the Victorian interest in the pseudo-science of phrenology, a belief that facial features showed personality. The red hair of the man looking at us through binoculars was enough to identify him as an impulsive 'rake'. Criticism of aristocratic characters appealed to the middle classes, who tended to think of them as a redundant, decadent element of society without their work ethic. The new visibility of the working classes and social issues was accompanied by a distinction between 'Deserving' and 'Undeserving Poor'. The thin little acrobat working for his bread is contrasted with the other little boy under the carriage, stealing a bottle.

Men and women were categorised according to stereotypes of 'natural' or 'deviant'. Women's deviancy was conventionalised as sexual, a 'fall', while men's focused on financial irresponsibility, gambling and idleness. In the picture, every sin is reassuringly accompanied by punishment. On the right-hand side, a demimondaine in a yellow dress sits in a carriage but her 'swell' is already tiring of her, his eye caught by the little gypsy girl. A narrative of drunkenness and gambling is set out on the left-hand side where a country wife tries to restrain her intoxicated husband; we follow his gaze to the thimble riggers and on to a man with empty pockets, a good example of Frith's superb composition. CJ

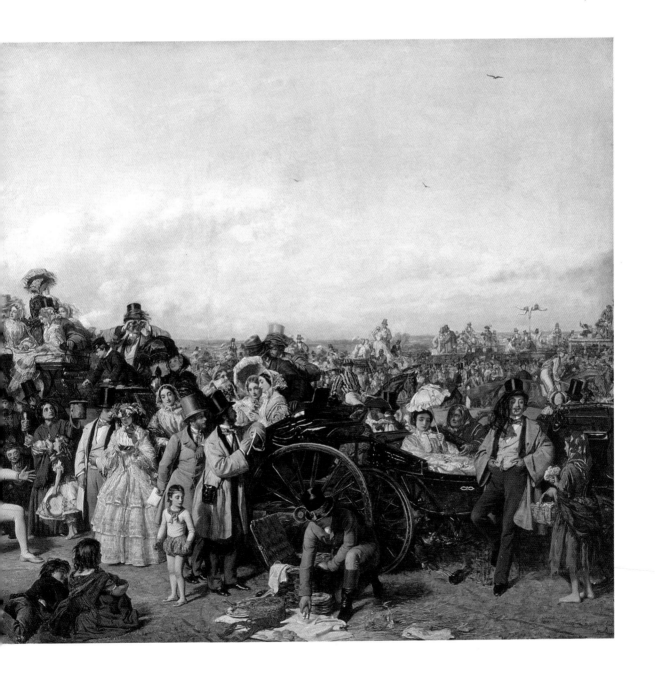

William Morris (Walthamstow 1834 – London 1896)
La Belle Iseult 1856–8
Oil paint on canvas 71.8 × 50.2. Acquired 1939

When *La Belle Iseult* was painted, William Morris was still living as a bachelor with Edward Burne-Jones at 17 Red Lion Square, London. Their lifelong friendship and artistic collaboration had started a few years earlier, while studying at Oxford. It was there that Jane Burden, who posed for the princess, was 'discovered' by Rossetti and Burne-Jones while attending the theatre. The 'stunner' subsequently began modelling for Rossetti and Morris, who fell in love with her. They wed in 1859. Jane later had an intimate relationship spanning several decades with Rossetti, and became his muse. *La Belle Iseult* is Morris's only painting of Jane, and indeed his only known easel picture.

The subject of this painting is taken from Malory's *Le Morte d'Arthur*, a fifteenth-century compilation of Arthurian legends that was also the source for the frescoes Morris and Burne-Jones painted for the Oxford Union new debating Hall from 1857, with a group of artists led by Rossetti. Morris's room at Red Lion Square forms the backdrop of *La Belle Iseult*. It shows the princess immured within her chamber in a dejected attitude, longing for lover Tristram, exiled from the court of King Mark. Her girdle symbolically refers to her imposed state of chastity, whilst the small greyhound on the unmade bed refers to a passage explaining that 'the queen had always a little bratchet [a bitch-hound] with her that Sir Tristram gave her ... and never would that bratchet depart from her but if Sir Tristram was nigh'. The sprigs of rosemary in her crown symbolise remembrance. They are entwined with convolvulus, representing attachment. Down the side

of her mirror is inscribed the word 'DOLOURS' (grief). The juxtaposition of rich patterns in the composition recalls Rossetti's medievalising watercolours of the period, but despite the failings of Morris's perspective, his painting has greater depth. He paid special attention to the drapery, most notably to the crumpled sheets. His interest in fabric, patterns and the delight he evidently took in representing the illuminated missal all point to his true vocation as a designer.

Morris struggled for months on the canvas, eventually abandoning the picture. It was described as unfinished in 1874 when presented it to Ford Madox Brown's son Oliver, and it seems to have been finished either by Brown or Rossetti, who was later given the painting. In 1861, having decorated both Red Lion Square and Red House (the home he had commissioned from the architect Philip Webb in Kent) with medieval-inspired furniture and embroidery, Morris founded the decorative arts firm Morris, Marshall, Faulkner & Co. (Morris & Co. from 1875), which produced wallpaper, fabrics, furniture and stained glass.

La Belle Iseult passed to Rossetti's brother, William Michael, and lay forgotten in a cupboard until his death, when it was returned to Jane. Her daughter May bequeathed it to the Tate Gallery in 1939. Although it may not be as technically accomplished as paintings by Rossetti and Burne-Jones, it is an important work in the history of the second generation of Pre-Raphaelites, the iconography of Jane Burden and the artistic development of William Morris. CCP

Emily Mary Osborn (London 1828 – London 1925)
Nameless and Friendless. 'The rich man's wealth is his strong city, etc.' – Proverbs, x.15 1857
Oil paint on canvas 182.5 × 103.8. Acquired 2009

This painting of an indigent lady vainly attempting to sell her artwork has frequently been used by art historians to address the representation of working women in Victorian society. The picture shows an orphaned female artist, escorted by her younger brother, diffidently offering one of her paintings to a dealer whose disdainful expression suggests rejection. An assistant looks down cursorily at the woman's canvas from his position on a ladder, while two lounging men, otherwise engaged in examining a hand-coloured print of a ballerina, eye her up from behind. Isolated in the centre of the composition between leering and contemptuous glances, she strikes a rather pathetic figure with her downward gaze and fingers nervously pulling a loop of string.

The title of the painting and the quotation from Proverbs that accompanied it when it was first exhibited at the Royal Academy in 1857 reinforce the idea of the metropolis as a man's domain. The single woman's vulnerable status is emphasised by the mud-splattered black crepe of her skirt, her dripping umbrella and protective cape that indicate the distance she has travelled and the conditions she has endured to brave the encounter.

Nameless and Friendless was conceived in part as a political statement by Emily Mary Osborn, an artist associated with the campaign for women's rights, and one of the signatories of the women's petition to the Royal Academy of Arts in 1859 to open its schools to female students.

The difficulties experienced by women in exhibiting and selling their works had led to the formation of the Society of Female Artists in 1857, a development coincident with the public appearance of Osborn's painting, a work that also raised questions concerning female independence and professional recognition.

Given Osborn's feminist sympathies, it would be misleading to equate her own career as a single female artist with that of the woman in the picture. As a student Osborn was encouraged by her family; she was later able to finance her own studio through the sale of a portrait, and had the support of wealthy patrons including Queen Victoria. *Nameless and Friendless* sold for the respectable sum of £250 to Lady Chetwynd; following Lady Chetwynd's death in 1861, it was lent by her husband to the 1862 International Exhibition. That same year it was reproduced as a wood-engraving by Edward Skill and published as a full-page print in the *Illustrated London News*. Another engraving of the work by J. Cooper was published in the *Art Journal* in 1864 to accompany a feature on the artist by James Dafforne.

Osborn went on to enjoy a long and successful career, her last recorded exhibit being in 1905. In 1968 *Nameless and Friendless* came into the possession of the collector Sir David Scott and subsequently his second wife, the alpine gardener and photographer Valerie Finnis. Following her death it was sold by Sotheby's in 2008 together with other works from the Finnis-Scott collection. AS

Augustus Leopold Egg (London 1816 – Algiers 1863)
Past and Present, Nos. 1, 2, 3 1858
Triptych, oil paint on canvas, each 63.5 × 76.2. Acquired 1918

When this triptych was exhibited at the Royal Academy in 1858, the asthmatic Augustus Egg only had five years left to live. He had formed The Clique in 1837 with his friends William Powell Frith and Richard Dadd, amongst others. His early works were genre paintings based on historical anecdotes or literary subjects, and success came with larger, more innovative paintings such as *Queen Elizabeth Discovers She Is No Longer Young* 1848. He is however best remembered for this triptych, first exhibited with the following text: 'August the 4th. Have just heard that B— has been dead more than a fortnight, so his poor children have now lost both parents. I hear she was seen on Friday last near the Strand, evidently without a place to lay her head, What a fall hers has been!'

This series of 'problem pictures' is an enquiry on the theme of the fallen woman. The Thames and garret scenes both represent the consequences of the central 'flashback'. Ruskin clarified their subject: 'In the central piece the husband discovers his wife's infidelity: he dies five years afterwards. The two lateral pictures represent the same moment of night a fortnight after his death. The same little cloud is under the moon. The two children see it from the chamber in which they are praying for their mother, from behind a boat under a vault on the river shore.'

Egg, influenced by Holman Hunt's *Awakening Conscience,* used numerous clues and symbols. In the central scene, the husband holds a love letter that was destined for his prostrate wife, whilst crushing her lover's miniature with his foot. Her bracelets give the impression she is in shackles, which perhaps underlines how the moral code fell on women, and not men, in Victorian Britain. At the base of the toppling house of cards, a novel by Balzac, who often addressed the theme of adultery, alludes to the cause of her downfall. The rotten apple by her side refers to the original sin, echoing the picture of Adam and Eve on the wall, whilst the reflection of the open door in the mirror foretells her own expulsion. The other half of the apple, stabbed to the core, represents the husband, whilst the shipwreck scene above him (a print after Clarkson Stanfield's *The Abandoned* 1856) presages his fate. As for the riverside painting, it shows the mother destitute under the Adelphi arches, sheltering the child she had with her former lover. Behind her are posters for three plays, *Victims*, *A Cure for Love* and *Return the Bride*, which all highlight the Victorians' anxiety in relation to marriage.

The triptych was not sold during Egg's lifetime, but purchased at the auction of his painting collection by Agnew's, the London art dealer. It was presented to the Tate Gallery by Sir Alec and Lady Martin in 1918. The public interest in narrative painting does not seem to have diminished since it entered the collection, where it counts amongst its most popular nineteenth-century paintings. CCP

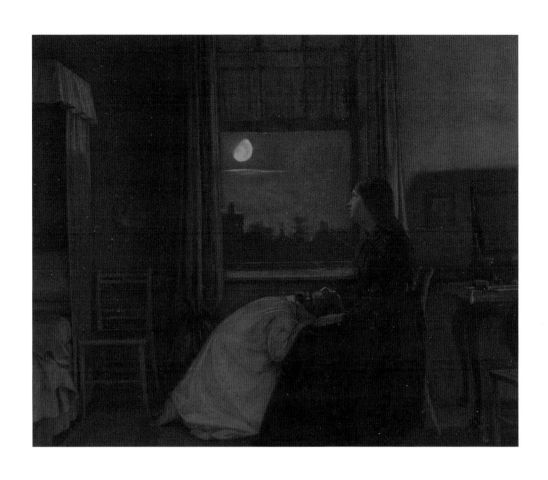

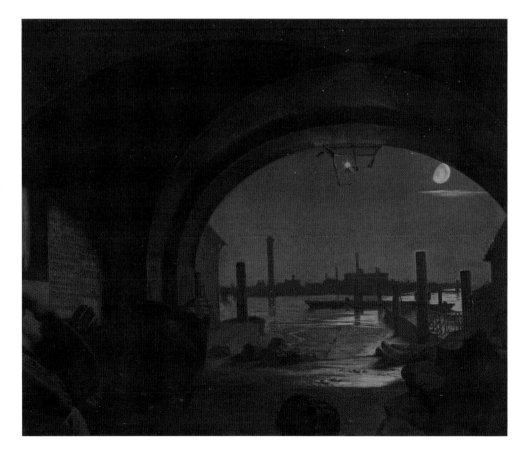

William Maw Egley (London 1826 – London 1916)
Omnibus Life in London 1859
Oil paint on panel 44.8 × 41.9. Acquired 1947

Omnibus Life in London was William Egley's most successful painting. Exhibited at the British Institution in London, it was widely praised for its detail and aptness to modern experience. The *Illustrated London News* described it as 'a droll interior, the stern and trying incidents of which will be recognized by thousands of weary wayfarers through the streets of London'.

Egley was trained by his father, a miniature painter, and at first specialised in illustrating literature. His meticulous style was influenced by the Pre-Raphaelites, but it was his work as an assistant to the modern life painter William Powell Frith that encouraged him to branch out. Contemporary subject matter was at this time more common in Britain than on the Continent, in part because of the example of the eighteenth-century satirist William Hogarth and the huge success of realist writers such as Charles Dickens.

The horse-drawn bus was introduced in 1826. As city life became the norm for more people in Britain, it grew to be a familiar sight. One observer commented that 'Among the middle classes of London the omnibus stands immediately after air, tea, and flannel in the list of the necessaries of life.' They were a spectacle of the streets, moving along decked with advertising signs. *Omnibus Life* depicts the interior of a bus in Westbourne Grove. Egley worked on the picture for forty-four days. The street was painted from a chemist's shop at the corner of Hereford Road where Egley lived. He studied the bus in the coachbuilder's yard in Paddington and built a wooden model in his garden to observe interior light effects. He used his friends and relatives as models for the passengers, including his wife as the mother.

A cross-section of the vehicle literally offers a cross-section of society, reflecting contemporary apprehensions about the crowd. We are invited to consider the random encounters that take place in public spaces. A fashionable woman tries to enter the space even though it is already full. The bulky luggage of another elderly lady inconveniences her neighbour. Egley particularly examines body language. The book, the veil, the parasol, gloves and shawls are essentially tools to protect personal space. Despite the physical proximity of the characters, the artist has focused on the implications of seeing and being seen. Gazes rarely meet. The young clerk stares at the veiled young lady while she keeps her eyes lowered. The only look that connects with another's is the child who acknowledges the viewer. Despite all this, Egley shows the omnibus in the spirit of its name, giving a sense of the good-natured awkwardness of equality.

Egley was an entrepreneur who embraced modern markets and commerce in his life as well as his art. In 1848 he designed one of the first Christmas cards. He exhibited his paintings in a wide range of venues, and sold directly to dealers. *Omnibus Life* was bought by William Jennings for £52 10s and remained in private hands until it was given to the Tate Gallery in 1947. CJ

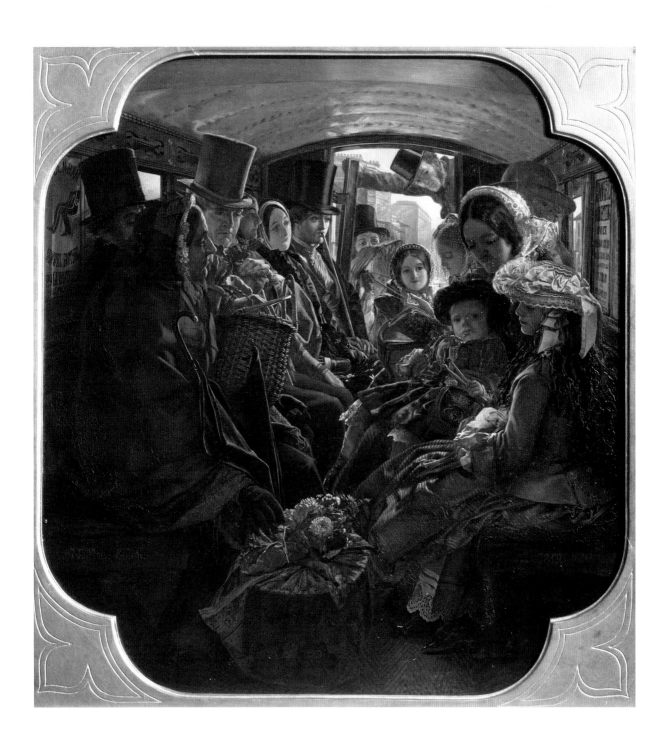

John Brett (Bletchingley 1831 – London 1902)
Lady with a Dove: Madame Loeser 1864
Oil paint on canvas 61 × 45.7. Acquired 1919

This small painting probably did not attract much atten-tion on the walls of the Royal Manchester Institution when it appeared for the first time. Although it had been finished for over a year, John Brett had not submitted it to the main venue for modern art in Britain, the annual exhi-bition of the Royal Academy. The evidence suggests that this was a type of painting that was as yet relatively uncom-mon in the Victorian era, a piece intended to satisfy the interests of the artist rather than a client or the public at large. Brett had met Jeannette Loeser in Florence in 1863. They became lovers, and it was only after the tempestuous affair ended in March 1865 that the painting was discretely sold and exhibited.

Jeannette Loeser's modish dress declares her member-ship of the intelligentsia that gathered in Florence. She was a cultured European of independent means and the com-panion of the composer and pianist Jacques Blumenthal. She was forty-four when the painting was begun, thirteen years Brett's senior. The full-length format captures a pow-erful presence, which complements her sculptural profile. The colour suggests half-mourning, as do the grey pearls. Brooches such as the one worn on her shoulder were permit-ted if they showed suitable scenes. This one depicts a dove.

Lady with a Dove: Madame Loeser was, as its double title suggests, as much an exploration of an idea as a portrait. The bird was an attribute of Venus, goddess of love, and the red rose implied that love was requited. These and the cupids at the corner of the frame designed by Brett were motifs familiar from Florentine Renaissance art.

In the nineteenth century, the dove's traditionally gentle character became tinged with new associations of freedom and natural unconstraint, as in the poetry of another in their circle, Robert Browning. It is un-caged and spreads a wing towards the empty space ahead.

The side view against a flat golden wall alludes to the style of the Renaissance portrait. The picture's buyer, Alfred Morrison, was a collector of Renaissance objects. The grey and umber also suggest the new medium of the photographic print, however, and the flattened effect looks forward to modern art. Pattern is created by the horizontal bands of wall, skirting board and floor as well as the carpet, skirt, bodice and even the regular undu-lations of the hair. This synthesis of Renaissance and modern beauty characterised the aesthetic style that was emerging in Britain at this time.

Brett was part of the Pre-Raphaelite circle that gave rise to the aesthetic movement. After training at the Royal Academy he made his name executing portraits and land-scapes of pristine precision. His mentor, the art writer John Ruskin, overlooked the poetry of these scenes, however, seeing only diligence, and dismissed Brett's ability as a figure painter. *Lady with a Dove* can be seen as a statement of defiance, but Brett never returned to this format. He died in obscurity, and continued to be admired mainly by fellow artists. The painter and gallery director Sir Charles Holroyd requested *Lady with a Dove* be given to the Tate Gallery after his death in 1919 and it has played its part in the revival of Brett's reputation in recent years. CJ

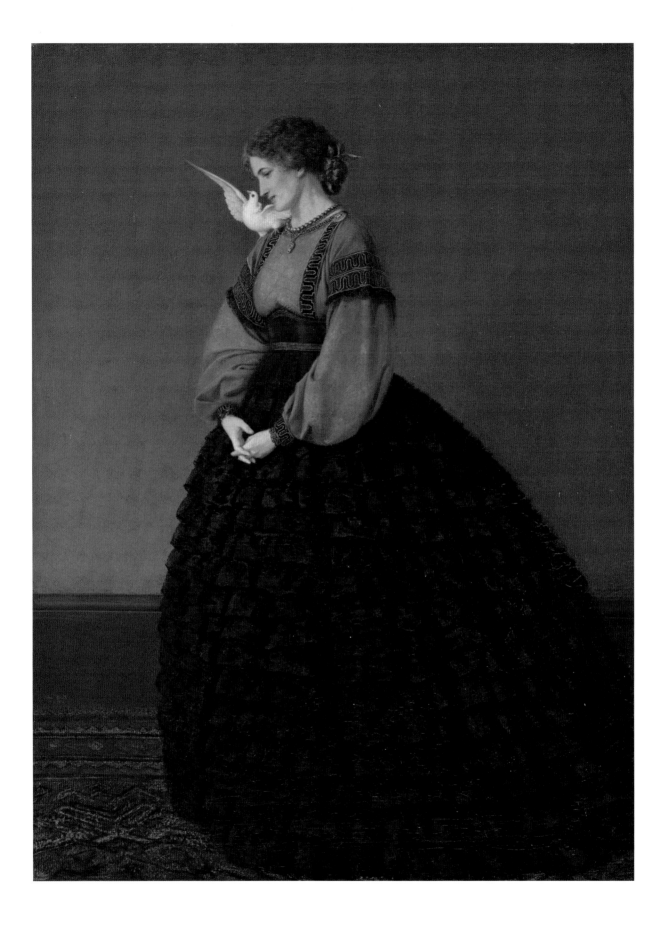

John Frederick Lewis (London 1805 – Walton-on-Thames 1876)
The Courtyard of the Coptic Patriarch's House in Cairo c.1864
Oil paint on wood 36.8 × 35.6. Acquired 1900

Although John Frederick Lewis started his career as a painter of animals, like his childhood neighbour Edwin Landseer, his name is inextricably linked to Orientalism. A trip to Spain in 1832–4 resulted in a keyed-up palette and a thirst for more exotic subjects. In 1837 Lewis left Britain to tour Europe and the Near East and sailed for Egypt in 1841. There, and for the next ten years, he lived *à la Turque* in a large Mamluk house, aloof from other European residents. The novelist William Makepeace Thackeray claimed that he lived 'like a languid Lotus-eater – a dreamy, hazy, lazy, tobaccofied life'. He was however industrious enough to produce 600 drawings and watercolours, his medium of choice after 1827. These, together with his collection of costumes and objects, provided him with enough material to go on painting Egyptian subjects for the next twenty-five years. He returned triumphant to England in 1851 after the resounding success of the first painting he sent to London from abroad, *Hhareem* 1850. This led to his being regarded as the greatest British Orientalist painter.

The present oil painting is a smaller version of another work on panel (private collection). Both appear to be based on a large unfinished watercolour executed in Cairo between 1850 and 1851 (Birmingham Museums & Art Gallery). Although Lewis was elected President of the Old Water-Colour Society in 1855, he returned to oil painting in the late 1850s on Ruskin's advice, and because it was more lucrative. His technique, however, remained the same.

He painted thinly and produced luminous, reticulated surfaces with intricate details. In this and his treatment of light, he equated the style of the Pre-Raphaelites, whom he admired, but reproached for not being delicate enough.

The Coptic Church is the ancient Egyptian Orthodox Christian Church. Its patriarch, as per the picture's title, is depicted here seated in the background, dictating a letter waiting to be despatched to a convent in the desert. Lewis worked with the precision of a goldsmith to render the leaves of the acacia tree, latticed woodwork screens (*Mashrabiya* in Arabic) and carved sandstone of the court-yard. No less than forty birds are shown congregating towards the shallow pool in the foreground. Lewis's vir-tuoso skills as an animal painter are also reflected in the depiction of the camels, goats and cat. Despite his great attention to detail and first-hand knowledge of Egypt, the documentary value of the painting may not be what it seems. The courtyard Lewis depicted was in fact that of his own grand old Cairo house, and there is no evidence that he rented it from the Coptic patriarch. He also took some freedom in depicting the women in the painting, since Coptic women wore veils, like their Muslim counterparts.

The painting was purchased with a parliamentary grant in 1900, more than twenty-years after Lewis's death. It was the second of twenty-seven works by Lewis to enter the collection, three years after *Edfu, Upper Egypt* 1860. CCP

Dante Gabriel Rossetti (London 1832 – Birchington on Sea, Kent 1882)
Monna Vanna 1866
Oil paint on canvas 88.9 × 86.4. Acquired 1916

Monna Vanna belongs to a series of decorative portrayals of sensual women executed by Rossetti in the mid-1860s. It contrasts with his original asceticism (see *The Girlhood of Mary Virgin*, p.75) and his richly patterned, medievalising watercolours of the 1850s. It is a portrait of Alexa Wilding, Rossetti's primary model between the mid-1860s and mid-1870s, but the essence of the painting is the representation of idealised female beauty, not the sitter *per se*. In this the painting follows the tradition of richly coloured, half-length pictures of courtesans by Titian and other Venetian High Renaissance artists. Hence its original title, *Venus Veneta*.

The model is portrayed in a confined space, amid a careful arrangement of luxurious fabrics, materials, textures and colours, which are as important as the woman herself. Despite her languid look, her general attitude is not so much enticing as aloof, and she appears as a vehicle for the display of sumptuous objects. The material, carnal and vegetal are incorporated into Rossetti's design on the same level. The model's lips are like the coral of her necklace; her complexion is echoed in the roses behind her; and her silky golden hair resembles both the fan of capercaillie feathers and the gold patterns of her dress. Rossetti described the painting as 'most effective as a room decoration' and later re-titled it *Belcolore*, judging it more apt for 'so comparatively modern-looking a picture'. The numerous pieces of jewellery Rossetti delighted in painting were part of his

own collection; the spiral pearl pin appears in several others of his works and was a particular favourite. Just like the spiralled carved armrest, it reflects the general circular composition of the painting, the main rhythm of which is imparted by the model's bulging sleeve, inspired by Raphael's portrait of *Giovanna of Aragon* (Louvre).

Monna Vanna, the title Rossetti gave the painting after its completion, is borrowed from a sonnet by Dante in *La Vita Nuova*. It was the name of the poet Guido Cavalcanti's beloved, deemed to be one of the sixty most beautiful women in Florence. It highlights the Italianate inspiration of the painting, which is still known under that title, whilst rejecting the superimposition of a narrative.

With its emphasis on decoration and ornament, *Monna Vanna* appears as an early example of aestheticism and 'art for art's sake'. Rossetti originally offered the painting to his patron John Mitchell of Bradford, the commissioner of *Venus Verticordia* 1864–8 (Russell-Cotes Gallery, Bournemouth). It was bought instead by the Cheshire collector William Blackmore, who also owned *Fazio's Mistress* 1863 (Tate NO 3055), and later passed into the hands of one of Rossetti's major patrons, George Rae of Birkenhead. It was one of the first Pre-Raphaelite paintings that the Art Fund helped purchase for the nation, in 1916, with the assistance of Sir Arthur du Cros Bt and Sir Otto Beit KCMG. CCP

Albert Moore (York 1841–London 1893)
A Garden 1869
Oil paint on canvas 174.5 × 88. Acquired 1980

A Garden puzzled some critics when it appeared at the Royal Academy summer exhibition in 1870. The title gave as little away as the figure, seen only from the back. The setting is closed off by a high wall and they found it hard to pin down a time or place. The chalky surfaces and draped lady were reminiscent of pastoral scenes from Roman wall-paintings excavated at Pompeii, but the painting lacked the archaeological details usually associated with such scenes. The asymmetrical pose and flowers were rather Japanese, but the sensuous textures of fabric, flowers, creased elbow and blushing cheek were immediately modern.

A Garden appealed to an alternative set of writers and connoisseurs who were exploring what was to become known as the aesthetic movement. It was purchased by Alexander Henderson (later Baron Faringdon) and passed through a series of other private collectors before it was bought by the Tate Gallery in 1980. For these connoisseurs the evasion of time and place left the image free to function as a contemplation of beauty alone. Art transcended the everyday experience of middle-class concerns and the nineteenth-century industrial city. The poet Charles Algernon Swinburne praised what he called Moore's 'exclusive worship of things formally beautiful … their reason for being is simply to be'. The artist became a paradigm of the concept of art for art's sake that was sweeping Europe, and exhibited regularly at its main venue, the Grosvenor Gallery.

Moore's achievement in synthesising art and decoration was shaped by his training as both a fine and decorative artist. He attended York School of Design and the Royal Academy where he also came under the influence of the Pre-Raphaelite Brotherhood. Correspondingly Moore practised as both a decorative muralist and a painter of religious subject pictures until 1865, when his study of the Elgin Marbles prompted him to turn to classically draped figures. Variations of these in different arrangements and colours would occupy him for the rest of his career.

Moore was influenced by his friend James McNeill Whistler. It was Whistler who introduced him to the syncopated arrangements of graceful line and distinct areas of colour in Japanese prints. Moore introduced Whistler to classical art. Both explored the way harmonised colours could lend an emotional timbre to their paintings. They pioneered the demand later described by the main spokesman of the aesthetic movement, Walter Pater, for an art that 'aspires towards the condition of music'.

The flat and faded appearance of the painting that was criticised in contemporary reviews was a way of accentuating two-dimensional harmonies of pattern and colour. Moore elaborated this 'musical' quality by carefully arranging the scene on paper before transferring it to canvas. The grid used for this purpose appears most obviously in the horizontal of the raised arm and the division of wall and sky, but can be detected underneath the paint across the whole surface. It introduces a visual tempo against which sway the more gentle diagonals of the criss-crossed yellow ribbon and green robe, counterpointed by branches and stems. Onto this linear pattern are sprinkled rhythms of colour in the form of flowers, the gentle cadence of larger leaves and blooms enlivened by a more staccato scatter of daisies in the grass. CJ

Alphonse Legros (Dijon 1837 – Watford 1911)
Rehearsing the Service c.1870
Oil paint on canvas 91.4 × 116.8. Acquired 1916

This is one of many works on a religious subject painted by the French artist Alphonse Legros. Neither intended for a church nor a devotional piece, Legros's interest, typically in his oeuvre, lies in the physical presence of the worshippers and priests and the tangibility of ritual in their daily life.

Legros's reputation was established in 1860, when he exhibited *L'Ex-Voto* at the Paris Salon. The monumental picture, representing eight women praying at the edge of a wood, was immediately associated with Courbet's *Burial at Ornans*. Perceived as the new leader of a young generation of realist painters, this did not translate into commercial success for Legros. Encouraged by Whistler, with whom he had formed the short-lived Société des Trois in 1859 alongside Fantin-Latour, Legros moved to London in 1863. There he was warmly welcomed by G.F. Watts, who admired the 'grave simplicity' of his style. Dante Gabriel and William Michael Rossetti were also staunch supporters. Legros soon found patrons and started exhibiting at the Royal Academy. There is no evidence, however, that *Rehearsing the Service* was shown there, unless it was exhibited under a different title.

The painting shows an organist and a priest rehearsing for the Divine Office. Their solid, life-size figures still recall Courbet, but from the late 1860s Legros found a source of inspiration in Ingres – which can be felt here in the emphasis on line – and in the Italian old masters. It is likely that Giovanni Bellini's *Doge Leonardo Loredan* 1501 (National Gallery) influenced his treatment of the youngest priest, with strong shadows cast on the left side of his face. Legros did not portray an actual clergyman, but the professional model Alessandro di Marco, also favoured by Burne-Jones, Leighton, William Blake Richmond and Walter Crane. Whilst he is wearing an appropriate cope for the Office, it has been pointed out that the chasuble of the organist is an oddity, since it is traditionally only worn to celebrate the mass, and not to play the organ. Legros was not so much interested in social reportage as in suggesting inner lives through characterisation. Between the two men, the overpainted head of a choirboy included in an early design for the work is now visible to the eye.

Although Legros's style and subjects were always perceived as French in his adopted country (he was naturalised British in 1880), he was better known in Britain. He was a founder member of the Society of Painter-Etchers in 1881; while etching being his favourite medium, Pisanello's medals inspired him to revive the cast art medal. He also left his mark as a teacher as Slade Professor between 1876 and 1893.

Rehearsing the Service was first exhibited at the Tate Gallery in 1912, at Legros's memorial exhibition. At the time, it belonged to Stopford Augustus Brooke, a celebrated preacher and former chaplain in ordinary to Queen Victoria who seceded from the Church to officiate as a Unitarian minister. He bequeathed the painting to the gallery on his death, in 1916. CCP

James Abbott McNeill Whistler (Lowell, Massachusetts 1834 – London 1903)
Nocturne: Blue and Silver – Chelsea 1871
Oil paint on wood 50.2 × 60.8. Acquired 1972

This painting, Whistler's first nocturne, was exhibited in 1871 at the Dudley Gallery, Piccadilly, as *Harmony in Blue-Green – Moonlight*, alongside its pendant, *Variations in Violet and Green* (Musée d'Orsay), a sunset scene. Both paintings were executed in August 1871 after a trip to Westminster, when 'the river [was] in a glow of rare transparency an hour before sunset'. On his return to Chelsea, where he lived, Whistler rushed upstairs to his studio and painted both pictures at one sitting. His mother, watching him, pointed out: 'it is yet light enough for you to see to make this a moonlight picture of the Thames', which he did in this work.

It shows Chelsea from Battersea Bridge at the *Heure Bleue*, or twilight. The tower of Chelsea Old Church is visible on the horizon, to the right, and in the foreground a barge and a fisherman are indicated with great economy of means, the silhouette of the latter with swift, calligraphic strokes. The creamy paint was applied broadly and fluidly on panel primed with grey to create subtle tonal variations, so as to reflect the Thames' stillness and mirror-like surface. The flat planes of subdued colour are reminiscent of Japanese woodcuts, a lineage more overtly claimed by the butterfly cartouche that Whistler used as his signature from 1869, and which also appears on the picture's custom-made frame, lower right. Whistler had developed a strong interest in Japonisme from 1863, introducing oriental objects from his own collection into his compositions. Having trained in

Paris at a time when Courbet's art was at the fore, Whistler was originally influenced by Realism, but his art took a new direction when he settled in England in 1859, at the contact of aesthetes such as Dante Gabriel Rossetti and Algernon Charles Swinburne.

The title *Nocturne* was not Whistler's invention but that of his patron Frederick Leyland, a shipping magnate and amateur pianist. It was soon adopted by the artist: 'By using the word "nocturne" I wished to indicate an artistic interest alone, divesting the picture of any outside anecdotal interest … A nocturne is an arrangement of line, form and colour first.' Whistler's nocturnes came to epitomise the ideas of the aesthetic movement and its motto, 'Art for art's sake'. In highlighting the formal qualities of his works, and emulating the condition of music, Whistler's artistic approach paralleled that of the French symbolist poet Stéphane Mallarmé. Throughout his career, Whistler was an important link between the avant-garde of Europe, Britain and the USA.

He was always recognised as one of the greatest masters of etching, but the full appreciation of his paintings suffered from the fact that many of them remained in private collections. This was the case of the present painting, bought in 1871 by the banker W. C. Alexander – father to Cicely, whose portrait is also part of the collection – and bequeathed to the Tate Gallery in 1972 by Rachel and Jean Alexander. CCP

Cecil Gordon Lawson (Wellington, Shropshire 1849 – London 1882)
The Hop Gardens of England 1874, reworked 1879
Oil paint on canvas 153.7 × 213.7. Acquired 2012

During his short career Cecil Lawson was regarded as the leader of a poetic mode of landscape painting in Britain. Together with John Everett Millais, he revived the large-scale exhibition landscape that had been eclipsed by the minute imitation of nature advanced by the Pre-Raphaelites during the 1850s. Born of Scottish parents, Lawson moved to London as a child where, encouraged by his artistic family, he emerged as a professional painter in his teens. By 1870 he was living in Cheyne Walk, Chelsea in the milieu of Dante Gabriel Rossetti and J.A.M. Whistler where he developed a distinct form of landscape painting. This was described by the *Times* as 'work that seems to be at once old and new, classical and modern, full of individuality, yet inspired by the great masters; Ruysdael and Constable expressing themselves in the language and with the feelings of today'.

The Hop Gardens was ranked among the most important of the artist's works by his contemporaries. It was painted during the summer and autumn of 1874 at Wrotham, in the heart of the Kent hop country. According to Lawson's biographer, Edmund Gosse, a local farmer lent the artist a barn where he worked from morning to evening building up the composition. The painting offers a sweeping panorama over the Kent weald, the eye looking down on a bank of hops in the foreground and then up to apple trees, barley and oast houses with their cowls directed away from the breeze to fields in the far distance.

In terms of its dynamic design and blue-green palette, the picture is indebted to Rubens's *An Autumn Afternoon with a View of Het Steen* c.1636 in the National Gallery, but the brushwork is atypically bold and vigorous with paint applied in think impasto strokes on a twill-weave canvas. The composition's daring, warped perspective accentuates the visionary quality of the picture, as does the isolated figure in the foreground wandering into the hop grove as if spellbound by the spectacle of nature in full bloom.

It may have been because of its compositional irregularities that the painting was rejected by the Royal Academy in 1875. However, it was accepted the following year and hung in a prominent position. Lawson subsequently repainted parts of the picture and exhibited it at the Grosvenor Gallery in 1879 under the title *Kent*. Upon being exhibited again at the Grosvenor in 1883, at a posthumous exhibition of the artist's work, it was accompanied by lines from a sixteenth-century air *The Jovial Man of Kent* (a favourite with Morris Dancers).

Altogether the picture was exhibited seven times between 1875 and 1897, including Chicago in 1893. It was widely discussed in terms of its sensational and experimental approach to landscape, features that were later picked up by Adrian Bury writing in the *Connoisseur* in 1944 at the time of a neo-romantic revival of landscape painting in Britain. It was acquired by Tate in 2012 where it fills a gap in the romantic lineage extending from Palmer and the Ancients to the landscapes of the mid-twentieth century. AS

James Tissot (Nantes 1836 – Château de Buillon, Doubs 1902)
The Ball on Shipboard c.1874
Oil paint on canvas 84.1 × 129.5. Acquired 1937

James Tissot had only been in England for three years when he exhibited *The Ball on Shipboard* at the Royal Academy in 1874. It is often argued that the Frenchman had attempted to escape reprisal after the Franco-Prussian War, having fervently defended Paris during the Commune, but he had also developed connections with London for some time. A pupil of Louis Lamothe and Hippolyte Flandrin, he exhibited at the Paris Salon from 1859, but also occasionally at the Royal Academy from 1864. He contributed caricatures to *Vanity Fair* as early as 1869. It was only after his move to London that he started painting pictures of elegantly dressed men and women, such as *The Ball on Shipboard,* on which rest his fame.

The scene is thought to be set during the annual regatta at Cowes, on the Isle of Wight. This would explain the bright awning made up of international flags. The atmosphere of the scene and the social game at play prevail, rather than recording precise historical circumstances. Tissot represented the upper deck peopled with a large number of unescorted young women, suggesting possible amorous encounters. Couples can be seen waltzing on the deck below. The composition, with an empty diagonal stretch of deck in the foreground, invites the viewer to join in, as do the direct gaze and smile of a lady in the middle ground, centre right. She is one of several 'twins' in the picture. A woman dressed identically is standing by her whilst two more pairs, wearing respectively blue and green dresses, can be seen around a table to the left, by the rigging.

A pink and burgundy dress also features at least twice in the picture. These repetitions appear too obvious not to be deliberate. They bring to mind fashion plates and play an important role in the picture's gentle irony. Tissot cast an amused eye on this fashionable society, of which he was a part but observed with some detachment.

His art proved very popular in England, enabling him to command high prices, but art critics did not respond so positively. The *Illustrated London News* described *The Ball on Shipboard* as 'garish and almost repellent'. The discerning dealers Agnew's purchased it in 1874 before it was exhibited. It changed hands several times, and was in Sir Alfred Munnings' collection when it was acquired by the Chantrey bequest for the Tate Gallery in 1937. It featured at an exhibition of the Chantrey collection organised at the Royal Academy in 1949, when it was presented as one of the collection's pillars. It is still a favourite with Tate visitors.

A friend of the impressionists, Tissot's oeuvre was overshadowed by theirs. Like them, he dealt with modern life but retained his traditional, meticulous technique. In 1882 Tissot returned to France following the death of his companion, Kathleen Newton. He dedicated himself to portraiture and began illustrating the *Life of Christ* and the *Old Testament* in gouache, to great acclaim. He was chiefly remembered for this after his death in 1902, but his most important work is now recognised as his depictions of fashionable life. CCP

Frederic Leighton (Scarborough 1830 – London 1936)
An Athlete Wrestling with a Python 1877
Bronze 174.6 × 98.4 × 109.9. Acquired 1877

Leighton first showcased this life-size bronze athlete at the Royal Academy's summer exhibition in 1877, under the title *Athlete Struggling with a Python*. Having made numerous earlier smaller plaster sketches, this final twisting figure was cast from its clay full-scale model in plaster, and then in bronze by the foundry Cox and Sons, whose name is inscribed on its base. The athlete's pose recalls that of the classical sculpture *Laocoön* (Vatican, Rome), but here Leighton presents a single muscular figure locked in battle with a swirling serpent.

Athlete Wrestling with a Python was praised by numerous critics, one describing it as a 'new step in modern English art'. Further international approval came when Leighton was awarded a first-class gold medal for the sculpture at the 1878 Paris International Exposition. This reception was remarkable given that it was Leighton's earliest full-size and finished sculpture. However, since he valued the copying of classical and ancient sculptures in his figure paintings so highly, he had previously made numerous small three-dimensional modellos for this purpose. In fact Leighton later described how he had begun working on this athlete whilst engaged in making models for his large-scale oil painting *Daphnephonia* 1874–6.

Much to Leighton's delight, the Trustees of the Chantrey Bequest quickly purchased the athlete in 1877. It was transferred to the Tate Gallery on its foundation in 1897 along with all of the works previously bought through the Bequest. Leighton's athlete was one of the first group of eight works to be purchased and, more significantly, it was also the only sculpture purchased until 1881. This is a mark of the work's significance to the development of British sculpture and its patronage. The year after the Tate Gallery acquired the athlete, Leighton was elected as President of the Royal Academy. He remains one of only three sculptors to have held this office and under him more sculptors than ever before were elected as Royal Academicians.

The sculpture was certainly a key catalyst at the earliest beginnings of what the art critic Edmund Gosse described in 1894 as the 'New Sculpture' – a fresh sculptural aesthetic that was gaining momentum in Britain in the late nineteenth century. For Gosse 'a wholly new force made itself felt' in *Athlete Wrestling with a Python*, and it exemplifies the innovative approaches to sculpture that Leighton and his contemporaries were making in Britain. Like Leighton, artists such as Alfred Gilbert and Hamo Thornycroft sought to capture the naturalism of the body through its movement and the modelling of the bronze surface. Although rooted to his base, Leighton's figure here appears poised with one foot hovering in anticipation of stepping off it. Leighton is thought to have visited the Zoological Gardens, London, to sketch the snake whose scaly skin slinks around the athlete's tense muscular torso and legs. The strength, movement and vitality of this arresting bronze figure makes it a key work in the Tate's collection and one that was truly modern in its time. JP

Edward Coley Burne-Jones (Birmingham 1833 – London 1898)
The Golden Stairs 1880
Oil paint on canvas 269.2 × 116.8. Acquired 1924

The Golden Stairs represented the triumph of aestheticism as a movement and Burne-Jones as its pre-eminent practitioner. Despite being a large and important picture the artist by-passed the mainstream Royal Academy and displayed it exclusively at the Grosvenor Gallery, the leading aesthetic exhibition space. It was acclaimed by critics associated with the circle and purchased by the aesthete Cyril Flower, Lord Battersea, a Member of Parliament, who displayed it in his stylish London home. This success was all the more surprising given Burne-Jones's limited training following his abandonment of theological studies at the University of Oxford in 1857. After joining the Pre-Raphaelite circle he became the leading artist and designer of its more abstract, symbolist second phase. As well as painting, Burne-Jones collaborated with William Morris on stained glass and other decorative objects.

The alternative titles for *The Golden Stairs*, *The King's Wedding* and *Music on the Stairs*, demonstrate its independence from any specific narrative, a key criterion for aesthetic paintings. The idea of a descent from Heaven to Earth complements Burne-Jones's conviction that art should turn away from the everyday and transport the viewer into 'a beautiful, romantic dream of something that never was, never will be – in a light better than any light that ever shone – in a land no one can define or remember, only desire'. Allusions to ritual processions of the past are enhanced by the archaic instruments, gauzy drapery, the classical laurel and Egyptian touches to the architecture.

The apparent simplicity of colour and arrangement disguises the formal sophistication of the painting. Burne-Jones worked on it for eight years from 1872. The resulting canvas overwhelms the viewer by its height and its repetition of eighteen women moving 'gracefully, freely, and in unison with their neighbours' as one commentator put it. The first and last are cut off at the edge suggesting the procession is endless. The figures are exquisitely arranged to curve from top to bottom, each pose different from, but related to, the next. All are executed in flowing outline filled with softly stippled surfaces of silver and cream that create a gentle, limpid atmosphere. The result is a kind of visual music that complements the instruments in the picture.

Aesthetic artists explored the enchanting effects of bodily beauty as well as formal beauty. The figures in *The Golden Stairs* remind us of those painted by the Renaissance master Sandro Botticelli, a favourite of the movement. Their decoratively crimped coverings are animated by swaying gaits and gestures and turns of the waist and head. Closer examination, however, reveals that each face is different, a collection of surprisingly immediate likenesses of contemporary young women, including the artist's daughter. The crisp folds of the robes, restless fingers and pink toes give them a compelling physicality.

Burne-Jones exhibited regularly at international exhibitions and from 1894 onwards *The Golden Stairs* was well known as a print. Artists as diverse as Paul Gauguin, Pablo Picasso and Francis Bacon admired his works. It is possible that Marcel Duchamp was thinking of *The Golden Stairs* when he painted his modernist masterpiece *Nude Descending a Staircase* in 1912. In 1924 the work was bequeathed to the Tate Gallery for the nation by Lord Battersea. CJ

George Frederic Watts (London 1817 – London 1904)
The Minotaur 1885
Oil paint on canvas 118.1 × 94.5. Acquired 1897

'All my paintings at the Tate Gallery are symbolical and for all time ... I want to make people think.' *The Minotaur* was one of eighteen pictures gifted by Watts to the nation in 1897. It was first exhibited and acclaimed at the 1885 Liverpool autumn exhibition, at a time when Watts was considered one of the greatest artists of the Victorian era, 'England's Michelangelo'. He had risen to prominence after winning the 1843 competition to decorate the new Houses of Parliament and took up sculpture in the 1860s, but was chiefly known as a portrait painter until the late 1870s, when he started exhibiting his symbolic paintings at the Grosvenor Gallery.

Half-man, half-bull, the Minotaur was appeased by the regular sacrifice of seven youths and seven virgins shipped from Athens to Crete, where he was confined to a labyrinth. Watts depicted the monster from Greek mythology leaning out across the Aegean Sea from a high parapet, at dawn, under a milky sky flecked with gold. Leering into the distance, he is shown crushing a bird, the symbol of purity and innocence, whilst his tense bulging muscles convey a sense of bestiality and male lust.

The subject of Watts's picture was inspired by a series of controversial articles by William Thomas Stead published in the *Pall Mall Gazette* in July 1885. 'The Maiden Tribute of Modern Babylon' denounced the wholesale trade of child prostitution in London, and repeatedly used the Minotaur as a metaphor for lust. It resulted in the age of consent for girls being raised from thirteen to sixteen. Galvanised by Stead's shocking revelations, Watts reportedly painted the Minotaur one morning, between five and eight.

It has been argued that the Minotaur kills the bird in eager anticipation of the arrival of the ship, whose white sail can be seen on the horizon, but Stead's exposé, drawing on his reading of Plutarch, noted that the sacrificial convoy's sail was black. The monster's gesture is therefore perhaps rather one of frustration at the realisation that the ship on the horizon is not the one he expected. The painting is often shown as a pendant to *Mammon*, which was painted shortly before *The Minotaur* and denounces material greed.

Watts's symbolic works, most of which are kept in his purpose-built gallery in Compton, Surrey, display a deeply personal imagery and place him as a precursor of European Symbolism. Despite a large memorial exhibition at the Royal Academy after his death, with sequels in the whole of Great Britain, Watts gradually fell into relative oblivion after his death. A space was dedicated to his works at the Tate Gallery when it was founded, and this principle lasted until 1938. Although his oeuvre was re-examined at a Tate exhibition in 1955, it was not until *Victorian High Renaissance* (Minneapolis Institute of Arts, Manchester City Art Gallery, Brooklyn Museum, 1979), *The Age of Rossetti, Burne-Jones and Watts: Symbolism in Britain* (Tate, 1997), and a series of exhibitions for the centenary of his death that he was put back on the artistic map. CCP

John Singer Sargent (Florence 1856 – London 1925)
Carnation, Lily, Lily, Rose 1885–6
Oil paint on canvas 174 × 153.7. Acquired 1887

'The only thing that one can care about is Sargent's picture', commented Philip Wilson Steer on the stir caused by *Carnation, Lily, Lily, Rose* at the 1887 Royal Academy exhibition. It established the American's reputation in England, where he had permanently moved from France the previous year. This was a new start after the scandal of *Madame X*, judged too provocative at the 1884 Paris Salon. Most critics praised *Carnation, Lily, Lily, Rose* for its play on light and colours, but it confused others. The *Daily Telegraph* noted: 'what the picture means and why it was painted are simply, to us, inscrutable mysteries'.

The painting's title was taken from *Flora's Wreath,* a popular song by Joseph Mazzinghi (1765–1844). The lanterns' warm glow on lilies was inspired by a scene Sargent observed during a boating holiday at the village of Pangbourne, Berkshire. He reconstructed it in the house of fellow artist Frank Millet at Broadway, Worcestershire, in the late summer and autumn of 1885 and 1886, using the illustrator Frederick Barnard's daughters Dolly, eleven, and Polly, seven, as models. Sargent summed up the difficulties his commitment to plein-air painting entailed: 'Fearful difficult subject. Impossible brilliant colours of flowers and lamps and brightest green lawn background. Paints are not bright enough. & then the effect only lasts ten minutes.' He nearly 'g[a]ve up in despair', but the canvas was eventually completed in 1886.

Neither a genre painting nor a portrait, *Carnation, Lily, Lily, Rose* eludes categorisation. Its theme, flower imagery and literary title could fit within the scope of Victorian sentimentality, but its reading is blurred by its large format, absence of narrative and Sargent's vigorous brushwork, influenced by his friend Monet. More importantly, the lilies and white pinafores of the little girls are also emblematic of the aesthetic movement, whilst the lanterns evoke the fashion for Japanese and Chinese objects, *Japonisme*. The picture's appeal to the senses and the rhythmic disposition of the flowers on the flattened green background are both poetic and decorative, thus conforming to the aesthetic motto of 'Art for Art's sake'. The critic R.A.M. Stevenson, perhaps responding to the *Daily Telegraph,* wrote in 1888: 'The beauty of light playing on the varied surface of things, that is the matter.'

The fact that the picture was immediately purchased for the nation by the Chantrey Bequest bears testimony to its popular success. The fund, administered by the Council of the Royal Academy of Arts, was led by Leighton who recommended its purchase, along with Henry Tanworth Wells.

Later Sargent chose the path of portraiture (see p.115) and pursued a highly successful career both in England and America. But after his death in 1925, he fell out of critical favour with the rise of modernism. For some years in the 1960s and 1970s, *Carnation, Lily, Lily, Rose* was not exhibited at the Tate Gallery, until Sargent's work was re-examined and appreciated once again in the late 1970s. CCP

Théodore Roussel (Lorient, France 1847 – Hastings 1926)
The Reading Girl 1886–7
Oil paint on canvas 152.4 × 161.3. Acquired 1927

Roussel's picture was exhibited at the progressive New English Art Club rather than the traditional Royal Academy. Even so, his decision to depict the nude not as a mythological, classical or historical character but as a modern young woman caused consternation. 'Our imagination fails to conceive any adequate reason for a picture of this sort', wrote the critic for the *Spectator*, 'It is realism of the worst kind, the artist's eye seeing only the vulgar outside of his model, and reproducing that callously and brutally. No human being, we should imagine, could take any pleasure in such a picture as this; it is a degradation of Art.' The painting enjoyed acclaim in the more avant-garde circles, however, and was exhibited on the continent in Munich and Amsterdam.

The *Spectator* criticism may have been given added zest by Roussel's foreign identity. He was born and educated in France and only settled in Britain after marrying an English woman in 1870. The New English Art Club promoted French styles of painting. The flattened forms and light/dark contrasts of *The Reading Girl* may have been a conscious nod to Edouard Manet's modern masterpiece, *Olympia*, exhibited in Paris in 1863. The unusually relaxed nudity may also have been connected to the familiarity between artist and sitter: Henrietta Pettigrew, a nineteen-year-old professional model and sculptor, was Roussel's lover.

Roussel's career is symptomatic of the decline of the Royal Academy's dominance towards the end of the nineteenth century and the diversification of training, exhibitions and audiences. He had very little conventional training and taught himself by studying Old Masters. For a short

while he was the pupil of James McNeill Whistler. He showed with the Royal Society of British Artists (led by Whistler), the New English Art Club and the International Society of Sculptors, Painters and Gravers. He was a founder member of the Allied Artists' Association in 1908.

Roussel met Whistler in 1885, a year before starting *The Reading Girl*. The older artist encouraged his enthusiasm for Japanese art and design, seen in the model's hairstyle, the kimono draped over the chair and the unusually uncluttered asymmetrical design. Roussel's picture also catches the atmosphere of reverie characteristic of aesthetic movement portraits of beautiful young women by Whistler and others. It reflects aesthetic concerns with the formal beauty of colour and line rather than anecdote or meaning. Although the title refers to 'reading', the pages of the book are blank.

Roussel was exhaustive in researching the style and techniques of other artists and elaborated his colours with a self-devised system that he called 'Positive Chromatic Analysis'. As well as recent French art, the suave contours emulated the cooler nudes of the French academic painter Jean-Auguste-Dominique Ingres. The softly diffuse blues and pinks set off against the dark background recall the style of the seventeenth-century master Johannes Vermeer. The painting exhibits a seventeenth-century type of craquelure unusual in modern painting.

Roussel kept *Reading Girl* in his studio and did not sell it until 1919. In the year following the artist's death, the buyers, Mrs Walter Herriot and Miss R. Herriot, gave the painting to the Tate Gallery in his memory. CJ

William Blake Richmond (London 1842 – London 1921)
Portrait of Mrs Ernest Moon 1888
Oil paint on canvas 127.5 × 102. Acquired 1996

Mrs Ernest Moon was exhibited at the Royal Academy in 1888 alongside three other portraits that were deemed to be among Richmond's best. William Blake Richmond, the son of George Richmond – one of 'The Ancients' (followers of William Blake) – had entered the Academy schools in 1858, at the same time as fellow classical aesthetes Albert Moore and Simeon Solomon. A friend of Edward Burne-Jones and William Morris, he deeply admired the Pre-Raphaelite Brotherhood as well as the art of G. F. Watts and Frederic Leighton. He was drawn to mythological subjects and became an accomplished landscape artist, but it was as a portrait painter that he established his reputation in his early twenties, most notably with *The Sisters* (1864), a portrait of Edith, Lorina and Alice Liddell (private collection). He was at the height of his maturity and recognised as one of the leading portraitists of the aesthetic movement when *Mrs Ernest Moon* was shown at the RA.

Emma Moon was the daughter of the Australian merchant and businessman John de Villiers Lamb. The English barrister Ernest Moon commissioned Richmond to paint her portrait to celebrate their marriage, hence her prominent wedding ring in the picture. The opulent fabrics, together with her idealised translucent features and hieratic pose, can explain why the *Athenaeum*'s critic praised the picture for its Bronzino-like qualities, especially in its original ornate frame. Richmond's trips to Greece in the early and mid-1880s influenced subject paintings such as *Hermes* 1886, but also the present portrait, in the choice of a white Grecian gown,

marble background and classical drapery. The portrait's rich hues and ethereal quality, however, are distinctly aesthetic and, as Simon Reynolds has noted, the sitter's 'large dreamy eyes and coiffured dark hair typify the later Victorian image of female society beauty'. As for the magnificent black and gold coat that Emma Moon embroidered herself, it is decorated with stylised sunflowers, emblematic of the aesthetic movement.

Mrs Ernest Moon remained in private hands until 1996, when it was presented by the Patrons of British Art through the Tate Gallery Foundation. As the sole portrait by William Blake Richmond in the collection, it addressed an important gap. An example of his landscapes and one of his subject paintings, respectively acquired in 1940 and 1995, are also part of the collection.

Although these were the three main genres in which William Blake Richmond worked, he is perhaps chiefly remembered for his mosaics for St Paul's Cathedral, executed between 1891 and 1904. These caused great controversy at the time. Opponents to the decorative scheme argued that it was alien to the English architectural tradition and would deface Wren's masterpiece. In 1913 his passion for classicism also got him publicly embroiled with the critic Roger Fry in the *Nation*, when he defended the art of Lawrence Alma-Tadema against Fry's advocacy of French contemporary art. With the rise of modernism, Richmond was perceived increasingly as a figure from the past, and appreciation of his art waned long before his death in 1921. CCP

John William Waterhouse (Rome 1849 – London 1917)
The Lady of Shalott 1888
Oil paint on canvas 153 × 200. Acquired 1894

Waterhouse was born to painter parents and trained in London at the Royal Academy schools, being elected as a full Member of the Academy in 1895. He often returned to Italy and rose to fame as one of a group of successful painters known as Olympians, who specialised in antique subjects. The most influential of these were Frederic, Lord Leighton, the President of the Academy, and Sir Lawrence Alma-Tadema. Waterhouse cared much less for historical and archaeological accuracy than his peers, however. Instead, he used the distant past to heighten imaginative and poetic mood, making his scenes at once life-like and strange. To this end he also explored the poetic and medieval themes favoured by the Pre-Raphaelites and their followers.

The Lady of Shalott is the first of three paintings that Waterhouse based on the poem of the same name by Alfred, Lord Tennyson published in 1832. His copy of the poet's collected works was covered with drawings of ideas for pictures. The story describes a woman cursed to remain in a tower on an island in a river, which flowed to King Arthur's Camelot. She longed for love but was forbidden from seeing the real world. Instead she wove her tapestries from images in a mirror. Tragedy descended when she was smitten by the reflection of Sir Lancelot riding past and dared to look at him directly. Immediately the curse descended and the mirror cracked. Waterhouse shows the Lady letting go of the boat's mooring to the tower, seen at the margin of the canvas, doomed to die before she reaches the object of her desire:

And at the closing of the day
She loosed the chain, and down she lay;
The broad stream bore her far away,
The Lady of Shalott.

Waterhouse revised his sketches and paintings many times to enhance their emotive effect. He incorporated atmospheric techniques derived from less mainstream styles of aestheticism and French art. The subdued wintery light and agitated square-brushed reeds of *The Lady of Shalott* coincided with Waterhouse's period of plein-air painting in the manner of French realism. A swallow swoops low over the oily dark water. The Lady's red hair is swept back by the wind and three candles, blowing out one by one, add to the sense of a damp, blustery day as well as signalling her death.

The Lady's mouth is open as she sings 'her last song'. Her attitude is ambiguous, suggesting the abandonment of both pleasure and pain alluded to in the erotic language of the poem. Tennyson described her attitude as that of 'some bold seer in a trance' and Waterhouse rendered her expression like the trance of an ecstatic saint, similar to John Everett Millais's famous image of *Ophelia* 1851–2 (p.76).

The Lady's tapestry is strewn across the boat. The references to music and art have led some commentators to equate her to the artist in the modern world. Others have connected her fatal rejection of entrapment to the so-called 'New Woman', struggling for social and economic equality in the later nineteenth century. CJ

George Clausen (London 1852 – Newbury 1944)
Girl at a Gate 1889
Oil paint on canvas 171·5 × 138·5. Acquired 1890

Girl at a Gate received acclaim at the annual exhibition of the Royal Academy and was immediately bought for the nation through the Chantrey Bequest. It also appeared that year at the Grosvenor Gallery, an alternative venue associated with the avant-garde and the aesthetic movement. This draws our attention to Clausen's tendency to synthesise an apparently realist treatment of rural poverty with aesthetic beauty.

Clausen was trained in his Danish father's profession of interior decoration but also took evening classes at the National Art Training School, South Kensington. Subsequent work and study on the continent, notably in the Académie Julian in Paris, ignited an enthusiasm for realist and impressionist styles and especially the painting of rural subjects. In 1886 he and fellow artists founded the New English Art Club to exhibit more avant-garde works in sympathy with realism and impressionism as practised on the continent.

Clausen pioneered ruralism in Britain, an artistic style closely connected to later French realists, such as Jules Bastien-Lepage, whose work they saw exhibited in London as well as on the continent. Their painting privileged what they saw as older more permanent values believed to have survived outside the cities and towns. They were in sympathy with the many conservation movements emerging at the time, the most famous being the National Trust. In 1899 Clausen teamed up with Thomas Hardy, for example, when it was rumoured that Stonehenge might be purchased and shipped to America.

The people and lifestyles of agricultural and fishing communities were thought of as less artificial than those of town dwellers and therefore a more authentic subject matter for art. In 1881 Clausen withdrew to rural Hertfordshire. 'People doing simple things under good conditions of lighting', he wrote, 'and there was always landscape. And nothing was made easy for you: you had to dig out what you wanted.' In 1889 he was living at Grove House in the village of Cookham Dean, Berkshire. *Girl at a Gate* depicts nearby cottages. The figures were posed by local people rather than professional models and wear their everyday dress. The couple were neighbours and the girl, fifteen-year-old Mary Baldwin, looked after Clausen's children.

The rural painting is imbued with metropolitan sensibility. Artists were only able to live in the country because the new railways allowed them to keep in touch with their peers and market in the town. City clients bought country views. The elderliness of the man and woman and the sad expression of the nursemaid give *Girl at a Gate* an air of poetic nostalgia appropriate for an urban audience who had left the country and enjoyed it mainly as a temporary retreat. The motif of a gate suggests departure and the patched buildings add to the sense that the painting is a precious record of a way of life that was already passing.

The poetic quality of *Girl at a Gate* was enhanced by its beautiful palette. The girl's blue tunic is picked up in the sleeve of the man behind, for example, and the asymmetrical scatter of flowers across the slats of the fence add an almost Japanese touch. Most appealing is the bravura brushwork for which Clausen was admired, softening the poverty of the subject with a sumptuousness of paint. CJ

Edward Onslow Ford (London 1852 – London 1901)
The Singer 1889
Bronze, resin, turquoise, garnet 90 × 22 × 43 including base. Acquired 1897

Although born in London, Ford was brought up and trained on the continent, first as a painter and then as a sculptor. This may account for the exquisite surfaces of his statues and his groundbreaking re-introduction of colour. Burnished areas contrast with resin patina to create cloisonné patterns, and red garnets and turquoises have been added to the circlet around the head of *The Singer*. This crossing of boundaries between fine and applied arts was a reaction against the mass production of the modern era. It built on the ideals of the Arts and Crafts movement and of the Art Workers' Guild, co-founded by Ford in 1884.

Ford was an important influence on the so-called 'New Sculpture' in Britain. He experimented with techniques such as lost-wax casting to perfect the statuette, a form of sculpture at once figure and ornamental object. Sir Henry Tate bought *The Singer* from Ford in March 1890 for the then considerable sum of 700 Guineas. It and Leighton's *Sluggard* of 1885 were the only sculptures included in his foundation gift to the Tate Gallery in 1897. However, Ford's early death only four years later led to his eclipse by other sculptors.

The Singer advanced a synthesis of the senses as well as the arts. The sculpture appeals to hearing as well as vision and touch. The girl's mouth is open in a chant while her fingers pull back the strings of the instrument and her bent knee suggests a rhythmic step. The visual arts aspired to the power that music had to stir its audience directly, without the mediation of a narrative or subject. In 1893 Ford made

an accompanying piece, *Applause*, depicting another Egyptian girl clapping along to music and dance.

European culture was substantially enriched in the nineteenth century by archaeological discoveries, especially those of ancient Egypt. The West had developed a myth of the East as an exotic 'other', which was often exploited in art, architecture, music and literature as well as design. The nude girl with her eyes closed as if in a trance expressed Western fantasies of a less inhibited, more authentic pre-industrial society, in touch with the mystical.

Ford studied antiquities in the British Museum and the Louvre and *The Singer* was first displayed on a bronze column with a lotus-flower capital. The present pedestal is decorated with symbols based on Ancient Egyptian hieroglyphs. Recent research has drawn attention to the similarity between stylised two-dimensional kneeling figures on the pedestal of *The Singer* and the three-dimensional figure *Applause*. There is a similar resemblance between two-dimensional figures on the pedestal of *Applause* and the three-dimensional *The Singer*. This combination seems to suggest a sequence from Egyptian representation, considered at the time to be static, to the more dynamic and naturalistic approach of the Greeks to Ford's modern figure, which is presented as an advance on them both. The idea of British art as inheriting and bettering that of the past has been linked to the imperial ambitions of the era. CJ

John Singer Sargent (Florence 1856 – London 1925)
Ellen Terry as Lady Macbeth 1889
Oil paint on canvas 221 × 114.3. Acquired 1906

'Sargent's picture is talked of everywhere and quarrelled about as much as my way of playing the part ... [It] is the sensation of the year', wrote Dame Ellen Terry of her portrait at the New Gallery in the summer of 1889. The *Athaeneum* dismissed it as a 'painting for the pit', but Sargent's bravura brushwork won most over, and there was talk of exhibiting the picture by itself. The *Pall Mall Gazette* wrote: 'It is in Mr. Sargent's methods that artists and art critics will be most interested; but every one alike will be impressed by the effect attained.'

On 29 December 1888 Sargent attended the first performance of *Macbeth* at the Lyceum Theatre with Sir Henry Irving in the leading role. Dazzled by Ellen Terry's magnificent entrance as Lady Macbeth, he persuaded her to sit for him. The American painter had made his name in England with *Carnation, Lily, Lily, Rose* in 1886 (see p.106), but portrait commissions were slow in coming so this picture was therefore quite a coup.

The virtuoso impressionistic treatment of Terry's shimmering dress was most commented on. At Irving's request, beetle wings had been sewn in for greater effect, and Sargent met the challenges of transposing their blue-green iridescence on canvas. Beyond the rendition of her glinting costume, Ellen Terry's over life-size portrait was praised for its powerful characterisation, which dramatised and synthesised the intensity of her acting. Her self-crowning Napoleonic gesture is not in Shakespeare's play, nor was it in Irving's production. Sargent's initiative, however,

exceeded expectations by encapsulating what Terry wanted to convey on stage. Her success as Lady Macbeth, played with unexpected softness, was indeed not immediate, and in this portrait, the 'charming' epithet that always stuck to her was shaken off. The *Birmingham Daily Post* tellingly reported: 'We could almost wish that Miss Ellen Terry's name were [not] associated with this picture, for the artist has given the face a look of ... serpentlike guilefulness in the grey eyes of it, which though proper enough to Lady Macbeth it would be libellous to speak of as Miss Terry's. There is wonderful power and grip in this strange but very powerful and impressive work.'

Henry Irving bought Sargent's portrait for the Beefsteak Room of the Lyceum Theatre, where it hung in an alcove. After the actor's death in 1905, the art dealer and major Tate benefactor Joseph Duveen (the elder) purchased it at Christie's at the auction of Irving's possessions to present it to the gallery. He wrote to Ellen Terry: 'I was as much influenced by the desire of letting the nation possess for ever a portrait of a famous actress, as by a wish to preserve in a National Gallery one of our great painter's masterpieces.'

Sargent went on to become the most successful portrait painter of his generation, but in 1907, he suddenly retired from portraiture to dedicate himself to landscape painting and public commissions. He made a few rare exceptions to make portrait sketches in charcoal, and also reluctantly agreed to paint *General Officers of World War One* 1922 (National Portrait Gallery). CCP

Walter Richard Sickert (Munich 1860 – Bathampton, Somerset 1942)
Minnie Cunningham at the Old Bedford 1892
Oil paint on canvas 76.5 × 63.8. Acquired 1976

This painting was first exhibited at the New English Art Club in 1892 under the title *Miss Minnie Cunningham 'I'm an old hand at love, though I'm young in years'*. Sickert was fond of narrative titles and this one picks up on a tradition of ribald popular song, drawn from the London music halls that he frequented. When living in France in the 1880s, he had been strongly influenced by Degas' theatre scenes, and adapted them to a British context, keeping many of Degas' formal innovations, such as angled perspectives, or partially obscured views of the stage, which captured for the viewer the feeling of being present in the audience.

The music hall was Sickert's main subject between 1887 and 1889 and he returned to it periodically throughout his career. In this period it was still considered a provocative subject because of its association with vulgarity, immorality and drunkenness. This painting depicts Minnie Cunningham who was advertised on contemporary theatre bills as a 'serio-comic and dancer' and 'an outstanding lady variety entertainer'. Sickert first saw her perform at the Tivoli Music Hall on the Strand in the spring of 1892 so it is likely that the music hall depicted is the Tivoli rather than the Old Bedford of the title. Sickert would often draw from life in the music halls and then work up the composition in his studio, but for this painting Minnie Cunningham posed for Sickert in his Chelsea studio, using a little stand so that he could achieve the perspective of looking up at the stage from the stalls.

The work is painted in very flat, thin, liquid washes, a technique that Sickert had learned as Whistler's studio assistant. The profile format of the figure and the shallow picture plane is also derived from Whistler. The composition is dominated by the brilliant reds of Cunningham's hat and dress against which her thin arms and legs appear fragile and contribute to a sense of the vulnerability of the performer: isolated on stage, and spotlit against a sombre stage set. The view is from the stalls with the rail across the stage cutting across her legs, and the conductor's bow just visible in the lower left corner. Despite the appearance of fragility evoked by Sickert's composition, Cunningham's act deliberately played on her youthful appearance to heighten the effect of the sexually provocative double-entendres in her songs. She was thirty-nine when Sickert saw her perform, but she adopted the stage persona and dress of a teenage girl and sang what Marie Lloyd described as 'romping schoolgirl songs' which included the song 'I'm an old hand at love, though I'm young in years' that appeared in the painting's original title.

The painting received a mixed reception when it was first exhibited; critics were divided between criticism of the awkwardness of the figure, which was compared to a wooden doll, and praise for the grace of the performer and the potential of the music hall as an amusingly different subject. The work was in two important collections, those of former director of the National Gallery Sir Augustus Moore Daniel and the tenor Peter Pears before being bought by the Tate Gallery in 1976. EC

Herbert Draper (London 1863 – London 1920)
The Lament for Icarus 1898
Oil paint on canvas 183 × 155·5. Acquired 1898

The Lament for Icarus was one of the great successes of the 1898 Royal Academy summer exhibition and was immediately bought for the nation by the Chantrey Bequest. Two years later it was chosen to represent British art at the international exhibition in Paris where it won the gold medal.

Herbert Draper reflected the increasing internationalism of the modern art world, synthesising French and British classical and symbolist styles. He studied at St John's Wood School of Art and the Royal Academy schools and won a travelling scholarship in 1890, which took him to the continent. He completed his training in Paris at the Académie Julian and in Rome.

This picture shows the dead Icarus surrounded by mourning sea-nymphs. According to Greek mythology, Icarus's father, the inventor Daedalus, made wings so that he and his son might escape from the island of Crete. Despite his father's warning, the exhilarated Icarus soared towards the Sun. Its heat melted the wax that held the feathers in place and he plunged to his death. Draper painted Icarus and the three nymphs from life and studied the wings from those of a bird. The classical appearance of the figures is thus enlivened by the sensual contrast of flesh and feathers.

The Lament for Icarus may have been a response to the deaths of the President of the Royal Academy, Frederic, Lord Leighton in 1896 and Draper's father in 1898. In 1868 Leighton's painting *Daedalus and Icarus* (Faringdon collection, Buscot Park) had presented Icarus at the beginning of the story as a proud youth in the classical tradition of the 'ephebe', referenced in Draper's painting by the classical laurel wreath. In choosing to depict the end of the story, Draper added a more sacrificial element. The pose reminds the viewer of *pietàs*, such as that of Michelangelo, which Draper had seen in St Peter's in Rome.

Icarus's dark skin suggests bronzing from approaching the sun. This fatal attraction chimed with the story of Prometheus, punished for stealing fire from the gods. Both were commonly understood in nineteenth-century art and literature as metaphors for the artist's doomed search for inspiration. Draper underlined this by placing Icarus in the shadows while the sun's last rays catch the cliff behind. Art does nonetheless survive in the 'lament' itself, sung by the nymphs to the accompaniment of a lyre, attribute of the sun god Apollo.

Draper's picture can be set in a broader context of anxieties about the future and the past that characterised the turn of the century. The prostrate boy stood for mankind's thwarted hopes. While Daedalus's inventions have been connected to the technical and scientific advances of the age, Icarus's fate suggests fears for their misuse. At the same time, the boy's naturalistic wings associated him with the animal past of man widely discussed in the aftermath of the publication of Darwin's *Origin of the Species* (1859) and *The Descent of Man* (1871). Water nymphs had similar associations. Feathers, in particular, were thought of differently after Darwin's writings about the role of bird's plumage in 'sexual selection'. A new more ambivalent understanding of beauty as instinct is alluded to in the desiring gazes of the nymphs. CJ

William Rothenstein (Bradford 1872 – Far Oakridge, Gloucestershire 1945)
The Doll's House 1899–1900
Oil paint on canvas 88.9 × 61. Acquired 1917

This work was painted at Vattetot in Normandy, where Rothenstein spent his honeymoon, with his younger brother Albert and his friends Augustus John and William Orpen. In this painting Rothenstein's new wife Alice modelled the woman and Augustus John the man. The setting was the staircase of the cottage that the Rothensteins were renting. The painting's title refers to Henrik Ibsen's 1879 play *A Doll's House*, which charts the breakdown of a marriage. It had its first London performance in 1889, and the controversy surrounding it precipitated a heated discussion about the roles of husband and wife in marriage.

Rothenstein did not specify which scene in the drama is depicted and, although there have been later attempts to identify it, the picture in fact relies on showing a moment of anticipation between dramatic scenes. The tension between the two figures is clear from their poses, but the precise nature of this interaction is not clear. In this it resembles a 'problem picture', then a popular genre, which explored relationships between men and women and their roles in contemporary life through ambiguous scenes that invited multiple interpretations. Rothenstein later wrote in his memoirs: 'we were all mesmerised by Ibsen in those days', and the title would have prompted the viewer to imagine the tortured relationships between men and women portrayed by Ibsen. However, the potential for multiple interpretations of the work was later parodied by Augustus John who described the scene as a moment of indecision where the couple discuss whether to go out and the appropriate clothing for the weather.

Rothenstein's refusal of a specific narrative distances his work from traditions of Victorian narrative painting and their clear resolutions. He had spent four years in Paris where Degas' work had a considerable impact on his development. *The Doll's House* provides a visual equivalent for the brooding intensity of Ibsen's play, and the playwright's use of silence and atmosphere, in the way that it avoids dramatic incident but concentrates instead on its anticipation and the tense emotions that this prompts. The starkly bare and sombre interior focuses attention purely on the figures and their separate mental anguish, emphasising the misunderstanding and lack of communication between men and women at the heart of Ibsen's play.

The Doll's House was exhibited in London in 1899 and then reworked before winning a silver medal at the *International Exhibition* in Paris in 1900 where it was exhibited in the British pavilion. It was bought by the artist's brother Charles who presented it to the Tate Gallery in 1917. In the 1900s Rothenstein continued to explore the combination of figures and interiors, developing a genre that he termed the 'portrait interior'. Drawing on a tradition of French *intimiste* painting, the execution and composition of these works with their tasteful artefacts and cool palette was also influenced by Whistler, and thus served as a statement of Rothenstein's artistic allegiances as much as an exploration of the interiority of the sitters. EC

William Orpen (Oriel, Blackrock, Co. Dublin 1878 – London 1931)
The Mirror 1900
Oil paint on canvas 50.8 × 40.6. Acquired 1913

The Irishman William Orpen was not yet twenty-two when he exhibited *The Mirror* at the 1900 New English Art Club (NEAC) winter exhibition. Considered a prodigy at the Metropolitan School of Art in Dublin, where he had been studying since the age of thirteen, he went on to the Slade from 1897 and became the star pupil of Henry Tonks, Frederick Brown and Philip Wilson Steer. All were leading figures of the avant-garde NEAC, where Orpen first exhibited in 1899. He became a member in 1900, once his student days were over. *The Mirror* was widely acclaimed by art critics that year. The *Pall Mall Gazette* noted: 'Mr. William Orpen shows much more than promise in *The Mirror*, a beautiful piece of painting, keen, yet broad, and curious in quality.'

The small, intimate interior shows a seated young woman in profile, her melancholy eyes shaded by her hat in the bright light that falls on her diagonally. In the small concave mirror above her, Orpen painted his own reflection in his lodgings, at his easel, a woman standing by his side. This points to the artfulness of his art, and to the relationship between artist and model. The seated woman in the painting was a model from the Slade, Emily Scobel, who was briefly engaged to Orpen, but broke it off, judging him 'too ambitious'. In *The Mirror*, Orpen made overt references to works by other masters, as he would throughout his career. The convex mirror, a recurrent element in Orpen's oeuvre, alludes to Jan van Eyck's *Arnolfini Portrait* 1434 (National Gallery), but also to Velázquez's *Las Meninas* 1656 (Prado)

and its reflected self-portrait. The atmosphere of the scene itself recalls seventeenth-century Dutch interiors, whilst the general composition is clearly indebted to Whistler's portraits of his mother (1871, Musée d'Orsay) and of Thomas Carlyle (1872–3, Glasgow Museum and Art Gallery). The painting, however, is not derivative. These quotations combine to form an original image and heighten its contemporaneity.

The Mirror was purchased by George McCulloch, a mining magnate who formed one of the greatest collections of contemporary British paintings between the mid-1890s and 1907, when he died. His widow bought the picture back at the sale of his collection at Christie's, in 1913, to present it to the Tate Gallery. It remains one of Orpen's most famous works, but it was not exhibited widely outside Tate until recently.

In 1917 Orpen was appointed an Official War Artist, but it was as a portrait painter that he made his fame and wealth, with studios in both England and Ireland. The atypical nature of his oeuvre, however, means that he was critically overlooked for several decades after his death, until a large retrospective at the Imperial War Museum, *William Orpen, Politics, Sex and Death*, in 2005. Orpen was also very influential as a teacher at the Metropolitan School of Art in Dublin, moulding a generation of students, such as Patrick Tuohy, Margaret Clarke, Leo Whelan and Seán Keating between 1902 and 1917. CCP

Gwen John (Haverfordwest, Wales 1876 – Dieppe 1939)
Dorelia in a Black Dress c.1903–4
Oil paint on canvas 73 × 48.9. Acquired 1949

Like many of Gwen John's works, this painting was not exhibited for many years after its completion. It was in the collection of Ursula Tyrwhitt, a friend of John's with whom she had studied at the Slade in the 1890s, and was bought by the Duveen Paintings Fund when it was first exhibited at John's acclaimed solo show at the Chenil Galleries in 1926.

John was one of a group of talented female students at the Slade in the 1890s and studied with Whistler at the Académie Carmen in Paris. It was from Whistler that she learnt her early technique of applying thin fluid paint in subtle tones, and a simplicity of subject where the figure was the pretext for an exploration of colour and atmosphere. This portrait was painted in Toulouse during an extended visit that John made to France between 1903 and 1904 with Dorothy McNeill (Dorelia), who had recently become her brother Augustus's model and mistress. John and McNeill set out in the summer of 1903 planning to walk to Rome, but in the end they only got as far as Toulouse, where they spent the winter before heading back to Paris in spring 1904. The work was painted directly onto the canvas without preparatory studies. Unlike Augustus's portraits of McNeill, where she is usually shown posturing in gypsy costume, this portrait is a more subtle exploration of the sitter's interior life, although it also sees her through the artist's preoccupations. Two sides of McNeill's character are simultaneously presented: her direct gaze suggests confidence while the way that her arms encircle her body indicates a more reticent side.

Although McNeill returned to England in 1904, John remained in France, where she was able to establish a professional career and avoid the domestic responsibilities that curtailed the artistic careers of so many of her talented Slade contemporaries. Her paint techniques would change to building up the motif through thick dry touches of paint in her later works, but the subtle variation of tones remained a constant, as did her subject matter of single female figures in interior settings. She regularly exhibited at the New English Art Club exhibitions until 1911, and exhibited at the Paris Salon from 1919, becoming a well-respected member of the Parisian art world in the 1920s, modelling for and developing a close association with Rodin, and meeting Brancusi, Matisse, Braque and Picasso.

John has become an emblematic figure in histories of women artists because of the way that she succeeded in working as an artist on her own terms. Her tenacious exploration of subtle variations of form and tone through repeated renditions of the same motif, executed with painstaking slowness, is often contrasted with her brother's flamboyant style and bravura execution. However, the relationship between the siblings was more mutually supportive than this suggests. Augustus used his high profile to support her ambitions, encouraging her to send work to group shows and introducing her to patrons such as the American collector John Quinn. On the other hand, Gwen's focused work provided an example for Augustus of the possibility of an alternative path in the art world, and he always acknowledged her as the better painter. EC

Augustus John (Tenby, Wales 1878 – Fordingbridge, Hampshire 1961)
Woman Smiling 1908–9
Oil paint on canvas 196 × 98.2. Acquired 1917

John's painting of Dorothy McNeill was made for the International Society's *Exhibition of Fair Women* in 1909. The exhibition showed both old master and contemporary paintings, and John's work combines stylistic references to historic portraiture by Rubens, Hals and Van Dyck with a challenging pose that was explicitly modern. It was a dramatic work intended to establish John's name at the forefront of the art world, in which it emphatically succeeded.

The work was made at the height of John's interest in gypsy culture, an obsession that was expressed both through the study of the Romany language and culture and through playing out a fantasy of a gypsy lifestyle. John contributed articles to the Gypsy Lore Society's journal but his caravanning expeditions with his extended family also formed part of a romantic trend for excursions in gypsy caravans in the Edwardian period. John exploited a perceived synergy between the figures of the artist and the gypsy, as unconventional freedom-loving figures that operated on the margins of society unconstrained by its rules, to imbue his work with the flavour of unconventional creativity and spontaneity.

He also created a gypsy identity for Dorothy McNeill, changing her name to Dorelia, and hiding her origins as the daughter of a mercantile clerk who had worked as a typist before meeting the artist. Instead he invented a false gypsy ancestry for her, and wrote love letters to her in Romany. However, her gypsy image in *Woman Smiling* and other portraits was a creation both of John's projected fantasies and the sitter's own consciously unconventional style; Dorelia is shown wearing a striking dress of her own design.

John also gave her a darker complexion, wild wisps of hair fall from her headscarf, her dress is suggestively unbuttoned at the neck and her inviting smile, gleaming eyes and confrontational pose subvert the usual conventions of Edwardian female portraiture. The portrait instead offers a figure that both communicates a sexual invitation, drawing on common perceptions of the licentiousness of gypsy women in this period, and challenges the viewer to accept it through the contrast between the feminine seductive expression and the masculine assertive nature of the sitter's pose. Reviewers were captivated by the painting, one describing the sitter as a 'gipsy Giaconda'. Its importance was reflected in the fact that, in 1909, it became the first painting purchased by the Contemporary Art Society, being donated to the Tate Gallery in 1917.

Woman Smiling marked John's first major success as a painter. He had previously been better known as a draughtsman, and considered one of the most brilliant students to have studied at the Slade School of Fine Art. Dorelia continued to feature in John's work throughout his career, in both the monumental allegorical tableaux through which he presented an ideal primitive family life, and in more informal portrait studies. Despite being acknowledged as one of the leading figures of contemporary British painting in the 1910s, John's works stood in an awkward relationship to continental modernism, and he was reluctant to align himself with post-impressionism, although one of the critics who had admired *Woman Smiling* was Roger Fry, who only a year later would stage the first exhibition of post-impressionist painting in London. EC

Lawrence Alma-Tadema (Dronrijp, Holland 1836 – Wiesbaden, Germany 1912)
A Favourite Custom 1909
Oil paint on wood 66 × 45.1. Acquired 1909

In 1909 Sir Lawrence Alma-Tadema sent only one small canvas to the annual Royal Academy exhibition. *A Favourite Custom*, a Roman scene, was typical of the work that had made him famous. It was immediately bought for the nation and put on permanent display at the National Gallery of British Art, as Tate then was. It was much more likely, however, to be viewed through a shop window, on a study wall or in an album in the form of a print. By the beginning of the twentieth century the copyright of a painting was often more saleable than the painting itself. Alma-Tadema's work was widely reproduced and circulated. It did not matter if his pictures were small, they could make their impact outside the gallery.

Alma-Tadema's atmospheric hues and alluringly draped and undraped figures had much in common with the decorative style of Aesthetic and Symbolist artists, such as Edward Burne-Jones. Oscar Wilde commended his ability to communicate the coolness of marble and water when Alma-Tadema exhibited with other Aesthetic artists at the Grosvenor Gallery. The greys, mauves and whites of *A Favourite Custom* suit the subject of the frigidarium, the coldest of the Roman baths, and enhance the eroticism of the warm pink bodies.

The success of such historical scenes with a wide public beyond the fashionable bohemian set lay in their apparent historical truth. They satisfied an appetite for knowledge as well as beauty. The realism implied by the painstaking technique was complemented by the display of archaeological accuracy, which flattered the classical learning of educated Victorians. This drew on the artist's extensive archive of antiquities, books and photographs, begun after his honeymoon in Italy in 1863. The setting of *A Favourite Custom* was based on the excavations at Pompeii that had begun after its rediscovery in 1748. The stucco figures and scrolls that decorate the upper wall were copied from the men's apodyterium of the Stabian Baths. The fluted ceiling derived from the caldarium in the Forum.

Alma-Tadema's frigidarium is not a ruin, however, but decked with marble in the manner of modern baths or banks. The rendering of surfaces – wet skin, silken hair, diaphanous fabrics, flowers, silver, glass, mosaic and marble – is startlingly physical. These luxurious materials appealed to a prosperous and consumerist bourgeoisie. The theme of bathing was also up-to-date. Hygiene was an important social and health concern in cities like London. With the industrial revolution and global markets came running water, sanitary ware and the beauty industry. In 1913 Roger Fry likened Alma-Tadema's figures to 'highly-scented soap'.

Alma-Tadema was originally trained in the genre tradition of his native Holland and his pictures are not so much history paintings as historical genre. He is often accused of painting 'Victorians in togas'. The inclusive tone of the title, *A Favourite Custom* invites this reading. The artist himself saw it the opposite way, 'the old Romans were human flesh and blood like ourselves, moved by the same passions and emotions'. Like many during this period, he was looking for a universal humanity. By the time he died in 1915 such criticisms prevailed and his art was superseded by more abstract styles. It had its descendents, however, not in painting, but in the new medium of film. CJ

J. D. Fergusson (Atholl, Perthshire 1874 – Glasgow 1961)
The Blue Beads 1910
Oil paint on board 50.2 × 45.7. Acquired 1964

When the Tate Gallery bought this painting in 1964, the artist's widow, the dancer Margaret Morris, recalled she had not seen it between 1914 and 1960, when it came back from Paris where it had been stored since 1939. 'I have no idea who the sitter was', she wrote; 'I should say a girl he saw in a café & sketched, he did many paintings just from sketches.' J. D. Fergusson was the leading Scottish artist of his generation and spent most of his career in France. Morris's recollection of the work in 1914, at the outbreak of the First World War, and its reappearance amongst a stash of things packed away at the onset of the Second World War, offers a striking insight into the movements of many avant-garde British artists of that time, living and working in what was seen as the artistic capital of Europe until forced back to Britain by war.

Fergusson visited Paris from the late 1890s, when he was in his early twenties, and settled there full-time in 1907 at a moment when the avant-garde artistic scene was dominated by Henri Matisse, André Derain and Maurice de Vlaminck, whose first exhibition in 1905 had gained them the name 'the Fauves'. The increasing impact of their art can be charted through the development of Fergusson's painting during his first few years in Paris from a style indebted to Whistler and Manet to one closer to that of the Fauves in its use of strong colours, bold outlines and interest in exotic fabrics. In Paris he engaged enthusiastically with the fashionable café culture of Montparnasse and, as Morris's memoir suggests, that scene supplied many of the subjects for his art.

Fergusson later remembered, especially, the Café d'Harcourt where for him the chief attraction were the regular female customers who were 'employed as dressmakers and milliners and wore things they were working at, mostly too extreme from a practical point of view, but with that touch of daring'. As well as her exotic clothing, the subject here is typical in its focus on a single accoutrement, the woman's necklace of the title. Her apparently overt sexuality is indicated by her coquettish pose, rich red lips and plunging neckline. The broad handling of different areas of colour and the dark eyes both add to this sense of luscious sexuality as well as echoing the work of Matisse especially.

In the year this work was made, Fergusson's art moved in a new direction. He became increasingly involved in the rhythm movement which asserted the idea of rhythm as the distinctive element of the modern movement in all the arts: painting, literature and music. Dance became a key theme, encouraged by his wife's work as a dancer. Luscious nudes, further detached from observed reality, came to dominate Fergusson's work from 1910 and it was these that secured his reputation in London as a leading modernist when they were shown at the Stafford Galleries in 1912. CS

Eric Gill (Brighton, Sussex 1882 – Hillingdon, Middlesex 1940)
Ecstasy 1910–11
Portland stone 137.2 × 45.7 × 22.8. Acquired 1982

Gill creates a sensual scene in this high-relief stone carving of a copulating couple. The tightly entwined figures grow out of a block of Portland stone designed to be viewed from the front and against a wall. A clue to Gill's original intentions for the work can be found in the small inscription of an eye enclosed in a hand that appears on its right-hand edge. Gill made this mark against a diary entry (11 November 1910) in which he discusses his plans to make an open-air temple near to his home town of Ditchling with his friend the sculptor Jacob Epstein. His vision to build 'a sort of twentieth-century Stonehenge' (as he described it in a letter to William Rothenstein in 1910) was inspired by the artist's interest in Indian temples. It would be dedicated to love and, like the *Ecstasy* relief, would communicate Gill's beliefs in the merger of secular love with spiritual and religious ecstasy. It is one of four stone-relief works from the same period that are thought to relate to this project; another, entitled *Crucifixion* 1910, is also in Tate's collection (N03563).

The title *Ecstasy* was first used when the sculpture was sold at Sotheby's in 1949. Gill had originally referred to it as *They* in his diaries. Such was the explicit nature of its subject that the work was not shown in Gill's first solo exhibition at the Chenil Gallery, London, in 1911. A related carving from the same year, *Votes for Women*, which Gill also first noted with the title *They* and which depicted an equally risqué couple, was only available to view on request. *Ecstasy* remained a private work; it was not exhibited in Gill's lifetime. The work was previously owned by Edward Warren, who had commissioned Rodin's marble embracing couple *The Kiss* in 1904 (Tate N06228). The curator who recommended the purchase of *Ecstasy* for Tate in 1982 suggested that the gallery then lacked 'the erotic side of Gill's work, and does not adequately represent his earliest and most primitive kind of sculpture'.

Gill carved *Ecstasy* over a period of several months. It was one of his earliest adventures in direct carving, a practice that he saw not as one of copying from nature but as the translation of the sculptor's imagined image into stone. Gill did in fact make models for some of his works, and related drawings of couples engaged in sexual intercourse provided an opportunity to try out ideas for this subject. Gill also used life models; in this case his sister and her husband are said to have modelled for the work.

Born in Brighton, Gill studied letter-carving at the Central School of Arts and Crafts, London; his own alphabets and numeral slabs were used by his teacher Edward Johnson for students to copy, and Gill later taught at the school (1906–9). After his conversion to Roman Catholicism in 1913, Gill took up religious subjects more frequently, writing in 1928 that 'all the best art is religious'. Although largely hidden in its time, *Ecstasy* demonstrates how Gill pushed the boundaries of modern sculpture. JP

Vanessa Bell (London 1879 – Firle, Sussex 1961)
Studland Beach c.1912
Oil paint on canvas 76.2 × 101.6. Acquired 1976

This painting spent many years in a private collection, before being bought by the Anthony D'Offay Gallery and exhibited for the first time in their Vanessa Bell retrospective of 1973. It was purchased by Tate in 1976, and subsequently became a key work in demonstrating the impact of French post-impressionist art on British painting in the 1910s.

Much of this impact was filtered through Bell's circle, the group of artists and writers known as the Bloomsbury Group, via the writings of her husband Clive Bell on 'significant form' and through the two exhibitions of post-impressionist art that Roger Fry organised in 1910 and 1912, bringing artists such as Matisse, Picasso and Gauguin to the attention of many British artists for the first time. Bell's *Studland Beach* can be understood as an exploration of 'significant form', which abandoned narrative content for the exploration of purely formal qualities in painting, but it also takes as its subject a location on the south coast of England where Bell and her family holidayed. It therefore combines formal experiment with personal narrative. Bell wrote to Leonard Woolf in 1913: 'if one of the principal aims of an artist is to imitate or to represent facts accurately it is impossible that he should also produce significant form … it can't be the object of a great artist to tell you facts at the cost of telling you what he feels about them.' This suggests that formal simplification for her was also bound up with an emotional response to the subject.

Bell visited Studland beach in Dorset regularly between 1910 and 1912, and made four other works depicting it.

These works become progressively less naturalistic with the Tate work reducing the picture to a few essential components. The simplification of the figures into massive monumental shapes, painted with flat blocks of colour and bounded by strong outline to emphasise their function as pure form echoes the work of Matisse. However, in contrast to the hot palette often adopted by post-impressionist artists, Bell retained a broadly naturalistic colour scheme albeit with intensified colour. The landscape is separated into three bands with no visible horizon, but the sea and sky remain blue and the beach a sandy cream colour, allowing the viewer to approach the work both as a depiction of a moment in time and as a formal experiment. It has been suggested that Bell's radical simplifications through the course of the four works depicting Studland beach represent a distillation of social experience rather than its rejection.

Bell continued to reduce the naturalistic content of her work, experimenting briefly with abstraction and producing a small number of purely abstract paintings in 1914. She also explored abstract pattern and colour in her textile designs for the Omega workshops. After the First World War her work, like that of many artists, reverted to a more naturalistic style, she exhibited with the London Group and the London Artist's Association and transformed her Sussex home Charleston with murals, painted furniture and textiles. EC

Henri Gaudier-Brzeska (St Jean de Braye, France 1891 – Neuville St Vaast, France 1915)
Red Stone Dancer c.1913
Red Mansfield stone, polished and waxed, 43 × 23 × 23. Acquired 1930

Red Stone Dancer takes its name from the material in which it is directly carved – a red fine-grained Mansfield sandstone. A Frenchman who settled in London in January 1911 with his partner Sophie Brzeska (whose name he took), Gaudier-Brzeska produced the work two years before his untimely death during military service in 1915; he was killed in actiom at Neuville St Vaast, France. In the work we see the amalgamation of many of his most important developments as a sculptor: his growing engagement with abstraction based on a knowledge of Parisian modernism and the art of Picasso, fascination with non-Western cultures (particularly Chinese ideographs and calligraphy) encountered in the British Museum, and absorption in the process of direct carving. Gaudier's friend, patron, and biographer, the poet Ezra Pound aptly described *Red Stone Dancer* as being 'almost a thesis of [Gaudier's] ideas upon pure form'. Indeed, gathering externally around this work, were many of the key protagonists and events that steered the artist's professional advancement.

The dancer was first displayed to the London public in Roger Fry's Grafton Group exhibition at the Alpine Club Gallery in January 1914. Out of the group of sculptures that Gaudier showed there, it was his most voluminous, abstract and challenging. *Red Stone Dancer* subsequently reappeared in many pivotal exhibitions of the period including the first vorticist exhibition at the Doré Galleries in June 1915. Gaudier exhibited there alongside Wyndham Lewis, Helen Saunders, William Roberts and others who had all previously signed their names to a vorticist manifesto which appeared in the journal *Blast No.1* in 1914. In his own written contribution to this publication, Gaudier declared that 'Sculptural energy is the mountain. Sculptural feeling is the appreciation of masses in relation. Sculptural ability is the defining of these masses by planes.' *Red Stone Dancer*, rhythmical in its own swirling vortex, the masses of its body being displaced on a figure whose rotation inspires its movement and perhaps also its seduction, took up a central position on a stage that offered audiences an important early encounter with abstract art in 1915.

This sculpture was one of a number of works presented to the Tate Gallery by C. Frank Stoop, whose bequest marked the establishment of the Modern Foreign collection at the Tate Gallery. It is an important indicator of the rapid development of Gaudier's own style, often traceable through his contrasting treatment of the same subjects – whether portraits, wrestlers or dancers. The shift from the more purely figurative elegant body towards a heaviness and interplay of angular forms and masses is revealed by a comparison between Gaudier's *Dancer* 1913 (Tate T03726) and *Red Stone Dancer*. Gaudier's time in London was brief, but his contributions to the collective atmosphere of artistic exchange and avant-garde developments were no less central. His posthumous legacy was secured by Ezra Pound's 1916 memoir of the artist and H.S. Ede's biography, *Savage Messiah*, published in 1931. JP

Jacob Epstein (New York 1880 – London 1959)
Torso in Metal from 'The Rock Drill' 1913–16
Bronze 70.5 × 58.4 × 44.5. Acquired 1960

This bronze torso is a truncated cast taken from a full-length plaster figure that formed part of Epstein's towering sculpture *The Rock Drill* 1913. In its original format, this machine-age torso, part-human, part-robot, sat on top of an actual rock-drill that Epstein bought second-hand. Epstein was powerfully affected by his experiences of war, and later characterised the work as a 'Frankenstein's monster' reflecting the violence that the world had witnessed in the First World War. After the full-scale work had been exhibited at the London Group exhibition in 1915, Epstein discarded the drill, altered the limbs and cut the body down to a head and torso; it is likely to have then been cast in metal. The geometric elements that make up this intimidating figure contrast with the foetus-like shape that is protected within its stomach. As well as an idea of progeny, this evokes a certain vulnerability that is enhanced by the broken torso, without its symbol of masculine strength – the powerful mechanised tool of the drill. Tate's is one of three bronze casts; a fourth in gunmetal was exhibited in 1916. This cast remained in Lady Epstein's collection until the Tate Gallery purchased it for £1,500 in 1960.

Epstein's peers responded positively to the full-scale *Rock Drill*; Gaudier-Brzeska, Ezra Pound and David Bomberg had seen it in his studio and Wyndham Lewis commended it as one of Epstein's best works. Press reactions were, by contrast, largely sceptical reacting primarily to its bizarre aesthetic appearance and Epstein's audacious use of a ready-made object in this monumental 'figure' sculpture. Epstein's own accounts of the 'menacing' work compounded its later negative associations with a war-time world. He said he had discarded the drill because he had lost his interest in machinery. Epstein's initial embrace of the masculine power of machinery is similar to that of the futurists and his interests in energy with the vorticists. These concerns are perhaps better traced through his numerous drawings for the *Rock Drill* (such as Tate T00363), which also reflect its debt to African sculpture.

Born and trained in New York (1894–1902) and then in Paris (1902), Epstein settled in London in 1905. *Rock Drill* is unusual in his output. He secured a reputation through his stone carving, then an avant-garde practice, and made countless portrait busts and torsos in bronze from the mid-1910s onwards. Softer in their modelled malleable surfaces, these works contrast with the hard-edged angular torso from the *Rock Drill*, but like it they hold an intensity that characterises Epstein's sculptural practice. When it was first displayed, this torso towered over its visitors as part of the full-length figure that was further heightened by the stepped triangular plinth on which it stood. The work has been reconstructed for a number of recent exhibitions, but we most often encounter Tate's torso alone, at eye level, and with a new closeness that, while perhaps tempering its ferocity, further enhances its evocative power. JP

David Bomberg (Birmingham 1890 – London 1957)
The Mud Bath 1914
Oil paint on canvas 152.4 × 224.2. Acquired 1964

The Mud Bath was first shown, soon after its completion, in Bomberg's one-man show at the Chenil Gallery in 1914. It was given the most prominent position, hung on railings outside the gallery surrounded by flags, where it was visible to passers-by as well as gallery visitors. Bomberg's show came at a moment when his art was the subject of considerable critical attention following his involvement with the important exhibition *Twentieth Century Art: A Review of Modern Movements* held at the Whitechapel Art Gallery in 1914. Bomberg and the sculptor Jacob Epstein were invited to select a 'Jewish Section' in which Bomberg exhibited five of his own paintings alongside works by fellow artists from the Jewish East End of London, Mark Gertler and Isaac Rosenberg. Bomberg's statements at the time indicated that he saw the 'Jewish Section' as an opportunity to define a modern Jewish school of painting, but art historians have subsequently debated the extent to which this allowed Jewish artists to define a distinctive identity for themselves or merely echoed the marginalisation of Jewish communities within British society. Bomberg's strategy was certainly successful in establishing a connection between Jewish artists and modernism in the public eye, although reviewers' reactions to the 'cubist' works were primarily hostile.

The painting depicts the Russian vapour baths in Whitechapel, used by the Jewish community for socialising and purification, and is perhaps Bomberg's strongest expression of how the representation of modern Jewish urban life might be combined with the search for pure form. His introduction to the catalogue for his solo show described his search for intense expression through the simplification of form. Associated with the vorticists and sharing their vision of machine-age abstraction, he was never a member of the movement although he exhibited with them in 1915.

Bomberg represents the bathing pool as a red rectangle with simplified geometric blue and white figures leaping in and out of it, evoking the colours of the Union Jack. This colour scheme has been read both as the deliberate use of non-naturalistic colour, and as a comment on British jingoism in the prelude to the First World War, but this fragmented British flag is also emblematic of the fragmented identity of the younger generation of Jewish émigré artists in this period with their allegiances to two worlds: the Jewish East End of their families, which provided vital subjects for their art, and the avant-garde artistic circles in which they needed to establish artistic reputations.

Despite the high profile of Bomberg's work in the 1910s, this did not translate into commercial success and many of his early paintings remained unsold, including *The Mud Bath* which stayed in the artist's collection and was not exhibited again until 1960. Tate bought the painting from the artist's widow in 1964. It now seems astonishing that one of the key works of early twentieth-century British modernism should have remained unrecognised for so long. EC

Wyndham Lewis (Novia Scotia 1882 – London 1957)
Workshop c.1914–15
Oil paint on canvas 78.5 × 61. Acquired 1974

The hero of Wyndham Lewis's first published novel *Tarr* (1918) exclaimed that 'all the world's a workshop', and this painting stands as a manifesto for Lewis's movement vorticism through its formal appearance as much as in what is suggested by its title. *Workshop* depicts an abstracted interior of jagged lines and discordant colour and relates closely to a contemporaneous series of drawings and watercolours by Lewis which celebrate the vertiginous skyscrapers that describe the landscape of the dynamic industrialised city – external views that show the result of the activity carried out in the workshop, the building of a new world. Vorticism was first announced to the public in the first issue of the magazine *Blast*, published in 1914, and within its pages Britain was praised as an 'Industrial Island Machine, Pyramidal Workshop'.

Workshop appears controlled and unsentimental, matter of fact in its description of space that is both solid and in flux, expressing contemporary shifts in understanding of the nature of both space and time. Lewis here offers no emotion or sense of a transcendent image; his view of vorticism was self-avowedly anti-Romantic and he set out to confront and describe the external material reality of the new machine age without compromise. Lewis was later to explain his aims with paintings such as *Workshop* as 'more than just picture-making: one was manufacturing fresh eyes for people, and fresh souls to go with the eyes. That was the feeling.'

Vorticism is often described in opposition to the illustrative dynamism of futurism and its romanticised attachment to the machine. In a similar respect cubism is derided for its reliance on the domesticated traditional subject matter of the still-life, what Lewis termed its 'passivity'. For the poet Ezra Pound, who was, alongside Lewis, vorticism's chief theoretician and apologist, 'The vortex is the point of maximum energy. It represents, in mechanics, the greatest efficiency.' *Workshop* is exemplary in that it describes the dynamism of the city without illustrating movement. Its abstraction is not reductive but instead efficiently opens up a space for an allusive multi-layered reading of an image of the discordant nature of contemporary urban life.

Given its status as a manifesto painting for vorticism, *Workshop* had been exhibited in the 1915 vorticist exhibition at the Dore Galleries, London. The following year it was bought by the American collector John Quinn and included in the vorticist exhibition at the Penguin Club in New York in 1917, which had been organised by Quinn and Ezra Pound. Following Quinn's death in 1927, his collection was sold at auction and many of the paintings and drawings by Lewis and fellow vorticists were lost. *Workshop* was bought from a Baltimore antique shop in 1963 by a collector who had initially believed it to be by an American artist. Some years elapsed before it was recognised to be Lewis's lost painting *Workshop* and in 1974 it was purchased by the Tate Gallery to join the only other surviving vorticist oil painting by Lewis, *The Crowd* c.1914–15. AW

Stanley Spencer (Cookham 1891 – Taplow 1959)
Swan Upping at Cookham 1915–19
Oil paint on canvas 148 × 116.2. Acquired 1962

Swan Upping at Cookham was begun in 1915, but Spencer's work on it was interrupted by the First World War and it was not completed until 1919. It was first exhibited at the New English Art Club in 1920 and was bought from the artist by J. L. Behrend, an important patron for Spencer who also commissioned his cycle of war paintings for the Sandham Memorial Chapel in Burghclere, Hampshire.

Swan Upping at Cookham depicts an annual ritual in which young swans on the Thames were marked. The Vintners' and Dyers' Companies held this right by Royal Licence, and the swans are shown being carried ashore for marking in carpenters' bags. The scene takes place in Turks Boatyard next to Cookham Bridge, with the lawn of the Ferry Hotel just visible in the background. It is still possible to identify the sites in Cookham that Spencer painted in this work. However, the scene also embodies Spencer's conviction that religion was always present in everyday activities and settings. The artist recounted how the idea for the painting came to him in church, when he could hear people on the river outside. He explained: 'the village seemed as much a part of the atmosphere prevalent in the church as the most holy part of the church'. This fusion of the everyday and the divine was typical of Spencer's attitude to his Christian faith. One of his influences was early Italian painting by artists such as Giotto, from which he derived his

simplified figures. Works such as *Swan Upping* have the feeling of the small predella paintings of figures engaged in everyday activities relating to the main narrative that accompanied many Renaissance altarpieces.

Spencer began this work by making a small oil study and several drawings from memory before visiting the boatyard to confirm his impressions. He then made the full-scale work away from the location. His customary practice was to paint the canvas systematically from top to bottom, and when he left Cookham in 1915 to join the Royal Army Medical Corps, he had only completed the top two-thirds of the picture, finishing the remainder on his return in 1919. While it is not immediately obvious to the viewer that the two sections of the painting have been finished at different times, Spencer found it difficult to return to painting after his war experiences, and said 'it is not proper or sensible to expect to paint after such experience'. This feeling was shared by many artists across Europe after the First World War and was responsible for a move away from abstraction and turn towards realism in the 1920s and 1930s known as the 'Return to Order'. In this context Spencer's continuing commitment to figuration and his minute observation of figures, objects and landscape shows an artist in dialogue with European realism along with other British figurative artists, such as Edward Burra and William Roberts. EC

Mark Gertler (London 1891 – London 1939)
Merry-Go-Round 1916
Oil paint on canvas 189.2 × 142.2. Acquired 1984

Merry-Go-Round was completed in 1916 but not exhibited until May 1917 when it was shown at the London Group. Gertler's pacifist convictions and those of his Bloomsbury circle are well documented, and Gertler's friends had advised him not to exhibit it publicly. They were concerned that the painting's anti-war sentiments might expose him to criticism especially in view of his Austrian-Jewish ancestry, and the previous defacement of his painting *The Creation of Eve* with a 'Made in Germany' sticker when it was exhibited in 1915. In the event none of the 1917 reviews of the work noted any pacifist agenda, instead accepting the painting at face value as a strident and dynamic modernist representation of a fairground scene. Although the painting was not universally liked, its mechanical figures and vibrant colours were thought appropriate to the playful nature of the subject. It was only exhibited once between 1917 and 1941, but since this date it has been regularly shown and acknowledged both as Gertler's most powerful artistic statement and as an iconic condemnation of the seemingly endless destruction of mechanised warfare.

In September 1915 Gertler's close friend, D. H. Lawrence described a fair for wounded soldiers that was held on Hampstead Heath. He noted the spectacle of soldiers in their bright blue uniforms and red scarves and the rowdy entertainment of the bands and thronging crowds. *Merry-Go-Round* began as a straightforward depiction of the Hampstead Heath fair, but preparatory studies show how its tone shifted as Gertler's realisation of the horror of war strengthened and his anti-war convictions deepened.

It depicts soldiers and their wives and girlfriends seated on a spinning merry-go-round, but rather than depicting a pleasurable diversion from active service, Gertler characterises the figures as mechanical dolls, their mouths open in an unending scream, and uses the relentless spinning of the merry-go-round to suggest the circularity of ongoing militarism which the figures are powerless to end. When he showed it to friends they were struck by its uncompromising power. Lytton Strachey famously said that although he admired the work, liking it would be the equivalent of liking a machine gun.

In a letter to Gertler written in October 1916, Lawrence described *Merry-Go-Round* as a painting that should be bought by the nation. Lawrence's intention in voicing this opinion may have been to ensure that a work that emphasised the psychological impact and cultural disintegration inflicted by war would also have a voice in its commemoration alongside the official works commissioned by the Ministry of Information. However, it took some time for the painting to make its way into a national collection. The work's early ownership is undocumented but it was included in the Leicester Galleries' Gertler memorial exhibition in 1941 and given by them to the Ben Uri Art Gallery in 1945, by whom it was sold to the Tate Gallery in 1984. Since this date the work has been central to Tate's representation of the First World War, often shown alongside Nevinson's *La Mitrailleuse* of the previous year to show the different responses of futurist and Bloomsbury artists to mechanised warfare. EC

Matthew Smith (Halifax, Yorkshire 1879 – London 1959)
Nude, Fitzroy Street, No.1 1916
Oil paint on canvas 86.4 × 76.2. Acquired 1952

This painting, and its companion piece *Nude, Fitzroy Street, No.2*, are perhaps as close as British art ever got to the fauvism of Georges Braque, André Derain and Henri Matisse. Certainly, Matthew Smith's use of bold, non-naturalistic colours and the highly simplified space in which the model sits relates it to those French antecedents. In the years before the First World War, Smith had lived and worked primarily in France and would have had plenty of opportunity to see the work of Parisian avant-garde painters, although he declined to engage socially or professionally with either Matisse or Derain.

This was the period in which Matisse made *Le Danse* and *Music* but Smith's nudes are, perhaps, more akin to the slightly earlier *Blue Nude* 1907 (Baltimore Museum of Art) in which the form of a lusciously sexy odalisque is described by bold brushstrokes of blue. Smith uses a sharp green for the shadows that model the yellow flesh of his nude. Otherwise his treatment of the female sitter's body is more conventional than that of Matisse and Derain. While their work is characterised by dark outlines that contain the figure, his depends entirely on this more traditional modelling through light and shade, albeit using a rich palette of only three primary colours: blue, green and red. The green of the shaded parts of the model's figure is echoed in bands of colour that traverse the red background, their apparent convergence towards the right-hand side of the composition being the only suggestion of the space of the room in which she sits. The use of a red background for an interior was a device used repeatedly by Matisse.

Smith was forced back to London by the First World War. Initially exempted from service as a result of poor eyesight, he was only called up in 1916. In the meantime, a generous bequest on the death of his father had granted him financial security. In an attic studio in London's Fitzroy Street, an area then associated with artists, he made a series of Matissean figure studies, perhaps all of the same sitter. She might have been Emily Powell, a professional model who also sat for Walter Sickert, who worked in a studio on the same street. *Nude, Fitzroy Street, No.1* and *No.2* were the culmination of that series; in them, the figure becomes more anonymous as she turns away with an apparent coyness at odds with the open sexuality of her raised-arm pose. The pose and the side-on view are characteristic of a life-room study.

In summer 1916, around the time of the start of the battle of the Somme, Smith sent both his Fitzroy Street nudes to the London Group exhibition, then in its second year. Despite the group being dominated by Roger Fry, a new acquaintance of Smith's and the great champion of post-impressionism in Britain, both were rejected. This, the first of the two, then remained with the artist for another twenty-five years before being acquired by the dealer Arthur Tooth in 1942 and changing hands several times before it was bought by the Tate Gallery in 1952. CS

Harold Gilman (Road, Somerset 1876 – London, 1919)
Mrs Mounter at the Breakfast Table exh.1917
Oil paint on canvas 61 × 40.6. Acquired 1942

Mrs Mounter was Gilman's housekeeper at 47 Maple Street. As in a larger version of this painting at the Walker Art Gallery, Liverpool, she stares out of the picture, neither questioning nor emotive, her eyes displaying a fierce intensity. An elderly, working class London woman, she is presented as strong and full of character. It is an intimate portrait set in a scene of confinement and feminine domesticity. Yet the lack of perspective and the tightly arranged foreground of the table laid for tea suggests she has joined the artist in his rooms and that we, in turn, are sitting opposite her. The artist's seemingly detached position and bringing together of people from different backgrounds is typical of Gilman's portraits of this period. Social backgrounds and class were pre-occupations for the Camden Town Group of which Gilman was a founding member. Pictures like *Mrs Mounter at the Breakfast Table* signal a new concern among British artists to represent a real way of life untainted by contemporary artistic taste and fashion. As well as distinctive images of individuals, such portraits can also be indicative of social types.

Stimulated by Roger Fry's *Manet and the Post-Impressionists* exhibition at the Grafton Galleries in 1910, Gilman used modernist devices of bright solid patches of colour, thick impasto and clean forms that invest this otherwise mundane subject with meaning, claiming the commonplace worthy of serious contemplation in art. Several details reveal what Gilman learned from a trip with Charles Ginner

to France in 1910: the vibrant orange of Mrs Mounter's scarf echoes the dazzling palette of the Fauves, and the lively patterned wallpaper recalls Henri Matisse's decorative interiors. Gilman always painted female sitters he knew personally, including his mother, sister and wife, and Mrs Mounter appears in five of his paintings. In *Interior with Mrs Mounter* 1916–17 (Ashmolean Museum, Oxford), the sitter's ambiguous stare is perhaps more indicative of the gravitas of the world beyond her workplace, as shocking casualty figures from the First World War were circulated daily.

After 1917 Gilman's work took on a new direction when he was commissioned to paint Halifax harbour by the Canadian Government, for whom he also worked on the War Memorial in Ottawa. His own memorial exhibition held at the Leicester Galleries in London marked the artist's untimely death in the influenza epidemic in 1919. This painting was certainly in the collection of Hugh Blaker by 1928. Thereafter it belonged to his sister Miss Jenny Blaker, from whom it was purchased by the Tate Gallery in 1942. It was first exhibited as *Portrait of Mrs Mounter* at the London Group exhibition of 1917 and in the 1920s and 1930s appeared in several notable exhibitions including *Contemporary British Art* at the Whitechapel Art Gallery in 1928. More recently it was exhibited in Tate Britain's major exhibition *Modern Painters: The Camden Town Group*, the first major survey of the movement for over twenty years, born out of Tate's Camden Town Research Project. HL

Winifred Knights (London 1899 – London 1947)
The Deluge 1920
Oil paint on canvas 152.9 × 183.5. Acquired 1989

Winifred Knights was the first woman to win the Rome Scholarship in Decorative Painting with *The Deluge*. Knights's work, along with that of her fellow competitors, was exhibited at the Grafton Gallery in London in 1920 and again at the Royal Academy in 1921 where the press greeted her victory with the surprised headline 'Girl Artist Remodels Flood'.

'Decorative painting' was a term that described paintings that abandoned naturalism and used colour and composition primarily for aesthetic effect. It was a category that overlapped with mural painting, and the Rome scholarship was established in 1912 to promote monumental public art while also producing artists capable of carrying out large-scale commissions for modern buildings.

Competitors for the Rome Scholarship were given a set subject and had to produce a cartoon and a painting in oil or tempera measuring six by five feet. Studies show how Knights's concept of this work evolved through compositional drawings. Initially Noah and his family and animals were shown walking calmly towards the ark, but in the final picture the ark is seen in the background having already set sail, and the composition focuses on the panic of those who have been left behind to drown. The painting is unified by a strong diagonal trajectory; this dynamic movement and simplification of form has echoes of pre-War abstraction. The painting also draws on the compositional traditions

of quattrocento frescoes. It is built up through defined areas of flat unmodulated colour in a limited palette using flattened perspective and a shallow picture plane to create a frieze-like effect. Knights's focus on the impact of catastrophic events on ordinary people evokes the recent devastation of the First World War. It has been suggested that the sense of panic in the composition may relate to Knights's first-hand experience of the destruction and loss of life caused by the detonation of a TNT plant at Silvertown, East Ham in 1917, which she witnessed from a nearby tramcar. It was the largest explosion on British soil during the First World War.

Knights studied at the British School at Rome between 1920 and 1925. On her return to Britain she continued to work on religious compositions. However, domestic commitments and her perfectionism in precisely planning her pictures through multiple preparatory sketches and slowly and painstakingly transferring these ideas to the canvas limited her artistic output. Only a few finished paintings exist. The Tate Gallery acquired a small *Italian Landscape* by Knights in 1922 when she was still studying in Rome, but *The Deluge* remained in the collection of the British School at Rome until it was sold at auction in 1988, and bought by the Tate Gallery in 1989. Knights has now been recognised as an important figure in the revival of religious painting in the 1920s alongside artists like Stanley Spencer. EC

C. R. W. Nevinson (London 1889 – London 1946)
The Soul of the Soulless City ('New York – an Abstraction') 1920
Oil paint on canvas 91.5 × 60.8. Acquired 1998

New York – an Abstraction depicts a section of an elevated railway track receding into the centre of the painting from which rise the soaring faceted skyscrapers of Manhattan. Despite its sombre colour range from grey to brown, it stands as a hymn of praise and celebration to the industrialised modern city. For Nevinson, as for many of his contemporaries, skyscrapers were 'the most vivid art works of the day', they symbolised a new optimistic age of construction after the destruction of war. It is an 'abstraction', not because of any pictorial simplification of form but because it is an imaginative condensation of a view of New York; the buildings and the view cannot be identified, instead the painting stands as an archetypal image for the success of modernity.

Nevinson's identification of New York as a city of skyscrapers embodying a new modern age is hardly surprising from a man who just before the start of the First World War had allied himself with the futurism of Filippo Marinetti and had together penned *Vital English Art: A Futurist Manifesto*. However, his celebration of the machine shifted with the onset of the First World War. He depicted the soldier without any recourse to heroic posturing, as an alienated and anonymous part of a mechanised dehumanised mass dominated by the machinery of war. This apotheosis of futurism was confirmed by a young officer who is reported to have said that both as an individual or as a group, a soldier getting ready to 'go over the top was as full of angles as he is in a Nevinson war picture'.

In 1919 Nevinson visited New York for the first time for an exhibition of his War prints. The following year he returned for an exhibition of recent paintings and prints, the majority of which had been the result of his visit the previous year. New York offered a fresh subject for Nevinson, who was keen to renew his painting following the War and yet at the same time hold fast to futurist principles. *New York – An Abstraction* was the frontispiece for the exhibition catalogue and as a result was widely reproduced, Adverse criticism directed both at his paintings as well as at his personality and ill-judged remarks about the lack of culture in America led to the failure of this second exhibition and his feelings to change towards New York. In 1922 Nevinson stridently maintained that 'I hate the mob, and most of all our present day Americanised "civilisation"'. He was never to visit America again, although he had a third exhibition in New York in April 1931 that for a second time included *New York – An Abstraction*. Unsold, it was probably as a result of his continued antipathy to New York that, after the painting's second return to his studio, Nevinson changed its title to the more poignant *The Soul of the Soulless City*, reflective of the urban dystopia he now discerned both in the painting and in the city that was its model. AW

William Roberts (London 1895 – London 1980)
The Cinema 1920
Oil paint on canvas 91.4 × 76.2. Acquired 1965

The first showing of *The Cinema* at the Tate Gallery was controversial. Ten years before it entered the collection it was included in the Tate show *Wyndham Lewis and Vorticism* in 1956. Roberts was furious at being presented as a follower of Lewis, and the show became a focus for his discontent at the way that he believed the history of vorticism had been rewritten to emphasise Wyndham Lewis's contribution at the expense of other artists associated with the movement.

Roberts studied alongside David Bomberg at the Slade in the early 1910s, and between 1912 and 1913 both artists' work began to be influenced by cubism, adopting an angular geometric approach to the figure. In 1914 after a short period at Roger Fry's Omega Workshop, Roberts became associated with vorticism, an avant-garde movement that expressed the dynamism of the modern world through machine-like angular forms. He signed the vorticist manifesto, published his work in the polemical journal *Blast* and exhibited with the group at the Doré Gallery in June 1915.

In the 1920s, disillusioned with abstraction, like many artists in the period after the First World War, he began to develop his distinctive simplified tubular figures and characteristic subject matter of ordinary people engaged in everyday urban activities. Roberts's compositions relied on first-hand experience of social situations. He would make observations of behaviour during his daily walks around London, recording them on scraps of paper. He then combined several of these visual notes in a detailed figure drawing which was squared up for transfer into watercolour and finally oil. *The Cinema*, in the past also titled *The Silent Screen,* depicts a small cinema in Warren Street that Roberts used to frequent when he was living nearby in Percy Street. It shows an American cowboy film with a hold-up taking place on screen. The silent film is accompanied by a pianist just visible behind a curtain, but characteristically Roberts is more interested in the responses of the audience. His acute observation of posture and gesture captures the various degrees of rapt attention shown by the audience, with the exception of an embracing couple in the back row who only have eyes for each other and a couple of late-comers who creep down the stairs. The work recalls the interaction between audience and stage in the views of music-hall performances painted by Camden Town Group artists, such as Walter Sickert, but Roberts has adapted the subject for a new era of moving image technology.

Before being purchased for the Tate Gallery in 1965, *The Cinema* belonged to the lawyer Wilfred Evill, whose collection championed twentieth-century British figurative painting by artists such as Roberts, Stanley Spencer and Edward Burra, all artists who were previously thought of as working in isolation with an individual vision. In retrospect, synergies between their work can increasingly be discerned, and taken together they represent the force and vitality of a distinctive brand of figurative realism in British art in the interwar period. EC

Glyn Warren Philpot (London 1884 – London 1937)
Repose on the Flight into Egypt 1922
Oil paint on canvas 74.9 × 116.1. Acquired 2004

This work was exhibited soon after completion at Philpot's critically acclaimed solo show at the Leicester Galleries in 1923. Having made his early reputation as a portraitist, Philpot began making large allegorical figure paintings in 1919 and used the exhibition to introduce the public to a wider range of work including his symbolist paintings and sculpture.

The work depicts the rest of the Holy Family on the flight into Egypt, a traditional subject in European painting to which Philpot brings an unusual interpretation. On the right the Holy Family are seen sleeping, Joseph crouched against a fallen statue and Mary cradling the Christ Child in her arms. However, in the remainder of the composition Philpot has allowed his imagination to run free, incorporating mythological figures including three centaurs, a satyr and a sphinx in a desert landscape littered with fallen Egyptian statuary and architectural fragments. The sleeping Holy Family are oblivious to the pagan creatures and monuments that surround them, and the painting is suffused with a dream-like atmosphere. The satyr, posturing nude and phallic cactus plant in the foreground also allude to pagan myths of unrestrained sexuality, but the implication is that this will be replaced by the new religion of Christianity. This represents perhaps an attempt by the artist to reconcile his adopted Catholicism and his homosexuality.

Philpot made regular visits to Italy in the 1920s to paint and to study the works of the old masters and *Repose on the Flight into Egypt* was painted in Florence on one of these trips. However, the most direct Renaissance influence on

the work is that of Piero di Cosimo's *The Fight between the Lapiths and the Centaurs*, now in the National Gallery, which had been in the collection of Charles Shannon in the 1920s. Philpot met Charles Shannon and Charles Ricketts in 1911 and became close to them after the War. Shannon and Ricketts had been among the major exponents of symbolist painting in England, and their influence on Philpot's imaginative painting was profound.

Elected to the Royal Academy in 1923, Philpot developed a lucrative career as a portrait painter but always continued to make imaginative paintings alongside these commissions. In 1931 he spent a year in Paris and Berlin, and began to respond both to Picasso's work and to *Neue Sachlichkeit* (new objectivity). Philpot's new style was attacked by the critics, leading to a drop in portrait commissions and severe financial problems, which persisted until his premature death in 1937. In these final years he made a powerful series of portraits and sculptures of his afro-Caribbean servant and model Henry Thomas.

Philpot never found a ready market for his imaginative paintings and *Repose on the Flight into Egypt* remained in the collection of the artist's sister and then his niece until the late 1990s. It was purchased by Tate in 2004. Seen alongside works from the 1920s and 1930s by other artists held at Tate, it demonstrates the wide range of work that was considered modern in the interwar period and a shared interest in religious and mythological subject matter across boundaries of stylistic affiliations. EC

Alfred Munnings (Mendham, Suffolk 1878 – Dedham, Essex 1959)
Their Majesties' Return from Ascot 1925
Oil paint on canvas 148 × 244.5. Acquired 1937

Their Majesties' Return from Ascot depicts King George V and Queen Mary, with the future Kings Edward VIII and George VI, returning to Windsor Castle after attending the Ascot races. The party is shown in the landau pulled by four Cleveland Bay horses driving back across Windsor Great Park from Ascot. The subject arose following a request from Queen Mary that Munnings paint the royal procession, and the resulting commissioned painting *The Procession Crossing the Park* encouraged him to paint this much larger painting (ten feet across to the commissioned painting's forty-four inches).

At this moment in his career Munnings had embarked on a lucrative line of business largely derived from painting commissions. Before the First World War his reputation had been built from impressionistic representations of the English countryside and particularly an idealised view of gypsy life. Following his success as an official war artist attached to the Canadian Cavalry Brigade, however, his ability to paint equestrian portraits – both horse and rider – led to a flow of commissions that followed his election as an Associate of the Royal Academy in 1919.

In 1919 the art critic P. G. Konody described Munnings as owing 'nothing to the French *milieu* because in his art he is English to the backbone … Munnings belongs to the race of Morland, and he is imbued with the spirit of the author of *Lavengro* and the creator of Jorrocks'. These qualities where 'his heart is set upon … the unsophisticated enjoyment of unspoilt nature', underscored the tenor of the popularity and success that came to him

after the War but also his distance from current developments in contemporary art. His painting, if derived from an understanding of impressionism, was avowedly traditional in its values and followed the achievements of landscape painters such as Turner, Cotman, Constable and Crome. This lineage defined for many critics an idea of Englishness, and given such a perspective, *Their Majesties' Return from Ascot* marks the apogee of his achievement in expressing both pageantry and tradition set within an idealised evocation of the English landscape.

After *Their Majesties' Return from Ascot* had been exhibited to great acclaim in the 1926 Royal Academy summer exhibition – the year in which Munnings was admitted to full membership of the Royal Academy on Derby Day – the painting remained in the artist's possession until 1937 when the then director of the Tate Gallery, the artist J. B. Manson, saw it at Munnings' home, when he and the chairman of the Tate board, Lord Sandwich were visiting to assess the painting *The Ball on Shipboard* c.1874 by James Tissot (see p.101), which at that time was owned by Munnings. This coincidence led to both paintings being purchased for the Tate Gallery under the terms of the Chantrey Bequest in 1937. According to Munnings's account, following Manson's retirement in 1938 his successor as director John Rothenstein 'has never given the picture a place on the walls. He has his Braques, his Picassos, his Matisses, Klees, Chagalls; but my picture of the King and Queen and the two Princes returning from Ascot has been kept out of sight, year in, year out.' AW

Alfred Wallis (Devonport, Devon 1855 – Madron, Cornwall 1942)
St Ives c.1928
Oil, pencil and crayon on cardboard 25.7 × 38.4. Acquired 1966

Many of Alfred Wallis's works were bought from the artist by a small number of people from 1928 until Wallis's death in 1942. One of those buyers was the painter Ben Nicholson who gave this work to the Tate Gallery in 1966. Wallis took up painting late in life having pursued a career as a seaman and, latterly, as a dealer in marine stores in the Cornish fishing town and artists colony of St Ives. In the summer of 1928, shortly after he had taken up painting, he met Nicholson and Christopher Wood, two leading young artists then exploring the possibilities of a naïve approach to painting. The untutored Wallis was seen as producing an art that was accomplished and yet unsullied by artistic convention, able to claim an authenticity because of its intuitive production free from academic protocols. An inscription on the back of this work in Nicholson's hand-writing indicates that Wallis gave him the work at the time of their first meeting in August 1928.

Wallis's paintings tend to depict the world that he knew, often from memory but also his immediate physical environment. This painting shows various buildings in St Ives, a number of which are readily identifiable. The large white structure that dominates the composition is a house on the corner of Porthmeor Square, visible from the house in which Wallis lived and worked. The building at the top of the composition is unmistakeably the chapel that sits on the crown of The Island, a grassy promontory on the seaward side of St Ives. While two inshore vessels sail past, in the top right-hand corner a larger ship emerges from what must be the port of Hayle, in reality some five miles east of St Ives.

The physical nature of Wallis's work is often unusual and this is the case here. The image is painted on an oddly shaped piece of scrap cardboard, with a hole crudely punched through it towards the top. This is consistent with Nicholson's memoir, in which he recalled the excitement of that first encounter: 'we passed an open door… and through it saw some paintings of ships and houses on odd pieces of paper and cardboard nailed up all over the wall, with particularly large nails through the smallest ones. We knocked on the door and inside found Wallis, and the paintings we got from him then were the first he made.' Wallis used a variety of materials for supports, ranging from bits of packing case or cereal packets to other artists' rejected canvases and household objects, including the kitchen table and wall panelling of his own house. The unusual nature of the paintings and Wallis's own attitude caused them to be treated differently to the work of conventionally established artists. Having been sold in bundles, they were often given away by his collectors, leaving Wallis to die in the poorhouse even as his work entered the esteemed collection of the Museum of Modern Art in New York. CS

Edward Burra (Rye 1905 – Hastings 1976)
The Snack Bar 1930
Oil paint on canvas 76.2 × 55.9. Acquired 1980

An odd tension exists between the barman, the customer and the slicing of the ham in *The Snack Bar*. Violence and an underlying sexual tension seem to be at play. *The Snack Bar* could just as well be an image of 1920s Paris or New York as London's Soho, which is the most likely location as it was one of Burra's favourite places. It was here that he frequented the Continental Snack Bar at the bottom of Shaftesbury Avenue, a well-known haunt for local prostitutes.

In Burra's unidealised images we encounter figures from all aspects of society, but *The Snack Bar* reveals his fascination with the low life of street traders, dancers and prostitutes. Burra emerged as an artist in the 1920s as new cultural forms emerged in Britain. *The Snack Bar* corresponds to a new world of cafés and bars, jazz and cinemas. Here Burra uses oil paint to spectacular effect, creating an exaggerated and luxurious surface playing with the new modes of electric lighting of the unsleeping metropolis. The subject of popular entertainment had been a concern of the impressionists in France and in Britain and was taken up after the First World War by the former vorticist William Roberts, in whose work we find parallels with Burra's sharply defined forms. Whilst suggestive of the new independence of women in the 'roaring twenties', the exaggerated make-up and style of Burra's female character also brings to mind the deviant female sexual stereotypes of prevailing film noir and detective fiction from

the continent. The sexual tension suggested by the woman's appearance and the proprietor's sideways glance is reinforced by the suggestive roll of the ham as he slices it. *The Snack Bar* shows a form of realism unusual in British art of the time, not simply because of its schematised forms and vibrant graphic style, but also because of its camp engagement with a unique aspect of popular culture and racy metropolitan life encountered in advertising and fiction, a subject until then dismissed as irrelevant to art.

The Snack Bar is one of only ten oils by Burra known to have survived and he is believed to have subsequently abandoned the medium altogether. That he chose to paint this subject in oil rather than his preferred medium of watercolour is perhaps indicative of his growing professionalism as an artist, and the public recognition he sought. Burra exhibited with the New English Art Club in 1927 and 1928 and had his first solo exhibition at the Leicester Galleries in April 1929. *The Snack Bar* was almost certainly exhibited at the Leicester Galleries in 1932 under the more directly anecdotal title *Snack*. It remained unsold at the time and was bought by Gerald Corcoran around 1946. During the late 1930s Burra's imagery became darker as the violence of war became his preoccupation. After a period of inactivity after the Second World War he turned to painting landscapes, visiting remote places around Britain where the forces of nature eased postwar tensions of urban decay. HL

Christopher Wood (Knowsley, Merseyside 1901 – Salisbury 1930)
Zebra and Parachute 1930
Oil paint on canvas 91.5 × 60.8. Acquired 2004

Christopher Wood's *Zebra and Parachute* conjures up a dream-like image that brings together the natural, the exotic and the modern in ways that suggest a rupture with Wood's previous manner of painting. Prior to this, he had typically channelled an authenticity of spirit that he had found in the Cornish and Breton fishing communities, which provided a subject for the majority of his paintings between 1926 and 1930. *Zebra and Parachute* shows him turning away from these archetypes, and the example that he had previously followed provided by artists such as Ben and Winifred Nicholson and Alfred Wallis.

The painting celebrates Paris as the pre-eminent modern city as exemplified by the painting's dominant motif: a white modern building of cylinders and diagonals that can be identified as the Villa Savoye designed by Le Corbusier. The villa was built between 1928 and 1931, and though unfinished at the time of this painting it would have been well known. Wood had first moved to Paris from London in 1921 and was well established in the circle around the artist Jean Cocteau and the ballet impresario Serge Diaghilev. If the experience of painting in Cornwall with the Nicholsons had freed him from a fashionable and stylish approach to painting in favour of something more primitive and earthy, *Zebra and Parachute* shows how by using this direct and uncompromising way of painting to picture a different subject Wood succeeded in visualising the mystery of the modern city.

It is a mystery also to be found in the psychic wanderings of surrealism and its love of strange, if emotionally forceful, juxtapositions. The pictorial elements of *Zebra and Parachute* do not rationally belong together; its logic resists explanation. The zebra stands in sunlight but strangely barely casts any shadow, yet despite this a dark diagonal shadow is cast just in front of the animal and over the right-hand portion of the depicted building. In the bright yet cloudy sky a yellow and red parachute descends from which hangs a limp and lifeless stick figure. The play of perspective, shadow and light, the flattened diagonal forms of the architecture and the gently drifting parachute suggest a stillness and mystery that echo not just the haunting atmosphere of Giorgio de Chirico's metaphysical paintings of city arcades as places of reverie and marvellous discovery, but also surrealist evocations of the senses – of weight and weightlessness – as a gateway to the unconscious.

Zebra and Parachute was painted at the same time as *Tiger and Arc de Triomphe* 1930 (The Phillips Collection, Washington DC); where the former pitches the exotic with modernity, the latter brings the exotic against an old world in which nationalism is celebrated. However, for Wood the zebra might serve not just as a sign for an exotic nature distinct from the modern ideals of the Villa Savoye, but also as a means to exoticise modernity, a modern style where the black and white stripes of zebra hide provided the acme of art deco decadence to a chair's upholstery or a building's interior design. AW

Dora Gordine (Latvia 1895 – London 1991)
Javanese Head 1931
Bronze 45.8 × 21 × 27.5. Acquired 1933

Dora Gordine identified herself as a Russian émigré; at the time of her birth Latvia was still part of the Russian empire. She moved to Britain in 1935 and was a prolific sculptor of portrait busts and produced bronze figures mostly of women in balletic poses. In Paris (where she had lived from 1924), she had certainly been inspired by the European figurative sculptural tradition of which Aristide Maillol (whom Gordine met in 1925), and Charles Despiau were a part. This was still a male dominated tradition and Gordine's tenacity should not go unnoticed, nor should her identity as a 'woman artist' define her practice.

In 1930 Gordine said that she was 'enthralled by the East, fascinated by its movement'. In Paris she made a life-size *Javanese Dancer* in 1927–8 before she had visited Java. In January 1930, she travelled to Singapore to begin a five-year trip through Southeast Asia. Early in 1931 she visited Borobudur, Java, where *Javanese Head* was modelled from life. The work closely captures the physiognomy of Gordine's unnamed model with a grace and vitality that is characteristic of many of her portrait busts. The bronze head is finished with a dark green patina and is the first of eight casts of the work made at Gordine's Parisian foundry Valsuani. Municipal commissioners in Singapore bought one of these in 1931, along with five further heads of different races (Malay, Hindu, Chinese, Tamil as they are entitled) and a torso to decorate the council rooms of the City Hall. Gordine's use of generalised titles, suggesting the busts depict racial types rather than individuals, reflects a strong interest during the 1930s in racial stereotypes.

The sculpture was presented to the Tate Gallery in 1933 by Gordine's second husband, the Honourable Richard Hare, who had purchased it from the Leicester Galleries in that year, three years before their marriage. The Leicester Galleries offered Gordine vital support, staging her first solo show in 1928 and numerous exhibitions thereafter. *Javanese Head* is one of four bronze busts in the Tate's collection by this artist, all of which were produced between 1928 and 1931 (the others are *Mongolian Head*, *Guadeloupe Head / Negress* and *Malay Head*). A number of Gordine's contemporaries took inspiration from the British Museum's collection of non-Western objects in this period. Jacob Epstein and others sculpted African models living in London, but none studied the different racial physiognomies from living models like Gordine. In this she was closer to French practice, following in the tradition of Rodin and of Malvina Hoffman. JP

Walter Richard Sickert (Munich 1860 – Bathampton, Somerset 1942)
Miss Gwen Ffrangcon-Davies as Isabella of France 1932
Oil paint on canvas 245.1 × 92.1. Acquired 1932

Having had an early career as an actor, Sickert took the stage as his subject matter throughout his career, but his methods changed substantially between his music-hall subjects of the 1880s and 1900s and his 1930s depictions of theatrical performances. Sickert preferred to work from drawings or photographs rather than directly from his sitters, partly because he believed in economy of means and thought that painting from nature introduced unnecessary detail. He occasionally used photographic sources as early as the 1890s, but by the 1930s this became his primary practice and he began using some of the qualities of photographs to inform the creative process.

Sickert sent the actress Gwen Ffrangcon-Davies a fan letter which led to a meeting in 1932. According to the sitter he selected the photograph from which this painting was derived by looking through her albums of press cuttings. The photograph by Bertram Park depicted a dress rehearsal of the Phoenix Society's 1923 productions of Marlowe's *Edward II*, in which Ffrangcon-Davies played the role of Isabella of France. It was squared up before Sickert translated the image to canvas, leaving these squaring lines visible in the painting. This acknowledgement of the image source was deliberate and Sickert also retained the photographer's studio stamp in the lower right corner. He added the inscription '*La Louve*' referring to the nickname of Isabella of France who was known as 'the she-wolf' because of her fierce character.

Sickert was attracted to photography because of its immediacy in seizing the moment and concentrating the subject by cutting out detail. He relished the way that arbitrary cropping and variable viewpoints had the potential to create interesting compositions, and was also fascinated by the way that flattened perspective and stark tonal contrasts resulted in almost abstract effects. Sickert's photographically based paintings do not simply transcribe a source but also explore the difference between the media of photography and painting. His transfer of image to canvas emphasises the way that photography depends on a translation process by the viewer to read almost abstract shapes as objects. Sickert's refusal to make these areas legible in illusionistic painting terms draws attention to the very different types of vision required by the two media. The combination of this literal transcription with the expectations of painterly touch undermines the connection between subject and painting, despite the apparent immediacy of the source.

The painting was exhibited at the Wilson Galleries in 1932 and was a critical success, described by the *Daily Mail* as 'Mr Sickert's Best Work'. It was purchased from the exhibition by the Contemporary Art Society and presented to the Tate Gallery. Subsequently Sickert's late work fell out of critical favour and his use of photography was considered to mark a decline in his powers of imagination and execution. But it is now recognised as a significant precursor to subsequent developments such as pop art's transmutation of found popular images. EC

LA LOUVE

Meredith Frampton (London 1894 – Mere, Wiltshire 1984)
Portrait of a Young Woman 1935
Oil paint on canvas 205.7 × 107.9. Acquired 1935

This painting was first exhibited at the Royal Academy in 1935, where Frampton exhibited annually between 1925 and 1945. It was purchased from the Royal Academy exhibition by the Chantrey Bequest and presented to the Tate Gallery. The Chantrey Bequest had been set up in 1840 to purchase work by British artists for the national collection and had frequently been criticised in the early twentieth century for buying dull traditional paintings by Royal Academicians when more progressive work was being exhibited elsewhere in London. The presentation of Frampton's portrait might be seen as one further instance of this. However, despite its debt to historical traditions of academic full-length portraiture, the painting also has clear links to more contemporary developments in Europe such as the realism of the German *Neue Sachlichkeit* (new objectivity) movement of the 1920s.

Frampton's painting technique is characterised by smooth surfaces with no visible brushstrokes. He deliberately retreated from the expressive facture of movements such as impressionism and expressionism where the hand of the artist was paramount. Instead he admired artists such as Holbein and Ingres, considering that in their works the viewer was more conscious of the subject than of the hand of the artist in representing it. However, despite this admiration for historic portraiture his almost photographic realism now appears distinctively modern in its detachment, austerity and sense of stasis.

Portrait of a Young Woman is unusual in Frampton's oeuvre in not being commissioned. Although we now know that the sitter was Margaret Austin-Jones, Frampton declined to name her. Instead he described the painting as a relaxation from commissioned portraits, and a celebration of objects beautiful in their own right. The sitter becomes one more formal element in a still life in which Frampton explores the different curving forms of the vase, the cello, the scroll of paper unfurling over the edge of the table, the hem of the model's dress and the curls of her hair. Many of the objects and costumes that appear in his portraits were specially made for the artist rather than belonging to the sitter. Here, the dress worn by the model was made by Frampton's mother and the mahogany vase was designed by the artist. At first glance the model might seem to be made from the same hard, smooth materials as the objects that surround her, but Frampton carefully observes the way that the flesh of her right arm yields to the gentle pressure of her fingers, creating a tension of opposing forces at the heart of the picture.

The son of Royal Academician George Frampton, Frampton was a successful society portraitist counting George VI among his sitters, but his reputation declined after he retired in 1953. In the 1980s a renewed interest in realism, exemplified by the Pompidou Centre exhibition *Les Realismes* of 1981, and a Tate retrospective of Frampton's work in 1982 made his brand of detached observation seem relevant to a new generation. EC

Paul Nash (London 1889 – Boscombe, Hampshire 1946)
Equivalents for the Megaliths 1935
Oil paint on canvas 45.7 × 66. Acquired 1970

Paul Nash is one of Britain's most influential modern painters, who sought to define a native English quality in art based on a revival of nature. In his statement for Unit One, the avant-garde group he co-founded in 1933, he defined the underlying spirit of English painting as a lyrical and symbolic expression rooted in the land as demonstrated by William Blake and J.M.W. Turner. Drawing parallels between modernity and the ancient world, Nash sought to find new symbols to express our reaction to the environment.

In a letter to the director of the Tate Gallery in 1951, the artist's widow wrote that this painting had 'a beautiful design, and is in my opinion, the most important of the Megalith series of paintings.' As such, it represents a key moment in Nash's career when he was beginning to revert to landscape for the first time since the late 1920s. It was painted shortly after Nash first visited the ancient stones at Avebury on the Wiltshire Downs. In a field a few miles from Marlborough, Nash encountered the impressive stones, patterned with lichen and the circle of weathering, remnants of a forgotten culture. Setting out to solve the equation of ancient mysticism and modernity, Nash's mysterious forms appear isolated, at odds with the surrounding fields. This is not a romantic or picturesque view but a bringing together of associations and memories. It is a distinctly English landscape, reconfigured and represented as a complex psychological experience.

The style and subject of this painting lies at the heart of the debates and ideas about modernism and representation in which Nash played an active role. It brings together three areas of relevance rarely encountered together in his work: a concern for geometric structure and design evident in the cylindrical masses, lines and planes of the megaliths; their irrational suggestion of a dreamlike super reality; and as remnants of an unknown civilisation tied to the English downland. This reconciliation of abstract form, surrealism and ancient history was briefly expressed in Nash's work; these formal and ideological principles are reaffirmed in other works such as *Landscape at Iden* 1929 and *Landscape from a Dream* 1936–8 also in the Tate's collection (N05047, N05667).

Equivalents for the Megaliths was bought directly from the artist by Lance Sieveking for £65 and sold at auction in 1970 when it was acquired for the Tate Gallery. It was exhibited in the British Pavilion at the Venice Biennale in 1938, the first to be organised by the British Council. Nash exhibited regularly at London's Mayor Gallery, where his work was often shown alongside modern European artists including Braque, Leger and the surrealists Dalí, Miró and Ernst. While British art was growing in international status, by the end of the 1930s its factions divided into 'abstract' and 'surreal' and when Nash exhibited at the *Living Art in England* exhibition in 1939 he did so as an independent. HL

Ben Nicholson (Denham, Buckinghamshire 1894 – London 1982)
1935 (white relief) 1935
Oil paint on carved panel 101.6 × 166.4. Acquired 1955

Ben Nicholson made his first relief in December 1933 and his first totally white relief the following year. The carving into his support had developed from the use of incised lines and textures in a manner comparable to that of Pablo Picasso and Georges Braque. Nicholson made a significant number of white reliefs between 1934 and the outbreak of war in September 1939 and this work is one of the largest.

The relief was carved out of the leaf of an extendable mahogany dining table. This is borne out by dowels that have been cut off the edge of the board. Looking back, the artist observed that 'This relief contains one circle drawn by hand and one by compass and therefore represents the transition between the more freely drawn and the more "mathematical" relief.' In fact there seems to be a striking emphasis on the man-made quality of the relief. The surface is extensively pitted, sometimes quite strikingly so. Nicholson would apply a number of coats of paint to such a work, suggesting that the chisel marks in the timber must have been fairly deep still to be readily visible after successive paint layers. An inscription on the back records that Nicholson's 'final coat' was of 'flat Ripolin', a French household paint. Close examination reveals that at least one of the underlying layers of paint is in fact not white but grey. The Tate Gallery bought the relief from the artist in 1955 by which time Nicholson was a leading international artist and his avant-garde work of the 1930s recognised as being

of seminal importance. It was perhaps in preparation for this sale that it was repainted that same year.

The relief dates from that period when Nicholson was the leading figure in Britain of the international modern movement of artists and architects including Barbara Hepworth, Piet Mondrian, Lázló Moholy-Nagy, Hans Arp and Alexander Calder. This group championed a purely non-representational art often based on ideals that existed beyond any simple physical reality: international cooperation, especially in the face of fascism, and the integration of art, architecture and design as part of a better future. Nicholson's white reliefs were seen to embody much of this utopian spirit. While they have frequently been seen as cold and mechanical in their austerity, the emphasis on their hand-made qualities invests them with a more human dimension. This was clearly an aspect of the work that Nicholson was keen to promote as, in the 1930s, he tended to have such reliefs photographed with a side-on light source that highlighted the texture and pits of their surfaces. Though seen by many as distant from human experience – Sir Kenneth Clark accused them of 'spiritual beri-beri' – Nicholson related his reliefs to a memory that 'listening to a lot of art-talk' made his mother 'want to go & scrub the kitchen table'. It is an association, though made some years after Nicholson created the work, that resonates especially well with this relief. CS

Eileen Agar (Buenos Aires, Argentina 1899 – London 1991)
Angel of Anarchy 1936–40
Fabric over plaster and fabric, shells, beads, diamante stones and other materials 52 × 31.7 × 33.6.
Acquired 1983

Angel of Anarchy is one of Eileen Agar's most important and innovative works in which the fantastical spirit of surrealism is powerfully expressed. This threatening head was originally made in clay at the artist's Earl's Court studio as a portrait of the Hungarian poet Joseph Bard, the artist's future husband. She cast it in plaster and had two copies made, one of which she left unpainted except on the lips and covered with whatever came to hand – coloured paper and paper doilies, green feathers and black Astrakhan fur. This *Angel of Anarchy* was Agar's first sculpture and she attributed its title to the critic Herbert Read, who in Britain was becoming known as the 'benign anarchist' of surrealism.

Angel of Anarchy was first shown to critical acclaim in the London Gallery's exhibition *Surrealist Objects and Poems* in 1937 where it was reproduced on the cover of its catalogue. Later that year it travelled to the *International Surrealist Exhibition* in Amsterdam, where it was lost. As a result, Agar created this second version in 1940, her inclusion of a blindfold symbolic of the descent from a tense political situation to total war. This time, wanting to make it more flamboyant, she incorporated more decorative materials including Japanese silk, feathers, fur and a headdress of African beads all sourced from antiques shops and her mother's wardrobe. Stored in a hatbox during the Second World War, it was forgotten until the early 1960s, when the Museum of Modern Art in New York enquired about it in relation to their

exhibition *The Art of Assemblage*. After its revival and many subsequent appearances on the continent, *Angel of Anarchy* came to represent not only a defining moment of the British surrealist group celebrated for its stand against fascism but also an important example of the surrealist object in twentieth-century art. Agar's 1971 retrospective in London cemented her status as Britain's leading female surrealist. This work was also shown in the exhibition *Milestones in Modern British Sculpture* in Sheffield shortly before the Tate Gallery bought it from the artist.

In her memoirs Eileen Agar revealed her surprise when eight of her works were selected for London's *International Surrealist Exhibition*, held at the New Burlington Gallery in 1936. Up until that moment, surrealism had barely touched Britain, and the language of Agar's collages and paintings such as *The Autobiography of an Embryo* 1933 (Tate T05024) defied easy categorisation. Despite having absorbed the work of Picasso, Miró and Ernst in Paris, Agar had claimed no formal ideological affiliations to the surrealist movement. Fusing fantastical imagery sourced from nature, cubism and the classical world, Agar's vibrant paintings and collages were occupied with universal themes of life and death, the passing of time and seasonal cycles. However, as her interest in the poetic and lyrical aspects of surrealism deepened, Agar came to believe it was in the feminine psyche that the movement's true essence could be found. HL

Ithell Colquhoun (Shillong, Assam 1906 – Lamorna, Cornwall 1988)
Scylla 1938
Oil paint on board 91.4 × 61. Acquired 1977

In 1977, when her work entered the Tate's collection for the first time, Ithell Colquhoun described *Scylla* as having been suggested by what she could see of herself in a bath. The two vertical rocks emerging out of the water become the artist's thighs with seaweed forming her pubic hair. *Scylla* was first exhibited at the London Gallery in 1939 where it appeared as part of a series of seven works titled *Méditerranée*. Colquhoun attributed the genesis of this series to her interest in Salvador Dalí and his concept of the 'double image', which can be traced through the increasingly anthropomorphic qualities of her paintings. After a period painting exotic plants, the subject of immersion in water seems to have offered Colquhoun a new point of departure for an exploration of the unconscious in her art.

During this period seascapes became frequent subjects for surrealist artists. Coastlines, the sea and rocks found particular forms of magical and comic expression in the art of Colquhoun's contemporaries Eileen Agar and Lee Miller. Like much of their work, *Scylla* has a powerful sexual symbolism, eschewing gender boundaries in its multiplicity of male and female forms. While the passage of the canoe between the rocks suggests the penetration of the vagina, the fleshy forms of the rocks recall male genitalia. The title derives from Greek mythology in which sailors had to sail between two monsters: the man-eating Scylla, which lived perched on top of a pair of 'clashing rocks', and the whirlpool Charybdis. While the idiom 'between

Scylla and Charybdis' symbolises the choosing between two dangers, here the theme seems also to suggest a threatening female sexuality.

Having grown up in England and India where she first became interested in alchemy and the Kabbalah, Colquhoun studied at the Slade in 1927–31. She first became aware of surrealism while living in Paris in the early 1930s. Impressed by London's *International Surrealist Exhibition* in 1936, Colquhoun went on to play an important role in the movement in Britain by contributing to its periodical the *London Bulletin*, but she did not officially join the group until 1939. That year she took part in an exhibition with Roland Penrose as well as in the exhibition *Living Art in England*. Soon after Colquhoun met André Breton in Paris where she developed automatic painting, a technique of painting spontaneously in an attempt to tap into the unconscious, which characterised her work for the next twenty-five years.

Colquhoun's association with surrealism was short-lived and she was excluded from the group because of her membership of occult societies. She moved to Cornwall in the late 1940s where she combined her pursuit of the occult and the automatic. The beginning of a revived interest in British surrealism that was marked by the important group exhibition *Dada and Surrealism Reviewed* at the Hayward Gallery in 1978 had, perhaps, been anticipated by Colquhoun's 1976 retrospective at the Newlyn Galleries from which this work was bought by the Tate Gallery. HL

Barbara Hepworth (Wakefield, Yorkshire 1903 – St Ives, Cornwall 1975)
Forms in Echelon 1938
Tulip wood on an elm base 108 × 60 × 71. Acquired 1964

At the heart of Barbara Hepworth's art is the idea that pure sculptural forms and their harmonious disposition in relation to each other both embody an aesthetic ideal and symbolise a broader idea of perfection, purity and of harmonious social interaction and cooperation. In light of this, it may be significant that early photographs of this sculpture show the two elements arranged on a plinth without the elm-wood base, which it seems to have acquired in the 1960s, suggesting that the spatial relationship between the two elements was changeable. It was first shown in an important exhibition of pure abstract art, *Abstract and Concrete*, at Peggy Guggenheim's London gallery, Guggenheim Jeune, in April 1939. At that time, it was shown as *Two Forms (Tulip Wood)*, gaining its current title in 1943 by which time the military term 'in echelon', meaning arranged in stepped parallel lines, might have taken on a particular resonance. The artist clearly saw the work as significant as she included it in all her major exhibitions as well as electing to donate it to the Tate Gallery in 1964.

Each of the sculpture's two forms rises from a narrow base, broadening into a thin form with one flat plane and one slightly curved. This is a formal motif that she would revisit at the end of the 1950s, reusing it in several sculptures, most notably the monumental monolith commissioned for the United Nations headquarters in New York, *Single Form*, 1961–4. Here, the flat plane of each form faces the other, the space between creating a sense of tension.

Such a relationship between two forms was a recurring motif in Hepworth's art, beginning with the subject of the mother and child in the early 1930s and extending to works of the postwar period, which appear to concern themselves with the relationship between two figures. From 1935, Hepworth made sculptures based on pure, non-referential forms; some of these were single monoliths while others consisted of several forms arrayed upon a base so that the spaces between them became active parts of the sculpture. *Forms in Echelon* seems to reside somewhere between those two themes.

In her 1970 autobiography, Hepworth recalled the years 1938 and 1939 as a period when she was 'obsessed by ideas for large works'. Though she had made at that time three large outdoor pieces, this work was amongst the larger of her tabletop sculptures. That she imagined it on a larger scale is indicated in the ways that she had it depicted. When it was first reproduced, it was shown superimposed onto a photograph of a garden alongside a text in which the artist asserted her belief that 'all good sculpture was, and still is, designed for the open air'. She returned to a similar idea in a film about her work made by Dudley Shaw Ashton in 1951 when she had *Forms in Echelon* filmed beside the Neolithic stones of the Men-an-Tol on the moors of west Cornwall. This association of formal rigour and associations with landscape and the longest sculptural traditions was a theme that ran through Hepworth's art from the 1930s until her death in 1975. CS

Graham Sutherland (London 1903 – London 1980)
Green Tree Form: Interior of Woods 1940
Oil paint on canvas 78.7 × 107.9. Acquired 1940

Graham Sutherland was principally a landscape painter until the later 1930s when his fascination with the shoreline and estuaries of south-west Wales fused with a growing engagement with Parisian modernism. At that time, he made a series of works based on such natural forms as fallen branches, tree stumps and exposed roots – the forms of which brought to mind the human body. Often suggestive and with erotic undertones, these forms took on a darker significance against the backdrop of their time, as Europe descended into war. Sutherland, at that time of crisis, became a leading figure in British painting and it is telling that this work was bought by the Tate Gallery shortly after its completion despite the outbreak of war. Consequently it was included in several exhibitions, which travelled to numerous venues in Britain and Europe during the 1940s.

This was the last of a series of works inspired by a fallen tree lying across a grassy bank. It is typical of the artist's image-making that the central motif has been divorced from its original context and then, in his terms, paraphrased so as to become suggestive of other forms. By removing his objects from nature, Sutherland believed he had achieved a 'heightened form of realism', reaching for the essence of the object distinct from superficial reality. Sutherland's idea that individual natural objects could embody or reflect larger natural phenomena echoed the romanticism of William Blake. At the time when this work was made, however, his use of ideas of metamorphosis was seen by some to reveal his debt to leading modernists like Picasso, Miró and the surrealists. Sutherland himself acknowledged that he

had learnt most from examining the numerous small studies for Picasso's *Guernica*, all of which had been exhibited in London in 1938. Sutherland used the term 'paraphrase' to characterise the way he adapted and distorted a found form in order to invest it with a greater degree of ambiguity and suggestiveness, and acknowledged that he was greatly encouraged in that activity by Picasso's work.

As much as Picasso's distorted human and animal figures, Sutherland's anthropomorphised branches also suggest the broken bodies of Hans Bellmer's *Poupées*: haunting, broken dolls that Bellmer photographed. That the original subject of Sutherland's painting had similarly been extended into something more generalised and suggestive is, perhaps, indicated by the title *Green Tree Form*. The subtitle of this work conjures up, perhaps, the somewhat eerie half light under a dense woodland canopy. Sutherland certainly had a record of adapting the traditional motif of a *sous-bois* woodland view. Consciously or not, the location of the tree/figure in the translucent green that dominates this painting brings to mind Dylan Thomas's 'The Force That Through the Green Fuse Drives the Flower'. Published in 1933, the poem, which uses such imagery as blasted tree roots, identifies the underlying force of nature as the same as that drives human activity. While the connection with Thomas may be unconscious, both painting and poem are typical of the neo-romantic culture that dominated British art and letters in the later 1930s and 1940s and which used nature and natural objects as vehicles of expression for human experience and concerns. CS

Naum Gabo (Russia 1890 – Connecticut 1977)
Spiral Theme 1941
Cellulose acetate and Perspex 14 × 24 × 24. Acquired 1958

Viewing the interlocking transparent elements of *Spiral Theme* in the round brings it to life. It is composed of plastic sheets cut and manipulated into a complex composition of curving planes with a spiral at its heart. Gabo made this sculpture while living near St Ives. It is small in scale and he had previously made hand-sized jewel-like models in the same material. It was Gabo's practice to make numerous versions, of different sizes, of a single idea, as was the case with *Spiral Theme*. He assured the work's first owner, Miss Madge Pulsford, that the object was not a maquette – but although he had intended to make another related piece on a large scale, that never came into being. Gabo did, however, subsequently make an almost identical work for MoMA in 1947. He began to make constructions during the First World War in Norway, first using card and paper, then metals, wood and plastics. His sculptures are built constructions – often plastic sheets joined or strung together, layers that twist and spiral, each one unique. In his works, Gabo explores time, space and perception.

In his review of the *New Movements in Art. Contemporary Work in England* exhibition, at the London Museum in 1942, Herbert Read acclaimed *Spiral Theme* as 'the highest point ever reached by the aesthetic intuition of man'. This response must have arisen partly from the unique appearance of Gabo's work, modern in its geometric abstraction and in its materials. Although even Gabo was later uncertain,

it was almost certainly Tate's version of *Spiral Theme* that was exhibited. Pulsford bought *Spiral Theme* shortly after the War and donated it to the Tate Gallery in 1958. When Gabo wrote to her in 1946 telling her that he hoped 'that it [living with the sculptures] will please you regardless of the passing of time', he could not have known that the cellulose acetate plastic that he had often used would prove an unstable material. Subsequently the Tate Gallery acquired an extensive collection of Gabo's work and his archive, which includes numerous sketches, models and maquettes from the artist.

Born in Russia and initially trained in the sciences in Germany, Gabo was one of the pioneers of constructivism in sculpture. He believed that art should reflect the forces and energies of modernity and he embraced developments in the sciences and engineering. He first published these ideas in his *Realistic Manifesto* (1920) whilst he was in Moscow. He subsequently travelled to Berlin in 1922, Paris in 1933 and then to England in 1936. He lived in London, where he met many artists including Barbara Hepworth and Henry Moore, and then Cornwall. He shared with Moore and Hepworth an interest in the use of strings in sculpture, and set out his understanding of the 'Constructive Idea' in the publication *Circle*, which he co-edited with Ben Nicholson and the architect Leslie Martin (1937). Constructivism for Gabo went further than abstraction: it was 'a mode of thinking, acting, perceiving and living'. JP

Francis Bacon (Dublin 1909 – Madrid 1992)
Three Studies for Figures at the Base of a Crucifixion c.1944
Oil paint on board, each panel 94 × 73.7. Acquired 1953

Francis Bacon's *Three Studies for Figures at the Base of a Crucifixion* marked a seminal moment in British art and beyond. The triptych was first shown in London in April 1945, at the Lefevre Gallery, just at the moment that the horrors of the Nazi concentration camps were revealed to the world. A landmark in modern painting, its meaning was secured by that coincidence though it attracted only limited comment at the time. Raymond Mortimer anticipated future assessment of the triptych when he saw in it an expression of Bacon's 'sense of the atrocious world into which we have survived'.

An inscription on the back of the right-hand panel suggests that it might have been made during the artist's time in the village of Steep, near Petersfield, in Hampshire during 1942 and early 1943. The triptych is painted on poor-quality soft boards and it is evident that their corners were somewhat battered when the artist started work. At least one had been used previously as x-ray photography reveals what appears to be a portrait of a bald-headed man who could be Bacon's lover Eric Hall or the Italian dictator Benito Mussolini, or another. Hall recognised the work's significance, bought it from the exhibition and a few years later donated it to the Tate Gallery. It has since maintained a position as one of the gallery's most celebrated works.

The title of the work associates the three humanoid creatures with those who gather at the foot of the cross in a traditional Crucifixion, though here the use of the indefinite article suggests Bacon's concern with a more generalised suffering. Later he said he had intended to add a crucifixion but never got around to it. There was a wider engagement with the theme of the Crucifixion in postwar British art and the revival of this depiction of ritualised suffering and human cruelty had particular resonance after the suffering of the War and the revelation of the Holocaust.

Though Bacon liked to think of the triptych as his first mature work, it actually belonged to a larger group of paintings made by the artist in the 1940s, all of which were based on photographs of the Nazi leadership. A number of the source photographs appeared in publications like *Picture Post*, but Bacon could have gathered others on visits to Germany during the 1930s. In particular, a sibling to the monstrous, serpentine-necked creature in the central panel appeared in *Man Getting Out of a Car* where it took the place of Adolf Hitler, the entire composition being based on a Hans Hoffmann photograph of the Führer taking the salute at a Nazi rally. The three panels share certain technical characteristics with other works, being painted on the same poor-quality boards using similar materials and techniques. These include a variation on the right-hand panel of the triptych, the creature now plunging its head into a bunch of flowers. Later the artist noted that flowers embodied the transience of life. While, subsequently, Bacon occasionally returned to his obsession with the Nazis, all of his work remained preoccupied with mortality in a more generalised sense. CS

Evelyn Dunbar (Reading, Berkshire 1906 – Ashford, Kent 1960)
A Land Girl and the Bail Bull 1945
Oil paint on canvas 91.4 × 182.9. Acquired 1946

This appears to be a painting of optimism; it was commissioned by the state and made at the end of the Second World War. The land girl, given heroic status by her position in the near foreground, seems to gaze into the distance where the sun is rising. The dawn reveals the snakeskin pattern of cirrocumulus clouds, an indication of improving weather.

The painting originated from Dunbar's work for the War Artists Advisory Committee (WAAC), an organisation established to provide artists with an income during the War and to provide propaganda images. The WAAC set out to match artists with suitable subjects. Dunbar wrote suggesting making images of the Land Army, a force of women who stood in for the male agricultural workers conscripted into the armed forces. Dunbar recalled that this work was 'painted at Strood towards the end of the war, about 1944–5'. Despite being made in Kent, where the artist lived, she recorded that it was 'an imaginative painting of a Land Girl's work with an outdoor dairy herd on the Hampshire downs'. The bail of the title is the moveable shed where milking is done, it being brought to the cows rather than the cattle being herded to the farmyard and back twice a day. Dunbar chose to depict a specific moment: 'Soon after dawn in the early summer the girl has to catch and tether the bull: she entices him with a bucket of fodder and hides the chain behind her, ready to snap on to the ring in his nose as soon as it is within her reach – a delicate and dangerous job.'

In the 1930s, Dunbar had specialised in decorative painting and, like her close colleague Charles Mahoney, in images of Eden-like English gardens influenced, perhaps, by her faith in Christian Science. Earlier in the War, Dunbar had proposed an illustrated book to help educate land girls and in 1942 she published, with Michael Greenhill, the illustrated *Book of Farmcraft*. Dunbar's focus became the work of women in wartime, ranging from nursing stations and hospitals to knitting parties and canning demonstrations. She spent several periods of time working on paintings of land girls, her process being a slow and laborious one of numerous preparatory drawings and significant self-doubt. The culmination of these was *A Land Girl and the Bail Bull*, begun in 1944 and worked on through to the following year. It was shown in an exhibition of *National War Pictures* at the Royal Academy in autumn 1945 and was one of a number of works that came to the Tate Gallery as part of the WAAC's wider distribution of its works.

Some at the WAAC were concerned that Dunbar's works insufficiently reflected the existence of the War, believing that they portrayed activities unchanged by conflict. The English landscape and rural life were, however, at the heart of patriotic imagery of what the War was fought to defend. Thus, while some saw the land girl's confrontation with the threatening bull as a reflection of wartime bravery, the very depiction of such rural practices against an unspoilt landscape had powerful resonances of national identity. CS

Lucian Freud (Berlin 1922 – London 2011)
Girl with a Kitten 1947
Oil paint on canvas 41 × 30.7. Acquired 2006

Girl with a Kitten was first exhibited in October 1947 at Lucian Freud's exhibition at the London Gallery that he shared with John Craxton. The previous year Freud had visited Paris before joining Craxton in Greece where they took lodgings together in Poros until February 1947. Shortly after returning to London, Freud fell in love with Kitty Garman – the daughter of Kathleen Garman and the sculptor Jacob Epstein – the subject of this painting (and of other paintings by Freud that chart their short marriage).

Girl with a Kitten is evidence of a shift in the way that Freud approached his painting as an expression of his greater intimacy and involvement with his sitters. His paintings were, from an early age, driven by his obsessive and intense scrutiny of his subject. However, this scrutiny was now allied to his desire not to make a literal transcription of a person's likeness but to realise a closer attention to fact within each painting, to embody character rather than just illustrate likeness. In claiming this intention he was able to express a distance from the illustrational caprice of surrealism as well as the supposed objectivity of the Euston Road School of realism, both of which were prevalent tendencies at the time. Freud's ambition also clarifies how far removed he was from the notion of the artist as either a creator of imaginary narrative or a disinterested observer, and how instead he saw himself as an artist intimately involved in the life of his subjects.

Garman averts her gaze from Freud's scrutiny; the kitten held up under her face and gripped tightly by the neck stares straight ahead, full of curiosity. The painter scrutinises the subject, the kitten (namesake and pictorial surrogate for Garman) returns the gaze. Garman, however, shies away deflecting scrutiny while at the same time betraying her emotion at being the subject of Freud's powerful and forensic analysis that exists side by side with their love for each other. The subjects of Freud's paintings from this point are portrayed gazing inwards while also projecting an image of themselves to be met by Freud's scrutiny in such a way that has to be either deflected or met head-on.

The condition of the subject of Freud's paintings was to exist firmly under the control of the artist's gaze, and Freud's paintings depict the embodiment of this penetrating gaze as one that provoked different forms of depicted anxiety. Contemporary responses to Freud's paintings in the late 1940s placed it firmly within the context of the existential philosophy of Jean-Paul Sartre, whose works had started to be translated into English and discussed in magazines from 1948; the degree to which watchfulness and scrutiny is a decisive aspect of the existentialist condition is instructive, leading, for instance, the critic David Sylvester to describe how the 'hysterical stillness' of this painting conveys a 'source of acute anxiety'.

The painting was originally owned by Freud's elder brother Stephen. It was subsequently in the collection of Simon Sainsbury and formed part of his bequest to Tate in 2006. AW

L.S. Lowry (Stretford, Manchester 1887 – Glossop, Derbyshire 1976)
The Old House, Grove Street, Salford 1948
Oil paint on canvas 45.7 × 61. Acquired 1951

The Old House, Grove Street, Salford was first exhibited in London as *The Old House* at the Lefevre Gallery in 1951. Soon after this the Tate Gallery bought it from the artist – the same year Lowry's *Coming Out of School* 1927 entered the collection. These significant acquisitions occurred during a period of growing interest in Lowry's art as his work began to be exhibited more frequently and he came to be celebrated as Britain's pre-eminent painter of urban life.

This thickly painted canvas of a suburban street differs from Lowry's more familiar images of urban working-class life set against a backdrop of cotton mills and terraced houses. In this picture Lowry instead invites us into a much grander area of his city dominated by an imposing Victorian dwelling standing in isolation. The three figures in apparently antiquated dress add to the impression this might be a scene of an obsolete yesteryear. Whilst *The Old House* forms a distinct and perhaps less well-known phase of Lowry's art of desolation, it shares the powerfully evocative memory of communities threatened by a rapidly changing world that pervades his career.

A distinctive characteristic of Lowry's work from the late 1920s onwards is his use of a shadowless white background, evident here, which gives his pictures a raw and dreamlike quality. Though he knew the streets of Salford from his life as a rent collector, Lowry's art is not straightforwardly realist and he often created images from his imagination, incorporating topographically accurate facets of the urban environment recorded in sketchbooks and drawings into new composite and experimental arrangements. In a letter to the Tate Gallery Lowry described how this painting was 'based on a pencil drawing of 1927 made as true to the drawing as possible'. The house depicted here has since been demolished but the street, in the area of Lower Broughton, remains.

After the Second World War Lowry's art increasingly looked back to past national values in order to salvage a personal as well as collective sense of security. His hopelessly ruined landscapes and scenes of desolation were recognised by some as symptomatic of a crisis of nostalgia, anxiety and uncertainty that was gaining currency in the art of Graham Sutherland and Francis Bacon. For others Lowry's detached depictions of working-class life were relevant to debates about realism. Lowry's work was shown alongside that of such artists as Josef Herman, Ruskin Spear and Edward Middleditch in the critic John Berger's major exhibition *Looking Forward* at the Whitechapel Art Gallery in 1952, which championed a strand of realism based on socialist values.

In 1952 Lowry retired aged sixty-five with a full pension from the Pall Mall Property Company, the same year the first monograph on his art was published. In it Lowry is laid down as one of the originals of modern art whose voice lay within a tradition of the eccentric and isolated outsider, untainted by the avant-garde. HL

Alan Davie (Grangemouth, Scotland 1920)
Entrance to a Paradise 1949
Oil paint on chipboard 151.8 × 121. Acquired 1972

Entrance to a Paradise was painted during an early, experimental phase in Davie's career. Having returned to Britain in 1949 from a travel scholarship around Europe, it is a culmination of the powerful absorption and synthesis of the artist's encounters there. Though painted in New Barnet, it is similar to work that Davie had made while working in Venice. This was a period of uncertainty in Western art and Davie became one of the first British artists to see the work of such American painters as Jackson Pollock whose work came to dominate the postwar scene.

Due to a shortage of space in his Venice studio, Davie had propped his canvases against the wall or lay them flat on the floor, a technique he has continued to use to this day. As a jazz musician, strong parallels between Davie's art and musical improvisation abound; the highly worked surface is a result of frenetic and physical action painting. Like many of Davie's titles, *Entrance to a Paradise* was attributed some time after this painting's completion. Whilst the artist maintains they are not to be taken literally they are nonetheless poetic interpretations, in this case an invitation into an enigmatic and explosive world of colour and light.

The surface of *Entrance to a Paradise* is richly layered. Overall, it has a dense grid-like structure, from which individual shapes emerge. Across its surface a web of signs and symbols suggest the artist's spiritual and personal mythology. Anticipating the artist's engagement with Zen philosophy and the surrealist principles of instinct in art, Davie's paint takes on a natural life of its own. Its rapid application suggests a composition open to chance and a visual world beyond the grasp of reason. With each layer new forms and gestures are made and others are buried. The artist told the Tate Gallery: 'The process of painting was very distinctive – layer upon layer destroying what was underneath – and always working spontaneously and automatically – so of all the works done, very little was kept – only those images which happened in the rare magical moments when I was completely surprised and "enraptured beyond knowing".'

Davie's work can be seen in major museums around the world and especially in his native Scotland at the Scottish National Gallery of Modern Art, Edinburgh. From 1937 to 1940 he studied at Edinburgh College of Art and later earned a living making jewellery. After serving in the Royal Artillery during the Second World War, he wrote poetry and worked as a jazz musician in the Tommy Sampson Orchestra. The meteoric rise of Davie's career as a painter was heralded when the American gallerist and collector Peggy Guggenheim purchased his work, bringing it to wider acclaim. After visiting America in 1956 and exhibiting his work in New York, Davie became internationally recognised and has since had many solo exhibitions in Britain and abroad. In London he has exhibited regularly with Gimpel Fils though in 1972 the Tate Gallery acquired this work directly from the artist. HL

Henry Moore (Castleford, Yorkshire 1898 – Perry Green, Hertfordshire 1986)
Reclining Figure: Festival 1951
Plaster and string 105.4 × 227.3 × 89.2. Acquired 1978

Commissioned by the Arts Council of Great Britain, *Reclining Figure: Festival* is Henry Moore's original plaster from which was cast a bronze sculpture for the Festival of Britain in 1951. During the festival the bronze version was exhibited in front of the Land of Britain Pavilion on the South Bank in London, and subsequently entered the collection of the National Galleries of Scotland in 1969. In total an edition of five bronzes and one plaster copy were made from this original. The work remained in Moore's possession until 1978 when it was included in the artist's gift of thirty-six sculptures to the Tate Gallery.

Early in his career Moore had regarded his plasters as intermediary stages in the process of bronze casting. However, by the 1970s he had started to regard them as works of art in their own right, each with a unique surface colour and texture. *Reclining Figure* is one of the earliest surviving large plasters and is notable for the use of thin strings embedded into its white surface (in the bronze cast these appear as ridges).

In 1968 Moore indicated that *Reclining Figure* marked a breakthrough in his experimentations with masses and voids. Rather than existing as a single solid mass, in this sculpture he was able to open out the human body into intersecting components that responded to the surrounding space. He stated, 'The "Festival Reclining Figure" is perhaps my first sculpture where the space and the form are completely dependent on and inseparable from each

other ... In my earliest use of holes in sculpture, the holes were features in themselves. Now the space and form are so naturally fused that they are one.'

When first exhibited, *Reclining Figure* was understood to adhere positively to the two central themes of the Festival: the land and the people. For some, Moore's female figure was a universal woman whose undulating limbs seemed to echo the natural environment. However, rather than a positive symbol of postwar Britain, by the later 1950s some saw the sculpture in negative terms. The forked, upward thrusting head, sometimes described as an open mouth, could be regarded as a sign of anxiety. With its perpetual silent scream, *Reclining Figure* may well be a pessimistic companion to Francis Bacon's *Three Studies for Figures at the Base of a Crucifixion* c.1944 (see p.160). In 1959 the analytical psychologist Erich Neumann regarded the sculpture as 'ghostly' and 'spectral' and linked it to Moore's experiences of war. In this context the whiteness of the plaster becomes reminiscent of bone.

By 1951 Moore was a well-respected member of the artistic establishment. As an Official War Artist his shelter drawings had met with widespread approval during the 1940s, and he acted as a Trustee of the Tate Gallery between 1941–8 and 1949–56. The inclusion of *Reclining Figure* in the Festival of Britain secured his position as one of the nation's most important artists. AAC

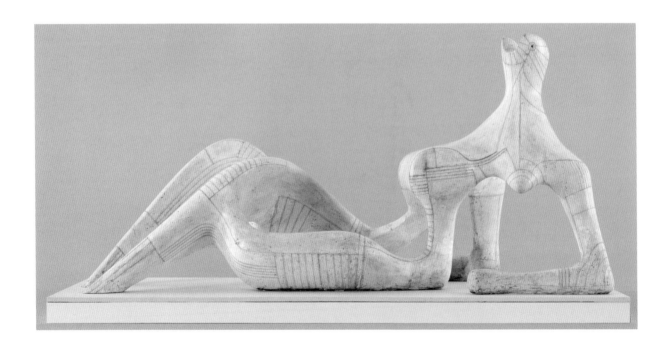

Marlow Moss (Richmond, Surrey 1890 – Penzance 1958)
Balanced Forms in Gunmetal on Cornish Granite 1956–7
Metal and stone 22 × 33 × 28.5. Acquired 1969

As its title describes, two shining metal spheres and a cone balance on top of a piece of pinkish granite, the contrasting materials and surfaces inviting our gaze. Moss embraced movement and space in her works and here the phallic cone shape can be pivoted. Moss, better known as a painter, took up relief work in 1935 and progressed to three-dimensional work in the 1940s. *Balanced Forms* is a striking example of one of the few sculptures that she produced.

Erica Brausen, founder of the Hanover Gallery, London, presented his work to the Tate Gallery in 1969. A significant supporter of British and international contemporary sculptors, Brausen bought *Balanced Form* after it was shown in Moss's second solo exhibition at the gallery in 1958, just four months before the artist's death. It appeared in a slightly altered form on the front cover of the exhibition catalogue. Moss changed the granite base of the work and the positioning of the cone after the photograph was taken, preferring to use another piece of granite she had recently found in St Ives.

The sculptures that Moss exhibited in her 1958 exhibition were diverse in their material make up: various combinations of steel, gun metal, painted wood, aluminium, granite and marble came together in abstract and largely geometric constructions in which space, mass and form are at play. *Balanced Forms* can be located stylistically within a British constructivist tradition that had been firmly established in the 1930s. Moss was a founder member of the Parisian group *Abstraction-Création* in 1931. She exhibited alongside Mondrian, Gabo, Hepworth, Nicholson and others, and contributed to the group's journal. In its first edition she described her pursuit of non-figurative art looking beyond nature to 'construct the pure visualization which can express the artist's awareness of the universe in its totality'.

Moss studied at St John's Wood Art School, at the Slade School of Art and later took sculpture classes in Cornwall at Penzance School of Art between 1924 and 1926. In 1927 she had her first exhibition with the London Group, but in same year moved to Paris. There she met Piet Mondrian whose work inspired her, and with whom she formed a close working relationship. Her paintings from the 1930s clearly pay homage to his linear and geometric compositions. However, theirs was a true exchange of ideas, and Moss is often credited with Mondrian's adoption of the double line in his works. The rhythms and balance of her paintings relate to her sculptural practice. Moss returned to Cornwall at the advent of the Second World War, settling in Lamorna but remaining largely removed from the significant artistic life around nearby St Ives. Her work is often overlooked in accounts of British art, but perhaps now is the time for its re-assessment. JP

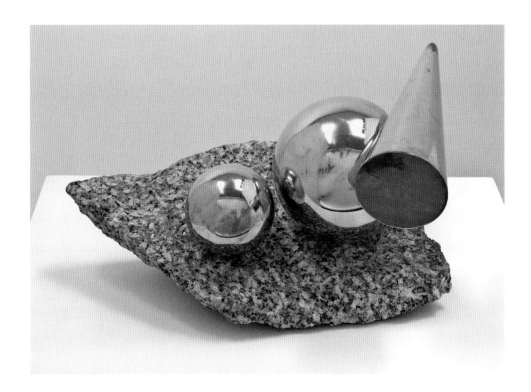

Gillian Ayres (born Barnes, London 1930)
Break-off 1961
Oil paint on canvas 152.4 × 304.8. Acquired 1973

The development of British abstract painting through the late 1950s and into the early 1960s broadly speaking charts a shifting balance between an approach to painting that had been built on the achievements of the French modern masters as it had been extended, for instance, by artists as various as Nicolas de Stael, Jean Dubuffet and Serge Poliakoff, and the effect of the impact of American abstract expressionism, especially following *The New American Painting* exhibition at the Tate Gallery in 1959. The sure touch of *belle peinture* was exchanged for an expansiveness of scale, a particular use of everyday materials that declared the painting to be an object and a record of an action rather than a straightforward pictorial composition. Gillian Ayres typifies this move: she visited Paris regularly in the 1950s, yet was equally excited by the new American painting that she would have seen between 1956 and 1959.

Break-off indicates an early adjustment in her approach to painting. Over the previous five years she had typically used Ripolin enamel gloss house paint on hardboard – the paint having been thrown, poured, splashed and brushed to create a ground of layered poolings of colour. *Break-off*, however, marks a return to a use of oil paint on canvas. This change of material and surface encouraged a greater compositional openness and subtlety in mark-making. It also suggests how the earlier use of chance and improvisation, in which an instinctive handling of paint is followed deliberately, could evolve into paintings that were spatially more open, simpler in composition and more reliant on an element of drawing.

The painting's title is not descriptive but chosen instead for its openness of interpretation; nevertheless the rupture it indicates is consistent within a way of working that is essentially improvisatory in defining an act rather than an object. For Ayres, the painting – like each mark within it – represented nothing but itself, whatever interpretation might be later brought to it or what allusions it might evoke in a viewer. In a statement written in 1962 she briefly reinforced this view. In three sentences she describes first her process and materials, then the sensation of the resulting image and finally an understanding of how the work might be approached as 'a mark making its own image in space – the canvas viewed as a whole image and space – an essence – perhaps like a space a sailor of Magellan's would have felt when the world was flat and he had sailed off the edge'.

Break-off and her earlier painting *Distillation* 1957 were purchased together from Ayres in 1973 by the Tate Gallery. These were the first works by Ayres to enter the collection, a contrast with the Arts Council Collection, for instance, who bought their first painting by Ayres – *Lure* 1963 – in the year it was painted, and continued by buying three more paintings by 1967. The purchase by the Tate Gallery, however, confirmed Ayres's position within the history of post-war British abstract painting, even though this occurred at a time when attention was more widely directed away from painting and towards conceptual practices within art. AW

Victor Pasmore (Chelsham, Surrey 1908 – Malta 1998)
Black Abstract 1963
Oil on clipboard relief on painted Formica 152.4 × 152.4. Acquired 1963

Much of Victor Pasmore's art was based upon ideas of organic development and, in the case of this work, this was made clear in its original title: *Black Abstract – Growing Form.* Pasmore reverted to the simpler and less determining title shortly after the work was bought by the Tate Gallery from his solo exhibition at Marlborough Fine Art the year that it was made. The following year it was shown at the Venice Biennale and, in 1973, it was included in a survey of recent British art at the international celebration *Europalia 73.*

During his early career, which started in the late 1920s, Pasmore worked through a wide range of artistic styles. In the 1930s, he was associated with the artists of the Euston Road School who took Cézanne as their master. He went on to make *intimiste*-type works in the manner of Bonnard and Vuillard and, during the 1940s, seemed to work through the manners of Turner, Whistler and Seurat before, famously, 'going abstract' in 1948 with a series of cubist-inspired newspaper collages. That one of Britain's leading artists should have made such a dramatic change of direction came to be seen as a seminal event at a time of artistic uncertainty and transition.

The idea of making a painting by the progressive development of a single motif first entered his work, under the influence of Paul Klee, in the late 1940s. From there, he began to make reliefs and constructions, becoming the leading figure in a British revival of constructivism. Typically Pasmore's works are based on a combination of geometric formulae, such as the golden section, and an intuitive approach to composition and application. Of *Black Abstract* the artist wrote to the Tate Gallery: 'the point of this painting … lies in the fact that its principal mass is built up systematically and organically from a predetermined unit, used like a brick. These units, starting along the top edge of a square, expand as they extend downwards and, in the process of expansion, change in shape, tone and size.' The black marks seem to multiply and grow around an unseen obstruction intruding from the left. In this way the painting reveals Pasmore's interest in the highly influential book *On Growth and Form* (1917, republished 1942) in which d'Arcy Wentworth Thompson proposed that the process of growth determined shapes and patterns in the plant and animal kingdoms. Pasmore's work echoes images of cellular structures in that book. It also has its origins in his earlier 'pointillist' style works such as *The Hanging Gardens of Hammersmith No.1*, 1944–7 (Tate T12615).

Like his fellow constructionists, Pasmore embraced the use of new building materials in his art. In this work a piece of fibrous chipboard is fixed to Formica, a hard-wearing melamine-based material that had become widely used in kitchens during the 1950s. As a result the black paint has different finishes, the absorbent chipboard providing a matt finish that is exaggerated towards the bottom by the artist's rubbing of the surface. In contrast, the glossy back lines on the Formica were painted precisely using masking tape. CS

Anwar Jalal Shemza (Simla, India 1928 – Stafford, England 1985)
Chessmen One 1961
Oil paint on canvas 92 × 71. Acquired 2010

Shemza painted *Chessmen One* in 1961, the year before he decided to settle permanently in England. Having studied at the Slade School of Art in London in the late 1950s, he travelled to Pakistan with his family in 1960, with the intention of getting a teaching job in Lahore, where he had lived after the partition of India in 1948. In a letter to his friend, the author Karam Nawaz, he explained that the decision to move back to Pakistan had been prompted by the responsibility he felt, as a postcolonial intellectual and artist, towards his own continent. 'Whatever I have obtained in this country [England],' he wrote, 'it was solely for the sake of students in my country.' However, he did not find employment and decided to return to England, where he settled in Stafford, his wife's home town.

Chessmen One depicts four horizontal rows of black chess pieces set against a lightly textured pale blue background. Each row is decorated with sinuous linear detail in different colours, red on the top row, blue on the second, cream on the third and green on the fourth. The chessmen are depicted in a schematic, near abstract frontal view that emphasises the flatness and two-dimensional surface of the canvas. During this period, Shemza was investigating the relationship between form and text in his compositions, making reference to Islamic motifs and Arabic calligraphy, which he incorporated into his works. He treated the flat surface of the canvas as a plane for experimentation in which abstraction, geometry and pattern were combined in compositions that merged traditional Islamic motifs with a European modernist tradition.

While studying at the Slade between 1956 and 1959, Shemza underwent something of a personal and artistic crisis. Having made a name for himself in Pakistan, he found that in England he had to start again: 'The "celebrated artist" was lost ... I was an exile, homeless, without a name.' This sense of displacement led him to question his previous work and prompted him to destroy 'paintings, drawings, everything that could be called art'. A visit to the British Museum provided the impetus to begin working again. Over the years, he explored a number of subjects, such as Mughal architecture, prayer carpets, female and plant forms, the letter *meem* (the Prophet Muhammad's initial) and chessmen. Shemza worked in series, often producing fifty or more works on one theme before moving to another. He experimented with different techniques and, influenced by his early exposure to traditional Indian carpet designs from his family business, he often included in his work references to fabrics, textiles and surface textures.

Chessmen One entered the Tate's collection in 2010 following Shemza's exhibition *Calligraphic Abstraction* at Green Cardamom Gallery, London in 2009. The work had been previously exhibited in *The Other Story: Afro-Asian Artists in Post-War Britain* curated by Rasheed Araeen at the Hayward Gallery, London in 1989, where Shemza featured prominently as one of the first South Asian artists to have settled in England. At Tate Britain, *Chessmen One* was included in the collection display *Gallery One, New Vision Centre, Signals, Indica* in 2011, and it was one of the works featuring in the exhibition *Migrations: Journeys into British Art* in 2012. CJ

Anthony Caro (born London 1924)
Early One Morning 1962
Painted steel and aluminium 289.6 × 619.8 × 335.3. Acquired 1965

Early One Morning signifies a decisive shift in Anthony Caro's sculptural language, from representational to abstract form. Between 1951 and 1953 he worked as an assistant to Henry Moore, whose figurative influence is evident in *Woman Waking Up* 1955 (Tate T00624). During a two-month Ford Foundation travel grant to America in 1959, Caro was also influenced by how artists Kenneth Noland and David Smith approached abstraction, scale and subject matter in new ways. On his return to London, Caro started to use pre-fabricated metal to construct sculptures that radically expand, divide and cut through space.

Early One Morning is a large and confident work from this formative abstract period. Caro originally referred to it as *Red one 5–62* and a year after completion gave it a title relating to time which groups it with works of the period including *Twenty Four Hours* (Tate T01987). *Early One Morning* comprises a configuration of pipes, sheet metal and I-beams that stretch with a strong horizontal force over six metres, and is unified by a coat of bright red paint. Elements are riveted together but appear propped and relate closely to Moore's large reclining figures and works from the early 1960s made up of two or three separate pieces of interlocking or supporting components such as *Three Piece Reclining Figure No.2: Bridge Prop* 1963 (Tate T02292). Caro's sculpture evokes space, lightness, tension and balance rather than Moore's concerns of weight, monument and solidity. However, both share a sense that the viewer's

body, scale and gestures are vital to the experience of the work. Although *Early One Morning* signifies an abrupt formal departure in Caro's work, in 1969 critic Michael Fried asserted that Caro's 'sculptures have always been intimately related to the human body'. He wrote that the change in Caro's work 'was impelled by his discovery that it was possible to express the lividness of the body more directly and convincingly by juxtaposing a number of discrete elements than by techniques of modelling and casting'.

Caro taught at St Martin's School of Art, London (1953–79), where his formalist approach divided ideas on sculpture in the department, influencing the so-called New Generation of sculptors and providing a counterpoint for conceptual practice. Since the 1960s his work has retained its constructivist and abstract concerns, but has varied in material including porcelain, clay and paper and a return to bronze.

Early One Morning was first shown at the Tate Gallery in 1965 in the group exhibition *British Sculpture in the Sixties* organised by the Contemporary Art Society, who then presented it to the Tate Gallery. The sculpture was shown in the Venice Biennale in 1966 alongside four abstract painters. It was exhibited in solo exhibitions in London at the Whitechapel Art Gallery (1963) and Hayward Gallery (1969), and in New York at MoMA (1975) – the museum's first solo exhibition given to a British artist since Moore in 1946 – and at Tate Britain (2005). MB

Roger Hilton (Northwood, Middlesex 1911 – Botallack, Cornwall 1975)
Oi Yoi Yoi 1963
Oil paint and charcoal on canvas 152.5 × 127. Acquired 1974

Oi Yoi Yoi epitomises the range of Hilton's painting and marks a distinctive and productive period in his career. It reveals how his art reinvented and moved freely between non-representational and figurative painting, as many artists of the early 1960s expressed a new sense of freedom about the future of the medium. Having made what the artist called an 'extreme abstract exhibition' at London's Gimpel Fils Gallery in 1954, subsequent exhibitions of Hilton's work revealed his continual oscillation between visceral abstractions and compositions of blocks of colour and sweeping charcoal lines which suggest erotically charged human forms.

The body here is unusually unambiguous, its movement freer and more confident than before. On the one hand, this is a conventional handling of the female body, a subject of erotic fantasy in which the female form is objectified. In it all is sensual and much is sexual as limbs are boldly splayed out across the canvas: buttocks, breast, thighs and vaginal shapes pronounced. Paradoxically its crudely direct and formal language is also indicative of the newly confident, open body of the 1960s. Unusually the composition of *Oi Yoi Yoi* was reworked in another canvas, *Dancing Woman* 1963 in the collection of the Scottish National Gallery of Modern Art, Edinburgh. This is the only time Hilton reproduced a painting, for the simple reason he thought it a good picture and

because he wanted to employ different colours. When asked to describe its subject matter, the artist explained the figure represented his wife dancing on the veranda during a quarrel. She was nude and angry at the time and dancing up and down shouting 'oi yoi yoi' with limbs akimbo. In a conversation with Tate curator David Brown, Rose Hilton later added that the incident that inspired the painting happened during the couple's summer holiday in France in 1962.

Oi Yoi Yoi was exhibited in the British Pavilion at the Venice Biennale in 1964 and purchased by the Tate Gallery from the artist ten years later. Some months before, it had featured in Hilton's retrospective at the Serpentine Gallery, the first exhibition to present a survey of his art to date. In 1965 *Oi Yoi Yoi* had been reproduced alongside Lord Snowdon's portraits of the artist in *Private View*, a book celebrating the London art scene that advanced Hilton's status as one of few British painters to stimulate a younger generation of artists, the vitality of his work eluding obvious classification but marking him out as one of Britain's most significant postwar painters. In the later 1960s and 1970s Hilton, his health failing, painted relatively few oils. From 1972, confined to his bed, Hilton was only able to draw and paint in gouache, but he continued to make hundreds of works on paper continuing his unique language of bright colours, figurative and non-figurative compositions. HL

Bridget Riley (born London 1931)
Hesitate 1964
Oil paint on canvas 106.7 × 112.4. Acquired 1985

Since the 1960s Bridget Riley has employed patterns, line and colour to create abstract sensations of space. *Hesitate* is part of a group of black, white and grey spot paintings made in 1964 where titles like *Chill* and *Disturbance* suggest emotional states of instability and tension. In *Hesitate* rows of evenly placed circles decrease and tighten to form ellipses that appear to recede into a horizontal fold. The geometric composition was refined by gouache studies and translated from an enlarged cartoon, using a combination of a compass, templates and freehand drawing. In relation to this series of paintings Riley explains: 'The basis of my painting is this: that in each of them a particular situation is stated. Certain elements within that situation remain constant, others precipitate the destruction of themselves by themselves. Recurrently, as a result of the cyclic movement of repose, disturbance and repose, the original situation is restated.' Nature is implied by the sense of perspective, horizontal emphasis and expanding visual field in this painting, which Riley later described in 1986 as a landscape, in comparison to the similar but vertical fold in *Pause* 1964 (private collection) which relates to the figure.

Riley's first abstract painting *Movement in Squares* 1961 (Arts Council Collection) excluded colour to achieve optical speed through a restricted vocabulary of sharp black and white contrasts and a chequerboard structure, a formal characteristic of her work from the period. The tonal shading in *Hesitate* and the juxtaposition of warm and cool greys in *Deny II* 1967 (Tate T02030) introduced light to the

paintings and informed her transition to using pure colour. Riley's perceptual understanding of colours stems from an interest in colour theory and art history, in particular Georges Seurat, and a heightened awareness of the natural world gained during her childhood in Cornwall.

Paintings from 1967 include configurations of coloured stripes, waves and curvilinear shapes. They produce visual vibrations associated with a nonrepresentational experience of dazzling colour, light, heat and movement in nature whilst retaining the inherent content of earlier black and white works described by critic Robert Hughes as 'a sense of slippage or threat to underlying order'.

In the mid-1960s Riley gained international recognition and was heralded as a leading exponent of op art; a style of painting concerned with creating playful and disorienting optical effects of movement on a static canvas. In 1964 she participated in *The New Generation* exhibition at the Whitechapel Art Gallery, London and in 1965 *Hesitate* was included in the group exhibition *The Responsive Eye* at the Museum of Modern Art, New York. The popularity of this exhibition reached a wide audience and the aesthetics of Riley's paintings were appropriated by the fashion and design industries.

Hesitate was first exhibited in 1965 at Richard Feigen Gallery, New York and from 1965 to 1980 it was part of the Aldrich Museum of Contemporary Art collection in Ridgefield, Connecticut. MB

Peter Blake (born Kent 1932)
Portrait of David Hockney in a Hollywood Spanish Interior 1965
Acrylic paint, graphite and ink on canvas 183 × 153. Acquired 2002

This painting combines Peter Blake's conventional approach to portraiture with his method of collaging different elements together to create an invented composition. Throughout his career, Blake has often used a straightforward pose in which the sitter's gaze looks out directly to meet that of the viewer, as seen in *Self-Portrait with Badges* 1961 (Tate T02406). When Blake came to paint his long-time friend, artist David Hockney (born 1937), he used a life-size print of a photograph of Hockney taken by Michael Cooper. He also used a separate print by Cooper, selected by Hockney from a magazine, as the source image for the young man leaning casually against the steps of the 'Spanish Interior'. Cooper was a chronicler of the 'Swinging Sixties' and photographed the artists, actors and models associated with this merging of British fashion, art and music, including well-known images of Hockney with his trademark blonde hair and black, heavily framed glasses. The portrait reveals the fondness that Blake has for his fellow painter, five years his junior, with whom he studied at the Royal College of Art. Both artists were leading figures within British pop art, which deployed graphic art techniques and subjects within a fine art context. Then as now, Blake has also worked as a commercial artist and supports

the conflation of fine and popular artists. Blake was to come together again with Michael Cooper in 1967 when Cooper photographed the iconic cover for the Beatles's *Sgt Pepper's Lonely Hearts Club Band* created by Blake and his then wife Jann Haworth.

Blake has combined different painting styles in this work to create a carefully composed scene, for example the realistically rendered balloons with the shower of confetti that gives a party atmosphere to the painting. Yet Hockney himself is loosely painted and looks more reflective than the carefree partygoer he was often portrayed to be. The man in the background is painted even more sketchily, giving the scene a personal and intimate feel. At this time Hockney was painting homoerotic images of young men in his own work, such as *Man in Shower in Beverley Hills* 1964 (Tate T03074) and the pairing in Blake's painting suggests a possible relationship. Blake worked intermittently on what was one of his biggest canvases for nearly four decades; however, he had actually swapped the work with Hockney in 1965 for a set of his *Rake's Progress* etchings. Hockney gifted the portrait to Tate in 2002 once Blake agreed it was finished. The painting was included in Blake's solo exhibition at Tate Liverpool in 2007. KS

Patrick Caulfield (London 1936 – London 2005)
Battlements 1967
Oil paint on canvas 152.4 × 274.3. Acquired 1967

Patrick Caulfield is known for his iconic and vibrant paintings of modern life that reinvigorated traditional artistic genres such as the still life. He came to prominence in the mid-1960s after studying at the Royal College of Art where fellow students included David Hockney. Through his participation in the defining *The New Generation* exhibition at the Whitechapel Art Gallery in 1964, he became associated with pop art. However he resisted this label throughout his career, instead preferring to see himself as a 'formal artist' and an inheritor of painterly traditions from modern masters, such as Georges Braque, Juan Gris and Fernand Léger, who influenced his composition and choice of subject matter.

Early on in his career Caulfield rejected gestural brushstrokes for the more anonymous techniques of sign-writers. *Battlements* 1967 is one of several paintings of simplified architectural details seen in close-up that Caulfield painted in the mid-1960s and which are characterised by flat areas of colour defined by simple outlines. It consists of a single row of crenellated battlements that crosses the canvas at a slight angle. As with the painting of a Parish Church (Scottish National Gallery of Modern Art, Edinburgh) made in the same year, *Battlements* was based on a line drawing of a typical country church that Caulfield found illustrated in a book, *The Parish Churches of England* by J. Charles Fox and Charles Bradley Ford (1954). The diagram depicts

a common type rather than a particular example of church architecture. This appealed to Caulfield's interest in creating generic images. *Battlements* and a related painting, *Stained Glass Window* 1967 (Musée National d'Histoire et d'Art, Luxemburg), represent fragments of this fictional church. As the artist wanted to depict his subjects at life size, he had to paint them on canvas rather than on his usual hardboard, which at the time could only be purchased in sheets with a maximum width of four feet (122 centimetres). This scale gives a sense that the scene was derived from a real object rather than an illustration. The atmosphere is similar to that of a slightly earlier painting *View of the Rooftops* 1965, which depicts a series of blue chimneys rendered in a similar manner against an empty red background.

Battlements was first exhibited at Caulfield's second solo exhibition at the Robert Fraser Gallery in 1967. It was acquired by the Tate Gallery in the same year, the first Caulfield painting to be acquired. In the 1970s Caulfield began combining different styles of representation, including *trompe-l'oeil*, to create highly complex paintings of startling originality. This shift coincided with a change in subject matter to topics that directly engaged with the contemporary social landscape and the representation of modern life. CW

David Hockney (born Bradford, Yorkshire 1937)
A Bigger Splash 1967
Acrylic paint on canvas 242.5 × 243.9. Acquired 1981

When David Hockney arrived in Los Angeles for the first time in January 1964 he was immediately attracted to the city's clear light and fascinated by what to him seemed a glamorous abundance of swimming pools. *A Bigger Splash* reflects his excitement which he communicated through the portrayal of a sun-soaked scene of languid leisure. This sense of light is emphasised by the flat application of paint for the large areas of pool, patio and sky, made using masking tape and rollers. The otherwise still scene is disturbed by the splash of water – an unseen figure having just dived into the pool from the diving board that protrudes diagonally from the bottom right-hand corner of the painting, adding a sense of perspective to an otherwise strictly planar composition.

A Bigger Splash was painted between April and June 1967 when Hockney was teaching for a summer term at the University of California at Berkeley, and was the third and final painting he made of a splash of water in a swimming pool; the two earlier paintings, both in private collections and painted in 1966, are smaller in size if similar in composition. The paintings' source was a photograph in a book about the construction of swimming pools.

Quite apart from its connotations of a lifestyle devoted to pleasure, the subject chimed with Hockney's abiding fascination in the challenge of depicting transparent substances like glass and water: here realised in the contrast between the ephemeral splash of water and the still pool water or the static reflections in the glass windows behind. He later described how 'I love the idea first of all of painting like Leonardo, all his studies of water, swirling things. And I loved the idea of painting this thing that lasts for two seconds: it takes me two weeks to paint this thing that lasts for two seconds.' Hockney also addressed this contradiction through his growing interest in photography at about this time (he bought a Pentax camera the same year). However, where a photograph might freeze the movement of water, Hockney's aim was to suggest a sense of flow within the water's movement, not just to capture a moment. The unpainted border of raw canvas around the edge of the painting may in this context suggest the border of a snapshot print; however, this was a device that Hockney returned to repeatedly in the mid-1960s as a way to underline the two-dimensional artifice that is marshalled to paint a picture.

A Bigger Splash was included in *A splash, a lawn, two rooms, two stains, some neat cushions and a table ... painted*, Hockney's fourth solo exhibition with Kasmin Ltd, a London gallery with a space-age cool – white walled interior, curved ceiling and khaki-green rubberised floor – that its owner John Kasmin described as 'a machine for looking at pictures in'. The painting was bought from this exhibition by Sheridan, 5th Marquess of Dufferin and Ava, Kasmin's business partner, from whom it was acquired by the Tate Gallery in 1981. AW

Richard Long (born Bristol 1945)
A Line Made by Walking 1967
Photograph on paper, print 37.5 × 32.4. Acquired 1976

Richard Long first came to prominence during the late 1960s as part of a generation of avant-garde artists who sought to redefine art as a concept, process or activity rather than necessarily a finished object. *A Line Made by Walking* is the first example of Long's art based on solitary walks in nature, documented using photography or text. Exploring time, geography and measurement through the medium of walking, it was created outside the confines of the artist's studio in the expanded space of the real world. To create it Long took a train from London's Waterloo station heading southeast, getting off after about twenty miles where he found the featureless field. Here the artist walked backwards and forwards until the flattened turf caught the sunlight and became visible as a straight line, taking a photograph of it before getting back on the train. Unlike subsequent endeavours that have taken the artist on extended excursions in remote places around the world, *A Line Made by Walking* is a walk going nowhere. At the same time, by locating the physical activity of sculpture in the natural world it is a statement that art can be made anywhere.

Long never makes significant alterations to the landscape, but the simplicity of his actions belies their radical implication. No human figure appears *In A Line Made by Walking*, yet the artist's corporeal presence and bodily action is present. For this seemingly simple and prosaic action to be understood as art was a breakthrough, anticipating the practice of performance art that was to become widespread

during the 1970s. Long's straightforward use of the camera also raises questions about the relationship between sculpture, photography and documentation. As the artist has made clear, this direct and roughly shot black and white image is only documentation of the work and does not constitute the work itself. As a result, several editions of *A Line Made by Walking* exist, each with a different format.

This work was made when Long was a student at St Martin's School of Art where his contemporaries included the artists Gilbert & George, Barry Flanagan and Hamish Fulton. During this period his work was included in a number of groundbreaking international group exhibitions including *When Attitudes Become Form* in Bern in 1969 and *Earth Art* at Cornell University, Ithaca in 1969 where he became associated with the land art movement. Long was also represented in *The New Art* at London's Hayward Gallery in 1972, the first exhibition to chart the development of a heterogeneous group of British artists dissatisfied with the conventions of modernism. The Tate Gallery's acquisition of *A Line Made by Walking* in 1976 coincided with a turning away from technological optimism set against a period of successive national crises. Despite his strong links with the English landscape tradition, Long sees himself as a sculptor and his work as conceptual art. This, and his consistent and radical rethinking of the relationship of art and landscape to this day, was demonstrated in Tate Britain's 2009 exhibition *Richard Long: Heaven and Earth*. HL

Frank Auerbach (born Berlin 1931)
Primrose Hill 1967–8
Oil paint on board 121.9 × 146.7. Acquired 1971

Frank Auerbach's paintings are characteristically densely layered with oil paint and activated by a broad vocabulary of gestures that drives a play of resistance between the image and the tactility of paint. The earth tones and impasto surface of paintings such as *Oxford Street Building Site I* 1959–60 (Tate T00418) evoke the patina of dirt and rutted earth of a postwar urban landscape. This visceral intensity and structural composition is indebted to Auerbach's tutor, former vorticist David Bomberg, who instrumentally taught him that art was a process of intense observation and intuition, not imitation. Auerbach has remained rigorous and consistent in his approach to painting a tight range of figurative and local London subjects since the 1950s.

Primrose Hill 1967–8 depicts a view looking up at the park north of Regent's Park in London, from the corner opposite the entrance to the city's zoo. Since moving to a studio in Camden Town in 1954, Auerbach has made the principal subject of his landscapes the area close by. He worked on this painting every day for a year, scraping back the image and accumulation of paint from the previous day and repainting the composition anew from drawings he made from life each morning. These drawings provided new impulses and ideas to work from, and generated different gestured marks and information; at one point *Primrose Hill* included a figure. The painting represents a visual record and analysis of what he saw, and it changed with and according to the seasonal and momentary appearances of the park. A zigzag of a leafless branch, two dimly lit lampposts, the yellowed ground crisscrossed by blue paths, possibly flooded by puddles and an overcast sky identify

the wet autumn morning it was completed. The resolve to depict his immediate visual experience reveals that the process of arriving at the image, rather than merely representing his subject, is central to his practice. In 1971, when Tate acquired the work, Auerbach commented: 'The painting is the result of a multiplicity of transmutations partly as the result of external information, alluded to in the drawings, partly as the result of internal intelligences.'

Auerbach was born in Berlin of Jewish parents and came to Britain in 1939 as a Kindertransport refugee. He is from a generation of painters, including Lucian Freud and Leon Kossoff, also from immigrant backgrounds, who have been loosely grouped as the 'School of London', a term first used by R. B. Kitaj in 1976. In the wake of avant-garde abstraction, minimalism and conceptualism, they were steadfast in their individual commitments and different approaches to figurative painting. Auerbach's first retrospective was held at the Hayward Gallery in 1978. His work was reassessed in the broader context of his contemporaries and younger painters in the seminal exhibition *A New Spirit in Painting* at the Royal Academy, London in 1981, which recognised a return to the traditional concerns of painting. In 1986 Auerbach represented Britain in the XLII Venice Biennale, when he shared the main prize, the Golden Lion, with Sigmar Polke.

Tate holds sixteen paintings by Auerbach dating from 1957 to 1991, as well as drawings and prints. Tate purchased *Primrose Hill* and five working drawings (T01271–T01275) for the painting in 1971. It has been shown in the Tate collection displays examining the diversity of postwar British painting. MB

Susan Hiller (born Tallahassee, Florida 1940)
Dedicated to the Unknown Artists 1972–6
305 postcards, charts and maps mounted on 14 panels; book, dossier,
each panel 66 × 104.8. Acquired 2012

A fascination with cultural artefacts, popular beliefs and rituals, and oral or other behavioural traditions underpins Susan Hiller's practice. She employs systems of classification and comparative analysis in collecting and presenting material, which has been attributed to her background as an anthropologist, but her methodology is used to subvert and disrupt accepted categories, encouraging a new engagement with what is mundane, familiar or overlooked. Lucy Lippard has observed that 'when [Hiller] uses cultural artefacts, from posthards to postcards, she does not project meanings onto them but retains their "idiosyncratic nature", which affects the way they are perceived and illuminates their significance in relation to our own culture'.

Dedicated to the Unknown Artists 1972–6 is one of the earliest large-scale works made by the artist, and the first incarnation of an ongoing series of related works. It consists of over 300 found postcards depicting waves crashing onto shores around the coast of Britain. They are arranged into a grid framework of fourteen panels, classified by type and format and accompanied by detailed charts and a map showing the locations featured on the postcards. The installation includes a copy of a postcard-sized artist's book and a dossier with supporting material, in which Hiller describes herself as a curator presenting these overlooked objects.

The American-born artist had recently moved to Britain when she discovered, in a shop in Weston-Super-Mare, the first postcard of a stormy seaside view titled *Rough Sea*. As she gradually found similarly named postcards featuring other seaside locations, she realised she had chanced upon the existence of a fascinating genre. 'I thought of the cards as miniature artworks', the artist has said, drawn to the labour involved in producing the painted images or often hand-tinted photographs. In contrast to the formal and stylistic tradition of marine painting, the postcards reveal an idiosyncratic, cultural expression, depicting Britain's notoriously bad weather. By making such commonplace objects the subject of a dedicated and extensive presentation, Hiller conveys significance on the mundane and provides the viewer with a familiar access point from which to engage with a work essentially about invisibility. The title of the work, *Dedicated to the Unknown Artists,* identifies it as a tribute to the forgotten artists of the postcards.

The visual language of conceptualism, represented by the serial presentation of the postcards and the typed annotations, is in marked contrast to the sentimental imagery of the postcards featuring sublime or picturesque motifs. Rational presentation of popular, overlooked or marginal subjects in the form of images, objects or language has formed the subject of Hiller's investigations for over four decades. 'I think materials carry ideas', Hiller explains, '... while I still, I think, produce works that don't disguise their methods and means or mystify my intentions, I've increasingly allowed space for the participation of viewers in the creation of meaning. I think the artwork is an instigation of a process of reflection.' *Dedicated to the Unknown Artists*, one of six major works in the Tate's collection, was acquired following its inclusion in a large survey exhibition of the artist's work at Tate Britain in 2011. SK

John Latham (Livingstone, Northern Rhodesia (now Maramba, Zambia) 1921 – London 2006)
One Second Drawing 17" 2002 (Time Signature 5:1) 1972
Acrylic paint on enamelled wood panel. Acquired 1976

One Second Drawing 17" 2002 (Time Signature 5:1) is one of a series of works that Latham made after 1970. These all result from a standard procedure in which paint is sprayed onto a prepared white board for one second only using a can of black spray paint set at a given distance away from the board. The resulting works represent Latham's concept of 'least event' or 'not nothing' where the white ground of the board is 'nothing' and the droplets of sprayed paint accreted to the board's surface are 'not nothing'. Such an indication of a primal event – concerned with time rather than space – underpins the cosmology that Latham evolved over fifty years through his work. For Latham the products of art were not mute objects that existed in a defined and measurable space but were instead exemplars of a new way of thinking about the world and the forces that act on it; suspended by a chain from a wall bracket, this work hangs in a space without fixed co-ordinates.

Latham's Time-Base Theory – concentrating on time and event as the ordering principle, rather than the more orthodox criteria of space and matter – can perhaps best be approached through his idea of 'event structure', which was founded on the collision of language, knowledge and time with human relationships; the use of spray paint in his painting served as an actual – rather than representational – sign of the action of time. Latham had first used black spray paint within his paintings in 1954, however, where his earlier paintings were still more or less conventionally composed, a *One Second Drawing* is essentially auto-generative and Latham, as operator of the spray can, would have been able to exert little conscious control over the finished result.

Each of these *One Second Drawings* is carried out according to a different 'Time Signature' that forms part of the work's title and indicates different relationships between: 1) the creating of the work; 2) the showing of the work; 3) the intrinsic nature of the work (colour and texture, for instance; 4) a work's changing state; and 5) the way a work might relate to something external to itself. This particular work has the Time Signature 5:1, where the 5 indicates that its subject is something external to itself and 1 refers to its creation as essentially auto-generative. The critic Rosetta Brooks and artist John Stezaker both observed in 1975 that though there is a sense in which these works 'are minimalist, his reduction is completely antipathetic to American minimal art's physicality … To Latham the art "object" is "only half the work", the remainder being contextual alteration which develops the shifts in "spectator" consciousness.' Latham's *One Second Drawings* exemplify a position in which making is as much a function of the artist (or 'operator') and the artwork itself, as it is concerned with a relationship with a spectator.

One Second Drawing 17" 2002 (Time Signature 5:1) was presented to the Tate Gallery by the artist in 1976 at the same time that three other works by Latham were purchased, all having been included in the survey exhibition held at the Tate Gallery that same year. From this and other least events, Latham's Time-Base Theory continued to evolve and influence younger artists, and since his death this activity has centred on the foundation of his studio and home in London, now named Flat Time House, as a site for enquiry and exhibition. AW

Tony Cragg (born Liverpool 1949)
Stack 1975
Wood, concrete, brick, metal, plastic, textile, cardboard and paper 200 × 200 × 200. Acquired 1997

Tony Cragg's work has been described as a 'study of the relationship of the part to the whole', an idea derived from particle physics. Cragg has commented that science lacks perceivable images for its theories and that art is thus 'an important supplement and expansion of the sciences'.

Stack consists of a multitude of miscellaneous objects and materials packed tightly together to form a solid cube. Geometry meets random selection in this ordering of assorted detritus, which ranges from building materials to discarded magazines. Pieces of wood of varying dimensions are placed horizontally throughout the structure, compressing the materials into dense strata and conveying the impression of geological layers. *Stack* resembles a cross-section view of long-forgotten, buried rubbish. This reference both to geology and archaeology resounds throughout Cragg's career. He identifies as key themes in his work his relationship to the natural world and humankind's impact on nature. Insisting that what we call the 'natural world' is increasingly man-made, Cragg has said that he 'refuse[s] to distinguish between the landscape and the city', adding that man-made objects are 'fossilized keys to a past time which is our present'. He seeks to build a 'poetic mythology' for the industrially produced objects of our time. In 1992 Cragg said:

I see a material or an object as having a balloon of information around it. Materials like wood already have a very occupied balloon. The objects of our industrial society as yet have very little information attached to them, so even if something like plastic can be accepted as a valid material for use, it still remains very unoccupied. There is a lot of work to be done to actually make a mythology for this material, over and above its extremely practical and utilitarian value.

This sculpture is one of five *Stack* pieces that Cragg made between 1975 and 1985, the first of which was produced while he was at the Royal College of Art. Cragg's policy at the time was not to preserve the materials used, but to recreate the sculpture anew each time. The *Stack* works were also Cragg's first large-scale sculptures. They relate closely to his very early works such as *Combination of Found Beach Objects* 1970 (no longer extant), in which he orders and classifies materials as disparate as stones, shells and crisp packets by arranging them according to type within a roughly drawn grid. They also anticipate Cragg's later practice of composing images out of myriads of discrete elements, such as *Axehead* 1982 (Tate T03791) and *Britain Seen from the North* 1981 (Tate T03347). HD

Gilbert & George (born Dolomites, Italy 1943; born Plymouth, Devon 1942)
England 1980
30 photographs, black and white, with dye on paper 302.6 × 302.6. Acquired 1981

As its title suggests, *England* 1980 deals with the concept of national identity, although Gilbert and George's position on this is deliberately ambivalent. Standing defiantly, they flank a traditional symbol of Englishness, the Tudor Rose. However, the rose is faded and blurry, suggesting its decline. The artists processed their own photographs of a wild English rose at their studio in Fournier Street, London, E1, colouring some of them red, some green. In adjacent black and white portraits the artists stand in a confrontational pose, which they described as making 'a physical salute' to England, one which involves 'all the physique, not just an arm'. Above, their images appear again, blood red, crouched down and gargoyle like. These images are reversed so that Gilbert appears above George and that of George above Gilbert, each making childish facial gestures that undermine the apparently patriotic stance of their counterpart below.

Gilbert & George met at St Martin's School of Art, London, in 1967, where they exhibited together and soon began to produce artworks in partnership. Their early work revolved exclusively around newly devised personas, for which they adopted the identity of 'living sculptures' both in their daily lives and in performances such as their first major work *The Singing Sculpture* 1969. Shortly after, they began to concentrate more on their films and large multi-part photographic works, which always include images of each other. Around 1977 Gilbert & George began to introduce images of the city and other people into their work.

A montage of self-portraits and photographic images taken around the streets of London, these works present an account of urban life around them, in particular the area in walking distance from their home in the East End. The *Dirty Words* series, which includes works such as *Cunt Scum* 1977 (Tate T07406) uses confrontational language and imagery to tackle issues such as morality, race and sexuality. It also reflects the racial tensions and atmosphere of hostility during the mid-1970s in East London, which experienced increased organised violence with the rise of the National Front. *England* is part of a subsequent series of over one hundred photo-works collectively titled *Modern Fears*. Produced between 1980 and 1981, these works focus on the death and decay they saw as permeating the urban environment. The colour red is used in many photographs of this period to heighten emotional impact and the visual intensity of the work.

The work was purchased by the Tate Gallery in 1981 having been exhibited in their exhibition *Gilbert and George*, Van Abbemuseum, Eindhoven, November 1980, which toured to Kunsthalle, Dusseldorf, January 1981; Kunsthalle, Bern, February; Centre National d'Art et de Culture Georges Pompidou, Paris, April; and the Whitechapel Art Gallery, July 1981. Most recently it was included in their retrospective exhibition at Tate Modern, *Gilbert & George: Major Exhibition* in 2007. KS

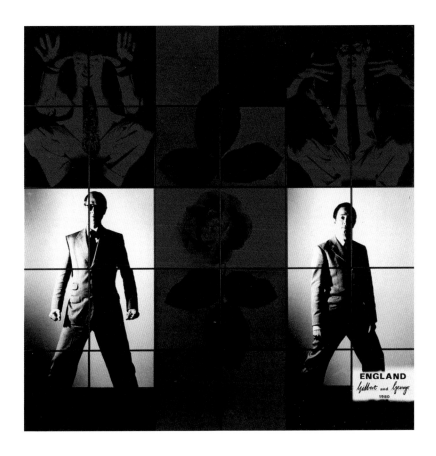

Richard Hamilton (London 1922 – Northend, Buckinghamshire 2011)
The citizen 1981–3
Diptych, oil paint on canvas, each 200 × 100. Acquired 1985

In episode twelve of James Joyce's *Ulysses* (1922) the book's protagonist Leopold Bloom finds himself in argument with 'the citizen', who is described as a 'Fenian bar-fly'. *Ulysses* had long been a source of inspiration for Richard Hamilton, since he had packed a copy of it in his kitbag in 1949 while on National Service. It is thus apt that in his first major work dealing with the 'Troubles' of Northern Ireland he turned to *Ulysses* to equate Joyce's character of the citizen with the civil rights struggle in Northern Ireland.

Hamilton's painting, *The citizen*, is based on BBC television footage of the Dirty Protest at the Maze Prison's H-Blocks in Northern Ireland between 1976 and 1981, and shows a man in his cell, the walls of which are smeared with his own excrement. In the right-hand panel of this diptych, Hamilton made his first full-length figure painting, showing a Republican prisoner with blankets wrapped around his waist and draped over his shoulders; bare-chested, a small crucifix hanging from his neck, bearded and with long hair, his head is turned to look straight out at the viewer. He stands at a slight angle on a mattress pushed up against the back wall and with his right foot forward. This stance – a form of *contrapposto* where a body's weight is shifted to one side – makes reference to Italian Renaissance depictions of saints. Over the cell wall are swirls of brown paint to represent his smearings of shit. The left-hand panel appears largely as abstract in its continuation of this loose pattern of brown paint. With this painting Hamilton shows the room as both prison cell and monk's cell, with the figure of Maze

detainee Hugh Rooney pictured as a member of the Irish Republican Army (IRA) and Christian martyr.

Updating Charles Baudelaire's formulation in *The Painter of Modern Life* (1863), Hamilton said at the time he painted *The citizen* that 'a major function of art has been to reflect contemporary appearances; social relationships, the style of life. Sometimes paintings have given expression to moral issues or political events.' The painting builds on earlier works by Hamilton that have an overt political content. That the painting derives from watching television news, its composition created through a distillation and collaging of images through the use of photographic process, signals Hamilton's interest in how mass-media images can be manipulated and what that manipulation could be made to mean.

The imagery deployed in *The citizen* is direct but also multi-layered. If one panel relates a story of martyrdom, in the other more abstract panel, Hamilton saw in the whorls of excrement echoes of the megalithic spirals of New Grange. The subject of *The citizen* is revealed as part of a continuum of Irish cultural history in which the past is always inscribed into the present. The figure of *The citizen* – locked into and determined by such a sweeping sense of history stretching far back beyond *The Book of Kells* to prehistory – also connects with a group of prints that Hamilton made in the early 1980s that link together the Fenian bar-fly of *Ulysses*, the H-Block protestors and the legendary Irish chieftain Finn MacCool. AW

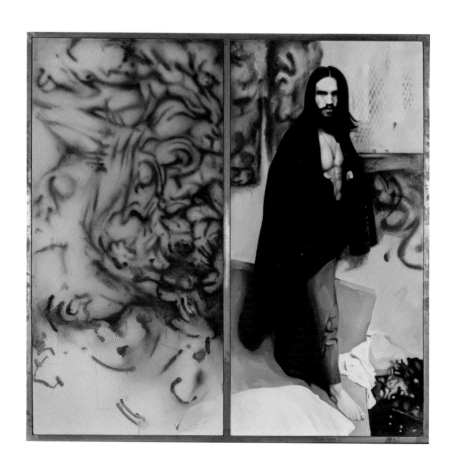

Richard Deacon (born Bangor, Wales 1949)
For Those Who Have Ears No.2 1983
Wood and adhesive 273 × 400 × 110. Acquired 1985

Richard Deacon is acknowledged as a leading figure whose work first achieved international acclaim in the 1980s. As a student at St Martin's School of Art between 1969 and 1972, Deacon concentrated on performance-based work. During his time studying on the MA Environmental Media Course at the Royal College of Art (1974–7), he became interested in the writing of sculptors William Tucker and Donald Judd. Both artists, albeit in different ways, sought to question the nature of sculpture. As a result Deacon began to make objects that explore relationships between the literal and the metaphoric, issues that continue to influence his practice today.

For Those Who Have Ears No.2 is one of a group of sculptures based on Deacon's ambition to make work that relates to parts of the human body, in particular those that pertain to hearing and seeing. It was made in the artist's studio in Brixton, South London for an exhibition of outdoor sculpture at Margam Park, near Port Talbot in West Glamorgan. As with all of his wooden sculptures from this period, form is described not by its mass but by its boundary. It is the interface between interior and exterior that is important. Deacon's extraordinary forms emerge from an interplay between his imagination and the intrinsic properties of the materials and the processes that he uses. The artist has commented: 'when you laminate things together... it seems to be more than just a technical process. It seems to be a very rich process.'

The work brings to mind the material world of everyday objects while his titles encourage a more metaphorical interpretation. Neither figurative nor abstract, the sensuously shaped laminated wood takes on associations relating to apertures and organs, such as ears or kidneys. The sculpture's contours, while charting the terrain between space and structure, also emphasise the discrepancy between different viewpoints. The work's title is linked to a number of biblical phrases concerned with those who have ears but do not use them. For example, 'we have heard with our ears', 2 Samuel 7:22 and 'they have ears, but hear not', Psalm 115:6. Like other works by Deacon, including *This, That and the Other* 1985 (Tate T06529) and *Struck Dumb* 1988 (Tate T05558), his use of titles helps to reinforce visual and verbal connections.

Throughout his career Deacon has placed importance on language itself. This interest is deep rooted and stems in part from his reading of poetic, philosophical and linguistic texts. The subject matter of the sculpture relates to a series of drawings he realised in 1978–9 collectively titled *It's Orpheus When There's Singing* 1978–9. These drawings were based upon his readings of the Austrian poet Rainer Maria Rilke's *Sonnets to Orpheus* (1922). In both Deacon explores the possibilities of an organic and curvilinear form. CW

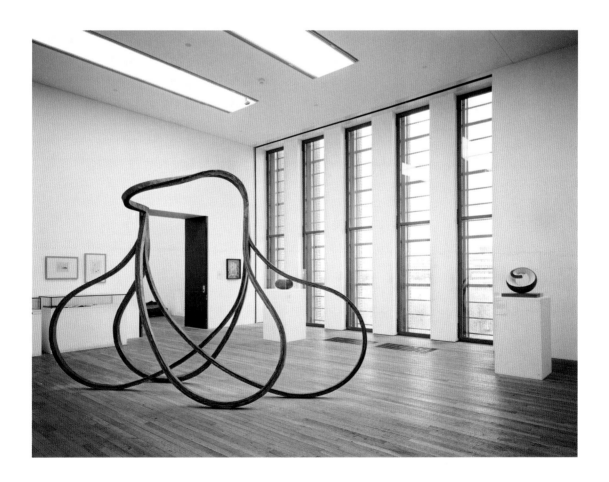

Bill Woodrow (born near Henley, Oxfordshire 1948)
Elephant 1984
Vehicle doors, 2 maps and vacuum cleaner 385 × 820 × 465. Acquired 1997

In the early 1980s Bill Woodrow devised a characteristic method of making sculpture from defunct household goods collected from London streets and junkyards. Cutting images from the metal casing of household appliances, such as a guitar from a Hotpoint washing machine in *Twin-Tub with Guitar* 1981 (Tate T03354), he juxtaposed images and objects, creating sculptures rich in visual associations. Woodrow continued to expand the range of his materials taken from ordinary life, whilst also elaborating the symbolic and narrative implications in his constructions.

Elephant 1984 is one of the artist's largest sculptural installations. A life-sized metal elephant head, constructed around an ironing board, is mounted like a trophy on the wall. Flanked by remnants of old maps of Africa and South America, linked as if by umbilical cord to the ear shapes that have been cut out of them, the elephant appears to be lifting an automatic weapon with its trunk from a watering hole suggested by a circle of car doors. Woodrow purposefully leaves evident the original identities of the objects he uses, as well as the mode of transformation. The potential of materials is exploited and symbols suggest a complex register of references about colonialism, consumerism, power, nature and industry.

The narrative element of *Elephant* differentiates Woodrow's work from other contemporary practice that had challenged the formalist concerns that dominated British sculpture in the 1960s. Woodrow's approach at this time brought him critical acclaim and prompted much international exposure, often alongside other British sculptors of his generation, Tony Cragg and Richard Deacon. Woodrow's use of abandoned appliances as a material also allowed for a very direct expression of disillusionment with the excesses of Western society and its throw-away consumer culture. The recurring imagery of guns in works like *Elephant* alludes to the increasing displays of power and violence on streets near the artist's South London home, which culminated in the Brixton riots in the summer of 1981.

In 1986 *Elephant* was shown in a solo exhibition at the Fruitmarket Gallery, Edinburgh and in *Entre el Objeto y la Imagen*, an exhibition of contemporary British sculpture in Spain. In 1996 it was exhibited in *Un siècle de sculpture anglaise* at Jeu de Paume, Paris affirming its significance in recent discourse on British sculpture. Woodrow was nominated for the Turner Prize in 1986. While retaining the symbolic and narrative elements of his work, he later began to weld steel, a sculptural technique that originated in the 1950s, and to use the traditional method of casting in bronze.

Elephant was acquired for the Tate's collection in 1997 as part of a substantial group of contemporary works presented by Janet Wolfson de Botton to celebrate the Tate Gallery centenary in 1997 and as a gesture of support for the creation of Tate Modern and Tate Britain. The gift was exhibited in 1998 at the Tate Gallery, and in 2000 *Elephant* was shown in the opening collection displays at Tate Modern. MB

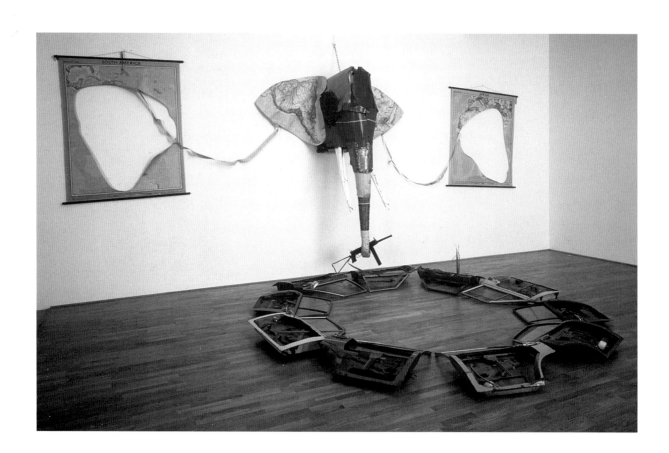

Howard Hodgkin (born Hammersmith, London 1932)
Rain 1984–9
Oil paint on wood 164 × 179.5 × 5.1. Acquired 1990

Howard Hodgkin began painting *Rain* in 1984, the year that he represented Britain at the Venice Biennale, an event that confirmed wide recognition of his mid-career success. When the work was purchased on completion by the Tate Gallery five years later, Hodgkin remarked: 'When I finished the picture, I came out of my studio thinking nothing could ever be quite the same again.' In his paintings Hodgkin has consistently explored what he has described as the 'representational appearances of emotional situations', yet while he had made his reputation with small, densely layered and worked paintings that relay remembered impressions of emotional intensity, *Rain* was unusually large for Hodgkin at the time. In this respect the painting heralded a new period of productivity for him by confirming the possibilities to be gained pictorially from increasing the size of his work in such a way that retained the immediacy of mark and intensity of colour found in much smaller paintings.

Early in his career, Hodgkin was in many ways viewed as an unusual artist; his work did not conform to the stereotypical view of artists of his generation who had emerged in the early 1960s between abstract expressionism and pop. In 1962, his first major exhibition was alongside the pop artist Allen Jones at the Institute of Contemporary Art (ICA) in *Two Young Figurative Painters*, described by the *Times* art critic, David Thompson, as 'a shot-gun wedding between a Bratby and some brash young abstract'. Even so, Hodgkin's painting has always been far from a pop cool, preferring an expressive register that has with time become increasingly romantic and personal. Similarly, Hodgkin deploys gestural abstraction to communicate feelings that are individually felt and intimate within a domestic scale, whereas abstract expressionism used size to underscore a mythic heroic rhetoric of artistic ambition – as did the neo-expressionism of the 1980s, influential at the time he was painting *Rain*. The success of *Rain* suggested not just that a large painting might be compositionally either more complicated or potentially more open, but most importantly it allowed him to make powerfully intimate paintings that could be more directly identified as part of the viewer's personal space.

Hodgkin's highly individual painterly language has developed through a gradual but continually evolving style over sixty years. The subject of his work and his means of retrieving this in his paintings through memory remains consistent. By the end of the 1960s, he had virtually eliminated all obviously figurative references from his paintings, restricting himself from then on to a shifting vocabulary of dots, stripes and overlapping planes of colour, while his subject matter encompasses portraits, interiors and social situations as well as experiences of nature and the outdoors (most often through the private spaces of a garden). One moment of transformation was the introduction of the painted frame, a device that was to become one of his signature motifs, whether physically incorporated into the painting or created as a painted illusion to define a subject as in *Rain*. LC-T / AW

Mark Wallinger (born Chigwell, Essex 1959)
Where There's Muck 1985
Oil paint, acrylic paint, charcoal, cellulose on metal and plywood 335 × 700. Acquired 2009

A strong element of political satire and social commentary underpinned Wallinger's practice when he first came to critical attention in the 1980s for his series of paintings using traditional genres to explore the representation of national identity. *Where There's Muck* 1985 was included in the artist's first solo exhibition in London, *Hearts of Oak*, held at Anthony Reynolds Gallery in 1986. Produced at the height of the Thatcher era, the work aimed to 'challenge the cosy mythology of British tradition'. It takes the form of a depiction of the painting *Mr and Mrs Andrews*, Thomas Gainsborough's best-known work held in the National Gallery, broken apart and collaged onto the wall on panels made up of bits of old packing cases from Collett's bookshop – the radical London bookshop where Wallinger worked at the time. A corrugated iron panel additionally carries an image of a human scarecrow carrying a rattle, and the word 'Albion', the oldest-known name for Britain, is spray painted across the various panels and the wall. The title refers to the old Yorkshire saying 'where there's muck, there's brass', meaning that there is money to be made from dirty jobs.

Gainsborough's original conversation piece displayed the extent of his subjects' estate, as well as the artist's proficiency in landscape painting; Wallinger's appropriation explored the disparities between history and heritage, issues of capital and property and the notion of Englishness in the context of the contemporary political landscape of Thatcherism. The artist has commented that he was 'trying to find a way to make work about how politics are represented, and to present some critique of the way the Tories had used that rolling hills, Elgar, jingoism strand that emerged around the time of the Falklands war.' In this work and in the series of history paintings made at in same period, Wallinger contrasts the image of Englishness with imagery that speaks of the anger of a dispossessed underclass in the 1980s. During this period three books were influential on his thinking: E.P. Thompson's *The Making of the English Working Class* (1963) that addressed the history of dissent and working-class organisation before and during the Industrial Revolution; Patrick Wright's *On Living in an Old Country* (1985) which explored the recent invention of a 'heritage' industry in Britain; and John Barrell's *The Dark Side of the Landscape: The Rural Poor in English Painting 1730–1840* (1980).

Wallinger's later work has often referred to issues raised in *Where There's Muck*. He has continued to explore the politics of representation, and his multi-ranging practice – which has also encompassed film, installation, performance and sculpture – has investigated issues of identity, race and class as well as the ambiguities of perception and the relationship between belief and faith. He returned to the subject of protest for his installation *State Britain* 2007, shown in the Duveen Galleries at Tate Britain. This was a precise reconstruction of peace campaigner Brian Haw's protest encampment in Parliament Square. Wallinger was awarded the Turner Prize for his contribution to British art in the same year. *Where There's Muck* is one of ten works by the artist in the Tate's collection. CW

Mona Hatoum (born Beirut 1952)
Performance Still 1985, printed 1995. Edition of 15
Photograph, gelatin silver print on paper, mounted on aluminium 76.4 × 113.6.
Acquired 2012

Mona Hatoum settled in London in 1975; she was on a short visit to London when civil war broke out in Lebanon, preventing her from returning to her Palestinian family. Hatoum became known in the early 1980s for a series of performance and video pieces that focused with great intensity on the body. Her work has consistently been interpreted in the context of her personal background, as a metaphor for universal conflict and resistance to oppression, and the artist has referred to the sense of dislocation that has informed her practice. Her background as an artist is, however, also clearly informed by the range of art that influenced artists studying in London in the late 1970s and early 1980s.

Performance Still 1985 is a black and white photograph that records one of three street performances that Hatoum carried out for the *Roadworks* exhibition organised in 1985 by the Brixton Artists Collective at their artist-run space in Atlantic Road in Brixton, a predominantly black working-class neighbourhood in South London. The exhibition, which included work by Rasheed Araeen amongst others, was organised by the artist Stefan Szczelkun, who described the project 'as an opportunity for ten artists to work in public for ten days and for the work to be documented in the gallery on a daily basis'. It was intended that the artists would produce their work in an environment and for an audience very different to that of the traditional gallery or museum.

The photograph shows the artist's lower body, barefoot on the street and wearing a pair of rolled up workman's overalls, with a pair of black boots tied to her ankles, which she is dragging along behind her. Her feet appear naked and vulnerable compared to the sturdy Doc Marten boots, worn at the time by both the police and by skinheads. The action took place at the scene of a number of racial clashes in the 1980s. This particular performance was first performed on the 21 May 1985 and consisted of the artist walking barefoot through the streets of Brixton for nearly an hour, with the boots attached to her ankles by their laces. The performance was subsequently repeated for the exhibition *Streets Alive* on 13 August 1986. It is one of some thirty-five performances Hatoum undertook between 1980 and 1988. They all demonstrated a high level of commitment, often requiring the artist to subject herself to actions that, on occasion, required participation from the audience.

Throughout her career Hatoum has persistently aimed to engage the viewer, eliciting emotional, psychological and physical responses to her work. In her early work she used her own body as a site for exploring the fragility and strength of the human condition under duress. In the late 1980s, Hatoum abandoned performances and turned her attention instead to installations and objects.

Performance Still, printed and published in 1995, ten years after the action, turns the original documentary photograph of the performance into a work in its own right and has come to identify this aspect of Hatoum's practice. CW

Leon Kossoff (born London 1926)
Christ Church, Spitalfields, Morning 1990
Oil paint on board 198.6 × 189.2. Acquired 1994

Kossoff has painted Christ Church at Spitalfields, East London, several times. Built in 1723–9 by architect Nicholas Hawksmoor (1661–1736), the church is faced with white Portland stone and with its imposing structure soaring upwards dramatically, it stands out from the surrounding brick terraced houses. Kossoff tackled the formal challenge this setting presented with a series of different compositions. In earlier paintings the focus is on the columns and portico while a severe perspective leaves the tower foreshortened and part of the spire off the canvas. In another version the facade appears awkwardly squashed to fit diagonally across the near square format of the painting. Similarly Tate's version shows the church leaning to the right, allowing space for the city life to intrude. The surroundings are indicated with rough impressions of lamp posts, trees and some figures in the foreground that contribute to the vibrancy of the scene. Kossoff has explained his ongoing interest in painting Christ Church:

> The urgency that drives me to work is not only to do with the pressures of the accumulation of memories and the unique quality of the subject on this particular day but also with the awareness that time is short, that soon the mass of this building will be dwarfed by more looming office blocks and overshadowed, the character of the building will be lost forever, for it is by its monumental flight into unimpeded space that we remember this building.

Of Ukrainian Jewish ancestry, Kossoff was born in North London. His early years were spent in Spitalfields, close to Christ Church, and nearby Bethnal Green, where he developed a deep connection with the area. The changing urban landscape, its architecture and inhabitants are a central and reoccurring theme in his work. Kossoff likes to return to his familiar areas, like the City of London, West End, Kings Cross and Camden Town, to paint intriguing architectural sites such as railways, swimming pools, tube stations and various imposing buildings. One can almost trace the life of his favourite subjects as they appear in multiple works in different light conditions, times and seasons.

Kossoff's paintings express an intense emotional engagement with his materials. Greatly influenced by Turner and by the old masters, the young Kossoff would spend a lot of his time in London's museums making hundreds of studies based on paintings by Rembrandt, Rubens, Goya, Constable and others. However, his painting style has common characteristics to that of his close friend Frank Auerbach, whom he met when they were both students at St Martin's School of Art in the early 1950s. Having been mentored and encouraged by David Bomberg, both artists celebrate the materiality of paint. While Auerbach prefers working on canvas, Kossoff always works on board, applying his thick mass of paint with a knife. Forms are built up with colours that blend and marble, bursting over the edges of the board, while delicate threads of thick paint lace the richly textured surface, revealing a tactile and energetic working process.

Although Kossoff has returned repeatedly to subjects he likes and knows well, he starts every new painting with a charcoal study on site in preparation for the painting he will then make in the studio. The preparatory drawing for this painting, *Christ Church, Spitalfields* 1990, was gifted to the Tate Gallery by the artist in 1993. SK

Damien Hirst (born Leeds 1965)
The Acquired Inability to Escape 1991
Glass, steel, silicone rubber, Formica, MDF, chair, ashtray, lighter and cigarettes
213.4 × 304.8 × 213.4. Acquired 2007

Damien Hirst first came to attention in London in 1988 when he conceived and curated *Freeze*, an exhibition in a disused warehouse which showed his work and that of his friends and fellow students at Goldsmiths College. In the years since that exhibition, Hirst has become one of the most influential artists of his generation. His works deal explicitly with such subjects as the fragility of life and contemporary society's reluctance to confront the subject of death.

The Acquired Inability to Escape is a sculptural installation that consists of an office table and chair enclosed in a steel-framed glass vitrine, or cell. It belongs to a group of vitrines that Hirst made during the 1990s, all of which contain combinations of everyday objects arranged in such a way as to evoke an absent human presence. The glass walls invite the viewer's scrutiny while emphasizing the sealed condition of the space inside. The vitrine has two sections of unequal size, separated by a 45 mm gap that allows a flow of air between the two chambers. While the smaller chamber is empty, the larger is just big enough to accommodate the table and chair. On the white laminate surface of the table is a packet of cigarettes, a cigarette lighter and a glass ashtray containing cigarette butts. While this suggests the presence of a recent occupant, the very idea of a human presence in the cell accentuates its claustrophobic nature.

The steel-framed chamber is a signature structure for Hirst, and the heavy industrial aesthetic references the sculptural forms of American minimalists such as Donald Judd (1928–94) and Carl André (born 1935). However, he has also cited the painter Francis Bacon (1909–92) as an important early influence, and paintings by Bacon feature cage-like lines around the figures, suggestive of the cell structures subsequently developed by Hirst.

Hirst has discussed the symbolism of the cigarettes in his work as relating to the cyclical nature of life: 'The whole smoking thing is like a mini life cycle. For me the cigarette can stand for life, the packet with its possibilities stands for birth, the lighter can signify God which gives life to the whole situation, the ashtray represents death.' The inevitability of death is evoked by the hopeless cycle of entrapment suggested by the title, which in turn is confirmed by the total enclosure of the glass cell.

In 1993 Hirst created three further versions of *The Acquired Inability to Escape* entitled *The Acquired Inability to Escape Inverted*, *The Acquired Inability to Escape Divided* and *The Acquired Inability to Escape Inverted and Divided* according to the processes they were subjected to. A version cased in a white-framed vitrine, *The Acquired Inability to Escape, Purified*, was made in 2008.

The Acquired Inability to Escape was first exhibited in Hirst's solo exhibition at the ICA, London, titled *Internal Affairs* in 1991–92, and was subsequently exhibited in the Third International Istanbul Biennial in 1992 and *The Agony and the Ecstacy*, Hirst's solo exhibition at the Museo Archeologico Nazionale di Napoli in 2004. It was presented to Tate by the artist in 2007 and was included in the exhibition *Classified* at Tate Britain in 2009 and Hirst's solo exhibition at Tate Modern in 2012. HD

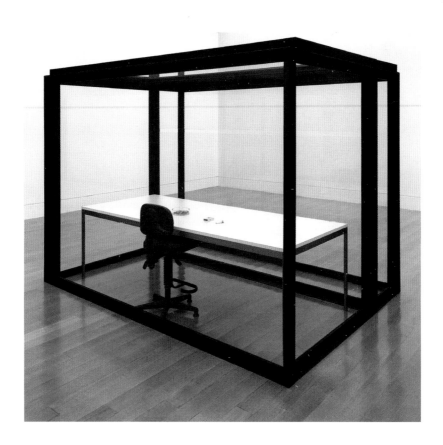

Gary Hume (born Tenterden, Kent 1962)
Incubus 1991
Alkyd paint on Formica 238.9 × 384.6. Acquired 1996

Incubus is a large, five-panelled painting, modelled on the generic swing doors found in hospitals and other institutions, with minimal features such as round windows and rectangular hand plates. Gary Hume started making paintings that replicated the geometric form of these doors in 1988, after coming across an image advertising private health care. The first hospital door he used as a template was found discarded inside St Bartholomew's hospital in East London. Made according to a standard size, and painted in glossy household paint, the flat, evenly applied planes of shiny, reflective colour offered an alternative to the neo-expressionist style of painting that dominated in Britain in the 1980s. In their use of synthetically coloured paint, and the reference to industrially produced forms, these distinctive paintings had a greater affinity with the work of earlier generations of American artists, such as Donald Judd or John McCracken, or the British new generation sculptors, such as Phillip King, William Tucker or David Annesley.

Hume has commented on his choice of subject:

I could represent something which didn't in itself have a clear narrative, but onto which you could project your own narrative; and represent the actual thing in a painting by painting the actual thing. So this whole fiction, is it a door, or an image of a door? Is it a representation of a door, or is it an actual door that doesn't function? All those ideas were going on within minimalism in British sculpture. So the painting really fitted in there just beautifully. I'd found this jigsaw piece that could satisfy my need to paint, and my intellectual thoughts about art.

Hume received critical acclaim for this body of work soon after graduating from Goldsmiths College, London. An early example of his 'door' paintings was exhibited in 1988 in *Freeze Part II*, curated by Damien Hirst, and often alongside a high-profile group of young London-based artists, his work was exhibited widely internationally. Although Hume distanced himself at the time from the political significance of his choice of subject matter, his decision to focus on hospital doors during a period when the Conservative Government, led by Margaret Thatcher, was systematically withdrawing funding for the National Health Service in Britain, now seems to symbolise the political ethos of the period.

Hume's initial door paintings were painted in nondescript colours such as magnolia, emphasising their institutional nature, but the seductive pink glossy sheen and title of *Incubus* suggests skin, or the veneer of make-up. This painting is made on Formica, but Hume painted later works on aluminium plate, which made it easier technically to achieve a smooth finish, and he continued to use this support when he started painting other subjects from 1993.

Hume was nominated for the Turner Prize in 1996, the same year that Janet Wolfson de Botton presented a gift of sixty contemporary works of art to Tate, including *Incubus,* which was first exhibited at the Tate Gallery in 1998. The work was also shown in Hume's monographic exhibitions at the Kunsthalle, Bern and the Institute of Contemporary Arts, London in 1995, and in *Gary Hume: Door Paintings* at Modern Art Oxford in 2008. KS

Steve McQueen (born London 1969)
Bear 1993
Film, 16mm, shown as video, projection, black and white, duration: 9 min., 2 sec. Acquired 1996

While Steve McQueen has worked in a variety of media, the language of film is at the heart of his practice. He has said that it is not the narrative potential of film that interests him but its poetic qualities, that it enables us to see an image in a fresh and new way. His pared down approach to filmmaking produces elegant, uncluttered works that evoke complex ideas and emotions.

In common with most of Steve McQueen's early films, *Bear* 1993 is black and white and silent. It was shot on 16mm film but has been transferred to video and is installed floor to ceiling across a single wall in a dark room. It documents an ambiguous encounter between two naked men, one of whom is the artist, which involves teasing and wrestling, shifting throughout between tenderness and aggression. Silent stares, glances and winks between the two men create a language of both flirtation and threat. Although not an overtly political film, for many viewers *Bear* raises sensitive issues about race, homoeroticism and violence. Close-up shots of the men's faces and bodies are dramatised by the stark lighting and unusual camera angles. The pace of the film varies between extremely slow movement over the contours of each man's body, intimately – even forensically – recording the bodies' details, and dynamic scenes of sudden sparring which disorientate the viewer with an intense flurry of limbs, light and shadow.

McQueen's strategy of showing the work in an enclosed space and on a scale far greater than human proportions has important implications, as does his decision to have no soundtrack. He has explained:

You are very much involved in what's going on. You are a participant and not a passive viewer. The whole idea of making it a silent experience is so that when people walk into the space they become very much aware of themselves, of their own breathing. Unlike silent movies, which weren't really silent because there was always musical accompaniment in the background, it is real silence ... I want to put people into a situation where they're sensitive to themselves watching the piece.

Similarly McQueen's use of unexpected camera angles has meaningful effects. As McQueen puts it: 'The idea of putting the camera in an unfamiliar position is simply to do with film language ... Cinema is a narrative form and by putting the camera at a different angle ... we are questioning that narrative as well as the way we are looking at things.'

After making his first films while still a student at Goldsmiths College, McQueen was awarded a place at the Tisch School of the Arts, New York University, but finding the school overly prescriptive, he left after a year. *Bear,* made towards the end of his studies at Goldsmiths College, was first presented in the exhibition *Acting Out* at the Royal College of Art in 1994. *Bear* was presented to the Tate's collection by Tate Members in 1996, by which time McQueen was emerging as a major presence in contemporary British art, winning the Turner Prize in 1999. More recently he has directed feature films, including *Hunger* 2008 and *Shame* 2011. *Bear* has been shown in displays of the collection at Tate Modern and in the exhibition *Real Life: Film and Video Art* at Tate St Ives in 2003. HD

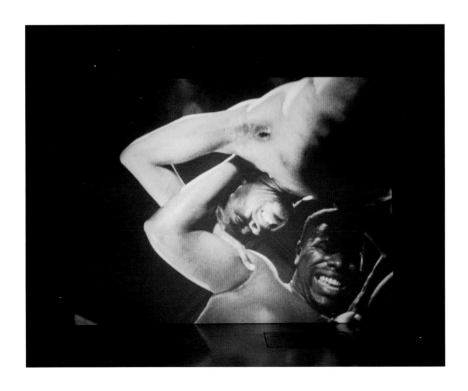

Peter Doig (born Edinburgh 1959)
Ski Jacket 1994
Oil paint on 2 canvases, support, right: 295.3 × 160.4; support, left: 295 × 190. Acquired 1995

The migratory nature of Scottish-born artist Peter Doig's biography has had a profound influence on the iconography and subject matter of his work. His partial relocation from London to Trinidad in 2002 signalled a return to the country in which he lived as a child. From Trinidad the family had moved to Canada, where they lived in various locations until settling in rural Ontario.

Ski Jacket is one of several large paintings depicting snowy landscapes made during the 1990s, when the artist was based in London. Like many of Doig's works, the painting originates from a photographic image sourced from the artist's own snapshots or found in books, newspapers and magazines, in this case a photograph of a Japanese ski resort in a Toronto newspaper. The original scene of people viewed at a distance is hard to distinguish since the bodies appear to dissolve into the blurry, pinkish surface of the two adjoined canvases. The dark, triangular mass of pine trees gives a central focus to the composition – their awkward, irregular shape the result of their reflected positioning on the diptych's asymmetric join. The use of doubling to create visual distortion is a device Doig used in paintings during this period. The sense of the painting depicting a place not quite real is heightened by the artist's distinctive and inventive use of colour, built up through overlaid washes. Doig has described his impulse at this time to paint landscapes so obviously alien to the urban environment of London. The work draws from the memory of his life

in Canada, but ultimately comes from creating a different place in his imagination. He has commented on this work:

Ski Jacket depicts beginner skiers. If you look carefully you can see that they are all groping to stay on their feet, they are in very awkward positions, and whilst there are other things going on in that painting, that sense of awkwardness was one of the things that attracted me to that image. And I think painting is a bit like that, it takes time to actually take control of the 'greasy' stuff – paint. But I have also used the way you perceive things when you are in the mountains; for example when you are feeling warm in an otherwise cold environment, and how light is often extreme and accentuated by the colours in the paintings, to the extent they appear seemingly psychedelic. There used to be these rose-tinted goggles that made everything look as pink as cotton candy.

Ski Jacket was included in the Turner Prize exhibition at Tate Gallery, when Doig was nominated in 1994 and was purchased in 1995. It has been regularly included in Tate displays and featured in his monographic exhibitions in 1998 (Kunsthalle Kiel, Kunsthalle Nürnberg, Whitechapel Art Gallery, London), 2001–2 (Morris and Helen Belkin Art Gallery, Vancouver, National Gallery of Canada, Ottowa and The Power Plant, Toronto) and in 2008 (Tate Britain). KS

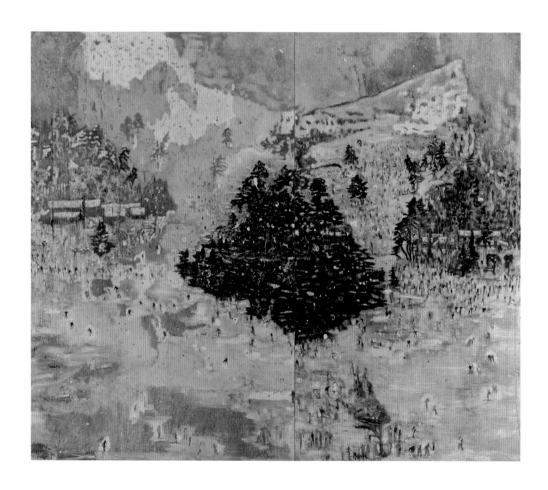

Rachel Whiteread (born London 1963)
Untitled (Floor) 1994–5
Polyester resin 20.4 × 274.5 × 393. Acquired 1996

Rachel Whiteread made her first cast of a floor in 1992 when invited to participate in Documenta IX in Kassel, Germany. She is renowned for her sculptural casts of the spaces in, around and underneath domestic objects and architectural features. Her earlier cast works were confined by the contours of existing objects, and this was the first time that she had fabricated the form of the sculpture, casting from the surface of the floorboards and the hidden space between the joists in plaster. *Untitled (Floor)* was made using a similar technique. It comprises seven rows of the spaces between the joists of a 13-square-foot (15.7-square-metre) floor cast in dark green synthetic resin. Whiteread describes the secret spaces between and beneath floors as the 'bowels' of the house, enabling the flow of inhabitants from room to room. She became captivated by the wooden floorboards of her apartment while on a DAAD Artist-in-Residency programme in Berlin during 1992–3 and these became the basis for the largest body of drawings she had produced to date.

Untitled (Floor) was begun in the same year that Whiteread made her first sculpture in resin, *Table and Chair* 1994, the result of eight months of testing in order to ensure the volatile polymer would be stable enough for use in such large quantities. In contrast to earlier works that used plaster and concrete to uniformly block out space, resin offers a more complex articulation of the space around an object, at once sealing and revealing the void. Resin also retains the quality of its original liquid state and our perception of the material changes according to environmental conditions. *Untitled (Floor)* is a deep, opaque green when seen in shade but is transformed to a translucent honey tone as if lit from within when penetrated by direct light.

Themes of absence and presence, mass and immateriality, and robustness and transience permeate Whiteread's work, which ranges in scale from chairs, mattresses, doors and windows to casts of entire rooms and a house. In solidifying the air around or inside everyday objects and architectural structures, using materials such as plaster, concrete, rubber and polyester resin, she creates monuments to the inconspicuous details of life. The spare, simple form of the sculptures and the use of industrial materials have associations with minimalism, but they are far removed from its machined finishes and reductive aesthetic. While the body is never directly depicted, the objects always relate to human proportions and bear traces of former use – wear and tear on furniture, trapped hairs in discarded mattresses – imbuing them with a sense of tactility, specificity and narrative potential.

Untitled (Floor) was purchased for the Tate's collection in 1996 and was included in her monographic exhibition *Shedding Life* at Tate Liverpool in the same year. It was also included in *Turner Prize: A Retrospective 1984–2006* at Tate Britain in 2007. She was awarded the prize in 1993, the same year she made *House*, a cast of a Victorian terraced house in East London that was destroyed the following year. LCT

Sarah Lucas
Pauline Bunny 1997
Wooden chair, vinyl seat, tights, kapok, metal wire, stockings and metal clamp 95 × 64 × 90.
Acquired 1998

Pauline Bunny was one of the eight female figures that formed part of the installation *Bunny Gets Snookered*, Lucas's first exhibition at Sadie Coles HQ, London in 1997. The show presented a group of eight 'bunny girls' made from stuffed tights and sitting on a variety of chairs arranged around and on top of a snooker table in the gallery space. Clamped to the back of their chairs, these headless female figures have floppy ears, limply dangling arms and passively lolling legs, undermining the fantasy image of the glamorous 'bunny girl' associated with Playboy Clubs from the 1960s to 1980s. Each bunny wears different coloured stockings corresponding to the balls in a snooker game. *Pauline Bunny*, named after Pauline Daley of Sadie Coles Gallery, is clad in black stockings, the highest rank of the snooker balls. The artist had originally titled this work *Bunny Gets Snookered #7* before changing its title in 2002. In the installation a series of black and white photographs depicting single bunnies were hung on the adjacent walls.

The origin of the bunnies can be traced back to the work *Octopus* 1993, a sculpture of an octopus made out of tights stuffed with newspapers. While working on her exhibition *The Law,* held in 1997 in a disused industrial space in Clerkenwell, Lucas reconfigured the stuffed tights to stand in for a female figure. 'I'd made a cage [*Round about My Size* 1997] for *The Law*', the artist has explained, 'and I wanted something to go with it, something quite sexy. So I got the tights idea out again. But this time I stuck the chair in.

I didn't know where I was going with it... And I just happened to have a chair around that had a certain kind of back. And once I'd got the legs actually stuffed, I wanted to see how they looked, so I just clipped them on the back of this chair and that was it. It was brilliant.' The bunny has since become a recurrent figure in Lucas's work, and it has recently reappeared in a more abstract guise in a series of works called *NUDS*, in which stuffed nylon tights are arranged as various biomorphic forms.

Lucas came to prominence during the 1990s with a body of highly provocative work. Following the surrealist tradition, she makes sculptures from an unexpected range of everyday materials placing familiar objects in shocking or unexpected arrangements. Many of these make explicit reference to male and female genitalia and exploit the sexual innuendo that is a key feature of popular British comedy, found in bawdy seaside postcards, *Carry On* films and tabloid newspapers. By literally adopting the language and media of popular culture, Lucas challenges gender stereotypes and accepted sexist attitudes. Similarly she has made many self-portraits that question traditional depictions of women as muse or seductress and challenge the clichéd image of the modern artist.

Pauline Bunny was presented by the Patrons of New Art to Tate's collection in 1998. The work was included in the artist's monographic exhibition at Tate Liverpool in 2005. CJM

Wolfgang Tillmans (born Remscheid, Germany 1968)
chaos cup 1997, from *if one thing matters, everything matters, installation room 2 1995–1997* 2003
Photograph, chromogenic print, on paper 30 × 40. Acquired 2007

chaos cup 1997 offers a close-up view of a cup of black coffee tea. A fine skin has formed on the surface of the liquid; the skin has split and created a network of delicate lines that resemble the silhouette of a leafless tree. This image is part of an installation of thirty-six photographs titled *if one thing matters, everything matters, installation room 2 1995–1997* 2003, which can also be displayed in groups and some individually. The title of the installation conveys Tillmans' desire for all of his photographs to be seen as equally significant. Tillmans' subject matter comes from unlikely sources – a half-naked man urinating on a chair, rats rummaging through city rubbish, snow melting on the pavement. He questions conventional aesthetics and codes of representation and, in doing so, reinvigorates the genres of still life, landscape and portraiture.

Wolfgang Tillmans came to England from Germany in 1990 to study photography. After graduating, his innovative style swiftly won him widespread acclaim. The immediacy and clarity of his images, combined with his often unusual choice of subject matter was matched by an equally unconventional mode of display.

In his gallery installations, Tillmans defies the usual linear presentation that often characterises photographic displays, and instead brings together an array of formats, using pins, tape and bulldog clips, for example, to attach his photographs to the wall in a rich variety of combinations, often mixing old images with new.

This apparently informal, casual presentation is deceptive, for each juxtaposition is rigorously thought through. With each collage of disparate work across a gallery wall, Tillmans constructs new narratives and meanings, while inviting the viewer to project their own.

His early colour images had a snapshot aesthetic, apparently recording ordinary moments in his and his friends' lives, and were circulated in magazines while also being exhibited in galleries. Portraits of his friends at raves, festivals or just spending time together proliferate and convey the sense of spontaneity and energy in Tillmans' early pseudo-documentary style. These images often appear artless and improvised but Tillmans knowingly adopted a 'language of authenticity' and many of the images are carefully staged.

Tillmans has pushed the possibilities for photography further through his printing methods. In 1998 he began experimenting or intervening in darkroom processes, manipulated images conflate the figurative with the abstract; landscape images have been disrupted by gestural streaks or blobs of colour, creating painterly effects. In 2000 Tillmans began to make entirely abstract 'cameraless' pictures that record the movement of various sources of light over photosensitive paper. In *Blushes #82* 2001, fine threads of colour, apparently drawn with light, swim over the surface of the photographic paper, emerging from and fading into pale backgrounds. The forms are suggestive of the body, as fibres or pores, but remain completely abstract.

After a period living in New York, Tillmans was based primarily in London from 1996 to 2007, after which point he began to divide his time between London and Berlin. He won the Turner Prize in 2000 and held a retrospective exhibition at Tate Britain in 2003. *if one thing matters, everything matters, installation room 2 1995–1997*, which was included in that exhibition, was presented to the Tate's collection by Tate Members in 2007. HD

Chris Ofili (born Manchester 1968)
No Woman, No Cry 1998
Acrylic paint, oil paint, polyester resin, pencil, paper collage, glitter, map pins
and elephant dung on linen 243.8 × 182.8. Acquired 1999

Chris Ofili came to prominence in the 1990s with exuberant paintings, such as *No Woman, No Cry*, that pulsate with the colour and energy of the artist's brushwork and bead-like application of paint, to which he adds intricate layers of resin and glitter, colourful map pins and collaged magazine cut outs. After a formative trip to Zimbabwe as a student at the Royal College of Art, Ofili began experimenting with elephant dung as a potential medium in his art and soon after began to apply balls of dung sourced from London Zoo directly onto the surface of his canvases, as well as using them to support the paintings on the floor and allow them to lean against the wall.

The form and content of Ofili's canvases from this period bring together a wide range of sources from contemporary and popular culture, as well as art from the past. His iconography combines aspects of the urban black experience, film, music and religion, whether from American gangsta rap, blaxploitation movies, pornography or the spiritual imagery of William Blake, which the artist encountered at the Tate Gallery as a student. Music has continued to be a decisive influence and Ofili has described how he approaches the construction of his paintings like a hip-hop DJ or rapper, sampling and mixing disparate sources to make a new whole.

Visually striking and technically innovative, *No Woman, No Cry* is one of a series of hieratic female heads from this period. The work refers to a particular moment in Britain's recent history, and was conceived as a tribute to the teenager Stephen Lawrence, whose murder in London in 1993 was first investigated by the Metropolitan Police. A subsequent enquiry found that the police investigation had been mishandled and described the police force as institutionally racist. While following the development of the enquiry on television, Ofili became deeply moved by Doreen Lawrence's strength and dignity throughout the investigation into her son's brutal killing. The tender portrait incorporates the universal themes of melancholy, loss and grief in a quietly powerful and poignant way. A woman's head is featured in profile as in a Renaissance portrait and in each of her teardrops and hidden in her pendent elephant dung necklace Ofili has pasted a newspaper cut-out cameo of Stephen's face. Just discernible to the naked eye, painted in phosphorescent paint underneath the image, are the words 'R.I.P. Stephen Lawrence', and the dates of his birth and death. It is not untypical for Ofili to name paintings after song lyrics, but Bob Marley's song 'No Woman, No Cry' has a somewhat deeper significance, as it was written in the year of Stephen Lawrence's birth. Ofili has since designed decorative windows for the Stephen Lawrence Centre in South London with the architect David Adjaye, with whom Ofili collaborated for his celebrated installation based on the Last Supper, *The Upper Room* 1999–2002, acquired by Tate in 2005.

No Woman, No Cry was first exhibited in Ofili's winning Turner Prize exhibition at the Tate Gallery in 1998 and was acquired for the Tate's collection in 1999. The painting has been frequently displayed at Tate sites and was included in Ofili's monographic exhibition at Tate Britain in 2010. HL

Tacita Dean (born Canterbury 1965)
Fernsehturm 2001
Film, 16mm, projection, colour and sound, 44 minutes. Acquired 2002

Tacita Dean is best known for her film works, characterised by their lingering shots and particular qualities of stillness and light. Alongside works using drawing, photography and sound, they share an exploration of time and place, fictional or real narrative and often the subject of film itself.

Fernsehturm 2001 is the first of several works by the artist that respond to the architecture and history of Berlin where Dean lives. It was filmed with static cameras in the revolving restaurant at the top of the iconic television tower in Alexanderplatz, located in former East Berlin. Dean first visited the Telecafé as a student in 1986, when it provided a vantage point to survey the extent of the divided city. She returned to it as the subject for her work when she relocated to the city in 2000, initially for a year-long DAAD Artist-in-Residence programme. The film documents the activity of the restaurant interior during the transition from afternoon to evening. Framed by a waitress setting tables at the beginning of the film and clearing plates away at the end, the static shots capture diners looking out at the almost imperceptibly rotating landscape. The widescreen cinematic format, achieved through the use of an anamorphic lens, resonates with the panoramic view of the city outside and emphasises the resemblance of the window frames to the structure of film. Light inside the restaurant gradually shifts as the day progresses and the sun eventually sets, the electric lights are turned on and the restaurant becomes a confined space mirrored by the reflections of the scene in the windows. The repetitive routine of the waiters, the cyclical

motion of the spherical restaurant and of the rotation of the earth is echoed in the display of the film on a loop.

Berlin's Fernsehturm, completed in 1969, incorporates the social utopian ideas of the German Democratic Republic. Dean explains:

> It was visionary in its concept and [as a] symbol of the future and yet it is out of date ... Revolving spheres in Space still remains our best image of the future, and yet it is firmly locked in the past: in a period of division and dissatisfaction on Earth that led to the belief that Space was an attainable and better place. As you sit up there at your table, opposite the person you are with, and with your back to the turn of the restaurant, you are no longer static in the present but moving with the rotation of the Earth backwards into the future.

Fernsehturm was first shown in 2001 in Dean's solo exhibition *Recent Films and Other Works* at Tate Britain, and was purchased for the Tate's collection in 2002. The rotating motion and the gradual setting of the sun have parallels with an earlier film, *Disappearance at Sea* 1996, shot in a lighthouse. However, the politicised and urban content signifies a departure from the themes of the sea and disappearance which had occupied her work in previous years, and sees her moving on to examine the process of time passing through filmic portraits of modernist landmarks and artists, such as Cy Twombly. MB

Jake (born Cheltenham 1966) and Dinos Chapman (born London 1962)
Chapman Family Collection 2002
24 wooden sculptures, metal, horn, coin, bones and shells, display dimensions variable.
Acquired 2008

The *Chapman Family Collection* comprises thirty-four wooden carvings, displayed on plinths and dramatically illuminated by pools of light in a darkened room. When first exhibited in 2002 at White Cube Gallery, the press release heralded it as an extraordinary collection of rare ethnographic and reliquary fetish objects from the former colonial regions of Camgib, Seirt and Ekoc, which the Chapman family had amassed over seventy years. The mode of presentation was typical of an ethnographic museum. However, the inauthenticity of the objects gradually dawns on the viewer, as the unmistakable face of Ronald McDonald leers out from one of the works. Flame-haired and grinning, the familiar mascot of the world's most famous burger chain forces the visitor to review

what has been seeing. Closer inspection reveals countless references to McDonald's – various squat fetishes can be re-read as cheeseburgers, while the spiky protruberances on many objects are clearly French fries. Indeed the supposed sources of these ethnographic treasures – Camgib, Seirf and Ekoc – can revealingly be read backwards. The catalogue numbers assigned to each object – CFC76311561, CFC77227084, etc – are the telephone numbers of McDonald's branches in central London.
The Chapman Family Collection is one of a number of works by the artists that make reference to McDonald's.

The *Chapman Family Collection* makes overt references to the history of modern art with, among other examples, a miniature version of Brancusi's *Endless Column* topped

by a red-haired mask. By invoking the iconography of modern art, Jake and Dinos Chapman make the issue of cultural trespass the broader issue addressed here, rather than any simplistic reference to a fast-food chain. Waldemar Januszczak has written that, with this work, the Chapman's seek 'to accuse modern art of ruthless colonial theft'. The *Chapman Family Collection* appears to comment on modernism's exploitation of so-called 'primitive' art by associating it so strongly with the very face of capitalism. But it also draws attention to the way in which some museums package ethnographic artefacts, draining them of their sociological and religious function and re-presenting them as aesthetic objects.

Brothers Jake and Dinos Chapman have been working together since the early 1990s. Their art is characterised by scepticism, parody and irreverence, and combines a vast range of influences, drawn from the history of art, philosophy, critical theory, psychoanalysis and popular culture. Their work engages with controversial issues including the human capacity for barbarity, war and violence, while it exploits an aesthetic of obscenity and horror. *The Chapman Family Collection* was exhibited in Tate Liverpool's monographic exhibition *Bad Art for Bad People* in 2007 and was purchased in 2008 for the Tate's collection, which holds examples of the artists' early practice, to extend their representation with this major installation. The work was first exhibited at Tate Britain in the exhibition *Classified* in 2009. HD

Richard Wright (born London 1960)
Untitled 2002
Gouache on wall, display dimensions variable. Acquired 2010

Richard Wright's delicate wall paintings sometimes occupy whole rooms or extensive areas, creating a sublime impact. More often they are small, subtle and awkwardly placed, claiming a modest existence on a ceiling, a cornice, or the edge of a wall. As Wright invents alternative spatial arrangements through his interventions, solid structures can look broken up, reconfigured, or seem transparent and fluid.

Untitled 2002 is an abstract wall painting made in red and grey gouache. Although it appears perfect and precise, the rutted brush strokes reveal its fragile nature. Free flowing and organic in form, its intricate composition conveys the flickering play of small flames as they burn bright in red or fade into smoky slivers of grey. The work is placed in a corner of the gallery, its transient impression at odds with the definitive rigidness of the architectural feature. From a distance it appears suspended and transparent. As the visitor is drawn closer to this liminal space, the painting gradually appears to unfold either side of the wall as a Rorschach inkblot. As Sarah Lowndes has observed, 'it makes the walls of the room appear like the pages of a book, with the line where the two walls meet as "the spine"'.

Wright adopts an intimate and improvised approach in the creation of his work. Context-specific, rather than site-specific, each painting is 'created' from the moment he steps into the space in preparation for an installation, and is still being changed and evolved until the final brushstroke. The form, colour and position of the work is developed in response to the architecture of the room, as well as the intrinsic conditions that relate to a particular place: the sensory impact of the surroundings such as light and shadow; the impact of memory and history; the time available to complete each painting; and various arbitrary and unforeseen possibilities that might occur during its creation. *Untitled* 2002 was first made as part of a large installation at Gagosian Gallery at Heddon Street, London in 2002, and was displayed alongside other wall paintings and works on paper. Each time it is installed in a different space and context, a new set of formal and spatial relations unfold.

Glasgow-based Wright's meticulous wall paintings, drawings and printed works incorporate traditional sign-painting techniques, and decorative imagery often associated with popular or underground culture, as well as a range of historical and contemporary influences. These different registers are plundered, amalgamated, adapted and re-imagined, according to surroundings and context.

Wright's painstakingly formulated wall paintings are short-lived, evanescent and ultimately invisible under layers of white emulsion after the end of each exhibition. His transient practice embraces fragility, erosion and disappearance as the natural conclusion of creation. Articulating the paradox between prolonged, intense labour and what the artist calls the 'fugitive aspect of the work', temporality appears as a solution to the anxiety of permanence and commodification. SK

Jeremy Deller (born London 1966)
The History of the World 1997–2004
Pencil and acrylic paint on wall, display dimensions variable. Acquired 2009

The History of the World is a work of social and community cartography that accompanied and provided a visual rationale for Jeremy Deller's project *Acid Brass*, initiated in 1996, in which colliery brass bands played arrangements of acid house music. To this end the work, adopting the form of a flow diagram, portrays the history, influence and context for the two very different music forms. In a bold hand 'Acid House' to the left of the wall and 'Brass Bands' to the right of the wall are written and encircled. Arrows lead both to and from these nodes, charting a flow that for instance details the influences on acid house and its own development in terms of bands (such as '808 State', 'Gerald' and 'KLF') as well as effect and sensibility ('E', 'Summers of Love', 'Media Hysteria', 'Free Parties', 'Castlemorton' and 'Civil Unrest'). Brass bands signal 'Civic Pride' and 'Melancholy' as well as 'Deindustrialisation' and 'The Miners Strike', from which it is but an arrow to 'Orgreave' and 'Civil Unrest', which links back across to 'Media Hysteria' and 'Summers of Love'.

While the brass band movement is identified here with the industrial era of the nineteenth century, acid house is a product of the post-industrial late twentieth century. Moreover, at the time that Deller conceived the work, the brass band movement was a poignant survivor of the Thatcherite break-up of the coal industry. *The History of the World* explicitly frames Deller's belief that the miners' strike in the mid 1980s and the start of the acid house movement in the late 1980s were, taken together as here, the most important social phenomena of the last fifteen years of

the century (hence the hyperbole of the work's title). From this perspective, the two musical forms correspondingly exemplify voices that dissent from the prevailing political and social order, and by placing them within the same matrix, the work proposes an index to such dissent and the ways in which it had been articulated.

The History of the World, and its counterpart *Acid Brass*, are both particularly significant works for Deller as they explicitly set up the terms that have continued to determine his artistic practice, which is rooted in a collaboration and engagement with particular communities, revealing his understanding that all forms of popular culture are both socially and politically determining. Instead of making objects, Deller is an artist who curates or facilitates the unfolding of situations between groups of people.

The History of the World exists in four different versions, a working drawing and drawing, both from 1997, that are the source for subsequent versions; an editioned screenprint produced in 1998; and this wall drawing, produced in 2004 and first exhibited as part of Deller's contribution to the exhibition for that year's Turner Prize, which he won. Deller added elements to the original work to bring the wall drawing up to date, so that 'Ibiza' now flows to 'Superclubs'; 'Deindustrialisation' flows to 'Privatisation'; and both flow from 'Advanced Capitalism'. The wall drawing was acquired as a gift to the Tate's collection in 2009 and the following year was shown in the exhibition *Classified* at Tate Britain. AW

Mark Leckey (born Birkenhead 1964)
Made in 'Eaven 2004
Installation. Film 16mm, projection, colour, duration: 1 min., 30 sec. Acquired 2005

Made in 'Eaven 2004 takes the form of a looped 16mm-film projection, presented on a white plinth. The mesmerising film appears to focus on Jeff Koons's iconic stainless steel sculpture of a bunny-shaped balloon, *Rabbit* 1986, placed within an otherwise empty Georgian-style room. The camera moves steadily around the sculpture so that the architecture of the space is warped by its looking-glass lens and the room's fireplace and symmetrical bays are transformed into substitute features reflected on the bunny's blank face. The interior is presented in a variety of different formats, often so that the four walls are flattened into a single plane without any discernible corners. After a while it becomes evident that neither the sculpture nor the room are real but that both have been brought together in a surreal encounter aided by the latest digital technologies. Playing on the tension between weight, material and transcendence, and the merging of high and low culture, this computer-generated construction is a simulacrum, a representation of something that in turn echoes Koons's own image of an inflatable toy.

Leckey's practice encompasses sculpture, sound, film and performance to communicate his fascination with contemporary culture. His interest lies in exploring the potential of the human imagination to appropriate and to animate a concept, an object or an environment. A London-based artist, who grew up in the north of England, Leckey returns frequently to the themes of desire and transformation. The work often explores the artist's own subjective reaction to particular films, images and objects and emphasises the physiological nature of the responses he presents. They are all in a sense self-portraits that offer fragments of the artist's presence – his voice, image or living space. For example, in keeping with much of Leckey's work during this period, the location chosen for this film was the artist's home in the Fitzrovia area of central London. In other films such as *Parade* 2003 and *Shades of the Destructors* 2004, the apartment interior featured alongside imagery that enabled him to explore the city as an epi-centre of fashion, street culture and dandyism. Leckey's fascination with the affective power of images is another recurring theme. Meticulously sourced and reconfigured archival footage is a predominant feature of some of his works. *Fiorucci Made Me Hardcore* 1999 is a seminal exploration of the history of underground dance culture in the UK from the mid-1970s to the early 1990s which also highlights the artist's interest in the themes of desire and transformation. Through the brands of clothing they wear, the way they dance and the drugs they take, the clubbers depicted seek metamorphosis to a state beyond the mundanity of their daily existence.

Made in 'Eaven was included in the British Art Show 6 in 2005, curated by Alex Farquharson and Andrea Schlieker, and the Tate Triennial 2006. CW

Rebecca Warren (born London 1965)
Come, Helga 2006
Clay, wood, steel and Perspex 215.5 × 64.5 × 158. Acquired 2006

Come, Helga 2006 is a work that comprises two standing figures, possibly twins, roughly fashioned from unfired clay and presented under a Perspex cover on a large pale, rose-pink plinth. The figure on the left is unpainted whereas the one on the right has been lightly and partially coloured with white, blue, yellow and pink acrylic. Warren's voluptuous figures have grossly exaggerated breasts and buttocks that are reminiscent of Mesopotamian or other ancient fertility figurines. Like all of Warren's sculpted female figures, including an earlier related work called *The Twins* 2004, the two girls seem cartoon-like. Highly sexualised, their striding poses and comical high heels make clear reference to the sort of clichéd images of the female form associated with male voyeurism.

Warren was originally attracted to working with clay because it has often been excluded from the modernist canon, and offered interesting possibilities as an unfashionable and potentially subversive medium. While artists such as Pablo Picasso, Joan Miró and Lucio Fontana all made works in clay, it is an aspect of their work that has often been seen as secondary. Warren taps into this neglected history, but her use of clay also signals a concern with the materiality of sculpture. The roughly modelled figures are made from clumped pieces of clay that have been simply left to dry. Although there is clearly an element of working and reworking of form, the overall impression is of primal vitality.

Warren's exuberant female forms, which often concentrate on particular parts of the human body such as the legs, are drawn from a variety of sources from Degas to Helmut Newton and Robert Crumb, from books, magazine photographs and popular culture in general, and she openly acknowledges these references. As she explains, 'It's about finding a way to be expressive. Expression is perceived as a problem. One way of negotiating that is to reuse existing idioms that are accepted as being expressive, for instance Auguste Rodin, Willem de Kooning or Otto Dix.' Poised between parody and celebration, if Warren's work can be understood as questioning the politics of representation and sexual stereotypes, she does so in a way that is deliberately ambiguous. Part of the strength of these works is the artist's use of the grotesque, which has always been strongly associated with ludicrous exaggeration or distortion. Loaded with references and visual resonance, Warren's sculptures can be understood as exuberant celebrations of materiality.

An important aspect of Warren's work is the titling, in which she often makes references that seem familiar. In the case of *Come, Helga* the artist has described how she wanted the title to reflect the sense of conversation between the two figures – one commanding the other to stride forward.

The work was acquired for the Tate's collection after being exhibited at Tate Britain in the 2005 Tate Triennial curated by Beatrix Ruff, Katharine Stout and Clarrie Wallis. It was one of a group of works by Warren centred in the Duveen Galleries. CW

Eva Rothschild (born Dublin 1971)
Legend 2009
Powder-coated aluminium and Perspex 288 × 220 × 210. Acquired 2010

Legend is a floor-based sculpture comprised of three triangular flat Perspex planes that are perforated by circles of various sizes and connected to each other by linear elements that zigzag around and between them. All parts are black, and the shiny, dark surfaces of the Perspex planar elements reflect the linear components, creating the optical illusion of a complex physical structure. Austere and fragile, the work functions as a drawing in space, never fully abstract or representational.

Interested in the relationship between volume and mass, skin and structure, surface and edge, Rothschild creates forms that embody her fascination in the spiritual and ritualistic qualities of objects. Her practice suggests both the spirit of hippie or new age culture and the hard-edged character of minimalism. This results from her use of both industrial processes and traditional craft; her use of tough materials associated with minimalist sculpture together with, for example, leather, paper or incense sticks. The structure of *Legend* suggests that of a pyramid, a form that recurs frequently in Rothschild's work. The pyramid interests Rothschild in part because of the strong associations it triggers in terms of its historical architectural uses, but also because it is a form that carries 'a kind of intrinsic rightness or presence'. Rothschild has described how, at the same time as invoking familiar structures, she seeks to thwart the expectation that such forms are instantly knowable:

> Ideally, I want the works to engage and confuse the eye, and for this confusion to allow a kind of hard looking to occur where the eye and the brain become aware of looking as a way of understanding a confused or deceptive materiality. Within this mode of looking there is also the hoped-for possibility of a kind of transcendent view, whereby belief in the possibilities of art, magic and transformation of both materials and ourselves as the viewer may, even momentarily, occur.

The colour of *Legend* is significant in that it is the colour Rothschild has used in her work more than any other. In 2010 she commented: '[black] has been more consistently present in my work for the past 10 years than any other element. Black defines the space a sculpture occupies, and in its different surfaces, matt or glossy, it can be deployed to create illusions of depth and reflectivity.' Rothschild introduces further associative references in her work through the titles she chooses. She has referred to the 'sense of underlying narrative' elicited by the titles, which prompts associations beyond the formal concerns of her sculpture.

Rothschild came to prominence in the early 2000s; her works were included in the exhibition *Early One Morning* at Whitechapel Art Gallery in 2002, which sought to identify a new generation of British sculptors whose work was largely abstract in composition, but varied greatly in style and formal register. *Legend* was created in the same year as Rothschild's 2009 Duveens Commission at Tate Britain, *Cold Corners*, in which she erected twenty-six interconnected triangles that stretched the length and breadth of the gallery. Both works resonate with the artist's interest in utilising shape to create illusions of space and depth. HD

Tomma Abts (born Kiel, Germany 1967)
Zebe 2010
Acrylic paint and oil paint on canvas 48 × 38. Acquired 2011

Tomma Abts's painting *Zebe* 2010 features blocks of red and green directional stripes that abut each other to cover the surface, creating a perpetual feeling of movement. At its centre two blocks of stripes meet in slight misalignment. Pale curvilinear shapes, mirrored diagonally across the painting, appear to float over the surface, but have in fact been created by exposing areas left untouched since transparent acrylic wash was first applied to the canvas. *Zebe* exemplifies many features that recur in Abts's painting: areas revealing a veil of wash on canvas, acting as a 'window' back through time; the use of shadowing to produce a three dimensional effect; and optical experiments created by the gradual fading of tones from dark to light.

Since 1998 Abts's paintings have conformed to a modest format of 48 × 38 centimetres. She uses no source materials and has no preconceived notion of the final composition. Instead, she begins by freely covering the surface of the canvas with loose, thin washes of bright acrylic paint to create an activated platform onto which layers of oil paint are then methodically applied. Forms and shapes gradually emerge and mutate through a continual process of readjustment. Starting from a point of abstraction, the internal logic of each composition unfolds to guide a series of decisions in which shapes are defined, buried and rediscovered. Abts works from inside out, blocking in areas around delineated forms. Where corresponding areas of paint accumulate at differing speeds, rifts and seams appear, extending outwards from the shapes' edges as if marking their own trajectory beneath the surface. Bearing the visible traces of their construction, the finished pictures are described by Abts as 'a concentrate of the many paintings underneath'.

Zebe might on first appearance seem to suggest a formal relationship to the abstract paintings of Bridget Riley and other op artists of the 1960s. Yet, like all Abts's paintings, the composition has evolved according to its own generative logic and does not refer to anything beyond the confines of the canvas. In Abts's paintings abstract elements might occasionally hover on the periphery of representation – perhaps alluding to objects situated within a semi-defined space – but are then disrupted by the artificial tonal scale or incongruous perspective. In this way, Abts is engaged in a continual game of push and pull, of abiding by and testing out her own self-imposed restrictions, until the painting becomes, in the artist's words, 'congruent with itself'.

Born in Kiel, Germany, Abts has lived and worked in London since the mid-1990s. In 2006 she was awarded the Turner Prize. *Zebe* was presented to the Tate's collection by Tate Members in 2011, after being shown at Greengrassi, London. LC-T

Chronology

1531 Henry VIII named Protector and Supreme
 Head of Church in England

1534 Act of Supremacy confirms Reformation

1536 Dissolution of Monasteries begins under
 Thomas Cromwell
 Anti-Reformation 'Pilgrimage of Grace'
 Union of England and Wales
 Hans Holbein appointed Court Painter

1538 Destruction of religious shrines including
 Beckett's at Canterbury

1539 Coverdale's *Great Bible* in English published

1540 Execution of Thomas Cromwell

1543 Death of Hans Holbein

1545 John Bettes, *Unknown Man in a Black Cap*,
 earliest painting in Tate Collection (p.10)
 Council of Trent begins Counter-Reformation
 (concludes 1563)

1547 Accession of Edward VI with Lord Somerset
 as Protector

1549 First Book of Common Prayer

1550–3 Height of first wave of iconoclasm in England

1553 Accession of Mary I who reintroduces
 Catholicism

1555 Start of burning of heretics ('Protestant
 Martyrs'); Thomas Cranmer burned

1558 Accession of Elizabeth I

1563 First edition of *John Foxe Book of Martyrs*
 Cecil's draft decree on royal images

1574 First Jesuits arrive in England

1577–80 Drake's circumnavigation of the globe

1581 Painter-Stainers' Company granted royal charter

1586 William Camden *Britannia* published, an
 influential antiquarian study of Britain

1588 Defeat of Spanish Armada

1603 Accession of James I and beginning of
 Stuart dynasty

1611 Authorised ('King James') version of Bible
 published

1618–22 Inigo Jones builds Banqueting House, Whitehall

1620 *Mayflower* Puritan ship sails to America

1623 First Folio of Shakespeare's plays

1625 Accession of Charles I

1629 Charles dissolves Parliament until 1640
 Rubens begins work on paintings for
 Banqueting House (see p.17)

1632 Anthony van Dyck settles in London
 First coffee shop opens in London

1640 'Long Parliament' called

1641 Death of van Dyck

1642–9 Civil War
 Second wave of iconoclasm

1649–60 Execution of Charles I in 1649 is followed
 by a Republic under Oliver Cromwell
 Second wave of iconoclasm in England

1660 Restoration of monarchy and accession
 of Charles II

1662 Restoration of Church of England
 Royal Society receives charter

1666 Great Fire of London; followed by rebuilding
 and rapid expansion of London

1679–81 Emergence of 'Whig' and 'Tory' parties

1688 'Glorious Revolution' and accession of William III
 and Mary II

1702	Accession of Anne following settlement leading to Hanoverian dynasty
1707	Union of England and Scotland
1708–12	Thornhill's paintings at Greenwich
1712	Sir Godfrey Kneller's Academy, London founded
1714	Accession of George I
1715	First Jacobite Rebellion defeated
	Jonathan Richardson *Essay on the Theory of Painting* published
1718	Thornhill's Academy, London founded
1720	'South Sea Bubble' financial crash
	John Vanderbank's Academy, London founded
1727	Accession of George II
1733	Society of Dilettanti founded to encourage connoisseurship and art collecting
1735	St Martin's Lane Academy, London, founded by Hogarth and others
	Engraver's ('Hogarth's') Copyright Act
1738	Beginnings of Methodism
1744	Samuel Baker's first auction of books – firm later becomes Sotheby's
1745	Second Jacobite Rebellion. Failure results in end of Stuart hopes
1753	William Hogarth *The Analysis of Beauty* published
1754	Society of Arts founded
1756–63	Seven Years' War between Britain and France – first 'world war'
1757	Edmund Burke *Philosophical Enquiry* published on ideas of sublime and beautiful
	British Museum founded
1760	Accession of George III
	First Society of Artists exhibition in London
1764	William Hogarth dies
1766	George Stubbs *Anatomy of the Horse* published
	James Christie's first sale of artworks
1768	Royal Academy founded
1770	Captain Cook arrives at Botany Bay
1776–81	American War of Independence
1780	Anti-Catholic Gordon Riots in London
1789	French Revolution starts
1792	Mary Wollstonecraft *Vindication of Rights of Women* published
	Joshua Reynolds dies
1793–1815	War with France
1798	Irish Rebellion
	Joshua Reynolds *Discourses* published

1800	Act of Union with Ireland
1801	First Census
	Population of UK 10.4 million (USA 5.3 million)
1803–12	Elgin Marbles transferred to British Museum
1805	Battle of Trafalgar
	British Institution for the Development of the Fine Arts founded
1807	Abolition of slave trade
1811	Regency begins
	Luddite disturbances against new machinery
1814	George Stephenson builds first steam locomotive
1815	Defeat of Napoleon at Battle of Waterloo
	Controversial Corn Laws passed
1819	Peterloo massacre by militia of political reform demonstrators in Manchester
	First iron steamship launched
1820	Accession of George IV
1824	John Constable's *Haywain* shown and highly regarded at Paris Salon
	National Gallery, London founded
1829	Catholic Emancipation
	Metropolitan Police founded
1831	'Swing' agricultural riots
1832	Great Reform Bill enlarges franchise
1834	Slavery abolished in British Empire
1837	Accession of Queen Victoria
	Death of John Constable
	School of Design (later Royal College of Art) founded
1839	W. H. Fox Talbot publishes a photographic negative
	Chartist riots in Britain
1840–52	Charles Barry and A.W.N. Pugin, Houses of Parliament
1844–6	Famines in Ireland
	'Railway Mania'
1848	Revolutions in France and elsewhere in Europe
	Karl Marx and Friedrich Engels *Communist Manifesto* published
	Founding of Pre-Raphaelite Brotherhood
1851	Great Exhibition, London
	Death of J.M.W. Turner
1852	Victoria and Albert Museum opens
1857–65	Transatlantic cable laid
1857	National Portrait Gallery, London opens
1859	Charles Darwin *Origin of Species* published
1861	UK population 23.1 million (USA 32 million)
	Death of Prince Albert
1867	Reform Act further widens franchise
1870	Elementary Education Act
1871	Slade School of Fine Art, London opens
1879	Public granted unlimited access to British Museum
1881	Population of London is 3.3 million
1895	National Trust founded
1896	First cinema opens in London
1897	Tate Gallery opens
1899	Magnetic recording of sound invented
	Start of Boer War

1901	Accession of Edward VII
	UK population 41.4 million (USA 75.9 million)
1910	Accession of George V
1914–18	First World War
1922	BBC founded
1926	General Strike in Britain
	Council for Preservation of Rural England founded
1929	World Financial Crash
1933	Hitler comes to power in Germany
1936	Accession and abdication of Edward VIII
	Accession of George VI
1938	Munich Crisis
1939–45	Second World War
1940	Beginning of Blitz (–1941)
	Council for Encouragement of Music and Arts founded, becomes Arts Council at end of war
1945	Dropping of first atom bomb on Hiroshima
	Labour landslide victory at General Election
1947	Nationalisation of coal and other industries in Britain
1948	West Indian immigrants begin to arrive in Britain
1951	UK population 50 million (USA 153 million)
	Festival of Britain on South Bank, London
1952	Accession of Elizabeth II
	First hydrogen bomb exploded
1956	Suez Crisis
1957	USSR launches 'Sputnik I'
1962	Cuban Missile Crisis and serious international tension and fear of nuclear war
	Commonwealth Immigrants Act limits immigration to Britain
1964	Harold Wilson Prime Minister of new Labour government
1966	Cultural Revolution in China
1968	Student riots in Paris
1969	First moon landing
	Ulster Troubles begin
1973	UK enters European Community
	USA withdraws from Vietnam
1979	Margaret Thatcher Prime Minister of new Conservative government
1981	Riots in Toxteth, Liverpool lead to plans for urban regeneration
1982	Falklands War
1984	Miners' strike in Britain
1989	Collapse of communism in Eastern Europe
1990	Gulf War
1994	Church of England ordains first women priests
1997	Labour Government elected
	English scientists clone a sheep
1998	National Assembly for Wales established
1999	Scottish Parliament established
2000	Tate Modern opens at Bankside. The Tate Gallery at Millbank becomes Tate Britain
2001	UK population 58.7 million (USA 285 million)
	Terrorist suicide attacks on New York and Washington
	Invasion of Afghanistan, led by US and UK forces
2003	Invasion of Iraq, led by US and UK forces
2008	Peak of global financial crisis
2011	Welsh Assembly gains direct law-making powers
2012	Diamond Jubilee of Elizabeth II
	Legal framework agreed for future referendum on Scottish independence

List of Works

John Bettes
A Man in a Black Cap 1545
Purchased 1897 *p.10*

Hans Eworth
An Unknown Lady c.1565–8
Purchased with assistance from the
Friends of the Tate Gallery 1984 *p.11*

Marcus Gheeraerts the Younger
Portrait of Captain Thomas Lee 1594
Purchased with assistance from the
Friends of the Tate Gallery, the Art Fund
and the Pilgrim Trust 1980 *p.12*

British School
An Allegory of Man 1596 or after
Presented by the Patrons of
British Art 1990 *p.14*

British School seventeenth century
The Cholmondeley Ladies c.1600–10
Presented anonymously 1955 *p.15*

Nathaniel Bacon
*Cookmaid with Still Life of Vegetables
and Fruit* c.1620–5
Purchased with assistance from
The Art Fund 1995 *p.16*

Peter Paul Rubens
*The Apotheosis of James I and Other
Studies: Multiple Sketch for the Banqueting
House Ceiling, Whitehall* c.1628–30
Purchased with assistance from the
National Heritage Memorial Fund, Tate
Members, the Art Fund in memory of Sir
Oliver Millar (with a contribution from
the Wolfson Foundation), Viscount and
Viscountess Hampden and Family,
Monument Trust, Manny and Brigitta
Davidson and the Family and other
donors 2008 *p.17*

Anthony van Dyck
Portrait of Sir William Killigrew 1638
Accepted by HM Government in lieu
of tax with additional payment made
with assistance from the Art Fund, the
Patrons of British Art and Christopher
Ondaatje 2002 *p.18*

Anthony van Dyck
Portrait of Mary Hill, Lady Killigrew 1638
Purchased with assistance from the
Art Fund, Tate Members and the bequest
of Alice Cooper Creed 2003 *p.18*

William Dobson
Endymion Porter c.1642–5
Purchased 1888 *p.19*

Henry Gibbs
*Aeneas and his Family Fleeing
Burning Troy* 1654
Purchased 1994 *p.20*

Peter Lely
Two Ladies of the Lake Family c.1660
Purchased with assistance from
the Art Fund 1955 *p.21*

Gilbert Soest
*Portrait of Henry Howard,
6th Duke of Norfolk* c.1670–5
Purchased 1965 *p.22*

Godfrey Kneller
Elijah and the Angel 1672
Purchased 1954 *p.24*

Mary Beale
Study of a Young Girl c.1679–81
Purchased 1992 *p.25*

John Michael Wright
Sir Neil O'Neill 1680
Purchased with assistance
from the Art Fund 1957 *p.26*

Jan Siberechts
*Landscape with Rainbow,
Henley-on-Thames* c.1690
Presented by the Friends of
the Tate Gallery 1967 *p.27*

Edward Collier
*Still Life with a Volume of Wither's
'Emblemes'* 1696
Purchased 1949 *p.28*

Philip Mercier
*The Schutz Family and their Friends
on a Terrace* 1725
Purchased 1980 *p.30*

Andrea Soldi
*Portrait of Henry Lannoy Hunter in Turkish
Dress, Resting from Hunting* 1733–6
Purchased with assistance from
Tate Patrons and the Art Fund 2004 *p.31*

Joseph Highmore
Mr Oldham and his Guests c.1735–45
Purchased 1948 *p.32*

Francis Hayman
*Samuel Richardson, the Novelist
(1684–1761), Seated, Surrounded by
his Second Family* 1740–1
Purchased with assistance from the
National Heritage Memorial Fund,
the Art Fund (with a contribution
from the Wolfson Foundation) and
Tate Members 2006 *p.33*

Allan Ramsay
*Thomas 2nd Baron Mansel, with his
Blackwood Half-brothers and Sister* 1742
Purchased with assistance from the
National Heritage Memorial Fund,
the Art Fund (Woodroffe Bequest),
the Friends of the Tate Gallery,
The *Mail on Sunday* through the
Friends of Tate Gallery, Arthur Young,
Mrs Sue Hammerson and others
1988 *p.34*

William Hogarth
The Painter and his Pug 1745
Purchased 1824 *p.36*

Thomas Gainsborough
*Wooded Landscape with a Peasant
Resting* c.1747
Purchased 1889 *p.37*

William Hogarth
*O the Roast Beef of Old England
('The Gate of Calais')* 1748
Presented by the Duke of Westminster
1895 *p.38*

Samuel Scott
An Arch of Westminster Bridge c.1750
Purchased 1970 *p.39*

Johan Zoffany
Three Sons of John, 3rd Earl of Bute c.1763–4
Accepted by HM Government in lieu
of tax with additional payment (General
Funds) made with assistance from the
National Lottery through the Heritage
Lottery Fund, the Art Fund and Tate
Members 2002 *p.40*

George Stubbs
Mares and Foals in a River Landscape
c.1763–8
Purchased with assistance from
the Pilgrim Trust 1959 *p.41*

Tilly Kettle
*Mrs Yates as Mandane in 'The Orphan
of China'* 1765
Purchased with assistance from the
Friends of the Tate Gallery 1982 *p.42*

Benjamin West
*Pylades and Orestes Brought as Victims
before Iphigenia* 1766
Presented by Sir George Beaumont Bt
1826 *p.43*

Joshua Reynolds
Colonel Acland and Lord Sydney:
The Archers 1769
Purchased (Building the Tate Collection
fund) with assistance from the National
Heritage Memorial Fund, Tate Members,
the Art Fund (with a contribution from
the Wolfson Foundation) and other
donors 2005 *p.45*

Joseph Wright
An Iron Forge 1772
Purchased with assistance from the
National Heritage Memorial Fund,
the Art Fund and the Friends of the
Tate Gallery 1992 *p.46*

Angelika Kauffmann
Portrait of a Lady c.1775
Presented by Mrs M. Bernard 1967 *p.47*

George Romney
Mrs Johnstone and her Son (?) c.1775–80
Bequeathed by Maj.-Gen. John Julius
Johnstone 1898 *p.48*

Joseph Wright
Sir Brooke Boothby 1781
Bequeathed by Miss Agnes Ann Best
1925 *p.49*

Thomas Gainsborough
Giovanna Baccelli exh.1782
Purchased with assistance from the
Friends of the Tate Gallery 1975 *p.50*

John Singleton Copley
The Death of Major Peirson, 6 January 1781
1783
Purchased 1864 *p.52*

Johan Zoffany
Colonel Mordaunt's Cock Match c.1784–6
Purchased with assistance from the
National Heritage Memorial Fund,
the Art Fund, the Friends of the Tate
Gallery and a group of donors 1994 *p.53*

George Stubbs
Reapers 1785
Haymakers 1785
Purchased with assistance from the
Friends of the Tate Gallery, the Art Fund,
the Pilgrim Trust and subscribers 1977
p.54

Henry Fuseli
Titania and Bottom with the Ass's Head
exh.1789
Presented by Miss Julia Carrick Moore
in accordance with the wishes of her
sister 1887 *p.56*

William Blake
Newton 1795–c.1805
Presented by W. Graham Robertson 1939
p.57

Philip James de Loutherbourg
The Battle of Camperdown 1799
Purchased with assistance from the
Friends of the Tate Gallery 1971 *p.58*

Henry Raeburn
Lieutenant-Colonel Bryce McMurdo
c.1800–10
Bequeathed by Gen. Sir Montagu
McMurdo 1895 *p.59*

Thomas Lawrence
Mrs Siddons 1804
Presented by Mrs C. Fitzhugh 1843
p.60

David Wilkie
The Village Holiday 1809–11 exh.1812
Purchased 1824 *p.62*

John Constable
Flatford Mill ('Scene on a Navigable
River') exh.1817, 1818
Bequeathed by Miss Isabel Constable
as the gift of Maria Louisa, Isabel
and Lionel Bicknell Constable 1888
p.63

Joseph Mallord William Turner
The Field of Waterloo exh.1818
Accepted by the nation as part
of the Turner Bequest 1856 *p.64*

John Gibson
Hylas Surprised by the Naiades
1826–c.1836
Presented by Robert Vernon 1847
p.65

John Simpson
Head of a Man (Ira Frederick Aldridge?)
exh.1827
Presented by Robert Vernon 1847 *p.66*

John Constable
Sketch for 'Hadleigh Castle' c.1828–9
Purchased 1935 *p.67*

Benjamin Robert Haydon
Punch or *May Day* exh.1830
Bequeathed by George Darling 1862 *p.68*

Joseph Mallord William Turner
Caligula's Palace and Bridge exh.1831
Accepted by the nation as part
of the Turner Bequest 1856 *p.69*

William Etty
Standing Female Nude c.1835–40
Presented by the Art Fund 1941 *p.70*

William Dyce
Madonna And Child c.1838
Bequeathed by Colonel Ernest Carrick
Freeman 1963 *p.72*

William Mulready
The Ford ('Crossing the Ford') exh.1842
Presented by Robert Vernon 1847 *p.73*

Edwin Henry Landseer
Shoeing exh.1844
Bequeathed by Jacob Bell 1859 *p.74*

Dante Gabriel Rossetti
The Girlhood of Mary Virgin 1848–9
Bequeathed by Lady Jekyll 1937 *p.75*

John Everett Millais
Ophelia 1851–2
Presented by Sir Henry Tate 1894 *p.76*

John Martin
The Great Day of His Wrath 1851–3
Purchased 1945 *p.77*

William Holman Hunt
Our English Coasts ('Strayed Sheep') 1852
Purchased for the nation by the
Art Fund in 1946 *p.78*

Ford Madox Brown
Jesus Washing Peter's Feet 1852–6
Presented by subscribers 1893 *p.79*

Richard Dadd
The Fairy Feller's Master-Stroke 1855–64
Presented by Siegfried Sassoon in 1963 in
memory of his friend and fellow officer
Julian Dadd, a great-nephew of the artist,
and of his two brothers who gave their
lives in the First World War *p.80*

Arthur Hughes
April Love 1855–6
Purchased 1909 *p.82*

Henry Wallis
Chatterton 1856
Bequeathed by Charles Gent Clement
1899 *p.83*

William Powell Frith
The Derby Day 1856–8
Bequeathed by Jacob Bell 1859 *p.84*

William Morris
La Belle Iseult 1856–8
Bequeathed by Miss May Morris
1939 *p.86*

Emily Mary Osborn
Nameless and Friendless. 'The rich man's wealth is his strong city, etc.'– Proverbs, x.15 1857
Purchased with assistance from Tate Members, the Estate of Paul Edwin Millwood and a private donor 2009 *p.87*

Augustus Leopold Egg
Past and Present, Nos.1–3 1858
Presented by Sir Alec and Lady Martin in memory of their daughter Nora 1918 *p.88*

William Maw Egley
Omnibus Life in London 1859
Bequeathed by Miss J.L.R.Blaker 1947 *p.90*

John Brett
Lady with a Dove: Madame Loeser 1864
Presented by Lady Holroyd in accordance with the wishes of the late Sir Charles Holroyd 1919 *p.92*

John Frederick Lewis
The Courtyard of the Coptic Patriarch's House in Cairo c.1864
Purchased 1900 *p.94*

Dante Gabriel Rossetti
Monna Vanna 1866
Purchased with assistance from Sir Arthur Du Cros Bt and Sir Otto Beit KCMG through the Art Fund 1916 *p.95*

Albert Moore
A Garden 1869
Purchased with assistance from the Friends of the Tate Gallery 1980 *p.96*

Alphonse Legros
Rehearsing the Service c.1870
Bequeathed by Rev. A. Stopford Brooke 1916 *p.97*

James Abbott McNeill Whistler
Nocturne: Blue and Silver – Chelsea 1871
Bequeathed by Miss Rachel and Miss Jean Alexander 1972 *p.99*

Cecil Gordon Lawson
The Hop Gardens of England 1874, reworked 1879
Purchased with assistance from Tate Members 2012 *p.100*

James Tissot
The Ball on Shipboard c.1874
Presented by the Trustees of the Chantrey Bequest 1937 *p.101*

Frederic Leighton
An Athlete Wrestling with a Python 1877
Presented by the Trustees of the Chantrey Bequest 1877 *p.102*

Edward Coley Burne-Jones
The Golden Stairs 1880
Bequeathed by Lord Battersea 1924 *p.104*

George Frederic Watts
The Minotaur 1885
Presented by the artist 1897 *p.106*

John Singer Sargent
Carnation, Lily, Lily, Rose 1885–6
Presented by the Trustees of the Chantrey Bequest 1887 *p.107*

Théodore Roussel
The Reading Girl 1886–7
Presented by Mrs Walter Herriot and Miss R. Herriot in memory of the artist 1927 *p.108*

William Blake Richmond
Portrait of Mrs Ernest Moon 1888
Presented by the Patrons of British Art through the Tate Gallery Foundation 1996 *p.110*

John William Waterhouse
The Lady of Shalott 1888
Presented by Sir Henry Tate 1894 *p.111*

George Clausen
Girl at a Gate 1889
Presented by the Trustees of the Chantrey Bequest 1890 *p.112*

Edward Onslow Ford
The Singer 1889
Presented by Sir Henry Tate 1894 *p.114*

John Singer Sargent
Ellen Terry as Lady Macbeth 1889
Presented by Sir Joseph Duveen 1906 *p.115*

Walter Richard Sickert
Minnie Cunningham at the Old Bedford 1892
Purchased 1976 *p.116*

Herbert Draper
The Lament for Icarus 1898
Presented by the Trustees of the Chantrey Bequest 1898 *p.118*

William Rothenstein
The Doll's House 1899–1900
Presented by C.L. Rutherston 1917 *p.119*

William Orpen
The Mirror 1900
Presented by Mrs Coutts Michie through the Art Fund in memory of the George McCulloch Collection 1913 *p.120*

Gwen John
Dorelia in a Black Dress c.1903–4
Presented by the Trustees of the Duveen Paintings Fund 1949 *p.121*

Augustus John
Woman Smiling 1908–9
Presented by the Contemporary Art Society 1917 *p.122*

Lawrence Alma-Tadema
A Favourite Custom 1909
Presented by the Trustees of the Chantrey Bequest 1909 *p.124*

J.D. Fergusson
The Blue Beads 1910
Presented by the Friends of the Tate Gallery 1964 *p.125*

Eric Gill
Ecstasy 1910–11
Purchased 1982 *p.126*

Vanessa Bell
Studland Beach c.1912
Purchased 1976 *p.128*

Henri Gaudier-Brzeska
Red Stone Dancer c.1913
Presented by C. Frank Stoop through the Contemporary Art Society 1930 *p.129*

Jacob Epstein
Torso in Metal from 'The Rock Drill' 1913–16
Purchased 1960 *p.130*

David Bomberg
The Mud Bath 1914
Purchased 1964 *p.131*

Wyndham Lewis
Workshop c.1914–15
Purchased 1974 *p.132*

Stanley Spencer
Swan Upping at Cookham 1915–19
Presented by the Friends of the Tate Gallery 1962 *p.133*

Mark Gertler
Merry-Go-Round 1916
Purchased 1984 *p.134*

Matthew Smith
Nude, Fitzroy Street, No.1 1916
Presented by the Trustees
of the Chantrey Bequest 1952 *p.136*

Harold Gilman
Mrs Mounter at the Breakfast Table
exh.1917
Purchased 1942 *p.138*

Winifred Knights
The Deluge 1920
Purchased with assistance from
the Friends of the Tate Gallery 1989
p.139

C.R.W. Nevinson
*The Soul of the Soulless City ('New York
– an Abstraction')* 1920
Presented by the Patrons of British Art
through the Tate Gallery Foundation
1998 *p.140*

William Roberts
The Cinema 1920
Purchased 1965 *p.142*

Glyn Warren Philpot
Repose on the Flight into Egypt 1922
Purchased 2004 *p.144*

Alfred Munnings
Their Majesties' Return from Ascot 1925
Presented by the Trustees of
the Chantrey Bequest 1937 *p.145*

Alfred Wallis
St Ives c.1928
Presented by Ben Nicholson 1966 *p.146*

Edward Burra
The Snack Bar 1930
Purchased 1980 *p.147*

Christopher Wood
Zebra and Parachute 1930
Accepted by HM Government in
lieu of inheritance tax and allocated
to Tate 2004 *p.148*

Dora Gordine
Javanese Head 1931
Presented by the Hon. Richard Hare 1933
p.149

Walter Richard Sickert
*Miss Gwen Ffrangcon-Davies as Isabella
of France* 1932
Presented by the Art Fund, the
Contemporary Art Society and C. Frank
Stoop through the Contemporary Art
Society 1932 *p.150*

Meredith Frampton
Portrait of a Young Woman 1935
Presented by the Trustees of
the Chantrey Bequest 1935 *p.152*

Paul Nash
Equivalents for the Megaliths 1935
Purchased 1970 *p.153*

Ben Nicholson
1935 (white relief) 1935
Purchased with assistance from the
Contemporary Art Society 1955 *p.154*

Eileen Agar
Angel of Anarchy 1936–40
Presented by the Friends of
the Tate Gallery 1983 *p.155*

Ithell Colquhoun
Scylla 1938
Purchased 1977 *p.156*

Barbara Hepworth
Forms in Echelon 1938
Presented by the artist 1964 *p.157*

Graham Sutherland
Green Tree Form: Interior of Woods 1940
Purchased 1940 *p.158*

Naum Gabo
Spiral Theme 1941
Presented by Miss Madge Pulsford 1958
p.159

Francis Bacon
*Three Studies for Figures at the
Base of a Crucifixion* c.1944
Presented by Eric Hall 1953 *p.160*

Evelyn Dunbar
A Land Girl and the Bail Bull 1945
Presented by the War Artists Advisory
Committee 1946 *p.161*

Lucian Freud
Girl with a Kitten 1947
Bequeathed by Simon Sainsbury 2006,
accessioned 2008 *p.162*

L.S. Lowry
The Old House, Grove Street, Salford 1948
Purchased 1951 *p.164*

Alan Davie
Entrance to a Paradise 1949
Purchased 1972 *p.165*

Henry Moore
Reclining Figure: Festival 1951
Presented by the artist 1978 *p.166*

Marlow Moss
*Balanced Forms in Gunmetal
on Cornish Granite* 1956–7
Presented by Miss Erica Brausen 1969
p.167

Gillian Ayres
Break-off 1961
Purchased 1973 *p.168*

Victor Pasmore
Black Abstract 1963
Purchased 1963 *p.169*

Anwar Jalal Shemza
Chessmen One 1961
Purchased 2010 *p.170*

Anthony Caro
Early One Morning 1962
Presented by the Contemporary Art
Society 1965 *p.172*

Roger Hilton
Oi Yoi Yoi 1963
Purchased 1974 *p.173*

Bridget Riley
Hesitate 1964
Presented by the Friends of
the Tate Gallery in 1985 *p.174*

Peter Blake
*Portrait of David Hockney in
a Hollywood Spanish Interior* 1965
Presented by David Hockney 2002
p.175

Patrick Caulfield
Battlements 1967
Purchased 1967 *p.176*

David Hockney
A Bigger Splash 1967
Purchased 1981 *p.177*

Richard Long
A Line Made by Walking 1967
Purchased 1976 *p.178*

Frank Auerbach
Primrose Hill 1967–8
Purchased 1971 *p.179*

Susan Hiller
Dedicated to the Unknown Artists 1972–6
Purchased with assistance from
the Art Fund 2012 *p.180*

John Latham
*One Second Drawing 17" 2002
(Time Signature 5:1)* 1972
Presented by the artist 1976 *p.181*

Tony Cragg
Stack 1975
Purchased 1997 *p.182*

Gilbert & George
England 1980
Purchased 1981 *p.183*

Richard Hamilton
The citizen 1981–3
Purchased 1985 *p.184*

Richard Deacon
For Those Who Have Ears No.2 1983
Presented by the Patrons of New Art
through the Friends of the Tate Gallery
1985 *p.185*

Bill Woodrow
Elephant 1984
Presented by Janet Wolfson de Botton
1996 to celebrate the Tate Gallery
Centenary 1997 *p.186*

Howard Hodgkin
Rain 1984–9
Purchased 1990 *p.187*

Mark Wallinger
Where There's Muck 1985
Purchased with assistance from
the Millwood Legacy 2009 *p.188*

Mona Hatoum
Performance Still 1985, printed 1995
Presented by Tate Patrons 2012 *p.189*

Leon Kossoff
Christ Church, Spitalfields, Morning 1990
Purchased 1994 *p.190*

Damien Hirst
The Acquired Inability to Escape 1991
Presented by the artist 2007 *p.191*

Gary Hume
Incubus 1991
Presented by Janet Wolfson de Botton
1996 *p.192*

Steve McQueen
Bear 1993
Presented by the Patrons of New Art
(Special Purchase Fund) through
the Tate Gallery Foundation 1996 *p.193*

Peter Doig
Ski Jacket 1994
Purchased with assistance from Evelyn,
Lady Downshire's Trust Fund 1995 *p.194*

Rachel Whiteread
Untitled (Floor) 1994–5
Purchased 1996 *p.195*

Sarah Lucas
Pauline Bunny 1997
Presented by the Patrons of New Art
(Special Purchase Fund) through
the Tate Gallery Foundation 1998 *p.196*

Wolfgang Tillmans
chaos cup 1997, from *if one thing matters,
everything matters, installation room 2*
1995–1997 2003
Presented by Tate Patrons 2007 *p.197*

Chris Ofili
No Woman, No Cry 1998
Purchased 1999 *p.198*

Tacita Dean
Fernsehturm 2001
Purchased 2002 *p.199*

Jake and Dinos Chapman
Chapman Family Collection 2002
Purchased with assistance from
the Art Fund, Tate Members, Tate
Fund, the Manton Fund and private
donors 2008 *p.200*

Richard Wright
Untitled 2002
Purchased with funds provided by the
Nicholas Themans Trust 2010 *p.202*

Jeremy Deller
The History of the World 1997–2004
Presented by The Cranford Collection
2009 *p.204*

Mark Leckey
Made in 'Eaven 2004
Purchased using funds provided by
the 2004 Outset / Frieze Art Fair Fund
to benefit the Tate collection 2005 *p.205*

Rebecca Warren
Come, Helga 2006
Presented by Tate Patrons 2006 *p.206*

Eva Rothschild
Legend 2009
Presented by Tate Patrons 2010 *p.208*

Tomma Abts
Zebe 2010
Presented by Tate Members 2011 *p.210*

Index of Artists

Copyright

Photography credits

First published 2013 by order of the Tate Trustees
by Tate Publishing, a division of Tate Enterprises Ltd,
Millbank, London SW1P 4RG
www.tate.org.uk/publishing

A catalogue record for this book is available
from the British Library

ISBN 978 1 84976 033 1

Distributed in the United States and Canada
by ABRAMS, New York

Library of Congress Control Number applied for

Designed by John Morgan studio

Colour reproduction by Evergreen, Hong Kong
Printed in Italy by Gruppo Editoriale Zanardi srl

Front and back covers: Interior views of Tate Britain,
2013. Photo: Lucy Dawkins, Tate Photography

Measurements of artworks are given in centimetres,
height before width